OUR GANG

OUR GANG

A RACIAL HISTORY OF
THE LITTLE RASCALS

Julia Lee

FOREWORD BY
Henry Louis Gates Jr.

University of Minnesota Press
Minneapolis | London

This book is dedicated to Michael and B Hoskins and Lucy and Bobby Sonneborn.

The publication of this book was assisted by a bequest from Josiah H. Chase to honor his parents, Ellen Rankin Chase and Josiah Hook Chase, Minnesota territorial pioneers.

The University of Minnesota Press gratefully acknowledges financial assistance for the publication of this book from the College of Liberal Arts, University of Nevada, Las Vegas.

"Tableau" by Countee Cullen, reprinted in chapter 6, was originally published in *Color* by Countee Cullen. Copyright 1925 by Harper & Bros.; renewed 1954 by Ida Cullen. Copyrights held by the Amistad Research Center, Tulane University. "One Today," by Richard Blanco, quoted in the epigraph to the Epilogue, was the inaugural poem read at the second inauguration of President Barack Obama in January 2013.

Published by the University of Minnesota Press
111 Third Avenue South, Suite 290
Minneapolis, MN 55401-2520
http://www.upress.umn.edu

Library of Congress Cataloging-in-Publication Data
Lee, Julia.
Our Gang : a racial history of *The Little Rascals* / Julia Lee.
Includes bibliographical references and index.
ISBN 978-0-8166-9821-9 (hc) | ISBN 978-0-8166-9822-6 (pb)
1. *Our Gang* films—History and criticism. 2. African Americans in the motion picture industry—History—20th century. 3. African Americans in motion pictures. 4. Racism in motion pictures. 5. Race relations in motion pictures. 6. Stereotypes (Social psychology) in motion pictures. I. Title.
PN1995.9.O8L44 2016
791.43'75—dc23 2015031957

Printed in the United States of America on acid-free paper

The University of Minnesota is an equal-opportunity educator and employer.

21 20 19 18 17 16 15 10 9 8 7 6 5 4 3 2 1

CONTENTS

FOREWORD

Henry Louis Gates Jr.

O ur Gang, known to my generation as *The Little Rascals,* en-
tered television syndication in 1955, less than a year after the
U.S. Supreme Court's landmark ruling in *Brown v. Board of Edu-
cation* outlawed racial segregation in the nation's public schools. I
was four years old, and life was about to change in my hometown
of Piedmont, West Virginia. Integration was the promise of our
democracy and its essential ingredient, we were told, even if melt-
ing what was in the pot was a messy, often violent affair.

The Little Rascals was a metaphor for that change. It was
impossible to ignore the frequently cringe-worthy stereotyping
that marked the humor of creator Hal Roach's rag-tag gang. Yet,
at the same time, *The Little Rascals* was a model of harmonious,
localized integration, with a revolving cast of children—black,
white, skinny, freckled, fat—more at ease in one another's com-
pany than would have been found in most American classrooms
pledging allegiance to the same flag. And let's be honest: it was
funny, in the same vein as Roach's other slapstick acts, Harold
Lloyd and Laurel and Hardy, only *The Little Rascals* also was lay-
ered with the charms that can be mined only in the misadventures
of childhood. It was straight out of a Mark Twain novel.

Then it hit us (at least those of us too young to know). The
magic reaching us through the tube wasn't *1950s* America at all.
What we were watching were reruns—actually, old cinematic
one-reels adapted for reuse by a technology that wasn't even in
existence when the bulk of them were produced in the 1920s and

1930s. Doing the math, this meant that the kids we were watching on our living room screens, black and white *in* black and white, had twenty years or more on us and the kids starring in *Leave It to Beaver* and *Lassie*. As shocking, unlike those "current" shows that were lily-white and custom-cast for the suburban, post–World War II boom, *The Little Rascals* was our *parents' "gang,"* conceived in the Jazz Age and hitting their stride when those wearied by the Great Depression needed them most. Thus, if the integrationist style of *The Little Rascals* was a step ahead of its time in 1955, for those growing up with them in the 1920s and 1930s, when the lynching of black bodies seemed like an everyday occurrence, it was downright radical. For all its twisted contradictions, America loved it, in both silent and "talkie" form. With our eyes and ears as wide open as one of Stymie's favorite facial expressions, we did, too.

The same is true of Professor Julia Lee, who was mesmerized by *The Little Rascals* as a child of Korean immigrants in the Los Angeles of the 1980s and 1990s, when the headlines of the day had shifted from Thurgood Marshall and Emmett Till to Rodney King and the L.A. Riots, West Coast rap, and AIDS. In the book that follows, *Our Gang: A Racial History of "The Little Rascals,"* Lee works her own magic, penning an absorbing, highly readable tale of an American screen treasure through the eyes of a childhood fan turned scholar. The result is the definitive cultural history of *Our Gang*. In wrestling with the series' racial representations against a broader backdrop of society, from the turn of the nineteenth century to today, Lee's book offers a major contribution to American and African American cultural studies. Like the series it traces, Lee's book is a gem.

Few franchises impacted American life, especially childhood, more than *Our Gang,* and through successive generations, the white and black cast reflected and helped shape perceptions within and across the color line at the high point of Jim Crow segregation—a time in Hollywood, just after "the nadir" of black–white racial relations, as the historian Rayford W. Logan named the period, when films like *The Birth of a Nation* (1915), with their stereotypic portrayals of a set of tropes we might call "the African American grotesque," could inspire thousands of hooded Klansmen to march brazenly down Pennsylvania Avenue in de-

fense of the Confederacy's "Lost Cause," much to the cheers even
of Northerners suddenly amnesiac about what the Civil War had
been all about and for which side their own ancestors had fought
and died.

Because the deceptively subtle yet extraordinarily sophisti-
cated performances of *Our Gang*'s black characters—from Er-
nie "Sunshine Sammy" Morrison to Allen "Farina" Hoskins Jr.
to Matthew "Stymie" Beard and Billie "Buckwheat" Thomas—
signified on received, base stereotypes, they invited subversive
readings that helped galvanize the assault on Jim Crow. For many,
Our Gang was a touchstone of our youth, popular but unexam-
ined in the American imagination. Now, for the first time, Julia
Lee gives the show the serious scholarly explication it deserves,
with unique access to personal archives and a keen sense of the
broader historical canvas in which the series unfolded.

As I recall from my era of viewing in the 1950s, white and
black kids alike, who knew so little of each other beyond the color
line, wished the *Our Gang* gang lived down the street. For white
kids my age in particular, many of whom grew up never laying
eyes on a black person outside television and the movies, charac-
ters like Sunshine Sammy, Farina, Stymie, and Buckwheat were
the first black pals they had (and, I've heard, some even felt jeal-
ous they couldn't hang out with them *for real*). In that way, the
black rascals' uniqueness, and elusiveness, only reinforced their
hold on the popular imagination. Whatever the scripts said, these
child actors brought it in ways that captivated audiences, with a
gravitational force that pulled us toward them, much as Louis
Armstrong could do on the musical stage or Jesse Owens in the
Olympic arena.

As a sign of its success, *The Little Rascals,* when it made its
television "debut," quickly became the "leading afternoon enter-
tainment for children" in New York City, J. P. Shanley wrote for
the *New York Times* on May 8, 1955. Similar results were regis-
tered in forty-five other American cities, with a "waiting list of
sponsors." "It is difficult to determine what makes the old films
so appealing," Shanley wondered, before speculating, "Perhaps
modern children, like those of another generation, find elaborate-
ly organized mischief appealing." (No kidding, Einstein!) But its
appeal, for me at least, also stemmed from *The Little Rascals'*

jumble of nostalgia and unspoiled hopes, its nod to diversity, and the humor it squeezed out of that diversity. Every ethnic group was fair game.

Of course in black neighborhoods no one was fooled by the stereotypes of the pigtailed "pickaninny" or his (or her?) wide eyes, or the watermelon and fried chicken jokes, or the ridiculous dialects that had to be taught to actors who made Los Angeles their home. Just because white America had been obsessed with those tropes since slavery didn't mean we knew anyone who spoke or acted that way. Still, we couldn't help it. We loved *The Little Rascals*, too, just as we couldn't get enough of another show that portrayed a closed, all-black world as hilariously as *Our Gang* did an integrated one: *Amos 'n' Andy*. With their comparatively fat Hollywood contracts, at least for a "hot minute" until Walter White and the NAACP forced their sponsor, Blatz Beer, to cancel their support, black actors like Tim Moore (as George "Kingfish" Stevens in *Amos 'n' Andy*) and Allen Hoskins in *Our Gang* gave African Americans a glimpse of what might be possible for black talent when the movement to end Jim Crow was finally won.

But did we ever really know the *Rascals?*

To recall them only as victims of a writer's or director's humor would be a huge mistake. They were, as Lee convincingly shows, comedic geniuses, and in delivering their lines they often signaled to us that they were not only in on the jokes and pranks, they were masters over them. For instance, in one memorable exchange in the 1936 short *Spooky Hooky*, the affrighted Gang (specifically Spanky, Alfalfa, Buckwheat, and Porky) has to break into school at night to retrieve a forged sick note excusing them from class on that rare day when they actually want to be there to join a field trip to the circus. Spanky tells Alfalfa, cowering in his rain slicker, shivering at every stray sound, "I told you once before there ain't such things as spooks," to which Buckwheat, who has just climbed in through the window from the rain, more knowingly says, "Oh, yes it is," achieving the line's humor by transcending the screenwriter's intended visual pun of a very dark Buckwheat as, himself, a "spook," but suggesting that Buckwheat, the black other, can see more than his white friends can.

Buckwheat sees the world Spanky doesn't—from "behind the Veil," as W. E. B. Du Bois famously described black consciousness

in *The Souls of Black Folk* (1903). The hijinks in *Spooky Hooky* are terribly silly, to be sure, and also demeaning when we see the school's black janitor, Sam, playing into the stereotype of the easily supernaturally scared black man a few beats later, smashing through the school wall to outrun an obviously fake skeleton, only to fall to the floor, unable to get out of his own way, as the rascals make their escape across his back. Yet, at the same time, one senses that Buckwheat, apart from the other actors in the Gang, is both the object and author of the jokes he signifies upon, beyond the director's cue. And the fact that we, the audience, have to struggle to understand him (as indelibly interpreted later by Eddie Murphy on *Saturday Night Live*) has an unexpected effect: what at first feels like a speech defect or a defect of intelligence, meant to be greeted with condescension, becomes a trick Buckwheat plays on *us*, requiring us to lean in and grasp at the wisdom we believe he knows and is holding back. Doing so, Buckwheat becomes something of the black sphinx among the colorful characters of *Our Gang*.

Later, in the 1960s, everything associated with this era's brand of minstrelized humor became controversial, a source of pain and shame for the Black Power generation. But in expurgating *The Little Rascals* shorts for a modern audience (literally cutting out the odious parts that offend our post–civil rights sensibilities), the censors went too far, draining the historicity of the show and, worse, undermining the genius of the original performers and preventing a new audience from seeing what they did with the roles they were given, and thus how they captured the story of black people in this country. "Making a way out of no way," as the tradition says.

Matthew "Stymie" Beard, Buckwheat's predecessor in the Gang, is a perfect example. Not only did Stymie earn the affection of everyone on set (we learn in Lee's book), but he impressed the comic legend Stan Laurel so much that Laurel gave him his bowler hat, which, despite its being oversized, Stymie fashioned into his signature prop—a child witty and wise beyond his age, who was so popular and commanding that he could not help but become a de facto leader of the Gang. Whatever Hal Roach's writing team had intended for this black character, it seemed, Stymie expanded it to fit his *own* brand of humor. He interpreted his

lines to perfection, including one of my favorites from the 1932 short *The Pooch,* in which Stymie, in the process of unpeeling an unfamiliar vegetable, the artichoke, says to a baby Spanky, with Pete the Pup looking on: "it might choke Artie, but it ain't gonna choke Stymie." (That was the first time I ever saw an artichoke, which I wouldn't eat until I went to Yale University.)

That for me became the transcendent metaphor for the entire series: the same would prove true of the African American people whose hopes Stymie represented. They wouldn't be *stymied* either. Rather than dismiss him and his fellow black rascals as caricatured objects, victimized by Hollywood's racism, we should understand how their masterful performances enabled their subjectivity to shine forth. We should honor their courage and the weight of the stress they carried for us on and off screen, including in serving their communities and country in the military and in the often tragic turns their lives took after they exited the stage. For those who want to know the whole story, read this marvelous book, a gift that keeps giving on each page.

They weren't just Hal Roach's Gang, or that of the principal actors or of any one age group or decade. They are, they will always be, *our* Gang, too, and whether it be the 1920s, 1950s, 1980s, or now, each generation brings something new to the clubhouse. As it was with readers of Twain's Jim, Tom Sawyer, and Huckleberry Finn, we continue to befriend the black and white members of *Our Gang* as if for the first time, with the innocence and wonder of children, before we have aged into adults who can see—and interrogate—the problems they replicated and subverted. Those of my generation cling to *The Little Rascals* much as we do to our democracy, however imperfect it is. As the black poet Langston Hughes, a paragon of the Harlem Renaissance whose career was contemporaneous with the emergence of *Our Gang,* wrote in 1930: "No matter how hard life might be, it was not without laughter." As Julia Lee's book reminds us, may it ever be so.

INTRODUCTION

All of Us

> He suddenly had an idea for a film. A bunch of children
> who were pals, white black, fat thin, rich poor, all
> kinds, mischievous little urchins who would have funny
> adventures in their own neighborhood, a society of
> ragamuffins, like all of us, a gang, getting into trouble
> and getting out again.
>
> —E. L. Doctorow, *Ragtime*

Some said he was discovered in "Nigger town" in Los Angeles by director Bob McGowan. Looking for someone to succeed Ernie "Sunshine Sammy" Morrison, the first black star of *Our Gang,* McGowan found Farina playing marbles in the street "with some of his little 'cullud' pals." The boy was wearing a romper suit, and his hair was in pigtails. McGowan couldn't tell whether he was a boy or a girl. He thought maybe this would bring "a touch of mystery to the Gang" and offered him a contract on the spot.[1]

Others said it was Sunshine Sammy's father who discovered Farina. He was searching for a "colored boy with long hair" to play Sammy's sister and "hunted all day and was just about to give up the search when he remembered that he had to stop by the grocers for some provisions for dinner." The grocer, hearing of his plight, cried, "Why, I know just the fellow you want!" While he was still speaking, the door opened and in walked Farina and his mother.[2]

Still others said Farina simply tagged along with Sunshine

Sammy to the studio one day. He was a year old and could barely walk. Producer Hal Roach asked him his name. Farina "rolled his eyes wide open" and blurted out "Hot Dawg!" He got the job, and from then on, the kids on the set nicknamed him "Hot Dawg."[3]

His real name was Allen Clayton Hoskins Jr. He was born in Boston, Massachusetts, on August 9, 1920, and his family moved to Los Angeles when he was two months old.[4] His mother called him "Sonny Boy," or "Sonny" for short, because of his sunny personality. "He had the sweetest disposition of any child I had ever seen, or at least I thought so," Farina's mother told a reporter. "He would play for hours and he was always smiling."[5]

He could also cry at the drop of a hat. In his first film, he was told to feed pearls to a flock of geese. Every time the director yelled "Lights!" and the geese began to cackle, the little boy would burst into tears. He cried so hard that it took three days to film the scene. Yet his tears were so convincing, so devastating that the studio officials went wild. He was a natural. Soon he was given parts "just to cry."[6] As he grew older, he could turn the tears on and off at will. Hal Roach remembered, "You'd think his heart was breaking, then they'd cut the camera and he'd be back playing again."[7]

H. M. "Beanie" Walker, the title writer of Hal Roach Studios, came up with the name "Farina."[8] Little Sonny Hoskins was so chubby and cute, he reminded Walker of "mush," so he took the name Farina off the mush-box.[9] They put Sonny in ragged clothes and oversized shoes, put his hair in ribboned pigtails, and had him play Sunshine Sammy's kid sister. His gender became the source of national curiosity. The studio was inundated with letters from curious viewers, wondering if Farina was a boy or a girl. His name had a "feminine ending," and he sometimes appeared in dresses and was referred to as "her." Other times he wore pants and played a boy. Roach, seeing an opportunity for some free publicity, fed the speculation by keeping Farina's gender a mystery, referring to him in press releases as a "chocolate-coated fun drop."[10]

Sonny quickly eclipsed the other children as the most popular and highest paid star of the Gang. Silent film star Harold Lloyd, who also worked at the studio, called him "not only one of our smallest, but one of our most natural motion picture actors."[11]

He was featured in lavish ads in trade magazines like *Exhibitors Herald.* "This is 'Farina,'" one ad read. "With 'Sammy,' 'Mickey,' and the rest of the 'gang' she has made a dozen laughs grow where none ever grew before." In the accompanying illustration, Farina held a watering can, surrounded by a thicket of beaming sunflowers.[12] He played the infant tag-along, joining a cast that included Sunshine Sammy, Mickey ("Freckles"), Joe ("Fatty"), Jackie Condon (the crazy-haired kid), Jackie Davis (the regular kid), and Mary (the girl).

In the early silent films, Sonny played the typical "pickaninny," falling into barrels of flour, eating watermelon, smoking a corncob pipe, jumping at ghosts. Cinema was still in its infancy, and the legacy of vaudeville and minstrelsy was everywhere apparent. Al Jolson was performing in blackface to enraptured audiences, an act he would later bring to the screen in *The Jazz Singer.* Less than ten years earlier, D. W. Griffith's *Birth of a Nation* had broken box-office records with its innovative film technique and virulently racist portrayals of African Americans. The Ku Klux Klan, capitalizing on the film's popularity, entered a period of renaissance, actively recruiting members against the triple threat of immigration, urbanization, and industrialization. The influx of Jewish and Catholic immigrants and the Great Migration of African Americans from the rural South to the urban North and Midwest stirred great fears. The nation was becoming less white, less Protestant, more urban. By the mid-1920s, the Klan claimed a membership of several million men, women, and children across the United States.[13]

It was the age of Jim Crow. Between May and October 1919, there were more than thirty race riots in American cities. James Weldon Johnson, field secretary for the National Association for the Advancement of Colored People (NAACP), called it the Red Summer. Lynching and mob violence were a problem, not just in the South, but in places like Chicago and Philadelphia. In the first decades of the twentieth century, laws were passed prohibiting blacks and whites from riding in the same rail car, using the same toilets and water fountains, and attending the same schools. Even circuses, picture houses, and ballparks were segregated.[14]

In the world of *Our Gang,* though, black and white children played together, went to school together, and got into mischief

together. It was a childlike, utopian vision of America, one that offered an alternative to the racial strife going on outside. The *Our Gang* kids couldn't care less if adults disapproved of their interracial friendships because they couldn't care less about adults at all. In fact, most of their enemies *were* adults—the cranky neighborhood policeman, the uptight society dame, the heartless dogcatcher. The *Our Gang* kids played hooky from school, crashed fancy parties, and started food fights. They built their own jalopies, created their own fire engine company, and staged their own vaudeville shows. Invited to a wedding, they accidentally set loose a circus of pet fleas. Visiting a friend at the hospital, they ended up inhaling laughing gas.[15] For the Gang, Jim Crow was just another foolish rule meant to be broken.

The kids were so innocent that in one film, they came up with their own version of the Ku Klux Klan, called the Cluck Cluck Klams. Not only did the club have black members, but Sunshine Sammy was elected its "Most High Terrible Seccaterry." Audiences thought it was a delightful joke, but actual Klan members were not so amused. In another film, the Gang competed against a rival baseball team in a kiddie version of the World Series. Sunshine Sammy was the pitcher and Farina the umpire, while Mickey played catcher and Jackie Condon daydreamed at second base. Professional baseball, meanwhile, wouldn't be integrated for another twenty-five years.[16] Once the cameras stopped rolling, the kids ate together at the studio cafeteria and attended a private studio school run by Miss Fern Carter. When Bob McGowan wasn't paying attention, Sonny would sneak up behind him and kick him in the ankles. "Look out Mac—Farina!" one of the other kids would yell.[17] With his earnings, Sonny's father bought a secondhand car and repainted it himself. While it was drying, Sonny frescoed the undercarriage with his handprints, a custom job that could have been worthy of an *Our Gang* short.[18]

Yet the studio's protective bubble could only extend so far. In 1928, the Gang went on a national publicity tour. En route to New York City from Chicago, production manager L. A. French wired ahead to the Roosevelt Hotel to arrange housing for the Gang. The hotel wired back, refusing to accommodate Sonny, his mother, or his personal manager. French then wired the Park Central Hotel, who agreed to take in Sonny and the rest of the Gang, plus

Pete the Pup. Even then, Jim Crow did not go away. A reporter from the *New York Amsterdam News,* a black paper, arrived at the hotel to interview French about the incident and was directed to the back door. The reporter ignored the order, entered through the front door, and stepped into a passenger elevator filled with white patrons. The operator refused to start the car, a manager was called, and the reporter was told to take the service elevator. Incensed, the reporter cried, "I am here to see one of your guests and I don't see why I can't be taken up in that elevator. In fact, the reason I'm here is to investigate color discrimination against 'Farina' at another hotel. Now I walk right into another one and meet the same thing." The manager quickly backtracked and allowed the reporter to take an unused passenger car, where he was "finally Jim-Crowed to the nineteenth floor, and obtained his interview."[19]

The African American moviegoing public followed Sonny's career with intense interest. He was their "Race boy," someone who offered hope for the future.[20] In a hyperbolic article in the *Pittsburgh Courier,* he was described as a tool of racial uplift even more effective than Negro spirituals and education. He had "probably done more to solve race prejudice than has any other phenomenon," the reporter breathlessly declared.[21] The studio echoed this view. Sonny "made the lot of small negro boys much happier through the greater tolerance for his race which he engendered in the hearts of white children," according to one press release.[22] He helped guide the series successfully into the era of "talkfilms," appearing alongside guest stars like Stepin Fetchit. In ads, much was made of his musical "Negro dialect."

But Sonny was growing up. In his own words, "I was too big, my voice changed, and I was no longer a cute little black kid."[23] His successor, Matthew "Stymie" Beard, was already waiting in the wings, having been introduced as Farina's little brother. Upon Sonny's retirement, *Photoplay* published a purple tribute. "Farina fascinated us because he (it was *she* at the time) was the perfect incarnation of poor, witless Man's struggles against inscrutable, and very rough and dirty, Fate," the magazine proclaimed. "We loved Farina—because Farina, a three-year-old fragment of ebony, was ourselves."[24]

Sonny had appeared in 105 *Our Gang* comedies over nine

years, more than any other member of the Gang. He had appeared in all but two of the silent films and in two seasons of talkfilms. When he retired at the age of eleven, he was being paid $500 a week, the most of all the kids.[25] But childhood was receding behind him—and not just for him, but for everyone. All the kids in the Gang eventually grew up. All of them were eventually replaced. All were eventually "graduated," "discarded," "shelved," or however else you wanted to put it.[26]

Like many child actors, Sonny struggled to make the transition to adult roles. He entered the vaudeville circuit and toured the country with his little sister, Jannie. He tried his hand at radio writing and cinematography but was prevented from joining the Screen Writers Guild because of his race.[27] The war came, and Sonny enlisted in the army, serving in the South Pacific as a company clerk for the Quartermaster Corps.[28] It was there that he claimed to have experienced discrimination for the first time.[29] The armed forces were still segregated, and "Uncle Sam's Negro boys" were forced to socialize in separate clubs and play on separate baseball teams.[30]

After the war, Sonny made one last go of acting. Returning to Hal Roach Studios, he unsuccessfully auditioned for a part in the television series *Amos 'n' Andy*. He earned a degree in drama from Los Angeles City College but eventually decided he wanted to "eat regular" and trained to work with the mentally disabled. He married, had six children, and moved to Oakland, California, where few people knew he was Farina or knew about his past. He went into hiding, and he stayed there. In his own words, "I stayed buried for a long, long time."[31]

The world continued to change. Jim Crow was under attack. Having served and sacrificed for their country in World War II, African Americans demanded an end to segregation and an assurance of their full rights as citizens. In 1948, President Truman signed Executive Order 9981, guaranteeing "equality of treatment and opportunity for all persons in the armed services without regard to race, color, religion or national origin."[32]

In 1951, Oliver Brown, an African American pastor and father of a third grader, joined twelve other parents in filing suit against the board of education in Topeka, Kansas, calling for an

end to school segregation. Three years later, in the landmark case of *Brown v. Board of Education*, the Supreme Court desegregated the nation's schools. The Ku Klux Klan responded with renewed violence. On Sunday, September 15, 1963, four of its members planted a bomb under the steps of the 16th Street Baptist Church in Birmingham, Alabama. At 10:22 a.m., it exploded, killing four little girls. The dream of Martin Luther King Jr.—the dream that one day, "little black boys and black girls will be able to join hands with little white boys and white girls as sisters and brothers"—still seemed that. A dream.[33]

Our Gang lived on in television syndication. Beginning in the mid-1950s, the shorts were repackaged as *The Little Rascals* and reached entire new generations of viewers. Farina, Spanky, and all the rest had long since grown up, but to millions of children, they were still suspended in eternal childhood. Adults who had seen the original films relived their own youths and looked on the episodes with affection and nostalgia. In living rooms around the nation, images of bus boycotts, sit-ins, and demonstrations shared screen time with old reruns of the Gang. The incongruity could not have gone unnoticed. Farina and his friends were enacting on the screen what was still a distant possibility in schools and playgrounds around the nation.

By the 1970s, however, the passage of major civil rights legislation and the final dismantling of de jure segregation meant that political reality had at last outstripped the fictional world of *Our Gang*. The show's use of racist caricature, once barely noted, now emerged as a source of controversy among stations that had purchased *The Little Rascals* syndication package. King World Productions, the distributor, edited some episodes and withdrew others entirely. They contacted the NAACP for its seal of approval and issued statements promoting the Gang's less controversial aspects.[34]

After several decades, Sonny Hoskins—or Al, as he now chose to be known—began to come out of hiding, drawn out by *The Little Rascals* television revival and the recent death of his mother, who had left behind boxes of clippings and *Our Gang* memorabilia. Along with Billie "Buckwheat" Thomas, Matthew "Stymie" Beard, and Ernie "Sunshine Sammy" Morrison, he faced growing criticism for his role on the series. Once celebrated

as a race star, he was now vilified for perpetuating racial stereotypes. He defended the series and its creators, pointing out its unusual message of interracial camaraderie. Invited to an *Our Gang* reunion in 1980, he died shortly before the event, just shy of his sixtieth birthday. A few months later, Billie Thomas passed away. The following year, Stymie Beard died of pneumonia. Ernie Morrison, the first and now the last of *Our Gang*'s black stars, passed away in 1989.

By the 1980s, much of the show's most offensive scenes had been expurgated. The films still enjoyed wide viewership and inspired an animated *Little Rascals Christmas Special* and Hanna-Barbera cartoons, which eliminated the worst of the racial stereotyping. But signifiers like electrified hair and rolling eyes died hard. In 1981, Eddie Murphy devastatingly parodied Buckwheat's incomprehensible speech and wild hair, in so doing mocking cinema's long history of infantilizing black men and romanticizing pickaninnies. Gradually, the series disappeared from the small screen. A 1994 feature film remake and its 2014 direct-to-video sequel updated the series for more racially progressive times but were widely considered dull and charmless.

The nation, it seemed, had outgrown *Our Gang*. What had once seemed progressive now seemed outdated. The show was a historical artifact, trapped in time, the children always young and always the same, even as the country grew up. Watching the show reminded us not only of our past but of America's. And it was a past that many of us wished to forget.

This book is the story of several gangs—of the series itself and its cohort of writers and gagmen, unconventional men like Hal Roach and Bob McGowan, who tapped into powerful American myths about race and childhood to present an unusual fantasy of interracial friendship. It is the story of the four African American stars of *Our Gang*—Sonny Hoskins, Ernie Morrison, Stymie Beard, and Billie Thomas—the gang within the Gang, whose personal histories have become lost with the passage of time and the shifting political landscape. And it is the story of America itself, the messy, multiracial nation that found in *Our Gang* its comic avatar, a slapstick version of democracy itself.

As a child of seven or eight, I had watched episodes of *Our*

Gang in our living room in Los Angeles, just a few miles from where Hal Roach Studios was once located. My parents were Korean immigrants who had settled in the city in the 1970s, the first in a wave of Korean immigrants who would transform the racial makeup of Los Angeles. Watching the show, I had no idea it had been filmed fifty years earlier, that most of the stars were dead, that it was once considered unusual for black and white children to play together. By watching *Our Gang*, I learned, however imperfectly, what it meant to be American.

Jim Crow might have died, but racial conflict had not. In 1992, Los Angeles experienced its worst race riot since the Watts Riots of 1965, triggered by the acquittal of four white police officers in the videotaped beating of the black motorist Rodney King. Racial unrest was further inflamed by the shooting of Latasha Harlins, a black teenager, by Soon Ja Du, a Korean American shop owner. It was at the height of the violence, as bystanders were beaten and businesses looted and torched, that King issued his famous plea, "Can we all get along?"

"Can we all get along?" The plea is childlike in its yearning. The kids in *Our Gang* got along. They were too young, or too naive, or too uncorrupted to know otherwise. And this is perhaps the key to the series' appeal. For nearly a century, *Our Gang* has served as a cultural touchstone. Even as it reflected the nation's racist heritage, *Our Gang* had always offered an idealized, hopeful vision of the nation's future. It represented both the best and worst parts of the nation's tortured relationship to race. It tapped into a deep vein of nostalgia, a longing for the innocence of childhood, an imagined space where black and white children could join hands. *Our Gang* was a melting pot, "a society of ragamuffins," a crew of misfits. It was an allegory of America. It was all of us.

1

The Eternal Boy

Hal Roach sat behind his desk, smoking a cigarette and watching the little girl audition before him. She was a little thing, maybe five or six, with blond hair cut in a fashionable bob. Her face was heavily powdered and rouged, her lips painted in a cupid's bow. Dressed in a white party frock, she pranced and curtseyed and shook her hair, singing a popular Tin Pan Alley tune in her thin, high-pitched voice. Watching her perform, Roach couldn't help but think of a trained circus seal or one of those dancing poodles in a tutu. He stubbed his cigarette out and quickly lit another. "That'll be fine," he said.

The little girl stopped and looked at her mother, who was sitting primly in a leather armchair across from Roach's desk. "She can tap-dance, too," the mother said brightly. "She's been taking lessons for years. Let her just show you a little bit." The little girl launched into a soft-shoe routine, her feet catching on the polar-bear pelt covering the floor.

"That's enough," Roach said, standing up. He was broad-chested and powerfully built, carrying himself like the cowboy he once was. The rug the girl was dancing on was from a bear he'd shot himself.

"But Mr. Roach, I know she'd be perfect for one of your pictures," the mother protested. "She's very talented."

"Indeed," said Roach. "I appreciate your coming in." He

1

escorted the woman and her daughter out of his office, vaguely promising to be in touch.

Since moving to his new studio on Washington Boulevard, Roach had seen a parade of child actors desperate for a chance at the silver screen. They were all the same—stilted and unnatural, with stage parents eager for fame and a fat payday. He'd only agreed to see this particular little girl because she was the daughter of a friend of a friend. "What a waste of time," he thought to himself.

Roach surveyed his office, feeling cooped up and restless. It was 1921, and Roach was almost thirty years old. In the distance, he could hear the cheerful whistle of the Red Car trolley on its way to Culver Junction.[1] He walked to the window, opened it, and looked out.[2]

Harold Eugene Roach was born on January 14, 1892, in Elmira, New York, a town south of the Finger Lakes, dropped like a nickel from an outstretched hand. It was a frigid and snowy day, typical of upstate New York in the depths of winter. The Chemung River, which had flooded just a few years before and destroyed much of the southern and eastern parts of the city, was frozen. Snow blanketed the streets, and the trees formed an elaborate fretwork against the sky. The day was overcast and gray, the buildings damp and brown, the entire landscape colorless, like an old Dutch painting. A few blocks away, a train rumbled through town, steam billowing from its cigarette-shaped smokestack. The sound of its whistle cut through the wintry air.[3]

Roach was the second child of Charles H. Roach and the former Mabel Bally. To his mother, he was "Harry," but most others called him "Hal." Benjamin Harrison was president of the United States, and Victoria was queen of England. It was the tail end of the Gilded Age, a term coined by Mark Twain, Elmira's most famous resident, who summered at nearby Quarry Farm. Railroads, which had helped create the fortunes of robber barons like Cornelius Vanderbilt and Leland Stanford, crisscrossed the town. The Lehigh Valley, New York, Lake Erie & Western, Northern Central, and Lackawanna & Western railroads all stopped in Elmira, connecting the major commercial centers of Rochester and Buffalo to Albany and New York City. When a train pulled into

the Elmira depot, traffic literally stopped. Pedestrians, carriages, and trolleys waited as a line of railway cars, sometimes ten blocks long, chugged by.[4] On some days, more than sixty passenger trains passed through Elmira.[5]

Before he hit it big in Hollywood, Roach had always assumed he'd end up "firing on the Lehigh Railroad"[6]—becoming an engineer on one of the coal-driven locomotives that ran through Elmira. In 1892, working on the railways was the ticket to a comfortable, middle-class existence. Hollywood as we know it didn't yet exist. Just a year earlier, Thomas Edison had exhibited his Kinetoscope, one of the earliest motion-picture devices, to members of the National Federation of Women's Clubs. Peeking into a small pine box, they saw "a most marvelous picture" of a man "who bowed and smiled and waved its hands and took off its hat with the most perfect naturalness and grace."[7] The first commercial motion-picture exhibition, in New York City, was still a couple years away. Cinema, like Hal Roach, was in its infancy.

Elmira, though, was thriving. Its population doubled between 1870 and 1890, reaching thirty-five thousand by the end of the century.[8] The Irish were the first wave of immigrants to arrive, followed by eastern European Jews and Italians. All were drawn to Elmira's booming economy, driven by the railroads and nearby steel and textile mills. The wealthiest lived in grand Victorian mansions on William Street or Maple Avenue. "Regular American people" lived on the west side of the railroad tracks, black people on the east side near Fourth and Dickinson. There were also several ethnic enclaves: the Germans in "Buttonwoods," the Polish in "Polandertown," the Irish in "Pickaway," the Jews in "Jewtown."[9] Charles and Mabel Roach lived at 208 Columbia Street, a few blocks north of the Chemung River, in what is now called the "Near Westside" district. It was a boxy, white clapboard house with bay windows that today houses a dentist's office. A few years later, the family moved down the street to 311 Columbia, a larger house with a gable roof.[10] Mabel ran the place as a boardinghouse, while Charles worked variously as an insurance broker, a steam carpet cleaner, and a store manager in downtown Elmira. The Roaches' neighborhood was a mix of stately Victorian mansions and smaller homes for upwardly mobile working-class folks.

The Civil War had ended almost thirty years earlier, but in

Elmira, its memory was still fresh. The city's location, so easily accessible by railways, made it strategically valuable to the Union army, which established a training camp near Fosters Island in the Chemung River. Camp Elmira was eventually turned into a prison camp for Confederate soldiers. Dubbed "Hellmira" by its inmates, it became a death camp for nearly three thousand soldiers, who were felled by the brutal cold, disease, and malnutrition. For ten cents, spectators could gawk at the prisoners from a viewing platform and snack on peanuts and beer.[11] John W. Jones, sexton of the First Baptist Church and a former slave, buried the Confederate dead for $2.50 a body, keeping such meticulous records that after the war, the site was declared a national cemetery.[12]

As a transportation hub, Elmira was a critical station on the Underground Railroad. Six routes ran from the city to freedom in Canada. Jones himself was a runaway slave, the houseboy for the Ellzey family of Leesburg, Virginia.[13] Fearing he would be sold, he fled the South in 1844, surviving the harrowing three-hundred-mile trek to Elmira. According to one story, he was being sheltered by Jervis Langdon, a prominent local businessman and Mark Twain's future father-in-law, when slave hunters arrived to reclaim him. Langdon instructed Jones to hide in the woods, smuggling him food every day until it was safe for him to return.[14] Jones in turn helped more than eight hundred runaway slaves make safe passage to the north. With the cooperation of railway employees, he hid the fugitives in baggage cars, which transported them to safety in Canada. Once the Northern Central Railway was completed in 1854, connecting Williamsport to Niagara Falls, the "Freedom Baggage Car" made regular departures at 4:00 a.m. from the Elmira depot.[15]

The Civil War was part of Roach family lore, as well. Charles Roach was from Virginia, the son of a wealthy plantation owner who counted Robert E. Lee among his neighbors. As an old man, Hal Roach was given a map of his grandfather's three-thousand-acre plantation by a film curator from the Library of Congress. "I'm an F.F.V.," Roach had joked. "First Family of Virginia."[16] Roach described his grandfather as a stone contractor who helped pave the streets of Washington. "During the Civil War," Roach recalled, "he had several hundred draught horses that were used to haul stone. The Northern Army wanted those

horses. My grandfather was very friendly with Lee, and he said he'd be damned if a Yankee ever got any of his horses. So both he and my grandmother were made prisoners in their home during the war, and there they both died of tuberculosis."[17] The family plantation was sold and the fortune divided, leaving Charles with about $1,500. He went into the insurance business with a school friend named Potter, who had moved to Elmira. There, Charles met the former Mabel Bally, and "that," as Hal Roach put it, "was the start of our branch of the Roach family."[18]

Roach described his family as poor, but they appeared comfortable enough, with a roof over their head and plenty to eat. Every evening after supper, Roach's mother, older brother Jack, maternal grandparents, and any boarders would gather in the sitting room and read aloud. Young Hal would eagerly await the nights his grandfather would take his turn. A former watchmaker who had gone blind from cataracts, John Bally was a Rumpelstiltskin-like character, with a gray beard and corncob pipe that extended two and a half feet. He let Hal and his brother invite the neighborhood kids over to hear his tales. Then, "he would make a very peculiar noise in his pipe," Roach remembered. "This meant that the fairies were coming to tell him the story. He would build up to a climax. Some of us couldn't keep from asking, 'And then what happened?' or something like that. He would bawl us out: 'Now you scared the fairies away!' He had to stop and light his pipe and get all set again to tell the conclusion of the story." The stories Roach's grandfather told were "the most dramatic things you could ever imagine kids hearing." Later, Roach realized he was retelling classic tales, tweaked for a juvenile audience, a skill his grandson would one day deploy to great effect in the movies.[19]

Roach's boyhood was, by all accounts, idyllic. "Elmira was a fine place for a boy to grow up," he would say.[20] The town was charming and picturesque, verdant in the summers, surrounded by tobacco farms and rolling hills and the majestic Chemung River. In the 1890s, the city's roads were paved with bricks, and electric lighting and the telephone came to town. A trolley ran down Main Street, but most people still got around by horse and carriage. During tobacco-cutting season, kids were let out of school to help with the harvest.[21] Little boys routinely played ball in the streets. In 1901, when Roach was nine, the local papers reported,

"an epidemic of mischief seems to have laid hold of Elmira small boys. The latest credit to these youngsters is the removal of a cover of a cesspool at the corner of Third and William."[22]

In March 1902, when Roach was ten, the Chemung flooded again. The *Elmira Gazette* reported, "Men and boys played and rode bicycles in the water 1 foot deep on South Main Street. The crowd cheered. When they fell in the water—people cheered louder. Boating parties were hastily organized and cruises were taking place in all directions. Water was still very deep around Hudson and Partridge Streets. Boats tipped over. People laughed."[23] In a photograph, Roach's father posed with a group of fellow townsmen in front of the Elmira Saddlery Company, where he was then working as a manager.[24] The men stood shin deep in water, a few seated in a floating rowboat.[25] The following year, Barnum & Bailey Circus came into town, delighting the children with red lemonade, toy balloons, peanuts, and elephants. There were "ninety-five cars to transport the paraphernalia . . . hundreds of horses . . . sword swallowing and needle eating . . . a lion-faced boy . . . a moss-haired girl."[26] Roach reportedly saw Harry Houdini perform stunts suspended over the Chemung River.[27]

Roach was high-spirited and impish, with a round, friendly face and a husky build. A natural leader who loved being the center of attention, he was kicked out of almost every school in Elmira, once for refusing to snitch on a friend who had farted loudly in class.[28] At the age of eleven, he picked up smoking, a habit he wouldn't kick until he was ninety-eight years old.[29] Sent to St. Patrick's, the local Catholic school, he terrorized the nuns. Asked to recite a beatitude by one, he responded, "He who sits on a hot stove gets burned."[30] Years later, he wistfully recalled one particular nun, "the most beautiful person I ever saw," who tried to reform the young scamp. "No one ever tried harder to make me do well," he sighed.[31] Roach's mother, in an attempt to civilize her son, signed him up for dance lessons. Roach grudgingly attended until one day Gracia Gannett, the sister of future newspaper magnate Frank Gannett, came by. "After the class, she danced with me," he remembered. "I thought she was the most beautiful thing I had ever seen. She must have been at least 18." Roach was acutely aware that Gracia was out of his league—she would later marry John Arnot Rathbone, scion of two of Elmira's wealthi-

est families.[32] Still, a boy could dream. "Well, after that, I went to those dance classes every week eagerly," Roach remembered, "just hoping that she would come and dance with me."[33]

School might have been a bore, but weekends and vacations were a blast. In the winters, Roach played hockey on Fosters Pond, skating recklessly over cracks in the ice and occasionally tumbling in. In the summers, he swam in the river, played football, and horsed around with his friends at nearby Second Street Cemetery, where he was nearly scared to death by a "ghost" that turned out to be a man walking a white mule.[34] One summer, he was caught skinny-dipping in the Chemung with his buddies and was told by a cop to move upstream. "Two weeks later the cop told us to move back downstream," he said. "An old lady had complained that we were indecent, but after we moved, she called the cop back and told him that it wasn't any better—she could still see us when she used her opera glasses."[35] Some summers, Roach's family rented a cottage on Keuka Lake, a wishbone-shaped Finger Lake to the north. Surrounded by vineyards and thickly wooded hills, the lake offered a breathtaking natural refuge from the city. Steamboats puffed through the waters, decked in bunting, flags flying gaily in the wind. A boy could spend his days swimming in the lake, or fishing for bass and trout, or picking raspberries in the woods. If he were feeling particularly venturesome, he could filch grapes from a nearby vineyard and eat himself sick.[36] The one thing Roach couldn't escape were his mother's boarders, who came along with them on their summer excursions. "I never had a bed of my own," Roach remembered.[37]

As a boy, Roach had a series of odd jobs around town. He worked at his grandfather's jewelry store, delivered ice, and was a paperboy for the *Gazette*. Hired to deliver groceries to the reformatory on the outskirts of town, Roach took to slipping the inmates tobacco samples from the nearby farms. He was barred from making any more deliveries when the warden discovered the men chewing and spitting the contraband the next day.[38] Roach also worked as an usher and ticket-taker at the Family Theater, the local vaudeville house. Featuring "refined and polite" acts by acrobats, dancers, and other performers, the theater also showed the "Latest and Best Moving Pictures."[39] In the darkened theater, Roach got his first taste of the "flickers," keeping one eye on the

screen, another on the patrons exiting the theater.[40] Already, the young boy was obsessed with show business. With his earnings, he "saw every show" at the Lyceum, home of the local stock companies and a popular venue for traveling minstrel shows.[41] When Roach was around ten, he and his brother were given a camera and set about making their own "pictures." Roach approached a neighbor, Mrs. Krug, and asked if he could "borrow" her baby, Albert Jr. "Knowing his propensity for mischief, I said he could take the baby but I kept my eye on them," Mrs. Krug later remembered. Roach and his brother took the child over to their yard, where they enlisted a boarder to join the cast. While Jack acted as cameraman, Hal directed. "Even then, he had very definite ideas of what he wanted and how the picture was to be posed," Mrs. Krug said. In a photograph later printed in the local paper, titled "Roach Takes His First Picture," little Albert blinks at the camera, one hand clutching a cowboy hat, the other hand his popgun. Hal crouches beside the young boy, his face obscured by his arm, caught in the middle of giving directions.[42]

Roach claims to have met Mark Twain at least twice when he was a child. Twain had married a local girl, Olivia "Livy" Langdon, daughter of Jervis Langdon. Every summer for twenty years, Twain stayed in Elmira at Quarry Farm, the vacation home of Livy's older sister. From his octagonal study overlooking the "distant blue hills" of the Chemung River Valley, he wrote portions of his greatest works, including *The Adventures of Tom Sawyer* and *The Adventures of Huckleberry Finn*. On summer nights, he watched steamboats slip by on the river below. "Every now and again," he wrote, a steamboat would "belch a whole world of sparks up out of her chimney. And they would rain down in the river. And look awful pretty."[43] By the time Roach was a boy, however, Twain was an increasingly infrequent visitor to Elmira, pulled away by financial misfortune and the deaths of his loved ones.[44] Roach remembered hearing the author give a humorous speech at Park Church in Elmira, presumably on the occasion of the organ's dedication in 1907. Twain, he recalled, told a story about listening to a preacher and vowing to donate a dollar if the sermon was short. In the end, the preacher was so long-winded that Twain took a quarter out of the collection box.[45] Roach, sitting in the audience, thought the story was pretty funny.[46]

A few years earlier, in what would turn out to be Twain's final visit to Quarry Farm, Roach had a chance to meet Twain face-to-face. Hired to deliver mail for the manager of a dairy farm, Roach rode up the steep hill to the large, gabled house. Twain was in his study, working on "A Dog's Tale," a short story that would be published in *Harper's* magazine several months later. Walking up to the ivy-covered pavilion, Roach saw Twain standing at the door, an old man with grizzled white hair and mustache, likely surrounded by curls of cigar smoke and perhaps a cat or two. "He talked to me for at least half an hour," Roach remembered.[47] What Twain must have thought of the young Hal Roach, we don't know, but the boy was a real-life Tom Sawyer, a cut-up and a scamp, chafing at the confines of small-town life. For Twain, the area was a refuge and a retreat, "the quietest of all quiet places" where he could write in peace.[48] But for Roach, it was too quiet, too dull for an irrepressible, growing boy. At sixteen, he was expelled from Elmira Free Academy, the local public high school. Exasperated, his father told him to travel and "grow up." Roach didn't need to be told twice. He lit out for the Territory.

Roach first headed to Seattle, where an aunt lived. Washington had been admitted to the union only twenty years earlier, and Seattle had been known primarily as a lumber town. That all changed when gold was discovered in the Klondike region of the Yukon in 1896. Over the next few years, Seattle, the largest American city and port in the area, was swarmed by prospectors headed to the gold fields in the Far North. The Seattle papers fueled the frenzy by printing sensational stories of good fortune and quick riches. "GOLD! GOLD! GOLD! GOLD!" read a headline in the *Seattle Post-Intelligencer*, announcing the arrival of the ship *Portland* from the Klondike. "Sixty-Eight Rich Men on the Steamer Portland. STACKS OF YELLOW METAL!"[49] Another local paper described how "Klondyke Fever" had infected the town: "All that anyone hears at present is 'Klondyke.' It is impossible to escape it. It is talked in the morning; it is discussed at lunch; it demands attention at the dinner table; it is all one hears during the interval of his after-dinner smoke; and at night one dreams about mountains of yellow metal with nuggets as big as fire plugs."[50] One "Klondiker," as the gold rushers were called, described how shiny

gold nuggets and sacks of gold were displayed in shop windows around town.[51]

By 1909, when Roach arrived in Seattle, the wild days of Klondike Fever were over, and the city had become "sivilized." Seattle was now a flourishing metropolis, with a newly developed downtown, parks, and boulevards. Yet the city's link to its gold rush past was omnipresent. The city's first skyscraper, the fourteen-story Alaska Building, had recently been built, its front door embedded with a gold nugget. In July, Seattle hosted the Alaska-Yukon-Pacific Exposition on the campus of the University of Washington. It served as a "'coming-of-age party' for the city, signaling the end of its pioneer era."[52] President William H. Taft opened the fair by telegraph, and eighty thousand spectators attended the commencement celebration. An amusement park called the "Paystreak"—a reference to a rich gold deposit—hosted carnival rides and concession stands selling "Pea Nuts," lemonade, and ice cream. Thousands of children attended, delighted by attractions like an Eskimo village and the "Gold Camps of Alaska," featuring Native Americans, cowboys, and miners.[53]

The lure of Alaska proved irresistible to Roach, who was seventeen and eager for adventure. Men were still shipping off to Fairbanks, where the gold rush continued unabated. Roach boarded a ship north, intending to get a construction job in the goldfields. On the way there, he and two of his new buddies, seduced by rumors of better-paying jobs elsewhere, snuck off the boat in the port city of Valdez, only to discover that those jobs were 130 miles inland—with no way of getting there but by foot. Roach and his friends gamely set off. "The first day I was really bummed out," he recalled. "The third day I thought I was going to die and I hoped I would." Somehow, the three men made it to the construction site, sprinting the last five miles in order to make it in time for the six o'clock meal.[54]

Initially, Roach planned to stay just long enough to earn the money for his return ticket to Seattle. The climate was harsh and the work rough. Summers were short, cold, and wet, and plagued with mosquitoes. Winters were windy and brutally cold, with temperatures plunging to sixty or seventy degrees below zero. Gold rushers from the turn of the century described a desolate landscape covered in rocks, moss, and scraggly willow

brush, not a single bird or tree around to relieve the dreariness.[55] The population was a mixed bag of "adventurers, gamblers, pugilists, alleged actors and actresses."[56] One prospector, arriving in downtown Nome in 1900, described a scene of "confusion, waste, and filth": "The main street was lined with hastily-erected two-story frame buildings, with here and there a tent—a series of saloons, gambling places, and dance-halls, restaurants, steamship agencies, various kinds of stores and lawyers' 'offices.' It was filled with a mass of promiscuous humanity."[57] For Roach, though, it was heaven. He befriended "the naughty girls" stranded at the construction camps and frequented the local gambling halls— an experience that would come in handy in just a few years. In Roach's own words, "every time I'd start to leave, I got a better job." He prospected, worked construction, then got a job loading six-horse pack teams. "That was terrific," he said, "and I stayed all winter."[58]

Soon, though, Roach became homesick. Depending on the story, the final straw was either nearly losing one of his feet to frostbite or being fired from a job for "goofing off" (Roach was caught lying in bed, idly incinerating lice with his cigarette).[59] Roach headed back to Seattle and got a job driving a truck for the Seattle Ice-Cream Company, which owned the first motor trucks in the area.[60] "I learned to drive," Roach said, "but they forgot that one man now had to do the work of four teams. In order to manage this, I had to drive the truck pretty fast and hard. The company fired me because I was wrecking the truck."[61] Roach was then offered a job in California as a foreman for a fleet of sixteen trucks. Weary of the wet Seattle weather, Roach jumped at the chance to experience the "nice warm desert." Unfortunately, "the trucks were not ready for the desert"[62]—or perhaps, more accurately, the trucks were not ready for Hal Roach. He needed about six weeks to wreck the fleet and was fired. From there, Roach found work as a mule skinner for long-line teams working on a gas pipeline in the Mojave Desert. He was nineteen years old and was quickly promoted to superintendent of freighting, keeping the books and overseeing twenty drivers and three hundred mules. From his stories, the skinners could be meaner than the mules. Once, one of Roach's best men got drunk on the job. Roach broke his bottle of liquor over a wagon wheel, and the man, spitting

with rage, made a run for his rifle. Roach tackled him and sat on his stomach when the boss drove by in his automobile. Instead of demanding the skinner be fired, Roach asked the boss to give the man a second chance and then waited with him overnight until he sobered up. It was a code of loyalty that Roach would bring with him to Hollywood, where he would one day oversee hundreds of employees as the head of his own studio.[63]

Roach was doing well. He was twenty years old, tan from the desert sun and fit from the grueling physical work. He was being paid sixty-five dollars a month with clothes tossed in for free. Yet Roach was restless. He was no longer a boy. In the space of three years, he had been a prospector, a truck driver, a cowboy. He had fled the East Coast, crossed the country, and explored the farthest reaches of the West. He could shoot a rifle, break a mule, and charm the ladies. And yet he was bored. While waiting for his next assignment, Roach moved to Los Angeles. There he would respond to a newspaper ad that would change his life.

Los Angeles in 1912 was just beginning to establish itself as the center of the motion-picture industry. The area's warm weather, plentiful, year-round sunshine, and easy access to mountains, desert, city, and sea made it immensely appealing to movie producers. Land was cheap and abundant, and so was labor—Los Angeles was the nation's largest open, nonunion shop. Independent producers, wishing to avoid paying fees to Thomas Edison's Motion Picture Patents Company, supposedly liked the city's proximity to Mexico, where they could beat a hasty retreat if patent agents did come sniffing around.[64] In the winter of 1909–10, Biograph sent D. W. Griffith to Southern California, where he filmed *In Old California,* a romantic melodrama credited as the first movie shot in Hollywood, then just a small village surrounded by citrus groves and farmland.

Large-screen motion pictures had begun in vaudeville theaters at the turn of the century and then moved into penny arcades and storefront nickelodeans, where they reached a predominantly working-class, immigrant audience. Indiscriminate crowds of men, women, and children packed the dark, stuffy theaters, where the air was "so foul and thick that you can almost cut it with a knife" and the floor was strewn with peanut shells and gobs

of spit.[65] Yet in these squalid surroundings, viewers were trans-fixed by the flickering, black-and-white images on the screen. Here, they found escape from their grim, hardscrabble lives and were indoctrinated into American culture. According to film historian Robert Sklar, "The programs lasted no more than fifteen or twenty minutes, short enough for a housewife to leave a carriage in the vestibule and carry her baby inside, for children to drop in after school, for factory workers to stop and see a show on the way home from work. In the evening and on Saturday afternoon whole families went together, sometimes taking in all the neighborhood programs in a single outing."[66] "Nickel madness" swept the country, with hundreds of storefront theaters popping up in urban, working-class neighborhoods.[67]

By the time Roach landed in Los Angeles, motion pictures were starting to emerge from their lower-class, "slum" origins and attracting more middle-class viewers. It was an auspicious time to get in on the ground floor of a rapidly expanding industry. On hiatus from work, Roach was idly flipping through a local newspaper when he spied an ad for movie extras: "Wanted, men in Western costume. Pay: a dollar, carfare, and lunch. Be in front of the post office."[68] From his years of mule skinning, Roach had the requisite Stetson hat, bandana, and cowboy boots. He knew his way around a horse and was game for a new experience. The next day, he showed up at the advertised spot and was chosen as an extra for a film produced by the 101 Bison Company, which later became Universal. The scene being shot was a gambling scene, but the crew couldn't figure out how to run a roulette table. Roach, who had plenty of experience from his time in Alaska, "breezed up to the director" and made his expertise known. "I know all about roulette," he boasted. The director answered, "We want the leading man to win at the start and then lose all he's got." Roach stood next to the actor playing the croupier and instructed him what to do. At the end of the day, he was told to return the next morning at eight and promised five dollars for his time. Roach was sold. Many years later, he explained, "You say five dollars today, it means nothing. Bear in mind that when I was a kid, a laborer got ten cents an hour, a dollar a day for ten hours. This was 1913. I quit the mule-train business."[69]

Roach was enthusiastic about his new gig. The work was easy

and well paid compared to his previous jobs, and there were plenty of opportunities to learn about the industry from the ground up. In the mornings, Roach would join other wannabe actors and extras in front of the studios, waiting to be hired. There were no casting directors or formal auditions at the time, just an assistant director who would select actors from the assembled group. Roach couldn't believe his good fortune. "Every day I would fall off horses for one dollar a fall!" he exclaimed. Sometimes Roach would play multiple parts in the same movie, one day appearing as a cowboy, the next day an Indian, the next day a "blue soldier," the day after that a "gray soldier."[70] Once, he was cast as an old cowboy and had to age himself forty years without the help of a makeup man. "I poured a whole can of talcum powder over my head and I had more lines on my face than a zebra, and I still looked 20 years old," he joked.[71] Roach was the first to admit he wasn't a very good actor, so he tried becoming an assistant director, then a jack-of-all-trades who was casting director, editor, costume designer, prop guy, assistant cameraman, and accountant all rolled up into one. It was a challenging but exhilarating education, and it helped humanize him when he later became the head of his own studio. His employees, Roach said, knew he'd worked his way up—that he'd been a truck driver and worked in every capacity at a studio and could relate to their problems because he had done their jobs.[72]

For now, Roach was hustling. In July 1914, using three thousand dollars from a small inheritance, he started his own film production company. He partnered up with Dan Linthicum, an industry acquaintance, and lined up financing through an automobile executive named Dwight Whiting. The new company was called Rolin Film Company, a portmanteau of Roach and Linthicum's names. Roach later admitted he had no idea what he was doing: "The first time I directed I felt very unsure of myself; the only thing I knew was that I was probably doing everything wrong. So I told my cameraman not to be afraid to tell me if I made mistakes; he looked very relieved and told me not to worry; it was the first film he'd ever photographed."[73] Over the next few months, Roach directed four one-reel comedies, intended for the nickelodeon market. It was bare-bones, guerilla filmmaking. Roach would pick up actors on street corners in his ten-year-old

automobile, then divvy up roles, ordering one extra to dress up as a cop, another as a drunk, another as a garbageman. They would head to the amusement park or the beach and begin improvising. There was no script, and the set was comprised of a piece of canvas. Comedy at the time was broad and slapstick—people slipped on banana peels, got bonked on the head, fell on their rear ends. Roach would spy a trash can in the park and tell a brawny, tough-guy actor to dump it over the head of a shrimpy fellow. Then he'd tell the guy playing the drunk to walk by, do a double take, and walk into the lake. The cast kept experimenting with different gags, trying to hit on something funny and racing to capture the sunlight since they had none of their own lighting. On cloudy days, they couldn't work at all.[74] Once they finished shooting, Roach would cut the film in his apartment.[75] The total cost of producing a one-reel short? $350.

It was a heady time. Roach and his crew were barely staying afloat financially, but the work was thrilling and the pace breakneck. Stout, charismatic, and opinionated, Roach was like a grown-up version of Spanky, mounting productions with a ragtag group of actors. In some sense, it *was* child's play. Roach always believed that great comedy came from imitating children. Charlie Chaplin's careening around the corner with a leg up was the act of a child. Hitting himself in the back of the head with his cane and then spinning around to see whodunit was the act of a child. Roach and his crew were acting like a bunch of goofy kids, hitting each other with hammers and bricks, pushing each other into puddles, throwing pies in each other's faces.[76] The whole atmosphere of Los Angeles encouraged such freedom. The early years of filmmaking in Hollywood, according to Sklar, were "a great adventure": "[Movie people] were doing something new and untried, and making an incredible success of it . . . their day-to-day working environment was more open, free, and egalitarian than it would ever be again. After working together all day, players and directors often dined together, went out on the town together, visited together."[77] Roach happily settled into his new life. In 1915, he married Marguerite Nichols, an actress. A few years later, they had their first child, a son named Hal Jr.

There were some misfires, to be sure. Roach's earliest shorts were criticized for being derivative and technically shoddy, with

poor direction and photography.[78] He tried to build a series around a knock-off Fatty Arbuckle, hiring a five-foot tall, 285-pound eighteen-year-old named Dee Lampton, who had previously appeared as Chaplin's sidekick in *A Night at the Show* (1915). Called the Skinny comedies, the seven shorts that Roach produced were so dreadful that Pathé, the distributor, cut the running time of five of the shorts by half. Roach lost $3,500 on that deal. He also tried to launch a series around a character named "Toto," the stage name of Arnold Novello, an Italian circus clown. Pathé found the series too "contortionist and burlesque" for their taste and cut the series to a single reel.[79]

The only thing keeping Rolin solvent was the success of one of its stars, the comedian Harold Lloyd. A friend from Roach's acting days, when the two roomed together at the Universal bunkhouse, Lloyd was signed on for three dollars a day as the studio's "top comic."[80] Until then, he had been known primarily as a dramatic actor, but it was Roach's idea to cast him in comic roles. Lloyd, according to Roach, was hopelessly *un*funny, "but he was such a good actor that he could play a funny man."[81] Roach would coach Lloyd through his roles, directing him to run down the hall and through a door, where Lloyd would stop, flummoxed, and ask, "What do I do funny in the hall?" "I couldn't get him to move to the hall," Roach remembered. "I either had to give him an old joke or a new joke or something, because he'd stay right there for ten years before he would go."[82] Roach directed Lloyd in a short called *Just Nuts*, where he played a Charlie Chaplin knock-off named Willie Work. Pathé thought the performance funny enough to enter a long-term distribution contract for a new series starring Lloyd as another Charlie Chaplin knockoff named Lonesome Luke. The Lonesome Luke series kept the studio alive, with Lloyd its top moneymaker. Back home in Elmira, the *Advertiser* reported breathlessly on the achievements of its hometown boy. Harry Roach was a "typically American" success story who had started out "broke" but who now had "money to burn" and was cruising around Los Angeles in "a huge motor car."[83]

As the decade progressed, the "big shots"—producers like Adolph Zukor of Famous-Players-Lasky (later Paramount)—began to move into feature-length films, hoping to attract middle-class viewers with lengthier, more expensive productions of pop-

ular plays or novels.[84] Exhibitors followed suit by building more elegant, luxurious theaters to appeal to this better class of customer. These moving-picture palaces were "dreamcastles" and pleasure domes, where viewers could pretend for a moment that they were kings and queens or millionaires.[85] Some had over a thousand seats and were decorated ostentatiously with marble, polished wood, plush carpeting, and large mirrors. To the surprise of exhibitors, working-class audiences also flocked to the movie palaces, delighted by the amenities. Producers like Roach realized they had to develop stronger narratives and a more sophisticated comic style to accommodate the audience's changing taste. He began to hire writers and helped Lloyd create a new comic character, one who departed from the stereotypical clown figure, with his baggy pants, monkey jackets, floppy shoes, freak hats, and grotesque makeup.[86] According to Roach, the character evolved serendipitously. One of the extras, who usually played a drunk, put on a pair of light brown glasses and began stumbling around the set. Roach was struck by how the glasses changed his character and ordered up a bunch of frames, one of which ended up on Lloyd. "As soon as we put the glasses on him, he became a profitable comedian," Roach claimed.[87]

Roach was now running Rolin Studios out of the Bradbury Mansion in the Edendale section of Los Angeles. It was a large, drafty building with five chimneys and five turrets, perched atop Court Street Hill where it "glowered down upon downtown Los Angeles like an old maid upon a bevy of young debutantes."[88] Lloyd referred to it more facetiously as "Pneumonia Hall." The house was shabby and run-down, with a towering palm tree in the yard and an overgrown rubber tree that was pushing up the pavement with its roots.[89] There was only one small open-air stage, so when the film crew needed to block out the sun, they simply pulled a curtain around the set. Every night, all the furniture and props had to be moved inside, just in case it rained.[90] Linthicum had long since exited the film industry, and Roach now bought out Whiting, replacing him with his father, Charles Roach.[91] In 1919, Roach debuted a new series starring Harry "Snub" Pollard, a member of Lloyd's stock company who performed in whiteface makeup and baggy clothes and wore a signature oversized mustache and eyebrows. The series was popular and profitable, and

Rolin was busy churning out a Pollard one-reeler every week. Lloyd's popularity, meanwhile, kept growing. His new "glasses" character was a hit with audiences, and Roach began to produce two-reel Lloyd comedies. Exhibitors rapturously welcomed these longer shorts, reporting record-breaking house receipts.[92]

Just when everything seemed to be going smoothly, tragedy hit. During a publicity photo session at a local studio, Lloyd picked up what he thought was a prop bomb and pretended to light his cigarette from the sputtering fuse. In some inexplicable mix-up, the bomb turned out to be real, detonating in Lloyd's hand. The explosion blew a hole in the ceiling and took off Lloyd's right thumb, forefinger, and half of his palm. Temporarily blinded, his face covered in severe burns and his right hand gravely injured, Lloyd feared his career was over. Without Lloyd, Roach knew his studio was in trouble. Enlisting the advice of Samuel Goldwyn, a former glove salesman who would become one of Hollywood's earliest movie moguls, Roach helped Lloyd devise a prosthetic glove to conceal his injury. Lloyd returned to work, and Roach breathed a sigh of relief. Few were even aware of the comedian's close brush with death.[93]

Flush with cash, success, and optimism, Roach began to search for a permanent home for his studio, one that would provide more space for his growing roster of actors, writers, and directors. In November 1919, Roach purchased a tract of raw land in the newly incorporated town of Culver City. This would become the home of Hal E. Roach Studios, the Laugh Factory to the World.

Culver City was the brainchild of Harry Hazel Culver, a real estate entrepreneur who was born in Milford, Nebraska, in 1880. After serving in the Spanish American War and working as a mercantilist, newspaper reporter, and customs agent in the Philippines, he arrived in California in 1910. He apprenticed under the real estate developer and businessman I. N. Van Nuys before announcing plans to develop his own city in 1913. Culver chose a parcel of marshy, undeveloped land halfway between the pueblo of Los Angeles and the resort community of Venice. In a speech at the California Club in downtown Los Angeles, Culver praised the region's climate and proximity to the ocean and described the state

as a latter-day Eden, with "thousands of fertile acres," "countless oil wells and mines of gold, silver, and other metals," and "more natural scenic attractions than any other equal area on the face of the globe."[94] Four large boulevards and three electrical railway lines intersected at Culver City, making it "the logical center for what we propose to develop, a townsite."[95]

Culver threw himself into marketing his new town. In an early advertisement, he vaunted the city's transportation facilities and courted prospective homeowners: "If you should sit on the shade veranda of a Culver City home—could sense the fresh tonic ocean air, see the delicate color-shades of the distant mountains and feel the comfortable, uncrowded, homey atmosphere of the place—you wouldn't wonder at Culver City's wonderful record of growth and development."[96] He lured busloads of visitors with the promise of a free lunch. He sponsored a "prettiest baby" contest and gave away a new residential lot to the winner.[97] He also aggressively courted the motion-picture industry. According to one story, Culver caught sight of the silent film director Thomas H. Ince shooting a western at Ballona Creek, a picturesque river lined with willows and bulrushes. He convinced Ince to relocate his studio to Culver City, and in 1915, Ince/Triangle Studios, a partnership of Ince, D. W. Griffith, and Mack Sennett, broke ground along Washington Boulevard. In 1918, Samuel Goldwyn took over the studio, and in 1924, the Metro-Goldwyn-Mayer merger took place. Ince meanwhile built a second studio, the Thomas H. Ince Studio, a bit farther east on Washington Boulevard. The main administrative structure, designed to look like Mount Vernon, was completed in 1919.[98]

Hal Roach Studios was the third major film studio to move to Culver City. Roach initially purchased ten acres for $1,000 an acre and erected an elegant, plantation-style building facing north on Washington Boulevard.[99] Behind the main building, Roach had his indoor stages, large hangar-like buildings made of concrete and hollow tiles.[100] Tucked in a corner was a pool that would eventually become known as Laurel and Hardy Lake, after Roach's great comedy duo.[101] On the back lot were the outdoor street sets, built to look like a New York City neighborhood or Old West frontier town or even an Eskimo village.[102] It was an entire city within a city. In fact, Culver City at that time probably

felt more like a stage set than a real town. When production staff first moved into the new facility, they complained about the spotty telephone and electrical service, part of the growing pains of settling in a brand-new part of town.[103] In the beginning, there was only one phone on the entire lot, and a young office boy darted to and fro, delivering messages. Mail had to be picked up in town and hauled back to the studio over dirt paths, since Washington Boulevard didn't yet have sidewalks.[104] In an aerial photograph from 1921, the studio, with its familiar circular driveway, formed a small compound in a broad swath of bean fields and undeveloped land.[105]

Roach had arrived. He was almost thirty years old and paterfamilias to a studio that was becoming an important presence in the comedy world. He furnished his new office in Old West style, with dark wood paneling, leather furniture with brass tacks, and bearskin rugs.[106] On the lot, he was known as "Mr. Roach," and he ran his studio with corresponding authority. In a photograph taken with Lloyd in 1920, he looked hale and prosperous, dressed in a tweed hunting jacket and tie, his hair slicked back and a pipe clenched between his teeth.[107] He could be intimidating and pugnacious—the early film actor George O'Brien described him as a "rock 'em, sock 'em kind of guy"—but he was also intensely loyal, a so-called straight shooter.[108] At his studio, he fostered a congenial, familial atmosphere. In fact, he lured his own family to Los Angeles from Elmira, installing his father, Charles, as the studio's secretary-treasurer and his brother Jack as a cameraman. He built a house for his mother right on the studio lot, where she entertained guests, played bridge, and even hung out her washing.[109] The "Lot o' Fun," as it was affectionately called, was a place where comedians helped each other with their gags, where employees ate together and children played together.[110] Roach held family-style Christmas parties and had one of the children's classrooms located right above his office.[111] He in turn commanded great loyalty from his employees. The actress Patsy Kelly called him "the best boss I ever had in the industry. I was almost ashamed to take his money."[112] Dorothy DeBorba, a child actress, remembered him as "big and burly, but he didn't growl. And he never talked down to us as little kids."[113] The wayward boy from Elmira was now being heralded as "the greatest comedy di-

rector and producer in the business," the man who had launched the careers of Harold Lloyd and Snub Pollard.[114] He would soon found and develop a new series that would outshine and outlast these two stars.

As the story goes, Roach was sitting in his office, watching a young girl perform a canned song-and-dance routine. "All I wanted to do was to get rid of her," he later recalled.[115] After ushering the girl and her mother out ("Don't call us; we'll call you"), he walked to the window of his brand-new office in his brand-new studio. It was a beautiful, sun-bleached California day. The city was developing so quickly that it felt like a genie had magically conjured it up overnight. Roach stood there, delighting in the mild weather, so different from the bleak winters of upstate New York and Alaska and the relentless rain of Seattle. Across the street from his office, on the other side of the train tracks, was a lumberyard, a dirt lot piled high with building materials for the new houses springing up around town. What Roach saw there was an evocation of his boyhood and his small town beginnings. It would also prove to be a vision of the future—for himself, his studio, and the motion-picture industry.

2

A Boy and His Gang

What Hal Roach saw in the lumberyard on that sunny, Los Angeles day was a motley group of five or six neighborhood kids. They were scuffling in the dirt, collecting pieces of lumber from the sawed-off ends of wooden planks and using them as makeshift swords. Each kid had five or six of the sticks, and they were squabbling over who got the biggest stick. "They were having the damndest argument," Roach remembered. "Now they were going to throw [the sticks] away another block away, but the most important thing in the world now was who owned which of those sticks at that time."[1] For over fifteen minutes, Roach watched them, charmed by their antics. They were real kids, "on the square," covered in sawdust instead of makeup. Roach suddenly thought, "Gee, if I could get some really clever kids as actors, just to play themselves, maybe I could make twelve of these things before I wear out the idea."[2]

The idea for *Our Gang* probably didn't happen in quite that way, but Roach was fond of a good story, and after many years, the tale developed the burnish of truth. We do know that Roach already had a little boy under contract, an eight-year-old African American actor named "Sunshine Sammy" who had an impish nose and radiant smile. His real name was Ernest "Ernie" Frederic Morrison Jr., and he was born in New Orleans, Louisiana, on December 20, 1912.[3] His father, Joseph Ernest Morrison, was a

New Orleans native who had worked for many years as a cook for the federal government.[4] The family originally lived on the corner of Canal and Carondelet Streets, near the bustling center of the New Orleans cotton trade.[5] Just down the street was the Cotton Exchange, a massive wedding-cake of a building surrounded by the offices of cotton factors, buyers, and brokers.[6] Across Canal was the French Quarter, then an unfashionable slum populated by poor blacks and Sicilian immigrants.[7] In the distance, the Mississippi River angled through the city, navigated by ferries and riverboats that deposited passengers, cotton bales, and sugar barrels on the Canal Street wharf.

Morrison Sr. was reportedly lured west to work in the household of E. L. Doheny, an oil baron and one of the richest men in America.[8] The son of Irish immigrants, Doheny was a failed miner and prospector when he landed in Los Angeles, virtually broke, in 1891. In a dizzying reversal of fortune, he discovered oil near downtown Los Angeles and parleyed his one well into a massive oil empire. Soon, thickets of derricks dotted the landscape, transforming Southern California into the center of the early twentieth-century oil boom. In the years before Hollywood took over as the reigning industry, Doheny and his second wife, Carrie Estelle Doheny, were the closest thing to royalty in Los Angeles.[9] For Ernie's father, the chance to relocate to Los Angeles to work for the Dohenys must have been daunting but irresistible. His eyesight had begun to fail, and the doctors were urging him to move to a healthier climate.[10] Like Doheny, Roach, and other transplants before him, Morrison Sr. saw Los Angeles as a place of spectacular possibility and new beginnings. It was a place where a washed-out prospector could become an oil tycoon, a high school dropout could become a studio head, and a young black man could become—who knows what?

There were other reasons, though, that the move seemed wise. As richly cultured as New Orleans was and as vibrant as its black community was, the city could not stave off the incursion of Jim Crow. Louisiana was ground zero for federally sanctioned legalized segregation. Twenty years earlier, Homer Plessy, a light-skinned Creole, purchased a first-class rail ticket and boarded the whites-only car departing from New Orleans. He was arrested and charged with violating the state's Separate Car Act. In 1896,

in the landmark case of *Plessy v. Ferguson,* the Supreme Court rejected Plessy's arguments that his Fourteenth Amendment rights had been violated, upholding the constitutionality of "separate but equal" statutes. Following Plessy's failed court challenge, race relations in the city continued to sour. In 1900, a race riot swept the city, leaving twenty-eight people dead. By the time little Ernie Morrison was born, Louisiana had passed laws prohibiting interracial marriage and segregating public schools and public accommodations.[11] In 1912, the year of Ernie's birth, there were more than sixty African Americans lynched in the United States, the vast majority of them in the South.[12] For the father of a young family, it seemed like a good time to get out.

Los Angeles, with its promise of adventure and greater racial tolerance, beckoned. According to the 1910 census, Los Angeles had a black population of 7,599 people—a miniscule 2.4 percent of the total population of the city. Nevertheless, it was home to the largest urban black population west of Texas. In the first two decades of the twentieth century, the black population multiplied more than sevenfold, drawn by the climate, greater economic opportunity, and the belief that the West offered some respite from racial oppression.[13] The city had desegregated schools by the 1880s, and the small black population dealt with less residential segregation, at least at first.[14] One historian called the period between 1900 and the stock market crash of 1929 the "Golden Era" for black Angelenos.[15] In addition to the city's improved economic prospects and civil liberties, African Americans could purchase their own lots and homes. By 1910, 36 percent of black Angelenos were homeowners—compared to 2.4 percent of the black population in New York City and 11 percent in New Orleans.[16]

The local papers seemed to confirm this vision of Los Angeles as a veritable promised land. In 1909, to commemorate the one hundredth anniversary of Abraham Lincoln's birth, the *Los Angeles Times* devoted an entire section of the paper to "the American negro." Several prominent local residents, as well as Booker T. Washington, were invited to write for the paper, and they extolled the virtues of the region. A *Times* reporter lauded the black community for its civic engagement, industry, and law-abiding ways. "They have hundreds of good, comfortable homes and not a few that rival in elegance and luxury the best in the whole city," he

wrote. "They buy and read books; their children attend the schools and often outstrip their white companions in ability . . . they are good, God-fearing, law-abiding men and women."[17] A few years later, W. E. B. Du Bois took a promotional tour through the state and described Los Angeles as a wonderland of roses and orange blossoms, home to a colored population "full of push and energy."[18] "Nowhere in the United States is the Negro so well and beautifully housed," he wrote, "nor the average of efficiency and intelligence in the colored population so high. Here is an aggressive, hopeful group—with some wealth, large industrial opportunity and a buoyant spirit."[19]

That spirit would inevitably be tested, however. Despite the hyperbolic praises of its boosters, Los Angeles was far from a racial paradise. "The color line is there and sharply drawn," Du Bois acknowledged, describing how black patrons were routinely refused service at certain stores, hotels, and restaurants.[20] Local authorities condoned and even sponsored discriminatory practices. In the summer of 1912, a black businessman, C. W. Holden, met a white colleague for a beer at a local saloon. The bartender charged Holden a dollar for his drink and his white colleague a nickel. Ignoring protests by the black community, City Attorney John Shenk issued what was called "the Shenk Rule," allowing businesses to overcharge black patrons.[21] Elsewhere, black residents were threatened and harassed by white neighbors, black businessmen were evicted from commercial buildings, and black children were relegated to segregated beaches. One local resident reported, "We suffer almost anything (except lynching) right here in the land of sunshine. Civil privileges are here unknown. You can't bathe at the beaches, eat in any first-class place, nor will the street car and sight-seeing companies sell us tickets if they can possibly help it."[22]

Ernie's father was undeterred by these warnings. While Los Angeles may have had its problems, it was still an improvement on the situation in the South, where racial terror and degradation were so unrelenting that the West, in comparison, seemed "heaven," "a land of golden opportunities," "Beulah-land."[23] By 1920, the black population in Los Angeles stood at 15,579—still less than 3 percent of the overall population, but rapidly growing.[24] The Morrisons joined a small but tight-knit community of black

Angelenos, most of whom worked as domestic workers, laborers, janitors, and porters.[25] They were part of an early wave of middle-class migrants from the South—from places like San Antonio, Dallas, New Orleans, Shreveport, and Atlanta.[26] Many settled around Central Avenue between Eighth and Twentieth Streets, an area that the black newspaper the *California Eagle* called "the Black belt of the city."[27] The neighborhood was ethnically diverse, a mix of Mexicans, Japanese, Chinese, Jews, and Italians. Black-owned businesses like the Dreamland roller skating rink, Robinson's Empress Ice Cream Parlor, and Rose's Variety Store opened along the avenue, soon joined by the Southern Hotel, the Colored YMCA, and Dunbar Hospital.[28] Ernie's father could get his hair cut, rent an apartment, buy a shirt, catch a moving picture, and play a game of pool, all without stepping off Central Avenue.

Ernie's family settled into a house at 5420 Long Beach Avenue, a colored neighborhood south of the Central Avenue district, near the corner of Fifty-fifth Street.[29] The area had been part of the Furlong Tract, a parcel of land once owned by an Irish farmer named James Furlong, who was interested in "the advancement of the Negro."[30] Starting in 1905, Furlong began selling lots to black families prevented from settling in other neighborhoods due to racial covenants or high prices. The Morrisons—in addition to Joseph, his wife Louise, and son Ernie, there were four daughters, Florence, Vera, Dorothy, and Ethel—lived on the western edge of the original tract, along the Pacific Electric railway line that ran down Long Beach Avenue. It was a neighborhood of modest homes and businesses, churches, and the first all-black school in the city, a one-story wood-frame building erected in 1910. It was here that Ernie's father would open the grocery store where, according to one story, Farina Hoskins was discovered.[31]

The Doheny family, the senior Morrison's employer, lived in Chester Place, a wealthy enclave close to the campus of the University of Southern California, then a provincial Methodist school.[32] The mansion, which still stands today, was painted the color of hot cocoa and designed in a hybrid French and Gothic Renaissance style, complete with a four-story peaked turret and ivy-covered walls. The furnishings inside would have made Hal Roach's heart sing. There were heavy oak paneling, bearskin rugs, a petrified-wood fireplace, and the mounted heads of buffalo,

moose, and elk.[33] The mansion's crowning feature was its twenty-four-foot-wide glass dome, designed by Louis Comfort Tiffany. Fashioned out of 2,836 pieces of glass, it glowed like the scales of an immense golden fish.[34] Morrison's father was part of a large staff of domestic servants that included a cook, second cook, relief cook, kitchen maid, waitress, parlor maid, two second-floor maids, personal maid, laundress, seamstress, cleaning woman, two housemen, three chauffeurs, and three or four secretaries.[35] The Count and Countess Jaro von Schmidt lived nearby, as did the railroad executive Harry W. Vermillion and the mining tycoon William Bayly.[36]

According to Hollywood lore, little Ernie Morrison was discovered while playing in the Doheny mansion. He was a precocious child, who was able to walk and talk at the age of eight months and already showed a talent for dancing.[37] The father of Baby Marie Osborne, a curly-haired moppet who became the first major child star of American silent films, happened to be visiting the house and thought Ernie would make a nice addition to his daughter's films. "I'm going to use a real colored baby," he reportedly said to Morrison Sr., mentioning that this had been done only once before, in *The Birth of a Nation*.[38] Ernie tagged along to the studio with Mr. Osborne, where he was tapped as a replacement for a little black child who wouldn't stop crying during filming.[39] Like other Hollywood discovery stories, this tale probably contained more than a dollop of fiction. The Dohenys were devout Catholics and teetotalers—newly minted frontier moguls, yes, but not likely to socialize with the louche arrivistes of the film industry.[40] When Theda Bara, the silent film actress nicknamed "The Vamp," moved into the Dohenys' neighborhood around World War I, she caused a "sensational flutter" in this staid bastion of the social elite.[41]

Whatever the true story behind little Ernie's discovery, he was soon a working actor, nicknamed "Sunshine" because of his cheerful temperament, to which his father added the moniker "Sammy."[42] From the beginning, he was a consummate professional. In one of his earliest roles, Ernie was required to jump out of a fiery building and fall seven feet into a net held by firemen. Not only did Ernie take the jump, he spent the rest of the day blithely playing around as if nothing had happened.[43] His wages

began at two dollars a day, and he worked steadily. He appeared in fourteen films with Baby Marie, as well as a two-reeler with Fatty Arbuckle called *The Sheriff*.[44] Hal Roach's wife, Marguerite, acted with Ernie in the Baby Marie films and, impressed by his professionalism, brought him to her husband's attention.[45] Seeing star potential in the young boy, Roach signed him to a two-year contract, with the intention of featuring him in his own series.[46]

Ernie was only seven years old, but he was reportedly the first black actor signed to a long-term film contract in Hollywood. In a photograph commemorating the momentous event, Ernie, wearing a dark sailor suit and sitting on his father's lap, grinned mischievously as Roach pointed to the dotted line.[47] The *Chicago Defender*, a black newspaper, reported that his weekly salary was a lavish $175 per week—the equivalent of roughly two thousand dollars a week today. The paper ran a formal portrait of the young star sitting primly in a chair, dressed in a coat and short pants, his hands clasped in his lap and his legs decorously crossed. He looked every bit the little prince. "Master Ernest Morrison," the newspaper marveled, even had a private tutor "who accompanies him to the studio daily and sees that he gets his lessons." The *Defender* had high hopes for Ernie, seeing in him a way to make racial inroads in the film industry. "It has been suggested," the paper reported, "that if this youngster is worth $175 a week to the Rollin [*sic*] Film company ... [he] would do the same if not better for a picture producing company owned and controlled by men of his race. Any one interested in such a proposition may communicate directly with the lad's parents."[48]

In his film roles, however, Ernie was more "pickaninny" than prince. A racial stereotype that gathered cultural force in the nineteenth century, the pickaninny was depicted as a small, jet-black child with rolling white eyes and grotesque red lips, wild hair, and a taste for watermelons and chicken. Pickaninnies were comic bait for alligators and virtually indistinguishable from monkeys. They were impervious to pain, nonchalantly enduring whippings and other forms of abuse. When they spoke, they used broken plantation dialect. They never seemed to have clothes on, or if they did, they were dressed in rags. Everything about them suggested they were ignorant, uncivilized, and inhuman. First popularized by the figure of Topsy, the naughty slave girl in Har-

riet Beecher Stowe's *Uncle Tom's Cabin,* the image of the picka-
ninny had become ubiquitous by the turn of the twentieth centu-
ry, adorning products as various as soap, tobacco, ashtrays, candy,
and postcards.[49] Along with the "coon" (a grown-up version of the
pickaninny, who was lazy, irresponsible, and dim-witted, with a
taste for chicken, watermelon, and shooting dice) and the "mam-
my" (a kerchief-wearing, heavy-set, ill-tempered black woman
who often beat her husband and children), the pickaninny was
a minstrel stereotype that justified slavery and segregation while
satisfying white nostalgia for a mythical antebellum South.[50] Well
aware of its appeal, Hollywood cast black children who looked the
part, namely ones "with a dark complexion, big lips, and kinky
hair."[51]

Ernie may have lacked some of the more stereotypical physi-
cal features of the pickaninny, with his close-cropped hair and his
generally well-dressed appearance. But the stage name "Sunshine
Sammy" was itself an homage to the most famous pickaninny of
the early twentieth century, Little Black Sambo, the title char-
acter of a popular children's book written by Helen Bannerman.
While the story was set in colonial India, it featured a protago-
nist whose name evoked the plantation "Sambo" (a stereotype of
the slave as a happy-go-lucky buffoon and overgrown child) and
whose distorted appearance evoked the American pickaninny.[52] A
best seller in England and America, the book became a cultural
phenomenon, spawning countless pirated editions and becoming
a staple of children's bookshelves. By the time Ernie's career took
off, Little Black Sambo was a classic children's character as fa-
miliar and beloved as Peter Rabbit or Mother Goose. White and
black children alike read the book and mounted *Little Black Sam-
bo* operettas and costume dramas at school.[53] Tapping into this
affection, Ernie initially appeared in several Baby Marie shorts
credited as "Sambo," "Little Sambo," and even "Sunshine Sam-
bo," soon shortened to "Sunshine Sammy."[54]

Only one short from Roach's "Sunshine Sammy" series was
filmed, a two-reeler called, predictably, *The Pickaninny.* Pathé, the
film's distributor, took out trade advertisements describing Er-
nie as "the funny little darkie of the Hal Roach comedies." "Hot
Dang! I'se Heah, Gemmens!" the copy read under a photograph
of a beaming Ernie:

Millions have laughed at him, exhibitors have commented
on his popularity with their audiences, though he wasn't
starred,—just a wide-grinning, little coon, loose-jointed,
full of pep, a "pip" of a "feeder" to the comedy stars he
supported. . . .

Hot dog! This one isn't a gamble, it's just sure to please.[55]

Released in 1921, *The Pickaninny* was a frenetic, chaotic film, full
of slapstick gags held together by the flimsiest of plots. As "Casi-
no," the eponymous pickaninny, Ernie goofed off on a treadmill
with a bunch of white kids, rigged his bobbing fishing pole to a
baby carriage to rock a baby to sleep, helped a drunkard hide his
moonshine from a cop, and got chased by a bear. The short con-
cluded with Casino's father, played by a white actor in blackface,
hauling him off by the scruff of the neck.[56]

The Pickaninny was mediocre stuff, with little narrative mo-
mentum, but Ernie displayed ample personality and a winning
smile as he cavorted from one set of hijinks to another. *Billboard*
described the film as "giv[ing] the colored youngster every op-
portunity to show just how keen a master of fun-making he re-
ally is."[57] The *Chicago Defender* called it "a scream from start to
finish, with a few pathetic spots which are bound to make you sit
up and take notice."[58] By then, Ernie's father had quit his job as
a cook in order to manage his son's blossoming career. Occasion-
ally, Morrison Sr. took bit parts in Ernie's pictures, but mostly
he chaperoned his son on set, oversaw his education, and helped
negotiate the demands of fame.[59] In a photograph from the early
1920s, he stood proudly behind his son, his hands clasped on the
boy's shoulders. Both junior and senior Morrison were sharply
dressed, Ernie in a costume from one of his films, his father in a
pinstriped suit. The family resemblance was undeniable from the
smile on their faces to the jaunty tilt of their heads.[60]

Both white and black children gravitated toward Ernie as a
hero and role model. At a huge parade held in his honor in Provi-
dence, Rhode Island, seven thousand children—the vast majority
of them white—besieged the young star.[61] He was profiled in trade
magazines like *Variety* and in mainstream newspapers like the
Los Angeles Times. At the same time, Ernie served as an inspira-
tion to black children, who voted him their "Favorite Movie Star"

in local newspaper contests.[62] Although Ernie was playing a racial stereotype, the African American community rallied around him, seeing him as a "race benefactor" because he made countless people—black and white—"laugh and forget their troubles."[63] He was featured in the "Little People of the Month" column in the *Brownies' Book,* a magazine for black children sponsored by the NAACP and intended to promote racial pride. Photographed with his sister in the arms of Snub Pollard, Ernie was reported to earn enough money "to own a fine home, several automobiles, and dogs and other pets, just like other movie stars."[64] Ironically, the *Brownies' Book* was created partly to counteract insidious stereotypes like that of the pickaninny, but Ernie, with his charisma and good nature, seemed to transcend its limitations to become a racial role model. He appeared in another issue a few months later, again posing with Pollard. This time dressed as a cowboy, Ernie pointed a toy pistol at Pollard, who raised his hands in mock fear. Just in case impressionable young readers took this as permission to stick up adults, the caption read, "'Sunshine Sammy' would never do this in real life, but it's all right in the movies."[65] In 1923, W. E. B. Du Bois, editor of the *Brownies' Book* and the official NAACP magazine, the *Crisis,* took a trip to Hollywood and visited Ernie on the Hal Roach lot. In a photograph that ran in the magazine shortly afterward, a bemused Du Bois looked on as Ernie hammed it up on an oversized bass, surrounded by prominent members of the Los Angeles African American community.[66]

Ernie was torn between two worlds. He was a ragged but endearing pickaninny to white audiences, a prince and "race star" to black. These worlds were separated by what Du Bois famously called the "veil," a color line so vast that it split black consciousness in two. Ernie was blessed—and cursed—with "double consciousness," the "sense of always looking at oneself through the eyes of others."[67] As a star and celebrity, he was already accustomed to being watched. But as a black child in a white industry, he must have been particularly conscious of his racial difference. He knew that white viewers saw him as a representation of the Negro first, an American second (if at all). Yet the scrutiny did not end when he went home. He was also held up as a credit to his own race, a rare positive portrayal of a black child in the media. Bessie Woodson Yancey, an African American poet writing during the

Harlem Renaissance, imagined Ernie's warring persona in her poem "To Sunshine Sammy":

> Then smile along, my little man,
> A prince with beggars cast,
> And smiling while
> You work away
> May lift the veil at last.[68]

Ernie was freighted with the hopes of an entire race. Beneath the smiling exterior and pickaninny guise was grim responsibility to help "lift the veil," dismantle the color line, and act as prince and savior of his people.

It was an immense burden, but Ernie, at least on the surface, made it seem easy. Every day, Ernie shuttled between his home in the colored section of Los Angeles to the almost all-white studio set. There, he might have heard offhanded racial jokes. He probably heard someone yell, "Bring that nigger over here"—referring not to him, but to the "nigger light," a device used to dim lights.[69] When Pathé declined to make any more episodes of the "Sunshine Sammy" series, Ernie was told it was because of his race. "[Roach] tried to give me a series of pictures," he remembered, "but because of being black at that time, they didn't go through."[70] The official reason, according to Pathé's U.S. Chief Paul Brunet, was that "kid pictures" were "box office poison," a reason that would be soundly discredited just a few years later with the overwhelming success of *Our Gang*.[71] In a possibly apocryphal story, Tay Garnett, a gag writer who would later become a renowned film director, described seeing Ernie on the studio lot during his lunch break, megaphone in hand, pretending to direct a movie. Walking past, Garnett joked, "Going to be a director when you grow up, Sammy?" to which Sammy replied, "Gee, no, Mr. Garnett, it's tough enough being colored."[72] Recalling the story many years later, Garnett clearly relished the joke about the difficulty of a director's job. But if the story was true, it also revealed Ernie's matter-of-fact awareness of his social status. It was tough enough being "colored," even though he was a film star. And even if Ernie *had* wanted to be a director, that avenue was foreclosed to him—there were no black directors working in Hollywood.[73]

After his lumberyard epiphany, Roach renewed his efforts to launch a kids series, with Ernie as the anchor. He quickly cast the

rest of the gang, recruiting kids from among his friends and associates. Mickey Daniels, a freckle-faced kid with a wide, gummy smile, had appeared in a few Harold Lloyd films and was already buddies with Ernie on the lot.[74] Jackie Davis was "a very good-looking boy" who happened to be Harold Lloyd's wife's brother.[75] Mary Kornman was the pretty blonde daughter of Roach's still photographer, Gene Kornman. Jackie Condon, with his wild curls, and Peggy Cartwright, with her sultry eyes and dark hair, had both appeared in Booth Tarkington's *Penrod,* where they caught Roach's eye. Farina, depending on the story, either followed Ernie to the studio one day, was discovered by director Bob McGowan on L.A.'s Central Avenue, or was discovered by Sammy's father at his grocery store. These six were what Roach described as "the nucleus" of the first group of *Our Gang* kids.[76] They filled prescribed roles: the leader, the sidekick, the infant tag-along, the bully, the girl.

Roach sent a copy of the first film to his friend Sid Grauman, the powerful movie exhibitor who had recently opened the lavish Egyptian Theatre on Hollywood Boulevard. As Roach remembered it, he didn't hear back from Grauman for a week. Then he happened to open the paper and spy an advertisement trumpeting his film as "One of the funniest comedies ever made. You can't miss it. *Our Gang*." Grauman was a notorious prankster, and Roach figured this was just another one of his jokes. He rang Grauman up and said, "What's going on? You can't keep this thing. It's the only copy I got!" but his friend just brushed him off. "I don't care," Grauman said. "I've already advertised it. Don't give me any talk." Joke or no joke, Grauman's showbiz instincts were impeccable. The comedy ran for a week and became so popular that Roach changed the name of the series from *Hal Roach Rascals* to *Our Gang*. "From there it just took off and went on for years," he said.[77]

There is no record that Roach and director Bob McGowan knew—or even cared—that building a children's show with a mixed-race cast was unusual. Instead, they emphasized the natural, unforced quality of the juvenile cast. In an interview, McGowan recalled Roach's only instruction to him at the beginning of the series: "Keep them human." The kids weren't stage kids but "just every day youngsters who can be found in any gang anywhere in the United States," McGowan said.[78] In a later interview, he elaborated,

"I am frequently asked to describe the type of child who is best fitted for *Our Gang*. I can tell you this in a few words. I do not like beautiful or artificial children. I like the kind of normal, every day kids who might be found in every neighborhood—typical children—kids who can play and get into mischief without malice or afterthought."[79] Exhibitors reported that audiences found the shorts delightful. "This bunch of kids will amuse anyone who was ever a kid himself," one exhibitor wrote in. Another announced, "Adults, as well as children, enjoy these children's pranks." Several applauded the "clean" and "wholesome" quality of the pictures and reported record box-office receipts.[80] According to one trade magazine, *Our Gang* films were grossing over $80,000 a release.[81]

Roach had hit upon a winning formula: clean comedies, starring appealingly unaffected, "every day" kids, that celebrated the institution of the neighborhood gang. The series was undeniably representative of its time, employing hackneyed racial stereotypes imported from vaudeville, minstrel shows, and popular literature. Yet it was simultaneously exceptional in its treatment of interracial friendship and its comparatively positive depictions of "Negroes." Geraldyn Dismond, a black gossip columnist writing during the Harlem Renaissance, considered Sunshine Sammy and Farina highly unusual for transcending the typical menial and fool roles available to Negro actors in the 1920s.[82] Seventy years later, contemporary film historians echoed Dismond's assessment. Donald Bogle wrote, "For the most part the approach to the relationships of the black children with the whites was almost as if there were no such thing as race at all," and Lindsay Patterson concurred: "on the whole, *Our Gang* maintained itself as one of Hollywood's few contributions to better Negro-white relations."[83] Thomas Cripps acknowledged that while the series did employ racial jokes, it also exhibited an "egalitarian tone" where "the Negro became a peer of the whites."[84]

Why was this the case? Why was *Our Gang* the exception to the rule of racial caricature and segregation on the silver screen? What was it about this mixed-race group of kids that circumvented the hardened racial sentiments of the time?

Part of the answer can be found in the fact that these were, after all, children. They were naïfs, not yet fully socialized, not yet

indoctrinated in the racial codes of the time. Historically, black and white children could play together relatively freely, as they often did in the antebellum and even postbellum South. Frederick Douglass, the famous African American orator and former slave, described befriending young white boys he met on the streets of Baltimore in the years before the Civil War. Not yet hardened by race prejudice, these boys taught the young Douglass how to read, even though this was then considered a crime. "I used to talk this matter of slavery over with them," Douglass remembered. "They would express for me the liveliest sympathy, and console me with the hope that something would occur by which I might be free."[85] According to one historian, slave and white children on Southern plantations played together "with a relative degree of social equality," pulling pranks like stealing chickens or playing a version of tag called "No Bogeyman Tonight."[86] While some white planters tried to prevent their children from mixing with slave children, their efforts were usually unsuccessful. C. Vann Woodward, the eminent Southern historian, described how during the 1880s, Northern visitors were often shocked by the degree of intimacy and interaction between blacks and whites, a part of the lasting legacy of slavery. Black and white children played together and often lived near each other.[87] As they grew older, however, a caste system would begin to infiltrate their play, with white children imitating overseers or masters and slave children relegated to subservient positions. Encroaching adulthood brought with it greater awareness of the social codes of racial inequality.[88]

Black children, or their stereotypical representation as pickaninnies, also tapped into nostalgia for the antebellum South, a period of time that—for its believers—seemed simpler, more pastoral, and more innocent. In a 1905 newspaper article titled "Concerning Pickaninnies," a white reporter wrote, "'Times change and men change with them,' but the pickaninny of Dixieland changes never. He is the same yesterday, to-day, and forever. He plays the same games the little slave child played, and sings the same songs that the little slave child sang."[89] To Southern nostalgists, pickaninnies had drunk from the fountain of youth. They were always happy, always young, and always the same, providing reassuring constancy against the upheavals of time. More importantly, they harbored no racial animosity and posed no racial

threat to white people. "Most pickaninnies," the reporter continued, "are fond of white people. The acme of many a little black girl's happiness is reached, her cup of joy runneth over, when she is allowed to play for half an hour with the dainty little white child of the 'big house,' as the planter's residence is invariably called by the little darkies."[90] Pickaninnies did not demand equal rights; they did not demand enfranchisement; they simply wanted to play.

Childhood further offered protection against the threat of miscegenation, still illegal in most states at the time. The taboo against interracial mixing was older than the nation itself, with the first antimiscegenation law established in 1661 in Maryland colony. Sex between blacks and whites was considered unnatural and immoral, a transgression of the color line and a danger to the purity of the white race. By the mid-nineteenth century, when the word miscegenation was first coined, those charged with miscegenation faced prison time or the wrath of the lynch mob.[91] Black male sexuality, in particular, was the source of anxiety bordering on hysteria. Speaking on the floor of the Senate in 1900, Benjamin Tillman, a former governor of South Carolina and a virulent racist, cried, "We of the South have never recognized the right of the negro to govern white men, and we never will. We have never believed him to be the equal of the white man, and we will not submit to his gratifying his lust on our wives and daughters without lynching him."[92] By 1913, thirty states had passed antimiscegenation laws, and there had been at least two attempts in Congress to add an antimiscegenation amendment to the Constitution. The previous year, Jack Johnson, the first black world heavyweight champion, was charged under the Mann Act for transporting a woman across state lines "for the purpose of prostitution, debauchery, or for any other immoral purpose." His real crime? Openly and unapologetically consorting with white women. Because they were presexual, children—especially little black boys—could skirt this risky territory. Physically and sexually unthreatening, they were the anti–Jack Johnsons—"prepubescent boon companions" cavorting in the sanctified space of childhood.[93]

The childhood gang, usually a pack of young boys, already held a cherished place in American culture. Closely tied to the myth of American boyhood, it coalesced in the late nineteenth century around images of small-town boys and their idylls in the woods or local swimming hole. Like the pickaninny, the image of

the carefree boy tapped into nostalgia for antebellum rural life, before urbanization's corrupting influence on American childhood. Little boys could run free and safely exercise their "savage" tendencies; their escapades were considered natural and healthy, a sign of vigor.[94] Mark Twain's Tom Sawyer is arguably the most famous of these American boys, with his penchant for mischief and his delight in leading games of pirates and robbers with his gang. At the end of *The Adventures of Tom Sawyer*, Huck is rapt as Tom describes the gang's elaborate initiation ceremony, a ritual that involves a haunted house, a coffin, and a blood oath "to stand by one another, and never tell the gang's secrets, even if you're chopped all to flinders, and kill anybody and all his family that hurts one of the gang."[95] Published in 1876, the novel re-created a world that was already disappearing in the second half of the nineteenth century—the world of Twain's own rural boyhood in Hannibal, Missouri, in the 1840s.

By 1922, the year of *Our Gang*'s debut, America was eager for the reassuring myths and comforts of childhood. The nation was going through its own set of growing pains, transformed by forces of immigration, urbanization, and industrialization. In the second half of the nineteenth century, a new wave of immigrants from southern and eastern Europe flooded into the country, settling in cities in the Northeast and Midwest. In places like New York City, they jammed into tenements in sordid, crime-infested slums. Jacob Riis scandalized middle-class readers with his exposé of urban living conditions and the plight of the tenement children who swarmed the alleys. Surrounded by filth, violence, and degradation, these children were drawn to ethnic street gangs that terrorized the neighborhood, committing robberies and even murder.[96] Against such urban poverty and alarming foreignness, the *Our Gang* kids seemed safe and familiar, providing a nostalgic escape for viewers who preferred their gangsters be descended from Tom Sawyer and Huck Finn, not Bill the Butcher or Al Capone.[97] At the same time, immigrants, the source of so much national anxiety, could also find joy in these kids' adventures while continuing their indoctrination in American culture.

The *Our Gang* kids existed at the safe intersection of the past and the present, but they also provided a roadmap for the future. Anxious parents, alarmed by accounts such as Riis's, fretted that urbanization was corrupting the youth of the country.

They pointed to boys' gangs in their own towns that crowded the "respectable citizen" off the sidewalk, or lured the mama's boy to the swimming hole, or played pranks on the local "Jew peddler" or "Chinese laundryman."[98] Yet educators such as Joseph Adams Puffer pointed out that these gangs, aggravating as they were, offered a potential solution to the increasing diversity of the country. Rather than leading to a life of criminality, like the ethnic street gangs described by Riis, these boys' gangs had more in common with Tom Sawyer's gang, allowing boys a healthy outlet for their energies. The boys' gang, in other words, was actually a *good* thing. It was a miniature society, a safe space and "training ground" where boys could learn how to get along with others.[99]

In his book *The Boy and His Gang*, published in 1912, Puffer interviewed local Boston-area gangs to bolster his hypothesis. He found that the boys' gang taught loyalty, cooperation, self-sacrifice, fidelity, and team play—the "knack of getting on with his fellow men"—so that one day, he could become an "efficient citizen of democracy."[100] Of the sixty-six gangs Puffer studied, fifty-four were of mixed race and ethnicity, and only one excluded Jews and "Negroes." On the whole, Puffer found that despite their pranks on immigrants, the boys' gang was "thoroughly unprejudiced and democratic." "Far more than we realize," he wrote, "the boys' gang is helping out the public school in the great problem of assimilating the diverse races of the United States."[101] As evidence, Puffer described the "Morse Hollow Athletic Club," a typical gang with members who were Irish, French, "American," Negro, and Scotch.[102] The club's only requirement for membership was the ability to play baseball or football. At night, the group would meet on a street corner and talk about games. Queried about their other activities, the boys recounted stealing apples from orchards, scuffling with the "Garden of Eden" gang over a football game, and playing hooky from school.[103] Their activities, in short, could have come from an episode of *Our Gang*.

Girls are notably absent from Puffer's analysis, reflecting the gender assumptions of the time and notions of democracy as a fraternal society. At the time of Puffer's writing, the Nineteenth Amendment, which gave women the right to vote, had not yet been passed (it would be ratified in 1920). Much of Puffer's work has the fondly indulgent tone of "boys will be boys." Boys will

steal apples. Boys will throw eggs at people. Boys will collect stray dogs. In one chapter, Puffer writes, "a boy joins a gang and a girl does not for precisely the same reason that he throws stones while his sister tends lovingly the dolls that are beneath his contempt. Each is doing instinctively, as a child, for play, what grown men and women have been doing these thousand years for work."[104] Interviewing several boys, he asks, "How does your gang treat girls?" to which he received responses like, "I don't know how to treat them. I never tried it" and "Sometimes do mean things to them. Swear at them. Fight them. Steal things off them. Call them names."[105] He-Man Woman Haters Club, indeed!

Despite the outdated gender politics of Puffer's work, *The Boy and His Gang* is curiously contemporary in its celebration of diversity. Here was a potential solution to the problem of the American melting pot, a way for young boys of vastly different backgrounds to learn how to get along. True, the boys Puffer followed were generally older, ranging in age from nine to sixteen, as opposed to the *Our Gang* kids, who ranged in age from one to eleven. But this allowed *Our Gang* to avoid the pitfalls of older gangs—the threat of more troublesome delinquency and crime. The *Our Gang* kids might pester policemen and storeowners, but their antics never strayed into the malicious or the immoral. Moreover, the presence of a girl or two in the Gang helped alleviate some of the more purportedly "savage" predilections of boys. This was no *Lord of the Flies*.[106] *Our Gang* was a reflection of American society, and that society included women as well as men, black people as well as white.

A training ground for citizenship, a miniature democracy, a virtual nation—the gang was all these things and more. It was a "society of equals" that could "fully know itself only against the background of a hostile world."[107] Without enemies, the gang could not exist. For the kids in *Our Gang*, that hostile world included sanctimonious adults, greedy shopkeepers, stuck-up rich people, and rival gangs. Jackie, Mary, Mickey, Peggy, Sammy, and Farina came from different backgrounds, but they were united in their resistance to a common enemy. When Mickey is adopted by a wealthy aunt and separated from his friends, the Gang swarms her house, creating such havoc that she agrees to let him return to his family and friends (*High Society*). When a bully named

Toughey terrorizes the neighborhood, the Gang draws straws to see who will vanquish the enemy (*Telling Whoppers*). And when a humorless surveyor tells the Gang they can't build an amusement park on a piece of undeveloped land, the kids go over his head to the property owner and charm him so thoroughly that he helps them set up the park himself (*Boys Will Be Joys*).

What the Gang did not realize was that its greatest enemy wasn't a society dame or a neighborhood bully or an uptight businessman. It was America itself. If *Our Gang* was a miniature vision of one kind of America—one that was happily multiracial and multiethnic—its enemy was a vision of a different kind of America: one that was strictly segregated and nativist. For the *Our Gang* kids, the "hostile world" wasn't just the world of grown-ups and killjoys. It was also the world of Jim Crow.

The origin of the term "Jim Crow" is unclear, but it entered popular usage in 1832 through a minstrel act called "Jump Jim Crow." Performed in blackface by the white comedian Thomas Dartmouth Rice, the song-and-dance routine was supposedly inspired by a crippled black stablehand Rice had seen during his travels. By 1838, "Jim Crow" had entered the language as a derogatory term for Negro and was soon applied to laws segregating the races.[108] In 1842, the Boston abolitionist paper, the *Liberator*, described how "the colored man" is relegated to the "Jim-Crow car,"[109] a policy that was later definitively upheld in the landmark 1896 case of *Plessy v. Ferguson*. The number of Jim Crow laws exploded in the first two decades of the twentieth century, with railways, steamboats, theaters, toilets, and water fountains segregated throughout the South. In North Carolina and Virginia, fraternal societies that allowed members of both races to call each other "brother" were outlawed.[110] The January 1912 issue of the *Crisis* decried laws "prohibiting Negro men and women entering public libraries, museums, parks, and theatres."[111]

African Americans were losing ground in other ways. The years after the Civil War had been full of promise, with the passage of constitutional amendments outlawing slavery, granting suffrage to black men, and providing equal protection to African Americans under the law. But as W. E. B. Du Bois wrote in *Black Reconstruction in America,* "The slave went free; stood a brief mo-

ment in the sun; then moved back again toward slavery."[112] With
the return to power of the Democrats in 1877, any Reconstruction-
era gains were quickly undone. African Americans in the South
were systematically disenfranchised through poll taxes and liter-
acy clauses, terrorized by vigilante groups like the Ku Klux Klan,
and straitened by legalized segregation. Lynching peaked in the
1880s and 1890s, as white mobs tortured, mutilated, hanged, or
burned alive black victims. A glut in the world cotton market and
the devastation of Southern cotton crops by the boll weevil threw
thousands of black tenant farmers out of work. The proliferation of
racist caricature—of coon, mammy, and pickaninny stereotypes—
acted as powerful propaganda to further justify racial inequality
and Jim Crow. If blacks were thieving, inhuman, and immoral,
didn't it make sense that they be excluded from the full rights
of citizenship? In 1898, Supreme Court Justice Joseph McKenna
justified black disenfranchisement by claiming that "by reasons of
its previous condition of servitude and dependencies, this [Negro]
race has acquired or accentuated certain peculiarities of habit, or
temperament, and of character, which clearly distinguished it as
a race from white."[113] Historian Rayford Logan called this period
between the last decades of the nineteenth century and first few
years of the twentieth the "nadir" of black experience.[114]

Faced with poverty, violence, and racism at home, many Af-
rican Americans decided to leave. This mass exodus from the rural
South to the urban North, which began during the years of World
War I, has been called, portentously, "The Great Migration." Is-
abel Wilkerson has likened it to the flight of immigrant groups
who, facing insupportable poverty or political oppression or geno-
cide at home, seek refuge and freedom in America. But unlike the
pilgrims escaping religious persecution, or the Irish escaping the
potato famine, or the European Jews escaping Nazism, African
Americans were escaping from one part of the nation to another.
Their "New World" was a train or car ride away, from small-town
Mississippi or Louisiana or Alabama to grand, clamorous cities
like Chicago, New York, and Philadelphia.[115] Between 1890 and
1930, 1.8 million African Americans migrated North, with the
largest influx coming between 1910 and 1920.[116] Alongside for-
eign immigrants, African Americans competed for jobs in facto-
ries, railroads, and other industries. The black population jumped

611 percent in Detroit, 114 percent in Chicago, and 66 percent in New York.[117]

Despite their hopes for the North, the new migrants did not find total respite from Jim Crow segregation and antiblack violence. Witnessing the rapid growth of the black population, white Northerners expressed unease that "the Negro problem," previously contained to the South, was percolating through the rest of the country. With the end of World War I, racial violence flared as increased competition for jobs and the end of wartime labor agreements and price controls ignited a series of labor conflicts and race riots. The worst occurred in Chicago in July 1919. As a result of the Great Migration, the black population in the city's South Side had tripled, straining housing resources and inflaming the animosity of white Chicagoans, who resisted the integration of their neighborhoods. Coupled with simmering labor hostilities between white and black workers, tensions erupted when Eugene Williams, a seventeen-year-old African American, swam across an invisible maritime color line at the Twenty-ninth Street Beach. A white mob stoned him from shore, and he drowned. The police refused to arrest any of the white perpetrators, inciting a race riot that would spread throughout Chicago over the next week. Black homes were torched, black stockyard workers attacked, and gangs of black and white youths ferociously defended their turf. By the end of the riot, 23 blacks and 15 whites had been killed, 537 people injured, and property damage exceeded a million dollars.[118]

The Chicago Race Riot was one of more than twenty-five race riots that seized the country in the so-called Red Summer of 1919.[119] In 1922, the Chicago Commission on Race Relations, a biracial committee created by Governor Frank O. Lowden in the aftermath of the riot, issued a magisterial 672-page report, *The Negro in Chicago,* that began with the ominous statement, "The relation of whites and Negroes in the United States is our most grave and perplexing domestic problem."[120] It was an echo of W. E. B. Du Bois's eerily prophetic dictum, published in his 1903 masterwork, *The Souls of Black Folk*: "The problem of the Twentieth century is the problem of the color-line."[121] The Chicago report was unflinching in its analysis of the race problem, tracing it back in time to the very founding of the nation. Centuries of the Atlantic slave trade and the institution of American

slavery had warped race relations and bred racial prejudice, not just in the South but in places like Chicago. Solutions such as mass deportation of the black population, complete segregation of the races, or the establishment of a separate black state were dismissed by the commission as untenable.

Instead, the Chicago report specified fifty-nine ways to improve race relations, from allowing black workers to join labor unions to eliminating crime in the colored sections of the city to improving housing options. Above all, the commission pleaded for tolerance and respect. Both races needed to realize that their "rights and duties are mutual and equal" and that "relations of amity are the only protection against race clashes." Imposing laws or enforcing rules was only one small step. What was truly necessary was a dramatic change in attitude from people of both races, a shared recognition of the severity of the problem and a commitment to its resolution. Blacks and whites, the commission implored, had to unite for "the common good," to see themselves as allies rather than as enemies, as fellow citizens of the same great nation.[122]

In other words, they needed to see themselves as a gang.

Created two years after the Chicago Race Riots and the same year as the publication of *The Negro in Chicago, Our Gang* seemed to offer an idealized, sentimentalized answer to the commission's report, showing that the races *could* play together and get along.[123] On celluloid, it provided a potent mix of racial fantasy and nostalgia. For black viewers, characters like Sunshine Sammy and Farina provided a rare, mostly positive portrayal of the race, and they were celebrated in the black press as pioneers and saviors. Charming and unthreatening, they disarmed both white and black viewers, demonstrating the power of media to potentially combat race prejudice. Bernice Patton, writing in the *Pittsburgh Courier*, a widely circulated black newspaper, vaunted the power of the silver screen to shape racial perception and acceptance: "The big, kind heart of this Ethiopian baby [Farina Hoskins], and the tears of his kind face have done more for understanding, and the creation of human interest, as well as sympathy, than nearly anything else in the entire civilized world. Is it not written that a little child shall lead them?" Patton's rhetoric is hyperbolic, to be

sure, but for many spectators, Farina was the most visible—and most likeable—representative of his race. Through the character of "this one little brown baby," Patton claimed, "the entire Negro people 'Speak.'"[124] Claude Barnett, president of the Associated Negro Press, reportedly wrote to the studio in praise of the films, "saying that the life of the small negro child has been made more tolerable by the examples set in 'Our Gang' comedies."[125]

Simultaneously, *Our Gang* provided a nostalgic bromide for white viewers. It heralded back to the "good old days," evoking the rollicking innocence of childhood, the rural pastoral of nineteenth-century America, and powerful antebellum myths of racial harmony and goodwill. A white physician interviewed by the Chicago commission following the riots could barely contain his nostalgia for his Southern upbringing. "My father owned slaves," he reminisced. "He loved them and they loved him. I was brought up [in the South] during and after the war. I had a 'black mammy' and she was devoted to me and I to her; and I played with Negro children." The physician's own children, on the other hand, had never had black playmates and were "less sympathetic toward the Negroes" as a result. "They don't know each other," he confessed.[126] Now living in a Northern city riven by racial tensions, the physician recalled the racial amity of his childhood with fondness and contrasted it with the almost complete segregation of his children's lives.

For the white physician, watching early *Our Gang* shorts would have tapped into nostalgia for a distant past of plantations, mammies, and pickaninnies. For his children, watching *Our Gang* would have depicted an alternate reality to the racially divided city outside their door, one in which a black child *could* be a playmate. For immigrants, the show would have introduced them to the myth of the American melting pot and the signifiers of American culture. And for African Americans, it would have offered a comparative respite from racial demonization during a politically volatile period. What all the viewers had in common was a belief in the films as allegory, as somehow symbolic of America. Whether it was an America of the past, an America of the present, or an America of the future was anyone's guess.

3

100 Percent American

It was 1923. The country was mad about movies. There were fifteen thousand silent movie theaters around the country, with an average capacity of more than five hundred seats. Every week, fifty million people went to the theater.[1] Most people attended a show once a week, making the movies one of the most popular forms of cheap entertainment. Kids went even more often, attending matinees after school or on weekends. Workers played hooky, mothers took their babies, entire families made it an outing on weekends. In the summer, the theater beckoned with its promise of electrical fans or—gasp!—air-conditioning.[2] If you lived in a big city like New York, you could attend a show at a lavish picture palace like the Rialto on Forty-second Street and Broadway.

At least, you could if you were white. If you were black and lived in New York City, you likely stuck to a "colored" theater in your neighborhood rather than risk being turned away at the door of the movie palace. And if you were black and lived in the South? Well, Jim Crow smacked you right in the face if you wanted to catch a flick. Maybe you could go only at a certain time or a certain day of the week. Or you had to take a separate entrance and climb two flights until you got to the balcony, the designated colored section, colloquially known as the crow's nest, the buzzard roost, or nigger heaven. You got to see your movies, all right, but

from so far away that one exhibitor joked you might as well have been on Mars.[3]

But say you're white and live in New York City in the sweltering summer of 1923. It's Saturday night and you want to take your whole family to the Rialto, advertised as the "Temple of the Motion Picture," a "shrine of music and the allied arts."[4] For twenty-five cents (ten cents for children), you gain admission into a sumptuous lobby with overstuffed chairs, lavish flower displays, thick Persian rugs, potted palms, and elaborate Corinthian columns. There are no concession stands yet; that amenity would be added to theaters in the thirties. But what do you think this is? A low-rent nickelodeon with peanut shells and candy wrappers crunching underfoot? No, this is a cathedral to the motion picture, a sacred place. Do you eat in church?

A cavalcade of ushers wearing scarlet tunics with gold piping and tassels welcomes your family into the theater, with pearl-tipped swagger sticks lighting up the darkness. Under an elaborate pleasure dome festooned with electrical chandeliers stretch nearly two thousand seats. Once seated, you gaze at a massive proscenium arch that frames the movie screen and two side stages, each now swathed in red plush curtains. A bugle call announces the beginning of the festivities, and the house organist takes his place behind the "Mighty Wurlitzer." Members of the orchestra, forty in all, take their seats, decked out in maroon velvet tuxedo jackets. Hugo Reisenfeld, the Rialto's elegant, mustached, Viennese conductor, strides onto the stage and launches into a bombastic overture—Wagner's *Flying Dutchman* or Rossini's *William Tell* or maybe Tchaikovsky's *1812 Overture*. After a round of applause, the curtains covering the movie screen slowly open. Perhaps there's a newsreel or a scenic film, followed by a masked dance or other vaudeville performance on one of the side stages, followed by an orchestral interlude or a singing performance. The feature film—maybe a western like *The Covered Wagon,* or a drama like *You Can't Fool Your Wife*—is yet to come, but first, if you're lucky, there's an *Our Gang* comedy short.

The audience rustles with anticipation as the organist begins playing an antic showtune. The opening credits appear on the flickering screen:

HAL ROACH
Presents
HIS RASCALS
"LODGE NIGHT"
Pathécomedy

Despite being a so-called silent film, the comedy is anything but silent. There's the raucous accompaniment of the Wurlitzer, of course, but there are also the eager cheers of the crowd as the film plays. If you go to the movies regularly—and most of this audience does—then you're already familiar with Hal Roach's rascals. The kids are cute, funny, and wholesome. You settle into your seat and get ready to laugh.

The first title card appears, illustrated with two colonial-era schoolchildren interrogating a bust of George Washington: "Some of the 'gang' say they are going to school—Others tell the truth."[5] Some members of the audience chuckle. You see a classroom with a teacher seated at the front, surrounded by blackboards covered in chalk script. Ten or twelve students sit hunched over their desks, listening to a little girl recite from a primer, the teacher reading along beside her. The next title card appears: "The teacher admits that she is twenty. It's her second time around." The chuckles turn into hoots of laughter as you get a close-up of the teacher: lean, frizzy-haired, bespectacled—and looking no younger than forty. You're introduced to wild-haired Jackie, "best liked—most spanked—boy in the class," who tugs at a handmade lodge pin on his collar. Instead of doing his lessons, he's tracing his fraternity logo on his slate with chalk. It is a medallion with a clumsily sketched chicken on top and the letters CCK below, standing for "Cluck Cluck Klams."

More people start to laugh, getting the joke. It's the summer of 1923, and the Ku Klux Klan has been all over the news. Since the release of D. W. Griffith's *Birth of a Nation* in 1915, based on Thomas Dixon's book *The Clansmen*, the Klan has enjoyed a surge in membership unseen since its postbellum heyday. With its heroic, romanticized images of hooded Clansmen battling lascivious, black brutes, Griffith's film has become a powerful propaganda and recruitment tool among white Protestants frightened by a nation that was looking less and less like themselves. The masses

of Jewish and Catholic immigrants from eastern and southern Europe, the growing presence of African Americans in the urban North, the yellow peril, the dubious morality of the Roaring Twenties and bootlegging culture, the increased competition for jobs—all these things inspire the current Klan slogan of "one-hundred-percent Americanism," where "American" means 100 percent white (of old immigrant stock) and Protestant. Unlike its postbellum forebear, the Klan of the 1920s is a full-fledged fraternal organization, with official dues and costumes. It even issues its own insurance policies! It has a substantial presence outside the South, in places like New Jersey, Illinois, California, and the Pacific Northwest.[6] In the papers, you can read of Klan lynchings, cross burnings, and public rallies. The Klan has even infiltrated Hal Roach's hometown of Elmira, which would host New York state's Klan convention, or Klolero, in July 1925.[7]

On the screen, the gang is making up its own version of the Klan, one with a similarly absurd name. Cluck Cluck Klams. Even the name is funny. The camera quickly moves to the freckled Mickey, "animal trainer" and "hooky expert," who is rehearsing his pet fly behind a propped-up textbook. Now the kids in the audience are giggling, watching the fly juggle spitballs and matchsticks with its legs as Mickey furtively keeps an eye on the teacher. Chubby Joe Cobb appears, the new kid at school, his hair slicked down with pomade and his satchel overloaded with books. Mary Kornman, "not yet a vamp—but give her time," makes eyes at Joe while Mickey and his friends try to recruit the new boy to the Klams. "What is it?" Joe asks, and the boys in the class launch into the secret hand signal—a clapping of the hands that imitates the opening and closing of a clam, or perhaps the opening and closing of a chicken's beak. Meanwhile, Mary and the rest of the girls swarm Joe, flirting so ardently that he is declared a "sheek" by his jealous playmates.

"Give Farina the Z. O. Z." (the Gang's misspelled version of SOS), one of the boys declares, and Mickey runs to the window, tugging a string that flaps the wings of a chicken atop a weathervane three times. A title card illustrated with a bug-eyed, fat-lipped pickaninny appears: "Farina—doesn't know what the lodge is all about—but is in favor of anything." Farina, all of two years old, toddles out of an adjacent barn wearing a cap, torn knickers,

and oversized shoes. Close behind him is Sunshine Sammy. Now the audience is roaring. Imagine that—a fraternal lodge based on the KKK that admits black members! It's clear the comedy is spoofing the Klan, with all of its theatrical codes and rituals. At the same time, though, it's highlighting the innocence of the kids, who are too young to understand the race hatred that undergirds an organization like the Klan.

Joe's "innishuation" into the Cluck Cluck Klams is set for six o'clock that night at Jones's barn, but Sammy and Farina are stuck hand-cranking the fans at Emancipation Hall, where "Professor T. Jefferson Culpepper" is giving a lecture. A title card appears: "Professor T. Jefferson Culpepper's audiences were usually carried away—Some of them for ten days." The card is illustrated with policemen dragging caricatured coons to jail. The audience guffaws at the joke about black criminality. Professor Culpepper appears, dressed in a dapper top hat, frock coat, and spats. Sammy, also dressed in a suit and wearing a hat, carries the professor's books and cane. The audience does not realize it, but Professor Culpepper is played by Sammy's real father, Ernie Sr., who has started taking bit parts in films.

Wearing a pince-nez and speaking down his nose at Sammy, Professor Culpepper prepares for his lecture, the subject of which is scrawled on a chalkboard:

PHILOZOPHY AND ITS RELATIVITY TO THE
ANTIPHLOGIZTIC PERIOD OR CAN PHILOZOPHY
BE TRACED TO THE AGE OF THE CAMAZAURUS
 IF SO WHY?

The faux erudition of the lecture, its neologisms and malapropisms, are all familiar stuff to the audience. This scene comes straight from a minstrel show's stump speech.

Before vaudeville and then motion pictures took over, the minstrel show was the most popular form of entertainment in America. Thomas Dartmouth Rice, whose imitation of a crippled black stablehand originated the term "Jim Crow," was the most prominent of the early nineteenth-century blackface minstrels. His Jim Crow was a Sambo-like figure, face smeared in burnt cork, shucking and jiving and speaking in a stereotyped black vernacular. He sang plantation songs, danced, and told jokes. Later,

George Washington Dixon, a rival blackface performer, popular-
ized a black urban dandy caricature known as Zip Coon. Probably
modeled on free blacks Dixon had seen up north, Zip Coon was
depicted as cocky and uppity, wearing a top hat, waistcoat, and
bright blue tails. In a popular 1834 illustration, he dangles a
pince-nez from his outstretched fingers.[8]

Professor Culpepper is Zip Coon updated for the 1920s. His
name, like his manner and his garb, is pretentious. Perhaps he's
a recent migrant from the South, who now affects the urban so-
phistication and intellectualism of the North. Perhaps he's even a
caricature of the most prominent African American intellectual
of the time: W. E. B. Du Bois, cofounder of the NAACP, first
African American to earn a PhD from Harvard University, and
professor of history, sociology, and economics at Atlanta Universi-
ty. Du Bois embodies the idea of the "New Negro," a figure of ra-
cial uplift and pride who through the power of his intellect could
counter the vicious stereotypes of the antebellum "darkie." It is
1923, and just a hundred blocks north of the Rialto Movie Palace,
a renaissance is taking place in the streets of Harlem, a flowering
of black literature, art, and music. Intellectuals like Alain LeRoy
Locke, Langston Hughes, and James Weldon Johnson are reshap-
ing what it means to be an educated, urban African American.

In the dark, plush theater of the Rialto, however, it's more
like 1870 than 1920, and Professor Culpepper is strictly a repre-
sentation of the Old Negro, not New. Adjusting his pince-nez and
opening a large book, he faces his assembled black audience in
Emancipation Hall and launches into his lecture. The title card
reads: "Mah subjec' will be de sanco-transmission o' de pseudo-
diphtheretic or de allagazam o' de patootamus region—." In the
minstrel show, the stump speech is a mainstay of the "olio," a sec-
ond act that featured a mishmash of songs, dances, and speeches.
The blackface performer would expound on anything from the
telegraphic cable to "freenology" to the workings of gravity or
electricity.[9] The audience would howl at this ignorant Negro mak-
ing a mess of scientific jargon, history, or current events. After the
Civil War, black performers joined minstrelsy in large numbers,
creating troupes and traveling widely. It was their only way of
breaking into the theater, of even getting on the stage. By the
turn of the century, vaudeville had taken over the minstrel show

as the most popular form of American mass entertainment, but it retained individual comic sketches from minstrelsy like the stump speech. The most famous black minstrel, Bert Williams, got his start on the vaudeville circuit in the late nineteenth century, joined the Ziegfeld Follies in 1910 (where he was the only black star), and appeared in some early silent films.[10]

On the screen, Professor Culpepper, channeling Bert Williams, motions wildly and continues with his gibberish. Bored, Sammy and Farina begin to play dice. "C'mon, bones!" Farina cries, blowing into his hand. Distracted, Professor Culpepper tries to continue his lecture, but it's too late—gambling fever has taken hold of him. He shakes his arm for rhetorical emphasis, but the gesture turns into the convulsive shaking of a handful of dice. Professor Culpepper's eyes roll to the back of his head. Despite his pretensions of intellect, he cannot resist his degenerate nature. Neither can his black audience. In a sudden frenzy, everyone is out of their seats and onto the floor, shooting dice. In the melee, Sammy whispers to Farina, "We gotta melt outta here—The Kluckers is waitin'." They retrieve their Cluck Cluck Klams robes from Professor Culpepper's jalopy and sprint to Jones's barn. They arrive just in time; the ceremony is about to begin.

The camera zeroes in on a childish, hand-painted sign affixed to two crossed spears. "X SALTED RULER" it reads, above a drawing of clasped hands, a chicken, and the initials "C. C. K." The leader calls the lodge to order, adjusting his rotating podium, which is topped by a clam shell and is decorated with the words "CLUCK CLUCK KLAMZ" and a drawing of a chicken. Everyone stands, and the X Salted Ruler instructs Sammy, "The Most High Terrible Seccaterry," to call roll.

Dressed in white robes, chicken helmet, and clamshell necklace, Sammy approaches his fellow lodge members, each of whom is seated in a makeshift throne with a hand-drawn portrait mounted above him. There's Farina, sitting beneath a doodle of a pickaninny with corkscrew hair. There's Mickey, sitting beneath a doodle of a freckle-faced kid. And there's "DOG JOE," Pete's predecessor, sitting beneath a doodle of a dog. One by one, Sammy taps them with his spear, and they stand to be acknowledged. As the camera pulls back, the viewer can even see Sammy's

empty throne, underneath a portrait labeled with the name "ERNIE."

Joe Cobb, looking nervous, arrives for his initiation and is stripped to his underwear, with a white sack tied over his head. The Cluck Cluck Klams march him through the initiation rites, most of which involve indignities like being spanked by what looks like a giant mousetrap, blowing a balloon until it explodes in his face, and being punched in the face with a boxing glove so he can use the blood from his nose to sign his initiation oath. The theater audience howls at the slapstick capers. The comedy ends with a farcical car chase, as the Cluck Cluck Klams pursue two auto thieves who have taken refuge in Jones's barn. Triumphantly, the Klams help the police apprehend the thieves and earn a huge reward. An iris shot ends the short, and the word "PATHÉCOMEDY" appears on a black screen. The audience at the Rialto claps appreciatively, now pleasantly primed for the main feature.

In fact, sometimes the *Our Gang* short was *more* satisfying than the main feature. In the trade magazine *Exhibitors Herald,* theater owners reported that the comedies helped salvage otherwise weak programs.[11] One exhibitor called them the best comedies on the market for adults and children alike. "They are clean, well acted and funny in every respect," he wrote. "Any time I advertise I will have one on they almost break the doors down trying to get in my theatre."[12] Another maintained that the *Our Gang* kids were even funnier than Charlie Chaplin and Harold Lloyd.[13] Still others chimed in that the films were "the snake's hips," appealing even to "the toughest old crab," and so funny that sometimes the pianist broke down with laughter and had to stop playing.[14] One theater owner joked that after running an *Our Gang* short, half his chairs were wobbly the next morning—"But [the audience] all enjoyed it so I didn't mind a little extra work."[15]

But not all theater owners, especially those in the South, were quite so sanguine. "Too much Sambo for some white houses in the South," a theater owner from Chattanooga, Tennessee, reported.[16] Another, from Tallassee, Alabama, sniffed, "Not much to it. The little negro seems to be the most important one in this bunch of kids. Pathé charged us more for these two reels than they did for others we liked better."[17] A third, from Loxley, Ala-

bama, reported, "Some of our Southern patronage object to the negro. Only kick [complaint] we've had."[18] The response was puzzling, at least at first. Stump speeches, Sambos, and pickaninnies were all standard fare to white southern audiences raised on minstrel shows and vaudeville. *Our Gang* was simply serving them comfortable and familiar racial stereotypes, passed down from antebellum times. There was nothing radical, nothing racially innovative about these comedy shorts. Or was there?

Coded in these exhibitors' complaints was the belief that *Our Gang* was somehow subversive. There was "too much Sambo," and "the little negro seems to be the most important one in this bunch of kids." Hal Roach and Pathé were too prominently featuring characters like Sammy and Farina—featuring them beside white children and sometimes featuring them even *more* than the white children. Roach had established the series as a starring vehicle for one black child, Sunshine Sammy, and it was now becoming a breakout vehicle for another black child, Farina. In reviews, articles, and advertisements, Farina was being crowned an "outstanding star,"[19] "the biggest drawing card,"[20] and "beyond a doubt one of the most popular members of the 'Our Gang' comedy cast."[21] One besotted fan even sent Farina a postcard that read:

> Dear Little Man—anywhere I see Our Gang pictures
> playing I go no matter how far. Farina you have many
> hearts. Best wishes always, Peggy Brooks.[22]

A short like *Lodge Night* was especially problematic. It might go over like gangbusters at the Rialto, with its more sophisticated, urbane, Northern audience. It might even go over well in larger cities in the South. A theater owner in Columbus, Georgia, screened *Lodge Night* and reported, "This one pleased, as all the rest, 100 percent."[23] But in places like White Castle, Louisiana, a small cypress logging town carved out of a former plantation near Baton Rouge, patrons were not so amused. The owner of Fairyland Theatre in White Castle wrote, "Lodge Night, with its Ku Klux Klan initiation, was good, although the klan [*sic*] here would not stand any show, but nevertheless this was funny."[24] Another exhibitor in Ozark, Alabama, a rural town in the southeast part of the state, sourly noted, "Lodge Night [was] about the poorest Gang we have had. Not much to this one. The rest have been

O.K."[25] And in Kansas, home to sixty thousand Klansmen and thirty local Klan chapters, the owner of De Luxe Theatre reported that *Lodge Night* was "a parody on the Ku Klux Klan which is funny if the KKK does not object."[26]

The Klan and its sympathizers knew that the kids in *Lodge Night* were making fun of them, and they didn't like it. In fact, it wasn't even the first time the Gang had spoofed the KKK. In an earlier short, *Young Sherlocks,* released in 1922, Sammy stumbles into a "secret session of the mystic J.J.J.'s—Jesse James Juniors." A group of boys in white hoods asks Sammy, "Only the Brave an' Fearless enter here—What have you ever done?" Sammy relates a fantastic adventure tale, in which he and Jackie become a crime-fighting duo, an interracial Sherlock Holmes and Watson. Sammy single-handedly rescues a rich white girl who has been kidnapped and tied to a tree. The girl's grateful parents give him the ransom money, which he uses to buy a city that he names "Freetown." A title card designates "ERNIE" as "MAYOR" and Mickey as "Chief of Police." Freetown, despite its name and its black mayor, is not a settlement of freed slaves, like the city of the same name in Sierra Leone. No, this Freetown is a "kiddie paradise" where everything—cookies, candy, toys—is free. On top of it all, it's also a racial utopia. There's a black mayor, a white police chief, and a town population of black and white kids who play together happily. Alas, Sammy's tall tale, which has transfixed the members of the J.J.J., is interrupted when his mother arrives to drag him home.

The world of the Gang was the world of fantasy, where kids could have ice cream for breakfast, catch criminals for huge rewards, run their own fire department, drive their own cars, and govern their very own town. It was harmless and it was funny— except when it tread too close to racial fantasy. Then, at least to some Southern audiences and Klan sympathizers, it became neither. Shorts like *Lodge Night* and *Young Sherlocks* were obviously making fun of the nativist and histrionic qualities of the Klan, contrasting it with the kids' amicable fellowship. But even shorts that didn't refer to the Klan at all, that simply showed the kids playing together in a junkyard or rigging together some contraption, were fundamentally incendiary. For at its very heart, *Our Gang* was a fantasy of interracial friendship.

The gagmen who came up with the *Our Gang* story lines were themselves a motley, idiosyncratic bunch. Charley Chase, the comedian and actor, was the unit's first director and supervisor.[27] Tom McNamara, a cartoonist and newspaper journalist, had been half of a travelling blackface minstrel act called "Mack and Marcus."[28] H. M. "Beanie" Walker, a former sportswriter, was a chain-smoking, cat-loving eccentric. Leo McCarey was the son of an Irish boxing promoter. Frank Capra, future Academy-Award-winning director, was a Sicilian immigrant.[29] Charlie Oelze, the prop man, had previously worked in a circus and on a cattle ranch.[30] Bob McGowan had worked at the Denver Fire Department and run a nickelodeon. They were adventurous and unconventional, risk-taking and well traveled, much like Roach himself. And like most of early Hollywood, they were generally out of the white Protestant mainstream. They were cowboys and the children of immigrants, vaudeville performers and clowns, misfits and outsiders, and they were swept up alongside African Americans, Catholics, Jews, bootleggers, immigrants, radicals, and political elites as less than 100 percent American. It was no wonder the *Our Gang* writers might find the Klan ripe for parody.

Yet the Klan was steadily infiltrating the West as well as the North. As more white Southerners migrated to Los Angeles, they brought with them deeply ingrained race prejudice and allegiance to Jim Crow. A race riot in Tulsa, Oklahoma, in 1921 stirred anxieties that something similar might occur in Los Angeles, home to a comparably prosperous, middle-class black community. That summer, the *Los Angeles Examiner* discovered that the KKK was organizing a Los Angeles and Pacific Coast chapter. At the same time, the Garrick Theatre in downtown Los Angeles was attempting to bring *The Birth of a Nation* back to the screen, leading to protests by black Angelenos and the local chapter of the NAACP. When the city prosecutor, Edwin Widner, agreed to stop the film, he received an unwelcome visit from William S. Coburn, the Grand Goblin of the Klan's Pacific States Division and a recent transplant from Atlanta. The local white newspapers joined the black community in condemning the Klan. The editor of the *Los Angeles Times* came out publicly for equal rights, writing, "When you consider that, man for man, in every way—in thrift, in property, in education, in art, in literature and in the highest forms of

culture, the American negro stands equal today with the American white man, how can you fail to honor and respect him?"[31]

During the spring of 1922, the Klan was again in all the local papers following a bizarre affair known as the Inglewood Raid. Twenty or thirty masked Klan members barged into the home of Fidel Elduayen, a Spanish immigrant and suspected bootlegger. They ransacked the house, tied up Elduayen and his brother, and terrorized his daughters and wife, who fled into the surrounding alfalfa fields. A Japanese neighbor, hearing the uproar, first called the local constable, with no success, then called the deputy marshal of the Inglewood police force. The marshal got into a shootout with the Klansmen, killing one and injuring two others. It turned out all three victims were members of the police force—and that the Klansman who was killed was the local constable whom the neighbor had initially tried to call.[32]

The district attorney, Thomas Woolwine, launched a grand jury investigation and discovered that the Klan had infiltrated all levels of local law enforcement. Nathan Baker, the Klan's Los Angeles Kleagle, was a deputy sheriff for Los Angeles County. Three members of Woolwine's own staff were Klansmen. All told, thirty-seven Klansmen were brought to trial. It was a spectacle, with moments of absurd drama and unintentional comedy. A fashionably dressed woman was evicted from the courtroom, screaming, "Help! Help! Help! Let me go! I want to see a Kleagle! I want to see a Kleagle!"[33] Then, during a dramatic point in witness testimony, Kleagle Baker collapsed, "crumpled up with a convulsion."[34] The jury returned a verdict of not guilty on all counts, much to the Klan's delight. The local organization, however, was in disarray, with political infighting and mismanagement. City and state officials proposed anti-Klan legislation, banning the wearing of masks or hoods and demanding complete membership lists. By the fall, local papers were reporting that the Klan had been run out of town.[35]

Lodge Night was conceived of and filmed during this period of local Klan drama.[36] Hal Roach and his gag writers regularly scanned newspapers for film ideas, and this one would have been irresistible.[37] After all, it wasn't hard to see the comedy in the court proceedings or the parodic potential of the Klan in general. One can imagine the gag writers tossing out ideas during their regular brainstorming session: "Let's call them the Cluck Cluck

Klams!" and "Let's have them dressed as chickens!" and "Let's have Sammy and Farina be CCK officers!" Roach himself might have been at the meeting, suggesting a gag or a story line and then directing the writers to come up with a "treatment."[38] Tom McNamara, with his background in blackface minstrelsy, might have filled out the script with the Professor Culpepper stump speech. And Beanie Walker, with his pointed wit and fondness for puns, would have drafted the title cards.

Of course, as easy as it was to poke fun at the Klan, Hollywood gagmen could never fully expunge the organization of its very real and terrifying power. In *Lodge Night,* the writers and juvenile cast might mock the racial politics, outlandish costumes, and pompous rituals of the Klan, but just as many people—among them children—saw the Klan as worthy of unironic imitation. A small but chilling item was picked up by national newspapers on September 27, 1923, around the time *Lodge Night* was playing in the area theaters:

Boys Playing "Ku Klux Klan" Bind and Injure Ohio Child

WARREN, Ohio, Sep. 26—Cyril Stoddart, 10 years old, is under a physician's care suffering from shock and minor injuries and police are hunting for a gang of small boys who, wearing masks and said to be playing Ku Klux Klan, attacked the boy, tied him to a telephone pole and gagged him.

He was rescued after being tied up for three hours.

The race of the boy, Cyril Stoddart, is left unclear. He may have been a neighborhood kid, a mama's boy, easy prey for a gang of bullies. What was clear is that "playing" Ku Klux Klan was not a very funny joke, especially for Cyril. But Cyril was lucky. He suffered "shock and minor injuries" from his mock lynching but survived his ordeal.[39]

Boys like Charlie Atkins, fifteen years old and black, were not so lucky. Accused of killing a white woman in Georgia, headquarters of the Klan, he was "tortured over a slow fire for fifteen minutes,"[40] then hanged from a pine tree with tire chains. His dead body was torched, and more than two hundred shots were fired into it. A mob of nearly two thousand people witnessed the lynching, a crowd that included prominent local citizens, as well

as their wives and children. The *Chicago Defender* described "tow-headed youngsters [throwing] rocks at each other and play[ing] around awaiting the spectacle that was to come."[41] A couple years earlier, sixteen-year-old Lige Daniels, accused of killing an elderly white woman, was lynched in Center, Texas, his body strung from an oak tree. A mob of nearly a thousand people gathered to see him killed. Photographs of Daniels's corpse, his neck broken and his head askew, were turned into postcards and souvenirs. Beneath his dangling body were the faces of white men and children, some staring impassively, others smiling broadly, as if at a local fair. A group of four young boys, ranging in age from seven to no more than twelve, stood in the foreground, almost directly beneath the hanging corpse. Especially disconcerting was the face of one of the boys, who was glancing up at the corpse and laughing.[42] No, it was not very funny at all. It was a dangerous time to be a young black boy, especially at a time of heightened Klan activity and racial intolerance.

Ernie "Sunshine Sammy" Morrison and Sonny "Farina" Hoskins were shielded somewhat by virtue of their fame and the protective bubble of Hal Roach Studios. By the mid-1920s, they were the most famous black film stars in the country.[43] Many years later, Ernie recalled, "We all got along. No problems. And when we weren't working, we were playing. And when we *were* working, we were playing! Hal Roach, Harold Lloyd, Bob McGowan—they didn't make it a job, they made it fun. It was a beautiful childhood."[44] He remembered taking the studio's bus, bright red and emblazoned with "'OUR GANG' Comedies" on its side, from the studio to that day's shooting location—often the Hal Roach Studios Ranch, an undeveloped, rural patch north of the studio where the studio kept a menagerie of farm animals and where Roach and Will Rogers would sometimes play polo at lunchtime. The kids would be hanging out of the bus, shouting "Zits! Zits!" whenever they spied anyone with a beard. "The poor guy always looked frightened to death," Ernie laughed. "That's kids." Back in his Central Avenue neighborhood, Ernie was treated like a "big shot," greeted by crowds whenever he arrived home in his "great big limousine a mile long."[45]

The *Los Angeles Times* visited the *Our Gang* set in the summer of 1923, catching the kids playing an impromptu game of

baseball during their lunch break. Mickey had just been struck out and was pleading with Ernie, "Aw, c'mon now, that wasn't any strike. It was a mile high, easy, wasn't it, Sunshine?" Ernie shook his head, smiling but unmoved. In the background, Sonny Hoskins, playing umpire, was sputtering, "'You're out' (or words to the same effect)" while simultaneously trying to eat an ice cream cone. And Joe Cobb, "fat and hearty," was, of course, the team's "Babe Ruth." They were partaking in "a miniature version of the great American sport," the reporter wrote—a sport that would not be integrated for another twenty-four years. Here on the Hal Roach lot, however, kids of all colors played baseball together, "represent[ing] ages from 3 years to 9, colors from the shining ebony of Sunshine Sammy and Farina to the glaring crimson of Mickey's sunlit freckles."[46] They also played baseball together on screen, in shorts such as *Giants vs. Yanks*, a riff on the 1922 World Series. When they weren't playing games or filming scenes, the kids attended the studio school, taught by Miss Fern Carter. Even Sonny, who was only three, was enrolled in an "undergraduate kindergarten course."[47] Every Christmas, Roach threw a holiday party at the studio, setting up a huge tree drenched in tinsel and distributing gifts to the kids like Santa Claus. In a photograph taken in 1924, Roach sits in front of the tree, surrounded by a riot of presents and children. Mary Kornman got a sleek new bicycle, Jackie Condon a shiny racer. Sonny, Joe Cobb, and Mickey all got electrical train sets.[48]

But after the cameras stopped rolling and the kids stepped off the lot, the color line quickly reasserted itself. Ernie and Sonny returned to their homes in the eastern part of Los Angeles, where the "colored" neighborhoods were, while Jackie, Mary, Joe Cobb, and Mickey went home to the westside, where racial covenants kept out blacks, Mexicans, Japanese, Jews, Italians, Russians— anyone who wasn't 100 percent American.[49] In the 1920s, whites and blacks lived in different neighborhoods, shopped at different stores, went to movies at different theaters, ate at different restaurants. The world of *Our Gang* was a fantasy, but this—this was the real world. This was America.

In September 1925, Hal Roach released his forty-fourth *Our Gang* short, called *Your Own Back Yard*. By now, the studio was

advertising *Our Gang* as the most popular two-reel comedies on the market, beloved by audiences, theater owners, and trade magazines alike.[50] One magazine called the gang an "aggregation of 'All American' youth" who represented "ideals and ambitions to the youngster" while inspiring "memories to the older patron."[51] The studio released a new short every four weeks. One advertisement showed the Gang posing on a staircase and waving:

> Mickey, Farina, Mary, Jackie,—
> What family doesn't know them,—look for them on the screen?
> More familiar, more popular, than princes and presidents; loved for their antics, their naturalness.[52]

The members of the Gang were practically family, shown marching down the staircase as if they were headed into your living room. Theaters all over the country were now running *Our Gang* two-reelers, and the kids had built up a devoted following. One exhibitor reported, "Many of my patrons have asked me to call them up whenever I have an Our Gang, as they care more for these comedies than they do for most of the long features."[53] Back home, crowds gathered to gawk at the kids when they filmed in the streets of downtown Culver City, creating such havoc that the police were called in.

The *Our Gang* short *Your Own Back Yard* capitalized on the intimacy and familiarity of the Gang. It took its title from a well-known "coon" song, "Stay in Your Own Backyard," first published in 1899. In the darkened theater, the pianist or organist would start playing the familiar, sentimental melody, with some people even humming along. After the opening credits, an iris shot pauses on the words "Pickaninny Ballad," the subtitle of the song, before expanding to reveal the entire cover of the sheet music:

<div align="center">

STAY IN YOUR OWN BACKYARD

Pickaninny Ballad

Lyric by

KARL KENNETT

Music by

LYNN UDALL

</div>

Much of the audience would have recognized the song from hearing it in their very own living rooms. Such parlor songs, as they were called, were popular in middle-class households in the late nineteenth and early twentieth centuries. Using sheet music purchased from Tin Pan Alley, any amateur pianist and singer could perform the song for friends and family in the comfort of their own home.[54]

The next shot is an excerpt from the song's refrain, also framed in an iris shot:

> Now honey, yo' stay in yo' own back yard,
> Doan min' what em white chiles do;
> What show yo' suppose dey's a gwine to gib
> A little chile like yo'?

The words are spoken by "Mammy" to her young son. As everyone in the audience knows, the lyrics recount the rejection of a little black boy, the "pickaninny" of the title, by the little white children in his neighborhood. Sobbing, the boy crawls into his mother's lap and is told to avoid the white children and ignore their taunts. Day after day, the white kids pass Mammy's house and see the "wistful, lonesome little coon" peering through the fence until, one day, the little face is gone. The pickaninny has died, and Mammy's words become an anthem of heartbreak. The song is maudlin, the setting nostalgic, the little "coon" (Beanie Walker had changed it to "chile" in the title card) pathetic. The message, though, is clear: "Stay in Your Own Backyard."

This is a ballad about Jim Crow.

Against the tinkling accompaniment of the piano, we see the tear-streaked face of Farina, now four years old, with his hair tied in ribboned pigtails. His "Mammy," heavyset, with a stereotypical handkerchief head, takes him to her chest and rocks him. The next title card appears: "Farina—in bad with the gang because his goat ate up two radios and a bicycle—." Farina's been spurned by the Gang—not because he's black, but because his goat is a pest.[55] Still, his rejection is real and it stings. Farina tries to join Jackie and Johnny, who are working on a contraption just outside his front gate. Looking up, Johnny tells Farina to bug off. Farina then tries to play with their scooter, at which point Johnny and

Jackie beat him up. Farina runs weeping to his Mammy, crying "—Bad boys—they walloped me—hard!—." His mother comforts him, but also offers the scolding advice: "—Yo' stay in yo' own back ya'd!—." Mammy's advice elicits some chuckles, because the very premise of *Our Gang* is that these kids—white and black—can't and won't stay in their own backyards. They gravitate toward each other in junkyards, alleys, barns, street corners, railyards, fields, swimming holes—anyplace that's outside of adult jurisdiction. Yet here is Farina, admonished by his mother to observe the color line rather than risk being hurt. Restricted to his own backyard, Farina is bored and forlorn. Without his friends, there's nothing to do. He plays half-heartedly with a mule and then watches a pair of chickens fight over a worm. Then he finds a nickel and, sure enough, ventures out of his backyard to find some ice cream.

The rest of Farina's day is a series of misadventures that elicits the audience's laughter as well as sympathy. See poor Farina get tricked out of his ice cream cone by Mickey. See him get spritzed with water from a trick camera. See him run away from cops, who he mistakenly believes are after him (they are actually pursuing a pack of rabid dogs). The other kids are the butt of jokes, too: Mickey is a previous victim of the gag camera, and the rest of the Gang likewise believes the cops are after them. Farina, though, is the victim par excellence. He just can't seem to catch a break. His only friend is his naughty pet goat, Narcissus.

Farina is the star of the short, its tragic hero as well as its laughingstock. He is the "wistful, lonesome little coon" of the parlor song, the victim of Jim Crow, the object of sympathy. But he's also the comic pickaninny, ripe for ridicule. In an allusion to the lyric about the "curly-headed pickaninny comin' home so late," Farina overhears the cops complaining, "The one with curly hair is the worst!—shoot him on sight!—." The cops are referring to a mad dog, not Farina, but the mix-up highlights the stereotype of pickaninny as little animal. The audience snickers at Farina's panicked confusion, but also the black humor of black child as target of violence. In a later scene, Farina gets caught in a revolving door—a gag that sets the audience roaring—and finds that a thread from his pants has gotten caught as well, unraveling his trousers until his bottom is hanging out. With his pigtails and

ragged clothes, his dialect and dropped trousers, he is a classic stereotype and easy comic relief.

Farina's fortunes begin to turn when he accidentally falls asleep on a beggar's stool, under a sign that reads "I AM BLIND." Passers-by take pity on the little boy, and his tin cup is soon filled with donations. He awakens to a small fortune in coins and crumpled bills, which he uses to buy himself a dashing new suit and a wagonful of balloons and toys. Parading down the street with straw Panama hat on his head, watch on his wrist, cane in his hand, Farina attracts the attention of the Gang. Mickey squints his eyes at the sight and cries, "—Hot dogs! Look who's comin'—." The gang crowds around Farina, inspecting the goodies in his wagon. Farina jabs at them with his cane, and they whine, "—Ah, come on—Give us some—." But Farina gets the last laugh. Shaking his head adamantly, he waves his finger and cries: "—Go an' stay in yo' own back ya'd!—" The audience is in stitches. "Take that, you mean ol' white kids!" Farina seems to be saying. "If you want Jim Crow, then I'll give you Jim Crow! Go play in your own backyard!"

Your Own Back Yard is a resounding takedown of the color line, even as it perpetuated the very stereotypes that enforced Jim Crow. We are meant to identify with Farina—hapless, gullible, and bullied. And we are meant to decry the bigoted behavior of the white boys in the coon song, as well as the mean behavior of the white kids in the Gang. We are even, perhaps, meant to see Narcissus—the white goat who is the source of all of Farina's troubles—as a pun and a stand-in for the narcissistic "white kid," whom Farina remains loyal to despite his misbehavior.[56] Yet we are also, more subtly, meant to see Farina as a scapegoat, a stereotype, someone less than human, someone, assuredly, of a different race.

The blurriness of the message worried some viewers. In a short piece called "The Race Question in 'Our Gang,'" one black newspaper reporter fretted over such portrayals of Farina. "Little Farina, perhaps the most amusing character in the cast as it now stands, was 'stamped' because he was colored. Perhaps the tragic and insidious aspects of the thing was drowned in the hilarious humor; perhaps it was not." The writer continues, in all caps,

IF GROWN UP MEN AND WOMEN WANT TO
PUT THE HELLISH CANCER OF HATRED AND
BIGOTRY INTO THEIR SOULS, THEY HAVE
THAT PRIVILEGE; BUT WHY TAKE THE JOY
OUT THE LIVES OF INNOCENT CHILDREN.
THEY WILL COME TO THAT SOON ENOUGH.[57]

Jim Crow was rarely explicitly invoked in *Our Gang*. It was part of the fallen world of adulthood and reality. To address it so blatantly, even in jest, was to bring the serpent into this racial paradise.

Hal Roach, recalling the making of *Your Own Back Yard* fifty years later, seemed to lend credence to this idea. Thrilled with the first cut of the film, Roach had gotten the Capitol Theater in New York to build its show around the two-reel comedy instead of a traditional feature. During previews, however, the film fell flat. "It never got one snicker," Roach remembered, "You never saw a picture die so much in your life." The original short, in Roach's recollection, depicted Farina being sent out to play by his mother, but "then these white kids do all these things to this black boy. And when the film was previewed, the audience didn't like the things these kids did to the black boy and therefore it wasn't funny."

Roach decided to do one retake and then preview the film again. This time, he said he had Farina whitewash a fence when the gang walks by. Farina "dips in and he goes boom!—like this—and the whitewash goes on those kids," Roach said. "So he did something to them before they did anything to him. Now we had the same picture, no change; they did everything exactly as it was before and the audience roared with laughter." Roach got some of the details wrong in his retelling—it's Farina's goat who angers the Gang, not a whitewashing gag—but the results were the same. Without a sallying prank by Farina, *Your Own Back Yard* became a humorless depiction of white children tormenting a black child. And Jim Crow, to use Roach's words, "wasn't funny." With the opening gag, the film sidestepped the very racial subtext of its title to become a comedy about "kids being kids," with black and white children playing pranks on each other. *Your Own Back Yard* transformed from a humorless documentary of race hatred to a charming comedy of interracial amity.[58]

Our Gang was walking a very fine line between pioneering progressivism and familiar stereotyping. But it was *Our Gang*'s negotiation of this line that allowed it to maintain its popularity. The films dealt with the comfortable and the familiar. It employed minstrel caricature but avoided any gags—racial or otherwise—that were too risqué. Frank Capra, for example, lasted less than two months on *Our Gang* because his gags clashed with Roach and McGowan's vision for the series. A self-described "Sicilian ghetto" kid who grew up in East Los Angeles, Capra preferred gags more suited to the neighborhood toughs of his childhood than the wholesome rascals of *Our Gang*. Moreover, his personal disdain for "niggers" came through in his proposed gags. In his working notes for *It's a Bear* (1924), Capra thought the kids should put on a Wild West Show, with cigarette-smoking and knife-throwing gags, plus a "nigger baby act" where "Ernie has Farina behind a canvas and is selling ten shots for a penny to hit the nigger baby."[59] It was perhaps no surprise that Capra never got along with McGowan. Capra thought Jim Crow was funny; McGowan did not.

Over and over, the studio and its exhibitors stressed how eminently relatable the gang was. "If any of your audience were ever kids they can see themselves in these Our Gangs," one exhibitor said.[60] McGowan called them "the kind of normal, every day kids who might be found in every neighborhood—typical children."[61] A reporter for *Photoplay* described the Gang as "exactly like *your* gang, or *my* gang. . . . Even on the screen, when you take your own descendants to see them, you slip back to the days when you used to hop wagons and climb trees and play in newly-dug sewers. When you meet them off the screen, you positively feel well acquainted with them—as though they were merely re-incarnations of your youth."[62] They were, in other words, "just like us." They reminded people of their own childhoods, recollected in a haze of nostalgia. They let viewers romanticize the past, providing soothing images of small town life and offering white viewers familiar racial stereotypes. In doing so, *Our Gang* was able to sneak in a more progressive message than its viewers might realize.

Farina, in particular, was familiar to the moviegoing audience in more ways than one. He was, of course, a caricature, recognizable from popular culture, a hackneyed "type." But he

was also familiar in that he was a kid—an "every day kid," a kid who cried when he was left out, who got into trouble, who reminded people of their own childhoods. Having Farina star in *Your Own Back Yard*—as he would star in so many more *Our Gang* shorts—made him even more familiar, the most familiar of the *Our Gang* kids, the one whom people immediately thought of when they thought of *Our Gang*. It also made him more human, more real, and freed him ever so gradually from the pickaninny stereotype to which he was chained. You could see it even in the official title of the short, *Your Own Back Yard*. The minstrel song was titled, "Stay in Your Own Backyard," an affirmation of Jim Crow. But the *Our Gang* film dropped the cautionary "Stay" and substituted the word "chile" in the lyrics for "coon." These were small changes, to be sure, but they served to humanize Farina and to make the short less about racial segregation ("Stay[ing] in Your Own Backyard") and more about a kind of familial intimacy (*Your Own Back Yard*). It was reportedly Hal Roach's all-time favorite *Our Gang* film.[63]

Farina shifted the center of gravity of the show. He was the star now. And as for Sunshine Sammy? Not only did he not appear in *Your Own Back Yard*, he hadn't appeared in an *Our Gang* short for a year now. From the beginning, Ernie's days on the show had been numbered. The founding star of the gang, he was also its oldest member and the first to age out. His final contract ended in March 1924, when he was eleven years old. Ernie's father claimed the decision not to renew was his—that his son could make more money performing vaudeville—but Roach likely hinted that it was time to move on. Ernie "Sunshine Sammy" Morrison had appeared in twenty-eight *Our Gang* shorts and worked at Hal Roach Studios for five years.[64]

Ernie's retirement did not go unnoticed. One theater owner observed his absence in the short *High Society* and complained to the trades, "Farina is in this, but Ernie is missing. Moral: Stick to the original gang."[65] Around the same time, the *California Eagle*'s gossip column reported that two *Our Gang* films made without Ernie had been returned to the studio marked "N. G. [no good]." "The kid situation seems to be worrying the powers that be at Hal Roach Studio," the paper wrote. "They are trying to get

along without Ernest Morrison (Sunshine Sammy) but the big question is will the exhibitors accept 'Our Gang' comedies without Sammy or a Race star other than Farina."[66] The Gang had become a part of people's lives, and people were loath to see familiar faces go. Yet time passed, kids grew up, and new faces replaced the old. Despite the chatter, *Our Gang* did just fine without Ernie. Sonny "Farina" Hoskins became the star of the series, and eight-year-old Eugene Jackson was brought in to play his older brother, a character named "Pineapple" (a name coined by Roach, who thought Jackson's head resembled the fruit).

The scepter had been passed. There was a new prince in town.

4

Sambo's Awakening

My Dear Miss Grey: I am a little girl eight years old
and I always like to see the "Our Gang" pictures
although my mother will not let me go to a show very
often. Another girl and I have been wondering if
"Farina" in the gang is a boy or girl. Can you tell me?
—Bubbles

My Dear Bubbles: Farina is a boy and I think he is the
cutest member of the "gang." You may be interested to
know that he is just your age.
—Cynthia, *Milwaukee Sentinel,* April 21, 1928

S onny was not cooperating.

A crowd had gathered at a corner of the Hal Roach Studios lot. There was a cameraman crouched behind a piece of fake shrubbery. The prop man was clutching a handful of donuts. A carpenter and assistant electrician were standing on their heads. Bob McGowan, the director, was dancing around like a drunken clown, his face stretched into a huge grin, his megaphone perched on his head like a dunce's cap. Other members of the crowd were jumping up and down, waving their hands, singing aloud.

At the center of it all was Sonny Hoskins. He was supposed to walk up to a small electric switch by a door and turn it. That's all. But it was now late on the second day of shooting, and Sonny still wouldn't do it.

A reporter for one of the movie magazines was watching on in amusement.

"Do they usually act like this?" she asked her guide, gesturing to the grownups.

"Sure," he replied. "It's the 'kid' company. That's the only way they can get Sonny Boy to act. He's only eighteen months old. Why, there's five comedy companies working on this lot, and all of 'em put together, including Harold Lloyd's and Snub Pollard's, don't get everybody so het up as these kids."

McGowan tried a different tack. He walked up to the switch and turned it on. He had Ernie and Jackie and Joe do the same. He had the assistant director do it. He had the painters do it. He had anyone who was on the lot do it. But Sonny remained unmoved.

"He's scared," McGowan apologized to the reporter. "You see, we fooled him the other day. He was supposed to take a drink out of a jug marked 'T. N. T,' and then spit it out. When he spit it out the stuff was supposed to explode. Well, we unfortunately didn't tell him it was going to explode, and when he recovered from the shock, he went and hid for three days, and he hasn't done anything we asked him to since."

"If you be a good boy now, and throw the switch, you can have these doughnuts," the prop man wheedled, dangling the donuts in front of Sonny's nose. Sonny eyed him coldly.

McGowan, usually a big marshmallow, decided to get tough. "If you don't do it right away, I'll whip you," he threatened.

Sonny burst into tears.

"All right," McGowan said, sighing. "We'll shoot another scene. Get ready, boys." He turned to the other kids in the gang.

Sonny immediately wandered off. McGowan chased after him and hauled him back.

"You can't go home till you've done it O.K.," he told Sonny.

"Donwanta do it!" Sonny yelled. He threw himself on the ground.

Suddenly, a throng of Mexican soldiers from Harold Lloyd's new picture came thundering across the lot, sabres drawn, before disappearing behind a building. Sonny sat up and laughed.

Encouraged, McGowan appealed to the director of the Lloyd film. "Hey Bill, ask your soldiers to go through that scene again. Maybe it'll put Sonny Boy in a good mood."

"If you didn't have children there, I'd tell you what I think of you," Bill retorted. "Do you think I hired these soldiers just to amuse your kids?"

Just then, Harold Lloyd appeared. "Harold," McGowan pleaded. "Come over here and help me make this kid act." He paused. "But don't steal any of our ideas for your comedies," he added.

"No, I wouldn't spoil my comedies by using your ideas," Lloyd retorted. But he came over nonetheless. Sonny and Harold Lloyd were pals. Sonny's favorite screen star was Lloyd, and Lloyd returned the sentiment. He thought Sonny was a talented actor and a riot to boot.

"Go on, Harold, get him to turn the switch," McGowan begged.

Lloyd pulled out his best tricks. He made faces. He blew raspberries. He executed a pratfall. By the end, he was sweating. But Harold Lloyd, comedy genius, had failed. Sonny was laughing, but he still wasn't going anywhere near that switch.

"Look here," Lloyd said to McGowan, mopping his face. "You don't seem to think I have any work to do around here. I'm already holding up my company and about a hundred Mexican soldiers. Why don't you hire the Barnum and Bailey Circus for your kids?" Lloyd hurried away, ignoring McGowan's continued pleas.

It was late and everyone was tired. "One more chance, Sonny," McGowan said halfheartedly. "Are you going to be a good boy and turn the switch?"

"Naw," said Sonny.

"All right," McGowan gave up. "That's all for today, boys."

The rest of the Gang raised a whoop and took off for their dressing rooms. The crew started packing up. The electricians shut down the lights, the prop man gathered up his things, the cameraman folded up his camera. Everyone put on their coats and got ready to leave.

All except for Sonny. Just as McGowan was about to leave the set, Sonny got up, walked over to the door, and turned the switch. He looked up at McGowan and smiled.

"Can you beat it?" McGowan cried.[1]

Allen Clayton "Sonny Boy" Hoskins was born in Boston on August 9, 1920, in the middle of a sweltering heat wave. Towns-

people fainted in the streets, factories sent their workers home at 10:00 a.m., crowds flocked to local beaches for some respite from the heat. Sonny's birth seemed to break the spell. The next day, thundershowers began to move in, and cooling winds began to blow in from the south. The city breathed a sigh of relief.[2] Sonny's parents, though, were done with the city. Before winter arrived, frosting the city with snow and ice, they were gone—gone to Los Angeles, where the weather was temperate and opportunity beckoned.

In an early picture, taken soon after they moved to the city, the family poses in front of their tiny, freshly painted California bungalow. Sonny's parents, Clayton ("Clay") and Florence ("Bobbie"), are dressed in their Sunday clothes, Clay in a suit and hat, Bobbie in a long dress with white cuffs and white stockings. Clay had found work as a cement contractor. Bobbie was giving piano lessons from her home; behind her, posted in the window, is a sign that reads "PIANO LESSONS GIVEN." The neighborhood is so raw that the road is unpaved and a street lamppost stands, headless, down the corner. The sidewalk, perhaps poured by Clay himself, is so fresh that the wooden form pins haven't yet been removed. An American flag hangs from the gable roof, flapping in the wind. In the distance are a windmill and water tower. Sonny, who looks about a year old, stands atop a wooden fence between his parents, dressed in a white smock and black leather shoes. His hair is long. Clay thought it made Sonny look like a girl, but Bobbie couldn't bear to cut her baby's hair.[3]

Sonny started appearing in *Our Gang* soon after this picture was taken. He was the youngest member of the original Gang and reportedly learned to walk and talk on the set. He could be cantankerous and temperamental—a typical toddler, in other words. Too young to understand the sight gags, too small to keep up with the older kids, he made up for his age and size with his enormous personality. Sonny got along well with Ernie Morrison. But Ernie, at age ten, was much older and already a seasoned professional. Ernie got things done on the first take. He did not need to be bribed with donuts or entertained by Harold Lloyd. He was the veteran of the Gang; Sonny, the novice. Together, they were the oldest and the youngest members of the original Gang, and the only black children.

If the kids in the Gang were renowned for being "real" and

"natural," Sonny was the realest and most natural of them all. He was so young that he wasn't acting most of the time. When a mule chased him around the set, he really *was* scared. When a gag prop exploded in his face, he really *was* surprised. McGowan recalled that on one of Sonny's first days on the lot, a worker played a seemingly innocuous prank on the little boy. Watching the kids prepare a scene, the worker stepped over, moved a bearskin rug toward Sonny, and cried, "Boo!" Sonny was hysterical, and it took quite some time for him to calm down. McGowan banned the playing of pranks on any of the kids in the Gang, but from then on, Sonny was always on guard. "He always had to know what everything was about before he would do anything," McGowan remembered, "and he would never stir a step if there were visitors on the set."[4] During a shoot in Venice Beach, a nearby resort community, Sonny was led to a spot on the set where a gust of air could be blasted from below. He was immediately suspicious. "Mist' Gowan, are you gonna blow my pants off?" he asked. Another time, he spied a custard pie. Instead of getting hungry, he got worried. "Mist' Gowan. Are you gonna hit me in the face with that pie?"

McGowan was forced to start telling the truth. "Sonny, we're going to play train," he would say. "Now, Mickey is going to be the engineer, Fatty Cobb the fireman, Jackie Condon the conductor, and you're going to be the Pullman porter. Now, I want you to go up by the engine where they're going to squirt flour in your face. It'll look like steam and it won't hurt."

Sonny balked. "It won't hurt?" He'd heard *that* before. In the end, the only thing that convinced Sonny to cooperate was when he heard the rest of the Gang was playing along.[5]

Goats were another sore point. Sonny hated the animals. Once, when he was told he'd be sharing a scene with a baby goat, Sonny put his foot down. Nothing would make him budge—not the promise of a new dress suit, tasty treats, or even an upcoming scene with "pretty Dorothy," Ernie's sister.

"Dey det by doat," he explained. ("I bit by goat," in toddler-speak.)[6]

It wasn't just Sonny who needed to be prodded into performing gags. All the kids had moments of stubbornness or just plain fear. The Gang was filming an airplane scene once, and a plane

had been attached to a block and tackle. It was to be hoisted forty feet into the air. McGowan noticed Joe Cobb had turned pale.

"If you're scared, you don't have to do it," McGowan gently told him. Joe, along with Jackie Condon, was one of the most sensitive members of the Gang. If McGowan raised his voice or scolded him, Joe was liable to burst into tears.[7]

"Gee, I'm sure scared, Mr. McGowan," Joe admitted, "but I'll do it if you want me to."

And he did. Six-year-old Joe Cobb climbed into the airplane, was hoisted into the sky, and filmed his scene.[8]

McGowan was beloved by all the kids in the Gang. He was an avuncular figure, freckled and balding, with a nose shaped like a potato and a shy smile that gave him the look of a little kid.[9] Previously a firefighter in Denver, he suffered a serious leg injury that left him with a limp for the rest of his life. He became a partial investor in a nickelodeon before coming out to Los Angeles, where he worked for Essenay Studios, best known for producing Charlie Chaplin comedies. Like Hal Roach, he worked his way up the ladder, first selling ideas to Essenay, then working as chief of staff to the studio carpenter before moving over to Universal, where he became an assistant to Al Christie's comedy producer and director.[10] In 1921, he joined Hal Roach Studios as a gagman. Kind and softhearted, he had an easy rapport with the kids. He could often be seen around the studio lot, a child riding on his shoulders. Or he could be found crouched beside his little actors, gently giving instructions. His seemingly infinite patience soon earned him the director spot in most of the first five seasons of *Our Gang*. If Hal Roach was the studio paterfamilias, jovial but vaguely intimidating, McGowan was its doting uncle, always ready with a piece of candy or a dime. The kids fondly referred to him as "Uncle Bob."

Sonny was as devoted to McGowan as the rest of the kids, willing to do for him what he would never do for anyone else. In *Seein' Things,* Sonny imitated his idol Harold Lloyd in *Safety Last,* climbing up the side of a skyscraper, walking to the edge of a plank extended from one of the windows, and clinging to a flagpole.[11] In reality, McGowan used camera tricks to give the illusion of danger and was proud of his safety record—he claimed none of the children was ever injured on his watch.[12] For the kids, the real menace was their animal sidekicks. Sonny claimed the only

thing he was really afraid of were goats—for obvious reasons—and pelicans (he'd been goosed by one). The minute shooting stopped, Sonny, who was fascinated by the clicking camera, would scamper over to the photographer, set up his own camera from three sticks and an old film can, and pretend to grind away.[13]

Acting was a family affair. Sonny's mother appeared in a couple of the early *Our Gang* shorts, playing a maid in *Giants vs. Yanks* and Farina's mother in *Young Sherlocks*. At the premiere of the latter film, Sonny burst into tears while watching his mother, playing a poor washerwoman, become ill and bedridden. Unable to stop sobbing, Sonny had to be escorted out of the theater.[14] Sonny's little sister, Jannie, born when he was two years old, later joined her brother on set, often playing Farina's tagalong sister. In 1923, Sonny signed his first long-term contract with Hal Roach Studios. With his earnings, his family bought an old jalopy. *Film Daily* joked that Sonny was being plied with ice cream cones by his grateful family.[15]

Of course, the reality was not so rosy. When Sonny was five, his mother filed for divorce from his father on the grounds of cruelty. Sonny and Jannie appeared in court to corroborate their mother's testimony.[16] After the divorce, Bobbie wasted no time finding a job. She worked as a real estate agent and bought a house on East Thirty-third Street, off Central Avenue. Unlike other stage parents, she never relied on her children to pay the bills. Bobbie's sister, Edith Fortier (nicknamed "Boodie"), stepped in as Sonny and Jannie's on-set chaperone.[17] In one publicity still taken around this time, Boodie holds a squirming Sonny in her lap as she wipes his nose with a handkerchief. Behind them, Joe Cobb and Jackie Condon wait restlessly for Sonny to rejoin them in their games.

Life on the set alleviated some of the instability at home. Sonny was a favorite at the studio, doted on by the adults. Fern Carter, the head of the studio school, claimed he was her best student. Hal Roach counted Sonny and Joe Cobb among his favorite rascals.[18] Bob McGowan loved all the kids, but his daughter later remembered that Sonny was "his favorite in all of *Our Gang*."[19] Uncle Bob gave Sonny fifty cents for every new gag he invented, and he marveled at Sonny's ability to do things "right on cue" (at least once his little star had outgrown the "terrible

208 Columbia Street, Elmira, New York. Hal Roach was born in this house on January 14, 1892. Today the building houses a dentist's office. Photograph by Allen C. Smith.

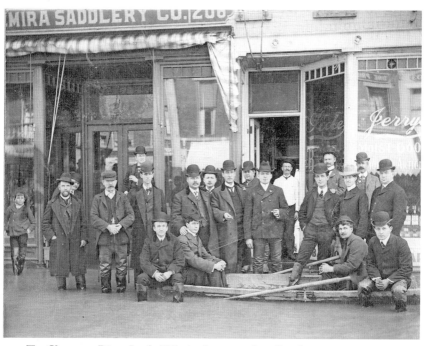

The Chemung River flooded Elmira in 1902, when Roach was ten years old. Roach's father, Charles, can be seen on the left, peeking over someone's shoulder. Courtesy of the Chemung County Historical Society, Elmira, New York.

Hal E. Roach Studios, 1921. Hal Roach poses with his car in front of his new studio. Courtesy of Marc Wanamaker/ Bison Archives.

Hal Roach's office, circa 1923. The rugs were made from bears Roach had hunted. Courtesy of Marc Wanamaker/ Bison Archives.

Aerial shot of Hal E. Roach Studios, 1921. Across the street from the studio was the lumberyard of *Our Gang* fame. Courtesy of Marc Wanamaker/ Bison Archives.

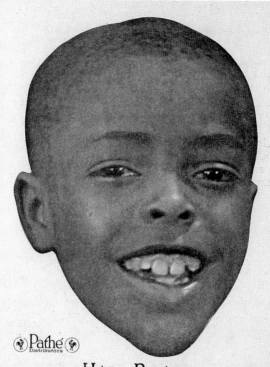

Ernie "Sunshine Sammy" Morrison in Hal Roach's *The Pickaninny*, 1921. Roach would build *Our Gang* around the eight-year-old Ernie, who was reportedly the first black actor signed to a long-term contract in Hollywood. Courtesy of Media History Digital Library.

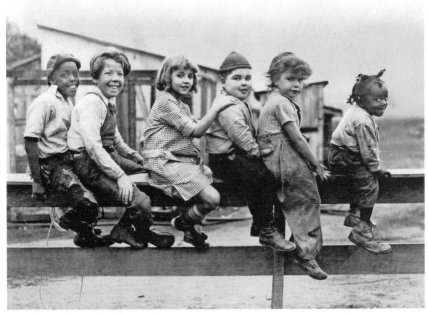

The original *Our Gang* cast, circa 1923. *From left to right:* Ernie "Sunshine Sammy" Morrison, Mickey Daniels, Mary Kornman, Joe Cobb, Jackie Condon, and Sonny "Farina" Hoskins. Author's collection.

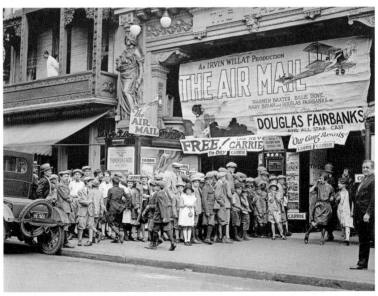

Crowds of children wait to see an *Our Gang* short and Douglas Fairbanks feature in front of Sidney Lust's Leader Theater in Washington, D.C., 1923. Author's collection.

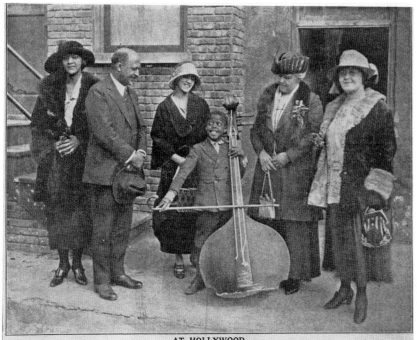

AT HOLLYWOOD
Dr. Vada Somerville, Dr. DuBois, Miss Anita Thompson, Ernest Morrison ("Sunshine Sammy"), Mrs. Beatrice Thompson and Mrs. F. M. Roberts at the Hal Roach Studios.

W. E. B. Du Bois and local NAACP members visiting Ernie "Sunshine Sammy" Morrison at Hal Roach Studios, 1923. This photograph was later published in the *Crisis*. Photograph courtesy of Miriam Matthews Photograph Collection/UCLA Special Collections.

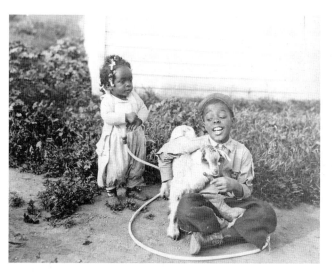

Ernie "Sunshine Sammy" Morrison and Sonny "Farina" Hoskins in *Young Sherlocks*, 1922. They were the oldest and youngest members of the original *Gang*. Courtesy of Michael Hoskins/ Allen Clayton Hoskins Papers.

Hal Roach *presents*

Our Gang Comedies

Two parts each

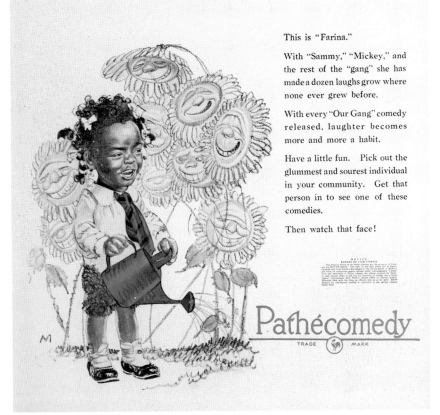

This is "Farina."

With "Sammy," "Mickey," and the rest of the "gang" she has made a dozen laughs grow where none ever grew before.

With every "Our Gang" comedy released, laughter becomes more and more a habit.

Have a little fun. Pick out the glummest and sourest individual in your community. Get that person in to see one of these comedies.

Then watch that face!

Pathécomedy

TRADE MARK

Our Gang advertisement, 1923. With his long hair and androgynous clothing, two-year-old Farina was often referred to as a girl, leading to widespread confusion among fans. Courtesy of Media History Digital Library.

Allen Hoskins, 1925.
Courtesy of Michael
Hoskins/Allen Clayton
Hoskins Papers.

"Uncle Bob" McGowan and Sonny "Farina"
Hoskins filming *Your Own Back Yard* in
1925. The film's title was from a popular
"coon" song and was reportedly Hal Roach's
favorite short. After years of appearing as
a girl, Sonny was finally allowed to wear
pants. Courtesy of Michael Hoskins/Allen
Clayton Hoskins Papers.

Clayton "Clay" Hoskins, Allen "Sonny" Hoskins, and Florence
"Bobbie" Hoskins in front of their new Los Angeles bungalow, circa
1923. Courtesy of Michael Hoskins/Allen Clayton Hoskins Papers.

Sonny Hoskins's aunt, Edith "Boodie" Fortier, wiping Sonny's nose on the Hal Roach lot, circa 1926. Joe Cobb and Jackie Condon wait in the background. Courtesy of Marc Wanamaker/ Bison Archives.

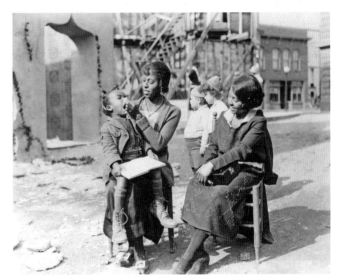

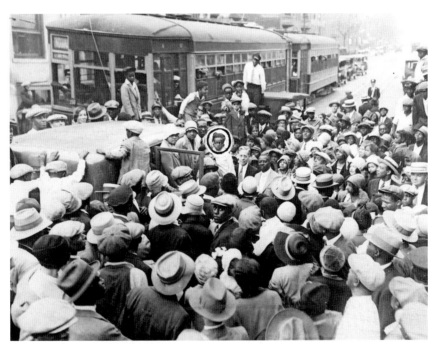

Sonny "Farina" Hoskins visits "Bud Billiken" in Chicago, 1928. The *Chicago Defender* circled Farina's face to help readers spot him in the crowd. Courtesy of Michael Hoskins/Allen Clayton Hoskins Papers.

Hal Roach Studios staff on the lot, circa 1927. Sonny stands in the front row, wearing pants and with his hair in pigtails. *Front row, left to right:* unknown, Joe Cobb, Jackie Condon, Johnny Downs, J. R. Smith, Peggy Eames, Sonny "Farina" Hoskins, unknown, Jannie Hoskins, Scooter Lowry. Courtesy of Michael Hoskins/Allen Clayton Hoskins Papers.

Bob McGowan and the Gang, 1929. Farina was Uncle Bob's favorite among all the *Our Gang* kids. Author's collection.

Our Gang cast in front of Hal Roach Studios, 1929. *From left to right:* Pete the Pup, Bobby "Wheezer" Hutchins, Jean Darling, Mary Ann Jackson, Sonny "Farina" Hoskins, Harry Spear, Joe Cobb, and Norman "Chubby" Chaney. Author's collection.

Bob McGowan and the Gang with new sound equipment, 1929. The introduction of sound helped prolong Sonny's career. Author's collection.

Farina and Stepin Fetchit in *A Tough Winter*, 1930. Fetchit's career would take off in the 1930s, while Farina's would come to an end. Courtesy of Michael Hoskins/Allen Clayton Hoskins Papers.

Sonny "Farina" Hoskins and Jannie "Mango" Hoskins in *Lazy Days*, 1929. Jannie had written: "I remember this scene. I'm about 5 or 6 yrs. old. Sunny's about 8 or 9 yrs. We had squabbled at home that day & Mamma said we had better behave our selfs at the studio. No if's or and's." Courtesy of Michael Hoskins/Allen Clayton Hoskins Papers.

Matthew "Stymie" Beard and Sonny "Farina" Hoskins in *Little Daddy*, 1931. Farina would retire shortly afterward at the age of ten. Courtesy of Michael Hoskins/Allen Clayton Hoskins Papers.

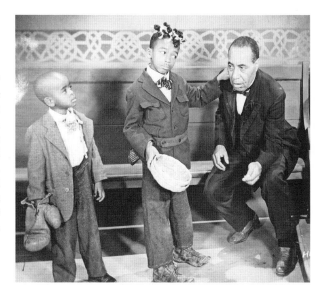

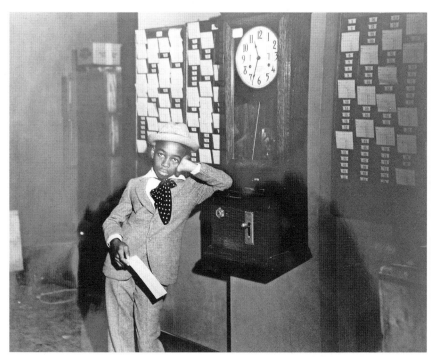

Time to retire: Farina ages out of *Our Gang*, 1931. Sonny appeared in 105 *Our Gang* comedies during nine years, more than any other member of the Gang. Courtesy of Michael Hoskins/Allen Clayton Hoskins Papers.

twos").[20] Whether it was a Do (a surprised expression, pronounced "D'oh!"), a Butterfly (arms flapping, then falling down), a Flipflop (Butterfly, plus a triple spin), or a European (aka, "you're a-peein'"), Sonny always hit his mark.[21] During breaks in shooting, he and Ernie would sneak over to a neighboring set, where Stan Laurel was working on a film. There, they would ogle the lavish spread laid out for a banquet scene, much to Laurel's amusement.[22] Harold Lloyd sometimes wandered over from his set to goof off with Sonny and the rest of the kids. A popular song was composed in Sonny's honor, "Li'l Farina, Everybody Loves You." Duke Ellington and his orchestra recorded a version, and Lloyd would provide a testimonial on the sheet music's front cover: "Farina is not only one of our smallest, but one of our most natural motion picture actors, and to him I extend my sincere best wishes for the success of this song."

Yes, everybody loved Farina. He was the most famous black film star of the mid-1920s. The *Los Angeles Times* reported, "No other child has breezed into favor with quite the same individual recommendations." His popularity, the paper declared, was "amazing."[23] Louella Parsons, the reigning Hollywood gossip columnist, declared Farina her favorite star.[24] President Coolidge was also a fan.[25] Sonny, meanwhile, seemed untouched by his newfound celebrity. In 1923, a reporter interviewed a three-year-old Sonny about his new contract with Hal Roach. It also happened to be the day of a total solar eclipse, and Sonny was otherwise distracted. Ignoring the reporter's questions, he kept looking up at the sky and asking, "When's 'clipse?"[26]

When's 'clipse, indeed? The reporter didn't yet know it, but there was more than one eclipse going on. In less than a year, Sonny Hoskins would eclipse Sunshine Sammy as the star of the *Our Gang* comedies.

Farina's gender was a mystery from the start. Ernie Morrison claimed that the studio was looking for a little boy with long hair to play his little sister. Practically, it made sense to find a baby or toddler who could play either sex. A change of clothes and a new hairdo was all you needed to fit a young child into a range of roles. Jackie Condon, with his long, unruly curls, was another actor who switched between boy and girl roles. He was practically born on

set, appearing in his first film when he was reportedly twenty-one days old. Like Sonny, he took little girl parts as he grew older, leading people to assume he actually was a girl.[27]

Ernie said that the real confusion over Sonny's gender began when Ernie's sister Dorothy was enlisted as a double for Sonny during one of his perennial tantrums. The two toddlers were around the same age and apparently looked quite similar. "That's why Hal was fooled at first, like everyone else, about the kid's gender," Ernie explained.[28] The *Our Gang* writers didn't help things along by having Farina appear as a girl in some films and a boy in others. In the 1920s, both baby boys and baby girls wore rompers and dresses, so Farina's typical costume of a skirt or smock didn't automatically identify him as a boy or girl. Then there was the matter of his name. "Farina" wasn't gender specific, like Joe or Sally. If anything, it sounded like a girl's name, with its feminine ending.

There was also a more cynical explanation for why Farina's gender was kept ambiguous. He was a pickaninny, uneducated and uncivilized. He tussled with chickens, pigs, and alligators. In other words, he was more like an animal than a human child. Already considered less of a sexual threat because of his youth, Farina was further neutered by his lack of clear gender. He was, according to one reporter, "the small colored person who is usually referred to on the lot as 'It.'"[29] He could be replaced, without most people noticing, with another black child—with Dorothy, for instance. He was like Pete the Pup, who was played by any number of unrelated pit bulls, sometimes appearing fatter, sometimes skinnier, sometimes with a ring painted around one eye, sometimes around the other.

The name "Farina" also contributed to the character's fungibility. Farina was a kind of rice mush, a product that could easily be exchanged and substituted, like one box of Cream of Wheat for another. It was a comic, edible nickname that perpetuated stereotypes of pickaninnies as both innately edible as well as prone to eating even the most inedible things. All the black children in "Our Gang" were given such names. Ernie was sometimes billed as "Booker T. Bacon" or "Sorghum" (a cereal and sweetener), Sonny appeared as "Farina" and "Maple," Eugene Jackson as "Pineapple," and Jannie as "Mango" (as well as the

bizarre "Aroma"). They were considered cute and innocuous, as wholesome as baby food, as sweet as sugar, and as safely exotic as tropical fruit. Sometimes a white child was seen eating motor oil and tacks, but usually it was a black child who swallowed needles and nails or nonchalantly chewed on a razor like it was a piece of beef jerky.

Even more so than Sunshine Sammy, Farina was the visual archetype of the pickaninny. Sammy was older and lankier. He had close-cropped hair. When he wasn't barefoot, he at least wore shoes that fit him. Farina, though, could have stepped off the pages of an advertisement or postcard. His hair was tied in pigtails and white ribbons. He ate watermelons, fell into vats of flour, and smoked a corncob pipe. He wore the clownlike, oversized shoes of a minstrel. With Sunshine Sammy's retirement, Farina became the vehicle of all the most hackneyed and racist sight gags. He appeared in whiteface while his white friends appeared in blackface. When he got the measles, white spots were painted on his face instead of black ones. He clutched voodoo amulets and was terrified of ghosts. He was called "Shine" while Mickey was called "Freckles" or "Speck" and Joe Cobb was called "Fatty."

But something strange started to happen. Despite his genesis in the flattest of stereotypes, Farina started to become—how else to put it?—human. He went through the minstrel motions, but even the narrowness of his scripted roles couldn't suppress his outsized personality. The public fell in love with him. To them, he wasn't just an "it." He was a person. And they wanted to know— was he a boy or a girl? Children were especially curious. They wrote letters to the studio, trying to figure out Sonny's "real" gender. Bob McGowan was asked to settle long-standing family arguments and wagers.[30] The press added to the confusion, sometimes referring to Farina as a "he," sometimes as a "she"—and sometimes switching from one pronoun to the other in the very same article![31] A few papers called him a juvenile Julian Eltinge, a reference to the famous vaudeville female impersonator; another referred to him as a "Girl-Boy."[32] The studio, meanwhile, played coy. According to Leonard Maltin and Richard Bann, "Hal Roach seized upon this widespread curiosity as a publicity gimmick, resulting in news releases that failed to disclose the lad's real name, Allen Clayton Hoskins, and avoided the matter of sex, instead

describing Farina with incredible appellations such as 'that chocolate-coated fun drop of Hal Roach's Rascals.'"[33]

At the same time the public was clamoring to find out Farina's real gender, Sonny was getting sick of donning skirts and being referred to as a girl. He was no longer a little baby or even a toddler. He had strong opinions and was beginning to revolt at playing so-called sissy roles. One reporter joked that Rudolf Valentino, a notorious prima donna, had "nothing on [Sonny] for temperament."[34] When the other kids teased him for wearing dresses, Sonny was beside himself, stamping his feet and insisting he was a "real boy." When shooting stopped and the crew broke for lunch, he ripped off his skirt and insisted on changing into pants. Sonny was becoming a full-fledged individual, with a correspondingly strong sense of identity.

In any case, it was getting harder for Sonny to pass as a girl now that he was older. The studio slowly allowed him to appear more often as a boy. In *Your Own Back Yard*, Sonny was clearly a "he" and got to wear a dapper suit in the final scenes. A publicity still from the film showed Sonny leaning rakishly against his cane, dressed smartly in a bowtie, Panama hat, and spectator oxfords. "The famous pigtails are gone," one paper captioned the photograph. "And Farina, celebrated pickaninny of the films, is growing up. Note too that he has adopted the long pants fad of Hollywood."[35] Sonny must have been particularly thrilled when a fan, using a postcard with a similar publicity photo, addressed him as "Dear Little Man." He was becoming a heartthrob, just like Valentino, the original "sheek."

After his parents' divorce, Sonny was living in a house full of women—his mother, sister, and Aunt Boodie. It made sense that he'd want to assert his masculinity and clamor for a haircut and a pair of pants. But Farina had become so associated with long hair that audiences resisted the change. A compromise was made, and Sonny began to wear his hair short, with one longer braid on top. The dresses, at least, were retired. Sonny began to appear in shirts and trousers, though he kept his signature oversized shoes. Ironically, Sonny started to miss the long hair that had been the source of so much gender confusion. He confided in a reporter, "When my hair was long I wanted it short and now that it's short I wants it long."[36] Soon after, the pigtails returned, tied up with strips of

white ribbon. Except for the occasional trim, Sonny's hair would stay long for the rest of his time on *Our Gang*.

The rumors about Sonny's gender, though, were hard to quash. They dogged him for years, well after he began to appear consistently as a boy. As one reporter put it, "To one half the world, he is a girl, to the other half, a boy."[37] When Sonny sent a congratulatory telegram to President Hoover on the occasion of his 1929 inauguration, he received a letter back from Hoover's secretary, addressed to "Miss Farine [*sic*]." On a visit to the MGM lot, Sonny stopped by the set where Lon Chaney was filming his latest picture. Heavily made-up to look like an aging locomotive engineer, Chaney did not look like Sonny expected him to look. "You ain't Mr. Chaney," he protested. Chaney retorted, "Well, then, if I'm not Lon Chaney, you're a girl." Sonny bristled. "The two stars finally reached the mutual agreement that Lon was Lon and Farina was a boy," a local paper reported.[38]

Some of the confusion was exacerbated by the proliferation of *Our Gang* look-alike contests, where girls were chosen to impersonate Farina.[39] So popular had the Gang become by the late 1920s that many of these contests, some sanctioned by Hal Roach Studios and some not, further confused gullible locals. In 1928, *Variety* described how one conman pretending to be Bob McGowan would travel from town to town, car overloaded with props, duping merchants, theater owners, and parents with claims that he was filming an *Our Gang* comedy using a local cast. Kiddie imposters appeared on vaudeville tours, claiming to be members of the Gang.[40] Sonny's mother recalled touring the East Coast with the *Our Gang* cast and constantly hearing from local townspeople, "Oh, I saw Farina when he was here last year." "But my son has never been East before," Bobbie protested.

In another amusing anecdote, Bobbie was sitting in the audience when Sonny appeared onstage. The woman sitting next to her leaned over and said, "You would never blink that Farina was a girl, would you?" "But he isn't," Bobbie said. "Farina is a boy." "I beg to differ from you," the lady insisted, "but two years ago when Farina and her mother were here, they stopped with me and I KNOW that she is a girl." Even when Bobbie exclaimed, "But I am Farina's mother!" the lady remained unconvinced. "[She] looked at me rather hard and I know she thought that I was not

telling the truth, though she was too polite to say so," Bobbie remembered. "So the facts that Farina made his screen debut playing little girl parts, coupled with little girls going about the country making personal appearances, gave the public good reason to think of him as such."[41]

Boy or girl, Farina was perceived as a morally upright and sexually unthreatening role model for children. On his seventh birthday, Sonny was thrown a party on the lot. In a small news item, the *Baltimore News* reported, "'Farina,' one of the most famous screen stars, who had never made a sex film, has celebrated her seventh birthday. Director Bob McGowan did the honors, and 'Our Gang' cut itself a piece of cake in the kid's honor."[42] In pre-Code Hollywood, "sex films" referred to any picture with dubious moral content, from suggestive behavior to nudity to homosexuality. The silent film industry had weathered some notorious sex scandals in the early 1920s, most famously the fall of Fatty Arbuckle, who was accused of sexually assaulting and then killing a young actress during a raucous party. The papers sensationalized the episode, depicting Hollywood as a vice-filled Babylon. In the wake of such scandals, *Our Gang* emphasized its "wholesome" nature, with its child actors the antithesis of supposed predators like Arbuckle or sex symbols like Theda Bera. Angelic Mary Kornman might be described as a "vamp" and toddler Farina as a miniature Valentino, but these were meant to be tongue-in-cheek comparisons. A 1924 parody column, supposedly penned by Farina, painted him as a junior William Hays, the censorship czar of the Motion Pictures Producers and Distributors of America (MPPDA). "Suppress Movie Scandals, Advises Little Farina," the headline reads.[43] In a publicity still from around the same time, Sonny glares at the reader from above Harold Lloyd–style glasses. "Are you behaving?" he seems to be saying.

During breaks in filming, the whole Gang would embark on tours of the country, piling into a Pullman car with their families, entourages, and a mess of toys—drums, dolls, erector sets, blocks, wagons, clay modeling sets, all strewn haphazardly around the car. As the train passed through smaller towns, fans would gather along the tracks, hoping to catch a glimpse of their favorite stars waving from the observation platform as they whizzed by. Once at

their destination, the Gang's schedule was packed with vaudeville appearances, radio shows, city tours, and promotional events. The police had to fend off crowds as the Gang visited landmarks and met local officials. In Albuquerque, the mayor came out to meet them on the sun-baked train platform. In Detroit, the kids toured the Ford plant, and Sonny burst into tears, terrified by the noise. In Chicago, the Gang met Carl Sandburg, the well-known poet and an avowed fan. Sandburg had reviewed *Commencement Day,* an early *Our Gang* short, for the *Chicago Daily News* and declared, "As a bunch of mischievous and cantankerous young catamounts, the gang in this film is unbeatable."[44] In New York, the Gang visited the Statue of Liberty, toured Chinatown, and had lunch at Delmonico's. Scheduled to meet the mayor, a cranky Sonny threw a fit, first pouting that his shirt was dirty and then complaining that the mayor was late.[45] In most of the cities, the Gang visited the local children's hospital and did charity work. They also indulged in plenty of Cracker Jack, popcorn, and ice cream.[46]

The kids were stars. They appeared in local, national, and even international advertising campaigns, selling everything from Ben-Hur Coffee to Bishop's Caramel Toffee to Sealpax underwear to Kellogg's Cornflakes. The whole gang piled into a "Bell Chesterfield Bed," posed around an "ice cream separator," and received brand-new Brandes radio receivers. In Oakland, Sonny appeared in an advertisement for the local Studebaker dealership, just above a picture of the new Commander Coupe, priced at $1,645. The whole gang appeared in an advertisement for Producers Milk, which supplied them with milk and ice cream during their stay in Northern California. In New York, the Gang appeared at Hearn department store and modeled clothes for their children's department. Back home in Los Angeles, they participated in a fantastic publicity stunt sponsored by *Hollywood News* where 1,500 bags attached to miniature parachutes and containing Baby Ruth candy bars and packages of peppermint gum floated down from the skies like manna from heaven. "Sweets Will Rain from Soaring Plane; also Chewing Gum," the subtitle read.[47]

Somehow, in spite of his packed tour schedule, Sonny always made time to visit the offices of the local black newspaper or sit for an interview with one of their journalists. In St. Louis, Sonny visited the offices of the *American*—a black newspaper

whose motto was "An American Newspaper for Americans"—and goofed around on the office typewriter before departing for his appearance at the Loew's Theater in town.[48] In New York, Sonny visited Harlem and was interviewed by the *New York Amsterdam News.* The story was picked up by the *Baltimore Afro-American,* which published a photograph of Sonny surrounded by "lots of other little brown folk."[49] In Chicago, thousands of children and their parents waited outside the offices of the *Chicago Defender* for a publicized visit. They erupted into cheers and applause when Sonny and his mother appeared in a Rolls-Royce driven by *Defender* founder Robert Sengstacke Abbott and escorted by a police squad car.[50]

Sonny knew he was a role model for African American children throughout the country, and he took the responsibility seriously. He became closely involved with the *Chicago Defender*'s Bud Billiken Club. Founded by Abbott in 1921 as part of the *Defender Junior,* the newspaper's children's page, the club was meant to promote racial pride, civic values, and community service among Chicago-area black children. "Bud Billiken" was the club's mascot, a smiling, Buddha-like figure that took its name from "Bud," Abbott's nickname, and "Billiken," a pudgy, elfin good-luck charm, first created by an American woman, Florence Pretz, in 1908. Bud Billiken looked vaguely Asian—the newspaper claimed he was the Chinese guardian angel and patron saint of children—and he preached tolerance, respect, cleanliness, and responsible citizenship.[51] His disciples, young and old, were called "Billikens." Starting in one Chicago neighborhood, the Bud Billiken Club soon expanded nationwide and even internationally. Children could join for free, receiving membership cards and buttons in the mail. Bud Billiken's mission was "to bring the children of the world closer together and show that all the world is kin," the *Defender* wrote. By 1930, Bud's "gang" had more than sixty-three thousand members.[52] Every year, the club held a huge parade and picnic in Chicago, dubbed the "Bud Billiken Day Parade"—an event that continues even today.

Sonny was the iconic Billiken. He was respectful and charming, and he starred in a comedy series that espoused the very values the Billiken Club promoted. His visit to the *Defender* office in August 1928 was publicized as a visit to Bud Billiken (David

Kellum, the children's page editor). In a short column dedicated to his trip, the paper vaunted the ease with which Sonny and his costars played with one another. Sonny did not fear his white friends, nor feel inferior to them. In turn, his white friends knew "no prejudices, and a dark face [did] not excite them." "That is the advantage of contacts," the paper declared. "That is a concrete example of what the Defender means when it advocates the outlawing of all forms of segregation, especially in the schools where children are given the first impressions that affect their lives."[53] During Sonny's visit, he was besieged by fans who had lined up along Cottage Grove Avenue, Thirty-fifth Street, and Indian Avenue to await his appearance. The *Defender* passed out balloons and "crickets," small metal noisemakers, to all the waiting boys and girls. When Sonny's motorcade appeared, the crowd began to cheer and scream his name. They rushed his vehicle, stopping traffic. Some kids climbed onto their parents' shoulders to catch a glimpse of the young star; others were more interested in Abbott's Rolls-Royce. In a photograph published in the paper, Sonny surveys the crowd, looking overwhelmed by all the attention. A street trolley, forced to stop because of the crowds, appears in the background, passengers craning their necks out the windows to see what all the fuss is about. The *Defender* circled Sonny's face in the photograph to help readers locate him in the mass of people, and it had the effect of giving him a halo. Already idolized by the black community, Sonny looked like a child savior, arriving to greet his flock. After posing for photographers, Sonny received his Billiken card and button, shook hands with his fans, and set type on the *Defender*'s linotype machines. His visit concluded with Abbott presenting Sonny with a silver loving cup for outstanding achievement as a Billiken.[54]

Sonny received fan letters from Billikens around the country, striving to be perfect, "100 percent Billikens" like Sonny himself. One letter from a member in Clinton, Iowa, begins, "Dear Billiken":

> Just a few lines to let you know that I'm also a Billiken
> trying hard to be a 100 percenter, and I find that it *is*
> hard. . . . My friend and I are Billikens and I am writing
> for her too, and we are very anxious to hear from you. Tell

me all about yourself and the rest of the gang. . . . I would
like for you to send me one of your pictures. . . .

As ever a Billiken,
Margaret Culberson

P.S. Just call me Marge[55]

Billikens like Marge and her friend hoped to qualify for the club's
"Honor Roll"—a published list of "Hundred percenters" who
faithfully followed the injunctions of the *Defender Junior*'s "Bud
Says" column. Depending on the week, this meant writing letters
to fellow Billikens, or sending an Easter card to the Billiken Club
office, or being good citizens and students. Children who could
never qualify as 100 percent Americans according to the Klan
could qualify as 100 percent Billikens.

The Bud Billiken Club offered African American children
an alternate model to the black child most often seen in popu-
lar culture—that of the pickaninny. Billikens were neatly dressed,
educated, and polite. Pickaninnies were ragged, uneducated, and
barbaric. Billikens could be white or black—in fact, one little girl
wrote to Bud, "though I am an English girl and white, I like the
Billiken Club better than anything I have ever joined."[56] Picka-
ninnies were always black. Billikens were part of "the most cos-
mopolitan club in the world";[57] pickaninnies, the most provincial.
The Bud Billiken mascot was a particularly American cultural
mash-up—an elf crossed with a Chinese Buddha, adopted by Af-
rican Americans. The pickaninny was an American creation, too,
but one manufactured by Southern whites to enforce, rather than
blur, the boundary between races. Billiken. Pickaninny. Even the
names sounded similar. They represented the Janus-faced image
of the black child in America.

The Billiken Club was part of a larger political movement
taking hold in the African American community in the 1920s.
Founded in 1916 by Hubert Harrison, a Harlem-based activist, the
New Negro Movement called for political equality and an end to
racial segregation and lynching. The term "New Negro" was sub-
sequently popularized by Alain LeRoy Locke, the famous black
intellectual, in his 1925 anthology of the same name. The New
Negro was a deliberate break from the previous century's image
of the "Old Negro." He passionately rejected the plantation ste-

reotypes of the Sambo or Uncle Tom. He was free, independent, and optimistic; a racial pioneer; a champion of "race pride."[58] The contrast between Billiken and pickaninny was this same racial struggle, writ in miniature. The Billiken was a juvenile version of the New Negro; the pickaninny, a juvenile version of the Old. Billikens were self-respecting citizens, little men and women who went to school, obeyed their parents, and elevated their race. Pickaninnies were a reviled and outdated stereotype, a throwback to slavery and its culture of degradation. Sonny Hoskins, the pickaninny who became a Billiken, was the poster child for this metamorphosis.

Sonny's castmates, too, became honorary Billikens, emphasizing the inclusive and integrationist vision of the club, a vision that matched the Gang's own evocation of interracial community. Along with Sonny, the *Chicago Defender* invited his five costars—Joe "Fatty" Cobb, Bobby "Wheezer" Hutchins, Harry Spear, Jean Darling, and Mary Ann Jackson—to a celebration at a Chicago theater, presenting the kids with Billiken membership cards, buttons, and engraved loving cups. Robert Sengstacke Abbott was there, as was Ray Coffin, the Gang's traveling manager, and W. K. Hollander, the publicity director for a local chain of theaters, who acted as master of ceremonies. Upon their induction into the Billiken Club, editor David Kellum spoke. "This little token that we present you today is given with the spirit of good fellowship," he said. "We have a large and happy little family of Billikens, and would be exceedingly glad to list you as a 100 per cent Billikens." The *Defender* later reported to its readers that *Our Gang* was welcomed into "the Chicago Defender's own gang," and Billikens were urged to drop "a line of cheer" to their newest friends c/o Hal E. Roach Studios, Culver City, California.[59]

Not all groups, however, were receptive to this integrationist vision. In New York, Sonny and his chaperones were rejected from their assigned hotel, and production manager L. A. French frantically searched for alternate accommodations rather than separate the cast. Yet even after the Gang was relocated to a new hotel, Jim Crow made its presence known. A reporter from the *Amsterdam News* was directed to the back door of the new hotel, an order that incited his fury. "The reason I'm here is to investigate color discrimination against 'Farina' at another hotel. Now I

walk right into another one and meet the same thing," he protest-
ed. The reporter eventually got his interview, but he made sure to
let readers know of his shabby treatment in the pages of the news-
paper. He was careful, however, not to mention the unpleasantry
in his conversation with Sonny.

"'Farina' doesn't talk much, just blurts out a few sentences
and then closes up," the reporter wrote. "He is that droll sort
of type not particularly emotional or bothered about what is go-
ing on around him."[60] Perhaps Sonny, a veteran actor, was good
at pretending as if nothing was wrong. Or perhaps, more likely,
Bobbie and the reporter were trying to protect the boy. Sonny was
still a child, barely eight years old. He would learn of the racism of
the adult world soon enough.

"Be sure and tell them I am a boy and not a girl!" was Son-
ny's one emphatic request. "I'm not Sunshine Sammy's sister."[61]

Back home in Los Angeles, change was afoot. In 1926, Hal Roach
Studios decided to leave its longtime distributor, Pathé. Roach
was aggressively wooed by distributors eager to take over the *Our
Gang* comedies. Louella Parsons reported:

> Just how important a part Farina, the dusky star of "Our
> Gang" comedies, plays in the ascendant fortunes of Hal
> Roach I do not know. But the fact remains that when Mr.
> Roach decided not to renew his contract with Pathé every
> producer in the business made Mr. Roach an offer to bring
> Farina and his playmates into their particular camp.[62]

Metro-Goldwyn-Mayer eventually triumphed. It was a mutually
beneficial alliance. MGM was trying to break into short features,
and *Our Gang* was a proven commodity, with producers who
were specialists in the field. Hal Roach, meanwhile, could get
Our Gang into more theaters by "block-booking" the shorts with
MGM features.[63]

Sonny, Joe Cobb, Johnny Downs, and Jackie Condon were
the only kids remaining of the original generation of Gangsters.
Ernie had left in 1924. Mary and Mickey followed in 1926. All
three ended up in vaudeville, the logical next step for child actors
who had aged out of the comedies. Eugene Jackson, who had been
brought in to play Farina's brother "Pineapple," ended up ap-
pearing in only six *Our Gang* shorts. Lured away by other acting

offers, he left before his three-year contract was up. New members were gradually introduced over the next few years—Bobby "Wheezer" Hutchins, Harry Spear, Jean Darling, and Mary Ann Jackson. Roach, meanwhile, was spending less and less time with *Our Gang*, distracted by his polo ponies, world travels, and the development of new properties like the Laurel and Hardy series. Bob McGowan had a nervous breakdown, likely exacerbated by the strain of wrangling so many kids and his own workaholic tendencies. He took two separate leaves of absence, handing over the reins to his nephew, Anthony Mack, widely considered a less capable director.[64] The films fell off in quality, perhaps because of the upheaval at the studio and the changes in the cast.

At home, Sonny continued to be a role model for his race. William Pickens, a founding member and field secretary for the NAACP, visited Sonny on the studio lot during a trip to Hollywood to lobby for "race pictures," movies that sympathetically portrayed African Americans. After touring Catalina Island and meeting with the supervisor of productions at Cecil B. DeMille's studio, Pickens hung out with the *Our Gang* kids. Sonny and Jannie clambered into his arms, and Jackie Condon gave him two of his latest photographs.[65] Pickens stayed in touch with Sonny after he left, sending him press clippings from the trip. "Hello, Farina! Here's 'you and me' in this Philadelphia paper. Wm. Pickens," he scrawled in pencil across a picture from the *Sunday Public Journal*. Little Sonny sits perched on Pickens's shoulder, his arm resting chummily on Pickens's head, his face beaming.[66]

It was a brief sunny moment in an otherwise dismal period of racial setbacks. The front-page headline, still attached to the clipping, read: "Supreme Court Refuses to Pass on Segregation," a reference to the landmark case of *Corrigan v. Buckley.* Irene Corrigan, a white woman, had attempted to sell her house in Washington, D.C., to a black couple but was prevented from doing so due to a racial covenant on her property. The NAACP brought the case before the Supreme Court, arguing that restrictive covenants were a violation of the Fourteenth Amendment. In a devastating defeat, the Supreme Court declined to hear the case, claiming a lack of jurisdiction. Racial restrictive covenants proliferated across the nation, standing unchallenged for more than twenty years.[67]

Bobbie owned her own house, but it was near Central Av-

enue, a designated "colored" neighborhood not subject to racial covenants. Her son was a movie star, appearing in more than eleven thousand theaters across the country, beloved by millions. He had been nominated for "Who's Who" as "the most useful Negro alive today" because "he has been in the movies since he was a year old and that he is unsurpassed in popularity throughout the country."[68] Yet even "the most useful Negro alive" could not live in the same neighborhood as his fellow, white stars. In fact, he couldn't live in most places in Los Angeles, period. The Gang continued to appear in publicity photos as one big, happy, integrated family, but Jim Crow was making inroads even in the comparatively tolerant West.

Around this time, the *New York Herald Tribune* published a photograph of the *Our Gang* stars dressed in matching striped bathing suits, playing in the California surf.[69] It was a charming, twentieth-century update of the famous 1872 painting by Winslow Homer, *Snap the Whip*. Instead of a one-room schoolhouse and a green meadow, there was a stretch of beach and the Pacific Ocean; instead of a string of white, rural schoolboys, running barefoot across the grass, there was a string of black and white children in bathing costumes, running barefoot across the sand. The sentiment was the same, though—childhood freedom, innocence, teamwork. The kids of *Our Gang* were re-creating Homer's own nostalgia for a simpler past. But little Sonny Hoskins, clinging to the end of the "whip," was straining to keep up. Usually, he wouldn't even be allowed on the same stretch of beach as the white children. If he hadn't been taking publicity stills, he would've been relegated to the Ink Well, a half-mile sliver of beach in Santa Monica, or Bruce's Beach, nine miles south in Manhattan Beach.

Bobbie was not blind to these injustices. She kept up with the careers of other black film stars who experienced their own battles with the color line. One star she avidly followed was Florence Mills, a vaudeville singer and dancer known as the "Queen of Happiness." Mills, like Sonny, was considered a race star, an "ambassador of good will from the blacks to the whites; a potent factor in softening the harshness of race feeling; a living example of the potentialities of the Negro of ability when given a chance to make good."[70] Mills spoke frankly about the race problem in

the United States, describing how she was better treated in Europe than in her home country. In an article Bobbie clipped from the *Amsterdam News,* Mills condemned the hypocrisy of the color line, where "colored mammies" in the South nursed and raised white babies, yet were forbidden to let their own children play with their white charges. She especially lamented the plight of American "colored boys," who, despite their intellectual ability, were shunted to menial jobs. "My greatest ambition in life," she vowed, "is to see white people ignore the colored question."[71] To that end, she took seriously her role as a representative of her race. In her signature song, "I'm a Little Blackbird Looking for a Bluebird," she sang,

> I'm a little jazzboat looking for a rainbow through
> Building fairy castles, just like all the white folks do
> Forlorn and crying, my heart is sighing
> But wise ol' Al says to keep on trying
> I'm a little blackbird looking for a bluebird.

Mills's jazz ditty became a powerful protest song, a poignant call for the same opportunities and dreams—the same bluebird of happiness—so readily accessible to white people.

Mills did not survive to see her greatest ambition fulfilled. A few months later, exhausted from performing her hit show *Blackbirds* in London, she succumbed to tuberculosis. She was thirty-two years old. Mills's premature death must have shaken Bobbie, who was around the same age. She joined in the collective grief that overwhelmed the black community, collecting press clippings about Mills's death and funeral. Ten thousand mourners, five hundred schoolchildren among them, reportedly paid their respects. James Weldon Johnson, executive secretary of the NAACP, attended the funeral. Prominent citizens, black and white, sent their condolences. Duke Ellington and Fats Waller composed musical tributes in her honor. In a published homage to her life, the *Pittsburgh Courier* commemorated Mills as "a symbol of the New Negro."[72]

Sonny continued Mills's legacy in his own way, becoming a kind of junior ambassador to the cause. When the NAACP held its national convention in Los Angeles the following year, Sonny and his sister headlined a "Negro Musical Review" benefit at the

newly built Shrine Civic Auditorium. All the leading lights of the African American community were in town for the convention—*Crisis* editor W. E. B. Du Bois, NAACP executive secretary James Weldon Johnson, novelist Charles Chesnutt, field secretary William Pickens, among others—and many were likely in the audience that night. Designed in a fantastic Moorish revival style, the Shrine could seat over six thousand people and would later become a frequent venue for the Academy Awards. Billed as "Farina and Mango," Sonny and Jannie appeared on a program divided into four "periods": "Plantation Days," "Impersonations of Former Stars," "Sambo's Awakening," and "Era of Syncopation." There were spirituals and folk songs, impersonations of Bert Williams and Florence Mills, and jazz performances by Carolynne Snowden, a film actress then appearing at Frank Sebastian's Cotton Club, just down the street from Hal Roach Studios.

Sonny and Jannie appeared, appropriately enough, at the end of the third period, "Sambo's Awakening." On the program, an explanatory note appeared below their names:

> NOTE: On account of Farina's Movie Contract, "she"
> will be allowed only to say "Hello." Mrs. Lauretta Butler
> and Kiddies from the famous Kiddies Minstrel will assist
> Farina.[73]

Contract or no contract, Sonny's presence there was enough. He was supporting the NAACP's call for an end to racial segregation, black disenfranchisement, and lynching. He was protesting discriminatory practices in housing and education. He was announcing the awakening of Sambo and the rise of the New Negro.

5

Everyman

"Wait a minute, wait a minute, you ain't heard nothin' yet." With those words, the sound era had arrived. Ad-libbed by Al Jolson in his 1927 film, *The Jazz Singer,* they were the first example of synchronized speech in a feature-length motion picture. The audience at the premiere, held at Warner Brothers' flagship theater in Times Square, greeted the words with shouts and applause. The excitement mounted with each musical number by Jolson, who played a blackface performer struggling with his Jewish identity. By the time Jolson began his dialogue scene with Eugenie Besserer, the actress playing his mother, the audience was hysterical. "Jolson, Jolson, Jolson!" they cheered as the film ended, jumping to their feet and applauding. It was a mob scene outside of the theater, with the police called in to control the crowds.[1] *The Jazz Singer* was a box-office smash, catapulting Warner Brothers, the film's producer, to the head of the industry. The studio continued to release talkies, earning such fat profit margins that rival studios soon jumped in the game. Paramount released its first talkie in 1928, and the rest of the major studios quickly followed suit.

Hal Roach was paying close attention. He was less than two months into his partnership with MGM when *The Jazz Singer* was released. In a report to stockholders the following year, the board of directors at Hal Roach Studios issued a cautious and impressively circumlocutory statement. "It is, of course, difficult

to foretell what the eventual outcome of talking pictures will be or the eventual form they will assume," it read. "One thing is certain, however, that is that they are at the present time an element in the amusement field apparently having a definite appeal to the public, and properly handled, it promises to be a great addition to the entertainment value of pictures."[2] Roach was far more blunt in an article for *Motion Picture News*: "Sound effects in pictures are going to find a definite niche in the market. There is no doubt about that. And they are going to add variety to the program."[3] In June 1929, Roach came right out and predicted the end of silent comedies, announcing that from then on, he would only produce sound films. "The talkies were made for comedy," he said. "We will try to make two or three laughs grow where only one grew before. Speech will give the comedy a new personality, greater vividness and punch."[4] Soundstage construction, supervised by the Victor Talking Machine Company, began on the Hal Roach studio lot.[5]

Bob McGowan, who had returned from his latest sabbatical, was sent to New York to study the Vitaphone sound-on-disk system, the same technology that had been used in *The Jazz Singer*. "After Mr. McGowan assimilates the intricacies of talkies, he will return to Hollywood and make comedies," a journalist reported, adding, "I would like to hear Farina speak. That is, if he talks more than he did the day I saw him last. He was obviously bored at the presence of a newspaper person and didn't care who knew it."[6] McGowan had his work cut out for him back at the studio. For experienced stage actors like Laurel and Hardy, the transition to sound was relatively seamless. They were accustomed to memorizing lines and delivering jokes with the right comic timing. But for a bunch of kids—some of whom couldn't even read—the talkies were going to be a serious challenge.

When he usually filmed comedies, Bob McGowan simply told the children what to do and then shot the scene without rehearsing it beforehand. While the cameras rolled, he would belt directions through his megaphone and coach the kids through their scenes. "Double-Do, Joe!" he could shout, or "Flip-Flop, Jackie!" Those who weren't in the scene could play freely off camera, knowing that their noise wouldn't be picked up by the equipment. With sound, however, the process became much more ardu-

ous. The kids now had to memorize and rehearse their lines. The ones who couldn't read had to have their parents repeat the lines to them until they had learned them. There was no more carousing during filming; the set needed to be silent so the microphones could pick up the scripted dialogue.

McGowan worried that all these changes would make the kids self-conscious, and the comedies would lose their vaunted spontaneity and charm.[7] To ease the transition, McGowan kept scenes short so the kids wouldn't be forced to memorize too many lines.[8] He limited rehearsals so they didn't start sounding canned. He encouraged the kids to ad-lib, to make the dialogue their own. But it was still a slog. On the set of their first talking picture, *Small Talk,* the Gang was much quieter than their usual, boisterous selves. They were now on a soundstage instead of an open-air set. They stared nervously at the microphones and the large, padded booths that now housed the cameras, preventing their whirring gears from being picked up by the microphones.

McGowan called them over and asked, "Did you learn your pieces?"

"Sure, I learned mine last night, and Dad made me say it about sixty times," Joe Cobb, now eleven years old, piped up.

"Me, too," Sonny said. "About a hundred times I kept sayin' mine."

Mary Ann, Harry Spear, Wheezer, and Jean Darling all jumped in, trying to outdo each other in their level of preparedness. Harry claimed his grandmother had made him repeat his lines "a hundred million times." Jean swore she could say her lines "backwards and forwards and upside down."

"All right, then," McGowan said. "Let's see how good you are. Put your pieces down, and run in and sit down at the table there."

The kids dutifully left their scripts with their chaperones and took their seats around a dining room table covered with a red-checkered cloth. They were meant to be orphans at "Mrs. Brown's Home for Children."

Joe, staring at an empty dish on the table, was confused. "Where's the spinach?" he asked. "The piece says we're goin' to eat?"

"We'll get to that in a minute, when we're ready to shoot," McGowan explained. "We're just rehearsing now, and we don't

want to get everything all mussed up. Just pretend that that's spinach in that dish."

Joe nodded.

"First of all, you will pass the dish," McGowan directed. "You all hate it, don't you?"

Yes! Everyone agreed they hated the stuff.

"Well, make terrible faces and don't take any of it," McGowan said.

The kids passed around the empty dish, making a big show of their disgust at the pretend spinach. Some shook their heads; others pinched their noses and stuck out their tongues.

"Now Joe, remember your piece?" McGowan prodded. "You talk first."

Joe couldn't remember his lines. He crinkled his forehead and thought hard.

"Oh, I know!" he said. Glancing at the microphones, he loudly and mechanically delivered his lines: "I wonder what they want to make spinach for?" He looked to McGowan for approval.

"Now Joe, that's not the way you really talk at all," Mc-Gowan said. "Say it to Sonny and the rest as if you were playing with them. Forget about the mikes."

Joe tried again. He still sounded wooden. It took four tries before his voice and delivery began to sound natural.[9]

And so it went, with McGowan moving on to the next child, trying to coax out a more natural performance, encouraging improvisation, soothing any nerves. It was enough to drive anyone crazy, prompting one movie magazine to call McGowan "Hollywood's Most Patient Man" and a "disciple of Job."[10]

And that was just the rehearsal. Once filming began, there were plenty more hiccups to contend with. Roach explained, "It takes so long for the interlock—that is, for silence to settle and the cameras to turn to their required speed and the other measures that have to be taken before a scene can be shot in sound—that by the time the red light comes up signifying the start, the children have forgotten their lines and we are forced to begin again."[11] The kids weren't used to calling each other by their stage names, either, so more than one take was ruined when someone referred to "Farina" as "Sonny."[12] To add to the madness, Roach was increasing the foreign distribution of his films. In the silent era, this

wasn't much of a problem—all you had to do was translate the title cards into whatever language you wanted. With sound, though, things became a lot more complicated. Kids who were already having trouble remembering their lines in English were now being asked to memorize their lines in Spanish and French, as well.

Roach set up language classes on the lot for his actors. With his usual optimism, he insisted it was just as easy for a child to memorize the words "Como esta usted?" or "Comment allez-vous?" as it was to memorize "How do you do, sir?" "With the child it is simply a trick of memory," Roach claimed, arguing that the words meant as little to them in English as they meant in Spanish or French. He did concede, however, that children's memories often failed and their attention strayed. He recalled a particularly funny moment during a long scene the *Our Gang* kids were filming. "We had them trained perfectly to declaim their tiny Spanish bits at the right moments," he said. Just as the scene was about to end, Sonny got distracted. Shoving his washboard-shield at one of the other boys, he said in English, "Heah, put this on, willya?"[13]

Sonny, for one, thought delivering his lines in Spanish was considerably more difficult than delivering them in English. Tapped to appear in an MGM trailer for the National Spanish Exposition in Barcelona, he was coached through his Spanish phrases by the director. "It will be all right if you hesitate a little," he was told. "Don't worry," was Sonny's reply. "There'll be plenty of hesitatin' when I start talkin' this lingo."[14] In the Spanish version of *When the Wind Blows* (translated as *Las Fantasmas*), the Gang ("La Pandilla") stumbled through its lines with atrocious gringo accents. As Jackie Cooper ("Juanito") remembered it, director James Horne shot in short takes "because as kids we could only manage so much Spanish in one mouthful." And unlike Uncle Bob, with his gentle directorial style, Horne preferred to "rant and rave." "He had us racing around and screaming, essentially mimicking him," Cooper recalled.[15]

The studio tried to drum up interest in the Gang's first "talk-film." "Have you ever wondered how the real voices of the famous Roach Rascals sound when they actually talk?" the studio's pressbook for *Small Talk* asked. Lest audiences were worried the voices wouldn't line up to their expectations, the studio reassured fans, "Their voices sound just as you imagine them." Moreover, all

six kids "talk just as realistically as if there were no microphones hiding to record their words." The studio released a publicity pho-to of the gang playing around with a mess of portable sound re-cording equipment loaded onto the back of a truck.[16] *Exhibitors Herald* reported that McGowan had just finished cutting twenty thousand feet of synchronized film for the Gang's first "audien." The kids, the magazine announced, had impressed the MGM staff with their easy adaptability to the sound equipment and the high quality of their recorded voices. None seemed particularly fearful or nervous. McGowan specifically praised Sonny and Wheezer for being "talking actors of mature artistry."[17]

Watching *Small Talk* today, one is struck by how awkwardly it plays. The pacing is off, dragging in spots, frenetic in others. So determined was the studio to play up the novelty of sound that the short is packed with extraneous sound gags—musical instruments, a talking parrot, a honking car horn, police sirens. The scene with the spinach isn't funny at all. Joe drones through grace, Wheezer childishly lisps something about wanting his new parents to buy him a pony, and Mary Ann delivers her lines like she's been medi-cated. A microphone bobs into sight at the top of the frame.

For the audience, however, the weak plot, acting, and pro-duction value almost didn't matter—just hearing the kids' voices and sound effects was wonderful enough. Listening to someone sneeze was better than even the best sight gag. The whole mov-iegoing experience was now changed. Before, audience members more freely talked at the screen or chatted with other movie pa-trons during scenes. Now, they were shushed for fear of missing important dialogue. As Robert Sklar put it, "The talking audience for silent pictures became a silent audience for talking pictures."[18] Like the kids themselves, who had to learn to be quiet while the cameras rolled, the audience had to learn to contain itself while the picture played. Sound meant both had to learn to behave.

Film Daily called it a "kick" to hear the *Our Gang* kids speak. Wheezer and Mary Ann were "cunning beyond words."[19] The *New York Mirror* also thought the children spoke "remark-ably well" and called out Sonny for a special mention: "And Fa-rina! Farina, who hails from Bahston, puts over some amazing diction."[20] Other critics were less kind. Reviewing *Railroadin'*, the second *Our Gang* talkie, one newspaper complained, "The

mike slows things down radically, aided and abetted therein by the fact that all who speak, excepting Farina, deliver their lines with the rote and falsity of a schoolhouse program. Some of the sequences are delivered in yelling tones entirely unnatural and completely destructive of illusion."[21] McGowan's fears, it seemed, were coming true. Sitting through an *Our Gang* comedy was like sitting through a really bad school play.

Despite their uneven performances, the *Our Gang* kids were doing better than other silent comedians. Harry Langdon, the former Mack Sennett star, was "not so funny articulate," as Roach memorably put it.[22] Charlie Chaplin resisted sound altogether, loath to meddle with his success in silent film and dubious of the artistic potential of talkies. From its ungainly start, the *Our Gang* talkfilms gradually improved in pacing, spontaneity, and dialogue. The kids became more comfortable bantering with each other. The writers got better at constructing plots and balancing the dialogue with gags. New children were brought in who were better at memorizing and delivering their lines. The films started to regain their footing and enjoyed a resurgance in popularity. Enthusiastic reviews appeared in South Africa, Great Britain, India, Australia, and even Shanghai.

The real question was whether Joe Cobb and Sonny, the two oldest members of the Gang, would be around much longer. Jackie Condon had retired before the transition to sound, at the age of ten. Joe was now twelve years old and weighed 122 pounds. Never small to begin with, he now clearly dwarfed the other members of the Gang. Sonny was nine years old and had lost his baby fat. He was taller and lankier, a far cry from the chubby toddler who had kicked off the comedy series eight years earlier. Jean Darling and Harry Spear, who were even younger than Sonny, had already given their notice, bowing out midway through the first year of talkies. The studio hired Jackie Cooper to replace Harry as the Gang's "tough guy." Cute and blond, with a signature pout, Jackie also happened to have a photographic memory. He quickly became a star of the talkfilms.

Rumors were now rife that Hal Roach was planning to have an entirely new set of kids in place by January 1930. Wheezer, who had proven himself a scene-stealer in the sound films, was the only member presumed to be safe. No one was surprised when Joe

Cobb announced that summer that he was quitting because of the talkies and was going into vaudeville.[23] Eleven-year-old Norman "Chubby" Chaney was already waiting to take Joe's place as the "fat kid." According to the studio's publicity department, Chubby had been chosen out of twenty thousand hopefuls in a national contest. Like Jackie Cooper, he had a knack for comic dialogue and an easy rapport with the other kids. To ease the transition for the public, Chubby appeared alongside Joe in a few shorts before taking over his role completely.

Our Gang was going through a generational shift, its second in eight years. The first had happened with the retirement of Ernie, Mary, and Mickey in the mid-1920s. Now Jackie Condon, Joe Cobb, and Johnny Downs were gone. After eight years and almost a hundred shorts, the comedy series was no longer the innovative, scrappy upstart of the silent era. The original Gang had grown up, and the shorts had become a bit stale. Sound offered an opportunity to "rejuvenate" the films and introduce a fresh new cast. Still, audiences couldn't help but feel a pang of regret at the disappearance of familiar faces. "You knew every one of them," the *Baltimore Evening Sun* reminisced in an article about Joe's retirement. "The gang has handed us more honest, body-rocking laughs than dozens of comedies by adult comedians."[24] Viewers were overcome with nostalgia. A comedy series that had been conceived as a love letter to the past was now evoking its very own love letters. The public had always identified with the Gang, seeing themselves in the faces and antics of the kids, reliving their own childhoods. Now that the kids had grown up, they once again saw a reflection of themselves, this time in the relentless passage of time. Kids grew up, times changed, new technology replaced the old. It was inevitable, but it was unnerving. In mourning the retirement of Joe, the public was also mourning for itself.

Sonny was the last man standing, but no one doubted he would soon meet a similar fate. Unless he stopped growing, he too would have to "start free-lancing," as one paper put it.[25] The gossip columns claimed authoritatively that he was to be replaced "by another of similar hue."[26] Several outlets, including *Variety,* announced his successor was to be James "Junior" Allen, "18-month old colored baby," whom Roach had just signed to a long-term

contract and was reportedly grooming to take Farina's place.[27] Junior Allen had appeared as Farina's baby brother in the *Our Gang* sound film *Lazy Days* and had already impressed McGowan with his easygoing temperament. "Junior is the best natured baby I have ever seen," he praised. "He never cries and seems perfectly contented wherever we put him. He has taken a great fancy to Farina, and follows him everywhere he goes."[28]

Sonny, for his part, missed his old friends. Mary Kornman, who was back home after a three-year stint in vaudeville, came by the *Our Gang* set for a visit and was startled by the changes. Now a pretty young woman with her blond hair styled in a sophisticated marcel wave, she was almost unrecognizable to Sonny.

"Oh, now, it's Mary!" he shouted when he realized who it was. He ran over and gave her a joyful hug.

"Where's everyone I used to know?" Mary asked, looking curiously at all the microphones and sound equipment.

"They're all gone," Sonny answered sadly. He went through the list: Jackie Condon, Mickey Daniels, Johnny Downs, Sunshine Sammy, and now Joe Cobb. All had departed for the vaudeville stage. "That leaves just me outa the old gang," he said.[29]

Sonny knew he was next. Age and the talkies had claimed all of his friends, and he assumed his fate would be no different. But he was wrong. While he couldn't stop time, he *could* master the talkies. Sound ended up saving Sonny.

Of the kids who made the transition to sound, it was Sonny who was most often commended for his skilled and natural verbal delivery. McGowan had noted it, and so had several reviewers. Sonny was good at improvising, and he conveyed spontaneity even when his lines were scripted. He was also a fan favorite. When audiences heard the rumors of his impending retirement, they swamped the studio with protest letters. Of course, this hadn't prevented the studio from letting go of numerous other stars. Fans had also complained when Sunshine Sammy, Mickey, Jackie, and Joe Cobb left. They complained when Roach switched from Pathé to MGM. They complained when the films transitioned to sound. People like to complain. Above all, no one liked change.

The real reason Sonny survived the transition was both

obvious and unexpected. Yes, Sonny was talented at dialogue. Yes, he was very popular with fans. But what made him truly exceptional was his race.

The advent of talkies changed the way Hollywood dealt with black actors and black voices. Sound brought with it a new emphasis on realism. Gone were the days that a white man in blackface could credibly pass for black. Even though *The Jazz Singer*, the film that launched the talkie era, featured blackface performances, it represented the beginning of the end of minstrelsy's grip on the film industry. Black roles now required black actors. What *The Jazz Singer* did anticipate was Hollywood's love affair with black music and black voices. As film historian Donald Bogle writes, "From the start, Hollywood was aware that talking movies needed sounds—music, rhythm, pizzazz, singing, dancing, clowning. And who, according to American myth, were more rhythmic or more musical than Negroes?"[30] The black voice was fetishized as richer and more responsive to sound technology. Bill Foster, a black filmmaker interested in producing race films, claimed, "tests proved one great outstanding fact—the low mellow voice of the Negro was ideally suited for the pictures."[31] Robert Benchley, a film critic for the *New Yorker*, declared, "In the Negro, the sound-picture has found its ideal protagonist."[32] Between 1927 and 1940, the number of parts for black actors exploded.

Studios scrambled to release black musical films. In 1929, Fox presented *Hearts in Dixie*, the first big studio musical to feature an all-black cast. Taking place on a Southern plantation sometime after the Civil War, it featured happy darkies, mischievous pickaninnies, and plenty of negro spirituals and dancing. Lincoln Perry, who went by the stage name "Stepin Fetchit," played Gummy, a figure Bogle devastatingly calls a "walking, talking, dancing, prancing piece of coon dynamite."[33] Eugene "Pineapple" Jackson and Dorothy Morrison, Ernie's sister, appeared as a young pickaninny couple, leading one reviewer to joke that they threatened to take over Sonny's title as the reigning "chocolate-drop on the screen."[34] White movie columnists were united in their enjoyment of the film. They praised *Hearts in Dixie* as a "true and sympathetic picture of the colored folk,"[35] and "the first motion picture to treat the American negro as a human being."[36] Black viewers, however, were more ambivalent. Walter White, future executive

secretary of the NAACP, called the film a "minstrel show, 'befo' de war' type,"[37] and Alain Locke and Sterling Brown noted the presence of "the usual types—the Daddy, Uncle, the Mammy, and the inevitable pickaninnies." Still, at least for Locke and Brown, in *Hearts in Dixie* "perhaps the greatest artistic triumph is that of the Negro voice in song and speech." They were less impressed with *Hallelujah!*, directed by King Vidor and released by MGM later that year. Also featuring a predominantly black cast, *Hallelujah!* was Vidor's depiction of "real Negro folk culture," following the travails of a Southern sharecropper and a no-good cabaret singer played by Nina Mae McKinney. Like *Hearts in Dixie, Hallelujah!* is a showcase of Negro music, but it also included "the usual claptrap"—scenes of gambling, a river baptism, a frenzied revival meeting.[38] White audiences loved it, though. It was even more successful than *Hearts in Dixie,* and Vidor was nominated for an Academy Award.

For the African American community, sound films were a mixed blessing. On the one hand, they opened up more job opportunities, increased screen depictions of black life, and pushed some of the studios to consult with the NAACP and other black organizations. On the other hand, sound films breathed new life into old stereotypes. Even though white men in blackface were now passé, black men in blackface were all the rage. This is not to say black actors actually smeared their face in burnt cork; rather, they performed blackface through their filmed actions, dialect, and appearance.[39] Bogle termed it Hollywood's "blackface fixation." From silent pantomime and visual gags, blackface caricature in the sound era shifted to singing, dancing, and hammy dialect.[40] On the screen, Sambos cantered to minstrel tunes, mammies crooned spirituals, and pickaninnies spoke an ungrammatical "Negro dialect."

Sonny, who had begun to emerge from the pickaninny stereotype, found himself thrust back into the past. Without being told explicitly, he was coached to use minstrel speech—to have his dialect match his appearance. During the rehearsal of the spinach scene in *Small Talk,* when Joe couldn't remember his lines, McGowan also spent time working with Sonny on his part. Unhappy with Sonny's delivery of the line, "That would be some meal," McGowan told him, "Say it as if you meant it, Sonny."

According to the reporter watching the rehearsal, Sonny rolled his eyes and licked his lips. "Hot Dawg," he said, "That would suh be some feed. If you didn't eat the spinach."

"That's the way, Sonny," McGowan said. "Talk as if you really meant it."[41]

Quietly, perhaps even unconsciously, McGowan was letting Sonny know the "right" way to speak, encouraging him to improvise minstrel mannerisms and slang. If his instructions weren't explicit, the scripts certainly were, taking the dialect from the silent era's title cards and putting them in Sonny's mouth. Instead of saying "I" and "you," like the other kids, Sonny's lines were always transcribed as "Ah" and "yo'." He dropped his "r's" and butchered his grammar. He was meant to sound like a minstrel's rendition of a pickaninny from the South. The studio even advertised Farina's dialect in its pressbook for *Small Talk*. The Roach Rascals "sound just as you imagine them," the publicity materials promised. "Joe has a husky, deep voice to match his roly-poly body. Farina possesses the slow, musical drawl of his native Southland."[42]

The only problem was that Sonny was from Boston. He did not actually have a Southern accent, even though his role required him to affect one. *Variety* reported that during early sound tests at Hal Roach Studios, "it was discovered Farina, colored, did not respond with the Ethiopian accent expected. She has a mixture of Bostonian accent, inherited from her parents, natives of Boston."[43] And the *Pittsburgh Courier* related a possibly apocryphal story about Farina's unexpectedly elevated diction:

A humorous story is told of how the "talkies" are playing havoc with the old actors. It is said that Farina was trying out in the "talkies" with the expectation that he would use the broken English suitable to the characters he portrays in the silent drama. However, Farina was born in Boston and has had the best of tutors, so when he opened his mouth his English did credit to Fifth Avenue's most polite social circles. On the other hand, it is said that when Adolph Menjou, the evening clothes idol, was tried out in the "talkies" his English was so atrocious it was suggested that Farina be allowed to do his talking while Menjou

acted and Menjou be allowed to do Farina's talking while
Farina acted. Such is the upset the "talkies" have caused
in the cinema world.[44]

Another black film critic expressed tongue-in-cheek confusion af-
ter seeing an early *Our Gang* talkie. "Funny thing, though," she
writes. "Farina's dialect in the talkies doesn't correspond with Fa-
rina's dialect of scenario script. Now who wanted to hold out on
me like that—having me believe that Farina had an ante-bellum
dialect when what he really sports is a Boston accent?"[45]

Now that movies could talk, what were studios to do if ac-
tors' voices didn't "match" their appearance? Menjou's own ca-
reer stalled with the transition to sound films, and Sonny's now
threatened to follow. The studio, as well as many white audienc-
es, wanted to believe Farina spoke in plantation speech. It was
the way he was "supposed" to sound, and it helped exploit Hol-
lywood's fascination with black voices. But Sonny Hoskins, who
was nine years old and had never spent a day in the South, could
only imitate the dialect—and not very well, in the opinion of some
critics. He was talking and acting the way he was expected—like
a pickaninny minstrel—but in reality he was practically a native
Angeleno. Indeed, he had moved to Los Angeles from Boston at
such a young age that he almost certainly did *not* have a "Bahston"
accent, either. Instead, what he had was an ersatz brogue, picked
up haphazardly from vaudeville shows, Stepin Fetchit films, and
perhaps even *Amos 'n' Andy*, which had recently debuted on West
Coast radio stations.

Sonny was a quick study, though, and his eventual mastery of
minstrel dialect ensured the survival of his career. White review-
ers commended him for "put[ting] across some negroid lines vo-
cally,"[46] and for exhibiting the "soft drawl of the southland."[47] The
studio marketed Farina as a kiddie Al Jolson, a miniature black-
face performer who effectively parodied the famous final scene
from *The Jazz Singer* in *Small Talk*: "With arms outstretched, he
cries 'Mammy' in a dramatic gesture that out-Jolsons Jolson."[48]
Sonny was even showcased in films like *Lazy Days,* an early talkie
that also starred his sister, Jannie. Less than three years apart in
age, Sonny and Jannie, like most siblings, squabbled their fair
share. Jannie remembered that the morning they were to film the

opening scenes, the two got into a fight at home. Bobbie would have none of it. "Mamma said we had better behave our selfs at the studio," Jannie recalled. "No if's or and's."[49] Sonny and Jannie piled into the car and sulked while Aunt Boodie drove them to the studio lot. Once there, they managed to shape up—or at least channel their irritation with each other into the scene they were filming.

In *Lazy Days,* Sonny played a particularly indolent Farina, and Jannie played his girlfriend, "Trellis." Reclining in a rocking chair under a tree, Farina wore his pickaninny pigtails and a pair of dirty, ragged overalls. His baby brother, played by Sonny's presumed replacement, Junior Allen, lay in a crib beside him. Farina's performance was pure minstrel coon, channeling Stepin Fetchit from *Hearts in Dixie,* which had just been released. Farina was so lazy, he seemed practically paralytic, directing Trellis to put a straw from a milk bottle into his mouth, bring him a rose to smell, and supervise a contraption that rocked his chair for him. Around him, a menagerie of barnyard animals slumbered in the heat. Glancing at a chicken lying prostrate on a wooden ledge, Farina sighed, "Roosta, Ah'm fo' times tireduh than yo' is 'cause ah'm fo' times bigguh than yo' is." The only excitement came from the sound effects—a bee buzzing, a balloon popping, Junior crying. After a brief interlude, where Farina briefly roused himself to bathe and dress Junior for a prettiest baby contest, the film ended where it started, with Farina sprawled underneath a different tree, this time with a watermelon between his legs. "If Trellis was here, ah'd have her open dat melon," he sighed. "Here ah is, Farina!" Trellis piped from off-screen. "Hello, honey, do you min' openin' dat melon fo' me?" Farina asked, barely even moving his eyes to look at her. Taking a wood plank, Trellis hacked the watermelon in half. Then, when a fly landed on Farina's nose, she used the plank to swat it away, an act that must have been particularly satisfying for Jannie after their morning spat. The short concluded with Farina sitting up, sporting a bulbous prosthetic nose where Trellis had apparently decked him.

From his slow, ungrammatical speech, to his aversion to work, to his proclivity for watermelons, Farina was a coon in training. In an echo of Stepin Fetchit's title as "the laziest man in the world," one reviewer described Farina as "the laziest coon

in the world."[50] The movie reviewer at *Billboard* complained about Farina's "over-exaggerated accent and Negro-character mannerisms."[51] For viewers, the film was, quite literally, a snooze. The dialogue was delivered so lethargically and the pace was so somnolent that it was hard not to nod off in the middle of the film. Yet the role saved Sonny his job. However demeaning, it showed that Sonny could carry a film and master the coon routine. Based on his performance in *Lazy Days,* Hal Roach renewed Sonny's contract. Louella Parsons was the first to get the scoop. In her column, she reported:

> [Farina] is getting to be a big boy now, so big in fact that they planned to leave him out of the Our Gang comedies and get someone smaller. The yell that went around the world convinced Hal Roach that Pickaninnies may come and Pickaninnies may go, but there is only one Farina.[52]

From there, newspapers around the country got wind of Sonny's reprieve. One paper ventriloquized Farina's coon dialect in reporting the new contract. "Farina to Retire? Not on Your Life," the headline read. "'No suh,' said Allan [*sic*] Hoskins, 'whenevah ah quits, they ain't goin' to be no 'Ouah Gang' comedies, Causen Ah'm mos ob de gang mahself!'"[53] The studio backtracked on earlier reports that it had been planning to replace Farina. The *Sacramento Bee* reported:

> Our Gang fans throughout the country were dismayed recently to read in the newspapers that Farina was leaving the gang and would no longer be frolicking with his pals. . . . How this story became circulated is not known to the officials of the Hal Roach Studios, for there never was any question as to whether or not Farina would continue to lend his darksome visage and musical dialect to the Our Gang talkfilms for some time to come.[54]

Lazy Days solidified Sonny's reputation as a star of the talkies. In it, he "prove[d] himself worth his contract,"[55] one paper announced. If that meant aping plantation speech and minstrel stereotypes, that was the price Sonny had to pay to maintain a film career in the sound era. There was at least one upside to the advent of talkies. With sound, no one could mistake Sonny for a

girl any longer. His voice, though warped to sound more Southern and ignorant and "black," was still his own—a boy's voice.[56]

In late October 1929, the stock market collapsed. Over the next year, more than one thousand banks would fail. Construction and factory production slowed as consumers began to cut back on purchases, and the unemployment rate began to rise. The mood of the country had darkened. But in Hollywood, the popularity of talkies initially staved off the effects of the Great Depression. Theater attendance increased in 1930, and studios and theater corporations were still profitable.[57] Black Hollywood clung to optimism. Charles Butler, head of the "Jim Crow" department at Central Casting, reported an increase in placement number and wages of black actors.[58]

In June 1930, MGM released the *Our Gang* short *A Tough Winter*, starring Stepin Fetchit. Hal Roach was an avowed admirer of Fetchit, calling him a "skilled comic" and "very funny guy."[59] By that time, Fetchit had developed a reputation for having a "lackadaisical" work ethic and difficult temperament. He had been fired by Fox and was being criticized in the papers for his extravagant lifestyle and reckless behavior. Later in the decade, he would become famous for his fleet of cars, including a champagne pink Rolls-Royce customized with his name in neon lights, and his retinue of "oriental" servants outfitted in traditional costumes.[60] For now, however, he was scrambling for jobs, now that his lavish Fox paycheck had disappeared. Roach was one of the few producers still willing to take a chance on Fetchit, and the two reportedly worked out a contract for a comedy series. Before the contract was finalized, however, Fetchit apparently booked more remunerative work, and only one film of the projected series—*A Tough Winter*—was made.[61]

A Tough Winter was a starring vehicle not just for Fetchit but for Farina. In the film, the two were a comic duo, the original movie coon paired with his junior partner. The studio highlighted their similarity in its publicity stills, showing Farina and Fetchit in matching top hats, baggy clothing, and oversized shoes, pipe clutched in one hand and giant shamrock pinned to their suspenders. Movie magazines reported that the two got along well during filming and had formed a "fast friendship."[62] In the film,

however, the two were more like mirror images of one another. Fetchit was the childlike grownup—"slow-moving, slow-talking, and slow-walking."[63] He was naive, illiterate, and idiotic, with such slurred dialect he was practically incomprehensible. Farina, in contrast, was the grown-up child—exasperated at Fetchit's lethargy, amused by his lovelorn behavior, hard-working and capable compared to the so-called laziest man in the world. He played the straight man to Fetchit's buffoon.

A Tough Winter opens on a snowy, frigid day. Farina and Fetchit sit side by side on a rickety wagon pulled by a mule. Farina drives while Fetchit slumps against him, so lazy that a rope pulley is required to hoist his arm up to make a right turn signal. Chubby, Jackie Cooper, and the rest of the gang are having a snowball fight when Farina and Fetchit arrive at the carriage house. While the gang immediately suspends its game to help Farina unharness and stable the mule, Fetchit drifts inside and leisurely undresses, taking off multiple pairs of gloves and jackets, as well as a hot water bottle taped to his head and a heating pad taped to his chest. As he undresses, he sings a minstrel tune:

> Yella' gal says Ah was sweet as honey,
> Ah git gals without no money.
> Jus' like bees aroun' they buzz,
> 'cause Ah got "it" an' tis an' wuz.

The gang trundles in, still bundled up and covered in snow (really cornflakes). Fetchit sits in a rocking chair, playing with some cats as the kids industriously clean up the house. Just then, a letter drops down the mail slot, announced by a ringing bell. "Stepin, there's a lettah for yo'," Farina announces.

Fetchit doesn't budge. "If Ah's yo', Ah'd bring it to me mahself," he wheedles, adding, "Ah'd do that much fo' yo'."

Farina obliges, bringing the letter to Fetchit and remarking, "Say, Step', this lettah's all perfumigated. It smells like licorice."

"It sho do," Fetchit says, dreamily. "I wonda' who it's from."

"Well, let's see. Can't yo' read it?" Farina asks.

"Yeah—Ah can't if it's in the day—yo' see Ah went to night school—an' Ah can't read 'till night," Fetchit replies.

"Well, Ah'll read it," Farina says. "Le's see who it's from."

The letter is from "Miss Maybelle," Fetchit's sweetheart

from Tennessee. Fetchit immediately perks up and bursts into a frenzy of celebratory tap-dancing, joined by Farina, Jackie Cooper, and even the barnyard rooster.

"Say, Ah want yo' to read this lettah to me," Fetchit instructs Farina once he is seated again. "See what it says, 'cause Ah can't read very good—Ah mean, Ah can't see so good. See what it says."

Farina begins reading aloud slowly. "My great big blue-eyed baby," he says, pausing and giggling.

"Yo' give me may lettah heah," Fetchit says, embarrassed. "Yo' know too much about mah business now." He grabs the letter and walks over to the fireplace, where he picks up some pieces of cotton from the mantel.

"Don't yo' want me to read it?" Farina asks.

"Yeah, Ah want yo' to read it, but Ah don't want yo' to hear it," Fetchit says, returning with the cotton and forcing Farina to put it in his ears before continuing to read.

Farina continues reading, becoming more and more tickled as he goes along. "Romeo of my heart," he reads. "Come to my balcony. The ladder is waiting." Farina rolls his eyes and sighs like a lovesick teenager.

Fetchit, looking blissful, remarks, "She ain't got no balcony. She talkin' 'bout de back porch. Go on 'n' read."

"You is my Ajax," Farina continues. "Your voice is an oyster of love songs played on golden harps." At this last line, Farina breaks off reading and exclaims, "Hot dawg!" The letter continues with more absurd sweet nothings, ending with Maybelle pleading, "Write to me, Step, honey, write to me in the soft ukulele words of a junebug."

"Some hot lettah!" Farina breathes, rolling his eyes.

In later years, Stepin Fetchit described his coon character as a "lazy man with a soul" and claimed he was the first person to play a black character that was acceptable to polite Jim Crow society.[64] "I made the Negro as innocent and acceptable as the most innocent white child," he said.[65] He did so precisely by acting like an overgrown child, too simple to be threatening, too dense to be dangerous. Performing next to Sonny, who *was* an actual child, Fetchit made it clear that the only acceptable Negro on film was one who had been safely emasculated. Sonny, who began his

career as a neutered pickaninny, and Fetchit, who embodied the infantilized man, were one and the same. The Stepin Fetchit of *A Tough Winter* was the Farina of *Lazy Days*.

Except for one thing. While Fetchit seemed to be getting younger, retreating into the second childhood of stereotypical coon-dom, Farina was undeniably growing up and becoming a young man. His voice in *A Tough Winter* is deeper and more mature than Fetchit's high-pitched singsong. He is smarter and savvier than Fetchit, he is literate, and he expresses bemusement at Fetchit's moony behavior. In *A Tough Winter,* we see the two countervailing strands of African American representation—one a pickaninny who is starting to mature into a more complex individual; the other a coon who is happy to regress into the simplest minstrel type.

Their careers were on similarly opposite trajectories. Fetchit's most successful years were still ahead of him. He would appear in more than twenty films over the next ten years and become a millionaire, even as black audiences became increasingly critical of his stereotypical performances and his wastrel ways. Farina, however, was "cooked," as one movie columnist facetiously put it.[66] Pickaninnies were not supposed to get old. Their appeal to white audiences was in their reassuring sameness, their seeming immortality. The talkies briefly postponed Farina's demise by rejuvenating the pickaninny stereotype, but they couldn't ultimately prevent Sonny from growing up. He was now almost eleven years old and "no longer cute, so he can't scrabble a dime out of Hollywood."[67] Although he was still short, his voice was starting to change. He was "on the verge of becoming a strapping young man,"[68] and was reported to be singing bass in his church choir.[69]

As they had with Joe Cobb, the papers depicted Sonny's retirement as a form of death. Unable to "hold back the clock," Sonny was being terminated, his "usefulness with the 'gang' [now] passed."[70] He was "walking the plank," "soon to be departed," "finished."[71] A headline for the *Los Angeles Times* put it bluntly: "Hollywood's Good Child Actors All Die Young." Even more so than the adult actor, the child actor was cursed with a tragically brief screen life. As a parodic version of the popular nursery rhyme went:

Twinkle, twinkle, baby star,
In your new imported car.
When you're older you'll have to hoard
To save enough to buy a Ford![72]

This was the curse of the child star—not alcohol or drugs, not unscrupulous parents or rapacious managers, not even death. The true curse was simply growing up.

Hal Roach, who had once been called Hollywood's "Ponce de Leon" because of his ability to "renew the youth of picturegoers the world over," also seemed to be losing his touch.[73] Between July 1930 and March 1932, Roach saw his studio go from clearing a profit of $87,000 to posting a loss of $41,000.[74] It turned out the movie industry was not, in fact, "depressionproof."[75] The rest of the studios were doing no better. In 1932, the total loss for all studios and exhibitors topped $85 million.[76] Paramount went bankrupt, RKO and Universal went into receivership, and Fox, on the brink of bankruptcy, merged with Twentieth Century Pictures.[77] Movie theaters began to shut down, admission prices fell, and attendance dropped. Things were not much better around the country. Soup lines were forming, unemployed workers were selling apples on street corners, and families were evicted from their homes. Unemployment accelerated, rising to eleven million by October 1932.[78]

At the end of the 1930–31 season, Sonny Hoskins joined the ranks of the unemployed. He had reportedly been earning five hundred dollars per week, an unheard of sum in these difficult times.[79] Six-year-old Matthew "Stymie" Beard, who had played Farina's little brother in several shorts, was designated to take his place.[80] The studio released a publicity still of a forlorn Sonny punching out his last time card, dressed in a suit and polka-dotted necktie, looking like a sad clown. The clock reads just after 11:30 in the morning. The photograph is captioned:

TIME TO RETIRE—And Farina has done just that. For this really is Farina, the little girl with the kinky pig tails of "Our Gang" comedies. Farina has retired from girl's parts, forever, he says. He's really a boy, and always was. He's tired of sissy parts and wants to be a He-boy.[81]

Like Ernie, Mary Kornman, Jackie Condon, Joe Cobb, and all the other kids before him, Sonny was destined for vaudeville, performing around the country with his sister, Jannie. Puberty had ended his *Our Gang* career, not only because it made him "no longer cute" but also because it made him no longer so unthreatening. A young black boy was one thing; a black adolescent was another. He could choose to grow into the coon persona of Stepin Fetchit, slumping his shoulders, slowing his speech, emasculating himself. Or he could embrace his young manhood and revel in the fact that he would no longer be mistaken for a girl.

Sonny chose to do the latter. He cut his hair short and wore long pants. In addition to doing vaudeville, he appeared next to Joe E. Brown in the Warner Brothers/First National picture *You Said a Mouthful,* this time playing the straight man to Brown's buffoon. *Variety* reported that Sonny, "freed from his *Our Gang* limitations, gives the story an added comedy flavor."[82] Other papers described the role as "his rebirth into a 'man' actor,"[83] and an "emerg[ence] from his cocoon into a sure enough boy."[84] The studio helped support the narrative of retirement as not so much a death as a rebirth. "Not until Farina outgrew the 'Gang' was it divulged that the youngster is Allen Clay Hoskins, Jr., a sturdy little boy," one press release read.[85] Anyone who had seen the talkies or kept up with movie gossip already knew Sonny was a boy, but his release from *Our Gang* was a final, official confirmation of the fact. He could finally embrace his true identity and begin a new life.

To commemorate Sonny's retirement from *Our Gang, Photoplay* published a gushing tribute in its June 1931 issue. It was, the magazine declared, "the end of an epoch." When Sonny first began appearing in *Our Gang* nine years earlier, he had been the prototypical pickaninny: "There was practically nothing to this dot but huge, rolling eyes and a mass of kinky woolen hair. It was christened *Farina,* dressed in rags, and immediately hit in the face with a cocoanut custard pie." But from this stock character of indeterminate gender, exaggerated features, and slapstick victimhood, Farina developed into something truly exceptional—"an unquestioned leader" and a star. As he grew, he gained personality, depth, and the audience's sympathy. He was no longer simply

the fall guy and stooge. Instead, he became a person, a real boy carousing with his gang.[86]

Now a lanky eleven year old, Farina was graduating from the Gang, and his many fans mourned his departure. In an industry where most actors, old as well as young, were considered washed out after three years, he had enjoyed success for three times as long—an eternity in Hollywood. "He must feel seventy," the magazine mused, not just from the physical toll of so many pratfalls and pies in the face, but from the weight of his experience. Farina had ushered the comedies from the silent era into sound, appearing in more shorts than any other child. He had survived several changes in cast, going from being the Gang's junior tagalong to its elder statesman. He had become a 100 percent Billiken, role model to thousands of white and black children, a credit to his race. In the process, he also became a symbol of all of us. "Things happened to Farina that could happen to us, and often did, in other ways," *Photoplay* wrote. "We, too, were Fate's footballs. When Farina was hurt, we were too." White or black, old or young, everyone identified with Farina. "We loved Farina," the magazine explained, "because Farina, a three-year-old fragment of ebony, was ourselves."[87] From tiny "pickaninny," Farina had transformed into something much larger than himself. He had become Everyman.

6

The New Negro

Locked arm in arm they cross the way,
The black boy and the white,
The golden splendor of the day,
The sable pride of night.

From lowered blinds the dark folk stare,
And here the fair folk talk,
Indignant that these two should dare
In unison to walk.

Oblivious to look and word
They pass, and see no wonder
That lightning brilliant as a sword
Should blaze the path of thunder.

—Countee Cullen, "Tableau"

Matthew "Stymie" Beard was a New Year's baby, born in Los Angeles on the first day of 1925. He was the fourth child of Johnny Mae, who occasionally worked as a movie extra, and Matthew Beard Sr., a preacher.[1] It was the height of the Roaring Twenties, and Los Angeles was on a roll. From a sleepy pueblo, the city had become a busy metropolis, home to five million people, more than five hundred thousand automobiles, and many thousands of new single-family homes. Los Angeles, the *Times* declared, was the new capital of the "great Pacific-Southwestern empire."[2] It was rich in romance, optimism, and natural resources, a center not just of the film industry but also of manufacturing, agriculture, construction, and shipping. One article proclaimed:

"The City Beautiful Achieved: How Los Angeles Is Leading the World in Evolving New Idea of a Wide-Flung, Decentralized Metropolis, Without Congestion or Tenement Slum."[3] Another smugly pronounced, "Economic Activities So Diversified That Only a Cataclysm Could Bring About Business Depression."[4]

That cataclysm would occur less than five years later, and it would fundamentally reshape Stymie's life. The New Year's baby, born in a time of giddy prosperity, became a Depression kid, responsible, at the age of five, for supporting a family that would eventually include twelve brothers and sisters.[5] Stymie's career on *Our Gang* began almost concurrently with the Depression. Only a few months after the stock market crash, his father heard through a friend that Hal Roach was looking for a black child to succeed Farina. Stymie wasn't a complete film neophyte—at the age of seventeen months, he had appeared in *Hallelujah!* in the arms of his mother.[6] His younger sister Betty Jane had already had minor roles in a couple *Our Gang* shorts, appearing alongside Farina. This was different, though. The role was major and recurring, and there were hundreds of children vying for the spot. Stymie's father and mother bickered over whether Stymie should be allowed to audition—Matthew Sr. was adamantly opposed, while Johnny Mae was ardently in favor. In the end, Johnny Mae won out, and Stymie was brought along to the studio. There, he was bowled over by the huge, ivy-covered main building and the sight of Laurel and Hardy running through the lot. According to Stymie, as soon as he walked onto the stage, Hal Roach knew he was "the one." "That's who I'm looking for. Sign him for five years," Roach reportedly said.[7]

An avid golfer, Bob McGowan nicknamed the young boy "Stymie" for his habit of getting in the way. "I would get on the set and be so excited and curious over what was going on, looking at the props and gimmicks at the wrong time, that I was always underfoot, interfering," Stymie later recalled. "And Mr. McGowan used to get frustrated and motion, 'Get that kid out of the way so we can shoot.' So he came up with this line after a while, 'Well, boy, this kid's beautiful, but he stymies me all the time.' That's how the name came."[8] Despite the nickname, Stymie proved remarkably easy to work with. In a 1933 article for the *Los Angeles Times*, McGowan had only praise for his young star,

calling him "a good little actor and easy to direct."[9] *Screenland* described him as "a finely strung violin," exquisitely attuned to his director: "Bob [McGowan] needs only to give him a hint of what is needed and Stymie is in it for all that he is worth."[10] So devoted was Stymie that in several of the films, you could actually see his eyes dart back and forth as he watched McGowan move behind the camera.[11] He was one of McGowan's favorites and was often seen around the studio, perched on Uncle Bob's shoulders.[12]

Stymie's first short, *Teacher's Pet*, was released in October 1930. He was reportedly earning $100/week.[13] These were unfathomable riches at a time when one quarter of the labor force—some twelve million people—was unemployed.[14] Every morning, desperate crewmembers gathered outside Hal Roach Studios, hoping for work. Tommy Bond, who played Butch on *Our Gang*, remembered, "There was no feeling among them of 'We're in this together.' Rather, it was highly competitive. Grips, prop men, electricians stood around until the assistant director might come out and say, 'Ok, I need ten prop men and fifteen grips." They would hold up their hands and he'd pick the ones he wanted. He had a pocket full of $5 bills, and as each man went in for a 12-hour day he'd be given a $5 bill."[15] The situation was even more dire for African Americans. By 1932, nearly half of all black workers in major cities were unemployed, and nearly one out of three African American families was receiving public assistance.[16] Stymie's salary ensured that his family could eat. Looking back, he recalled that for a dollar, he could get "three pork steaks, a half a dozen eggs, a loaf of bread, a quart of milk, and get eight cents in change."[17]

As the family's primary breadwinner, Stymie was treated with especial solicitude. He was kept apart from the neighborhood children, for fear he might get injured and be unable to work.[18] "I couldn't go in the street, play kick the can, or go under the house or nothing," he later remembered. "I did it anyway. I got a whetz on my back for it, but I did it."[19] His world was limited to the studio lot and the confines of his home near Central Avenue. Outside, the neighborhood was changing. Despite the newspaper headlines claiming Los Angeles lacked congestion and tenement slums, the area around Central Avenue was becoming increasingly crowded and run-down. By 1930, restrictive covenants and

segregation had relegated African Americans to a few isolated neighborhoods in the city. The influx of migrants from the South further strained the housing supply, and parts of Central Avenue began to develop the characteristics of a "slum-ghetto," with deteriorating buildings and growing crime and congestion.[20] Stymie, the golden child, was bullied by the neighborhood kids. He wasn't one of them. Every day, he was driven across town, to a studio that looked like a graceful antebellum plantation, with its pristine white facade thickly covered in ivy, its manicured lawn, and its elegant circular driveway. There he hung out with stars like Laurel and Hardy, ZaSu Pitts, and Charley Chase. He didn't go to the local public school like everyone else but attended the studio school on the Hal Roach lot. He made gobs of money and was petted by the adults and got as much ice cream and candy as he wanted. It was no surprise that his peers and even his siblings resented him.[21] "It was confusing most of the time," Stymie remembered. "[I was] a spoiled brat on the set and a ghetto kid at night."[22]

Stymie found refuge on the studio lot. It was a place where he was adored and praised. Laurel and Hardy bought him Cokes, Patsy Kelly and ZaSu Pitts gave him ice cream, Errol Flynn even took him fishing.[23] As soon as he was finished shooting, Stymie would rush to the neighboring set, where Laurel and Hardy were filming. Stan Laurel was Stymie's idol, a comic genius who took the time to joke around with a lonely kid.[24] One day, Stymie playfully reached for Laurel's famous derby and put it on his head. "Get the kid a derby. Make him happy," Laurel cracked, and that's how Stymie acquired his trademark hat.[25] His other trademark, the shaved head, was kept meticulously groomed at the studio barbershop, his first stop every morning when he arrived on set. Sometimes a younger sibling or two would tag along with Stymie, appearing in small parts, often as his on-screen brother or sister. Other times, Stymie filmed at the studio ranch, an idyllic spot a short drive away where the Gang could romp in the fresh air with their dogs and other assorted animal sidekicks. Stymie would marvel at Charlie Oelze, Roach's longtime prop guy, who came up with such ingenious contraptions that Stymie was sure he must have twenty hands.[26] The studio day ran from eight in the morning until five in the afternoon. By law, three of those hours was set aside for schooling and one hour was set aside for lunch.

Fern Carter still headed the studio school and either taught the children from the official schoolroom in the main office building or set up a folding table on the corner of the set. At lunch, all the children and their mothers ate at the studio commissary, where a bowl of chili, French fries, and a malted milk cost fifteen cents.[27]

By now, McGowan had figured out how best to direct the *Our Gang* talkies. Once a script was completed, he would gather the gang together and explain the story in the simplest terms, assign parts, and then let them loose. The script was meant more as a general outline, with the kids encouraged to improvise or ad-lib.[28] In this way, McGowan hoped to retain the spontaneity that had characterized the films from their inception. As an added incentive, Uncle Bob was always ready with a dime, or a Coke, or an ice cream treat from the Good Humor man who stayed on the lot. Stymie remembered, "They would take maybe three-four lines at a time, then they'd cut the camera. We would go at it very easy. They wouldn't expect us to memorize too much." Even then, Stymie recalled, "we muffed a lot of lines, or said them our own way; it happened a lot of the time. But if we said something different, or improvised something, then if it got a laugh and fitted in, they'd keep it."[29] Stymie was a natural, at ease in front of the camera and so dependable that he became known as "One-Take Stymie."[30] McGowan admitted that it was much more difficult to direct children than adults. "It's not merely a question of their undeveloped mentality, but of getting their confidence and cooperation," he said. "Of course the kids tire quickly and you can't afford to keep them on the job if they show the least signs of fatigue. Then too, it's hard to get them to settle down to picture making as a serious business."[31] McGowan seemed wistful, talking about the need to balance the kids' "carefree spontaneous spirit" with the exigencies of filmmaking.

There were other reasons for McGowan's wistfulness. *Our Gang* was now an established brand, and with its success came some inevitable downsides. For one, McGowan could no longer go anywhere without being accosted by fans and wannabes. During a vacation in New York, word got out that the director of *Our Gang* was staying at a particular hotel; so many children and their parents mobbed the building that hotel management asked McGowan to leave. The man who had taken great joy in working

with children now described himself as a "hunted man."[32] On the studio lot, his greatest nemesis was the stage mother—or grandmother or other designated adult chaperone. "If I give Johnnie a close-up and skip Jimmie—no matter how important it may be to the picture—there is war in camp," he ruefully noted. The children themselves, he was always quick to mention, were never the problem. He doted on them, and they responded in kind. "I spoil my kids, I guess," McGowan admitted. "All the parents say I do but I find you can get more out of them if you love them and get to see their side of things. They are pretty nice to me and tell me all their secrets and troubles. Whenever there is a spanking or any sort of punishment coming to them they tell me and get me to beg off for them."[33]

In an article that appeared in the *Los Angeles Times,* McGowan recalled the early days of *Our Gang* with unconcealed fondness. "The children in the original gang were friends and had played together on the lot. So when I began casting, I took the whole bunch of them," he said. Filming was similarly serendipitous. "Our first comedies came easily," McGowan said. "The kids worked beautifully for me." In retrospect, it seemed "all fun and no grief." After twelve years of the grind, however, McGowan was exhausted. Finding children to replace the original gang was an exercise in disappointment. "The original gang came to me ready-made and I never knew how lucky a thing that was until I faced the problem of replacing them," he said. Hal Roach scouted the country for new talent. The two men watched beauty contests and interviewed countless youngsters. Jack Roach, Hal's brother, took a camera crew on the road for six months, filming potential candidates. They found Chubby that way, but he was an anomaly. The newest members of the Gang tended to come through more traditional routes. Jackie Cooper and Dickie Moore were already established actors. Dorothy DeBorba came from a show business family. George "Spanky" McFarland had appeared in some local advertising films in Dallas, Texas. "I found [Spanky] through the mail," McGowan later joked, recalling how Spanky's aunt had mailed him a film strip.[34]

Uncle Bob was suffering from a bad case of the "Good Old Days." It was a familiar malady, striking anyone who possessed a sentimental streak and a selective memory. "Good Old Days" also

happened to be the name of *Our Gang*'s famous theme song, a melody that would quickly become inextricably linked to the series. Composed by musical director Leroy Shield and introduced in *Teacher's Pet*—Stymie's first short—"Good Old Days" captured the mood of the nation: nostalgic for an idealized past, worn down by the present Depression. For McGowan, it also captured a sense of personal regret. He missed the early days of Hollywood, when the film industry was rough around the edges and more intimate and informal. He missed the optimism of the 1920s, the decade's sense of infinite possibility and excitement. And he missed the original cast of *Our Gang,* kids who weren't professional actors, who didn't have hectoring stage parents and unreasonable demands, who played with each other off screen as well as on. Hollywood was now a big business, with costs to control, actors to manage, and theaters to run.

Hal Roach Studios had clung to its reputation as the most familial of the major studios, remaining loyal to its employees even as other studios were letting crewmembers go. But even Hal Roach was feeling the pressure. Sound technology had caused his production costs to rise sharply. Short subjects, too, were becoming less marketable, as theaters moved to double features. Reality had even infiltrated the sheltered world of *Our Gang.* The cast members may have played friends on film, but they were rarely friends in real life. They were professional actors, sometimes lent out to other studios, always busy with their shooting schedules and their fledgling careers. Their guardians hovered over them, demanding higher salaries, more screen time, or preferential treatment. "All the mothers were competing every minute," Stymie recalled. "Each would push us right up front and command us to smile."[35] Sometimes the antagonism took on a racial edge, and this Roach would not tolerate. He personally intervened in such cases, making clear that such bad behavior was unacceptable on the set. By the next day, everything was back in order. "Incidents were always motivated by the parents of members of the Gang," Stymie was quick to point out. "We kids got along perfectly when a parent wasn't doing any influencing."[36] More than ever, the world of the grownups was encroaching on the world of the kids.

Competition now trumped camaraderie. Child actors, many

of whom were supporting their families, were taught to view their fellow castmates as rivals, not friends. Jackie Cooper remembered, "When I was doing *Our Gang*, I wanted to become friendly with the other kids. But that turned out to be an impossibility. They all had mothers, ferocious women who guarded them and championed them and hated any interlopers who might in any way jeopardize their positions." They eyed Cooper with particular hostility. "I was the new kid in the group, and I got bigger scenes than the others," he explained. "I got the crying scenes, which were most important."[37] He remembered how Wheezer, in particular, was prevented from playing with the others by an overzealous father who was determined to make him a star.[38] To be fair, Jackie's own grandmother was no angel. She would hover over him "like a bird," pinching him on the inside of the legs to make him cry while hissing at him not to flub his part. With a final slap, she would back away, leaving McGowan to shoot the coveted crying scene.[39] Jean Darling, too, remembered the viciousness and jealousy that pervaded the set. Her own mother viewed Mary Ann Jackson's mother with absolute disdain, and Jean herself admitted that Mary Ann drove her "absolutely *nuts*" because she was "*always* playing jacks and eating sen sen [liquorice-flavored breath mints] for some reason."[40]

Jackie Cooper was wrong about one thing. Two of the kids *did* become friends off set. They were an unlikely duo, not because they were professional rivals but because they were different races. Dickie Moore was doe-eyed and fair-skinned, and he usually played the rich kid in the *Our Gang* shorts. Stymie Beard was doe-eyed, too, but dark-skinned and usually played the role of the urbane wise guy. Dickie was an only child; Stymie one of many. Dickie had started his career playing an infant John Barrymore in *The Beloved Rogue*. Stymie had started his career playing a nameless "pickaninny" in *Hallelujah!* What they shared was precocity and talent, as well as the loneliness and burden of being child stars. Both were freighted with adult responsibilities and yet were undeniably children. Stymie wasn't allowed out of his house and was forbidden to play with the neighborhood kids; Dickie was forced to wear short pants and still wet his bed at night. Neither had many friends. On screen, they played the odd couple, the rich little white boy and the poor little black boy, drawn together despite their superficial differences.

In *Free Wheeling* (1932), Dickie played a rich kid suffering from a stiff neck and overprotective parents. Stymie lures him outside and takes him on a wild ride in the Gang's taxi, driving them through a haystack and magically curing Dickie of his neck condition. It was Dickie's favorite *Our Gang* film. Stymie, too, had fond memories of filming the short. Charlie Oelze, the prop wizard, designed the ramshackle taxi.[41] "They built a hollow frame and covered it with hay," Stymie later reminisced. "The driver hid under the floor of the car. That was a lot of fun."[42] In another short, Dickie and Stymie pretended to bake a cake for Dickie's screen mother. "We pretended to use too much baking powder," Dickie recalled. "The cake was really made of rubber, a big rectangular balloon inflated through an unseen hose. It grew so large that Stymie couldn't remove it from the oven."[43] Once, while shooting a scene with Pete the Pup, Dickie suddenly noticed that his trademark ring was around the wrong eye. "Later, Stymie told me that Pete had five sons, all of whom worked," Dickie said. "On his oldest son they painted the ring around the wrong eye."[44]

Hal Roach Studios, seeing the boys' rapport, worked the relationship into its publicity materials. In press releases, the studio touted the charmed quality of the boys' friendship. "Although screen players have fans the world over they seldom find fellow members of the profession who idolize them," one pressbook read. "But such was the strange case of Dickie Moore, who, for many months before he joined 'Our Gang,' was an ardent fan of little 'Stymie,' colored member of the group. Dickie was overjoyed at the opportunity of playing both on and off the screen with his favorite 'star.'"[45] Dickie was as captivated with the series as any other kid—he, too, worshipped the actors and even imagined being friends with them. The fact that Stymie was black and Dickie was white made no difference. But unlike other kids, who only dreamed of meeting their matinee idols, Dickie actually got to meet his idol *and* star alongside him! Better yet, Stymie was no diva. He did not see Dickie as an interloper but as a boon companion. It was a friendship that could have come out of a Hollywood movie.

The friendship that was depicted on screen developed naturally off screen as well. Dickie remembered being invited to Stymie's house for a party. The Beards lived in a two-story clapboard house with peeling paint, near the corner of Fifty-fourth Street

and Compton Avenue.[46] "We swung on a tire tied to a huge pepper tree, wore old clothes—long pants—and got dirty," Dickie recalled. "Stymie's mother fried chicken, his dad showed us how to crank an ice cream maker. They had a dog. Nobody performed."[47] In other words, it was a typical playdate. What made it unusual was the crossing of the color line. This was Los Angeles of the 1930s, a city of rigid residential and social segregation. Perhaps the Beards felt comfortable inviting Dickie over knowing their son's fondness for his costar. Perhaps, too, they recognized that Dickie's parents were more open-minded than other white folks. Dickie's father was born in France, grew up in Guadaloupe, in the French West Indies, and attended school in Antigua, in the British West Indies.[48] The large black and mixed-race population in the Caribbean, the absence of a Jim Crow system of segregation, and the more liberal racial attitudes of the British and French probably influenced the Moore family's acceptance of their son's interracial friendship.

The Moores, in turn, invited Stymie to their home. Dickie and his family lived at 721 Genessee Avenue, near the corner of Fairfax and Melrose, in a modest bungalow with a large apricot tree in the yard. Fairfax Senior High School was a hop, skip, and a jump away, and a bit farther down the road was a large oil field dotted with spires.[49] After finishing work at the studio one day, the two boys returned to Dickie's house, changed into old clothes, clambered into the tree house, and played cops and robbers with their cap guns. In honor of their guest, Dickie's mother roasted a leg of lamb with garlic for dinner. Stymie spent the night, and Dickie, for once, didn't wet his bed. The next day, the two boys went to a vacant lot to play—just like the kids they played in *Our Gang*. It was a blissful day. "Stymie was the only child actor who spent the night at our house," Dickie said. "Of all the kids in pictures, Stymie was my best friend."[50] In the late afternoon, Dickie's mother called the boys in to await Stymie's parents, who were to pick him up at five o'clock. Five o'clock came and went, and still Stymie's parents did not arrive. Dickie's father, who had been peeking out the window, decided to go outside to see if the Beards had gotten lost. He found Stymie's parents a block away, seated in their parked car. Collecting the boys from the house, Mr. Moore walked to the car, leaned in, and joked, "Mrs. Beard, what's the

big idea of parking way up here? We live down the block." Years later, Dickie still remembered Mrs. Beard's response. "Oh, you know how it is, Mr. Moore," she said. "We didn't want your neighbors thinking you go around with colored folks."[51]

Dickie left *Our Gang* soon after, destined for a career in feature films. He starred in *Oliver Twist* and *Little Men* and appeared alongside stars like Spencer Tracy, Gary Cooper, and John Crawford. As a teenager, he gave Shirley Temple her first on-screen kiss in the 1942 film *Miss Annie Rooney.* In the meantime, he lost touch with Stymie. The two maintained fond memories of each other, though, and Stymie even named one of his younger brothers "Dickie" in honor of his best friend. Years later, when they were both in their fifties, they reunited in Los Angeles and reminisced over old times—playing at Dickie's house, taking the big red *Our Gang* bus to the studio ranch, hanging out the windows singing "Hail, hail, the Gang's all here!" Stymie admitted to Dickie, "I have to say it, man, you were my favorite when I was a child, Dickie Moore. You never called me 'nigger.'"[52] Dickie, for his part, said he felt "safe" with Stymie. With brutal honesty, he later wondered if this was partly because he and Stymie would never have to compete for the same jobs. Stymie would never be considered for the title role in *Oliver Twist* or the part of Shirley Temple's love interest in *Miss Annie Rooney,* just as Dickie would never be considered for the "pickaninny" roles available to Stymie. The color line in casting was as indelible as the color line in the real world.

Competition was also threatening the movie industry—specifically competition from the radio. Commercial radio broadcasting had been around since 1920, when most radio receivers were primitive, crystal sets that could be assembled for about two dollars.[53] Over the next two decades, as radio technology improved, nearly forty-one million radios would be manufactured in the United States. Audiences were immediately captivated by the entertainment possibilities of this new medium—the opportunity to enjoy music, sporting events, news, and educational programs from the comfort of their own home. With the creation of NBC and CBS in the 1920s, Americans could now tune in to national network radio programs, receiving the same news, entertainment, and even

advertising as citizens around the country. By 1929, radio sales had reached $842 million.

The networks began to develop serial dramas and comedies, attracting large and loyal audiences who tuned in regularly to find out what happened to their favorite characters. Advertisers such as Proctor and Gamble, seeing the marketing potential of such programs, sponsored serials that became known as "soap operas." The most popular radio serial of the early 1930s, by far, was *Amos 'n' Andy*, a comedy based on a blackface minstrel act created by Freeman Gosden and Charles Correll. Airing from 7:00 to 7:15 p.m. every weeknight, *Amos 'n' Andy* attracted, at its peak, an audience of forty million people—nearly one third of the American population. Despite its use of racial stereotypes and dialect, the show was popular among both black and white audiences, following the picaresque travails of two Southern transplants to the South Side of Chicago. For consumers, such serial dramas were amusing, something to look forward to in the evening after a long day of school or work. There was no need to get dressed or even leave your living room—the show came right to you. And best of all, especially in the dark days of the Depression, there was no price of admission. If you didn't own a radio, you could drop by a friend or neighbor's house and catch an episode for free.[54] For African Americans, the radio had the added attraction of ensuring a more congenial entertainment experience, away from the public indignities of Jim Crow movie theaters.

The studios, already broke from the cost of installing sound technology in theaters and their speculative investments in theater chains, now saw their moviegoing audience siphoned away by the radio. Ticket sales fell 25 percent between 1930 and 1933.[55] Motion-picture stocks sunk to new lows, and studios laid off workers and cut payroll. Under pressure from its Wall Street financiers, industry executives were forced to curb their former extravagance, streamline operations, improve management and accounting practices—in other words, act like responsible grown-ups. Theater owners too were forced to tighten their belts. They laid off ushers and got rid of extras like vaudeville acts and other stage shows. They hustled to attract audiences by cutting ticket prices, screening double features, selling popcorn and candy, and holding raffles and lotteries, with prizes ranging from grocery

baskets to automobiles to even, in one case, free psychoanaly-sis and ice cream dished out in the lobby.[56] Still, prospects were grim. Samuel Katz, who ran Paramount's theater chains, mused, "There is no use kidding ourselves. We are not half-grown boys, but mature, seasoned men and we should look things squarely in the face. As I see it, we have not as yet come to the turn in the road. There is still a hard pull ahead of us."[57] By mid-1932, 6,500 movie houses had gone out of business.[58]

The exuberant, freewheeling days of 1920s Hollywood were over. And though every industry in the country was suffering during the Great Depression, its effects on the movie industry were magnified. Until then, Hollywood had seemed charmed, impervious to recessions and wars, free of any real competition, smugly secure in its centrality to popular culture. As film histo-rian Thomas Doherty writes, "From kinetoscope to nickelodeon to motion picture palace, box office had been all boom and no bust."[59] Sound technology had provided renewed vigor to the in-dustry and more proof that Hollywood was special, unique, invul-nerable. It was a naive and hubristic attitude, and it caused many in the industry to experience an existential shock when the mov-ies, it turned out, weren't so special after all. Hollywood, Doherty writes, was forced to confront its own mortality and was "trauma-tized" by its sudden drop in status.[60] From unfettered optimism, the industry now indulged in bleak pessimism. *Variety* wondered whether motion pictures would "ever again know the popularity of those peaks it reached in the silent era and then again with sound."[61] The *Hollywood Reporter* intoned, "The studios are in trouble. The picture business is in trouble. The whole of America is in trouble."[62]

The good old days were over.

Backed into a corner, the studios fought back. Radio was the en-emy, but if Hollywood couldn't destroy this new competitor, at least it could exploit it. Taking advantage of radio's national ad-vertising reach, studios plugged their latest films on the airwaves and also partnered with radio networks through programming tie-ins—Paramount, for example, with NBC, and Warner Broth-ers with the local Los Angeles radio station, KFWB. Film ac-tors made promotional appearances on radio shows (though not

during prime evening moviegoing hours!), and studios tried out new performers on the air. Screen entertainers, eager for more work, saw the radio as an opportunity for extra exposure and cash. Theater owners, meanwhile, tried to integrate the radio into the moviegoing experience, broadcasting radio shows in their lobbies and even interrupting film screenings to allow audiences to catch the latest episode of *Amos 'n' Andy*. (A radio set was simply placed in front of the movie screen.) This latter strategy was eventually deemed a failure, as audiences found it discombobulating to listen to the folksy antics of *Amos 'n' Andy* among strangers in a public theater, rather than in the comfort and intimacy of their own living rooms.[63]

Audiences may have been pinching pennies, but that didn't mean they stopped going to movies altogether. Beleaguered as they were, they found in films an escape—if just for the length of a matinee—from the miseries of everyday life. Every week, sixty million Americans still managed to scrape together the twenty or thirty cents to see a show.[64] What they saw on the screen in the early 1930s was often surprisingly gritty and sensational—crime dramas, horror films, melodramas. Studios, desperate to lure audiences to the theater, appealed to the lowest common denominator. Gangsters, sex, and scandal were the way to get people into the seats. Moreover, sound technology heightened the thrills on screen. The sound of gunfire, a bloodcurdling scream, a coy double entendre—movies titillated the ears as well as the eyes.[65] In some ways, the turn to social realism on screen reflected the rawness of the world outside. Life had been turned upside down, and the bourgeois values of the 1920s now seemed hopelessly out of date. Social disorder and subversion reigned.

Our Gang, that copacetic fare for children, probably seemed even more old-fashioned now than it had before. How could a gang of kids playing with toy guns compete with actual gangsters toting tommy guns? For McGowan and his staff of gagmen and writers, the trick was to freshen up the series while retaining its signature throwback charm. They had already rejuvenated the cast, replacing aging members like Farina with newer, younger actors like Stymie. But they also began to adapt their story lines to reflect the changed economic landscape. Since the turnaround for each *Our Gang* comedy was short—each episode was usually

shot in a week or two and then released a few months later—the writers could respond more quickly to current events. The *Our Gang* kids were perfect protagonists for the Depression era. They were already underdogs because of their age, their lack of status, and their lack of funds. Now they seemed to represent the nation as a whole. As early as *A Tough Winter,* filmed in the early months of 1930 and released that June, the theme of economic suffering was emphasized again and again. Stepin Fetchit, weathering the "tough winter" by wearing multiple layers and strapping hot water bottles to his head and chest, was enacting the tough and seemingly endless winter following the stock market crash of October 1929. In *Helping Grandma,* released in early 1931, the Gang defends a kindly grandmother from losing her general store to a rapacious crook. In *Fly My Kite,* released a few months later, the Gang again defends Grandma, this time from a loutish son-in-law who wants to steal her valuable gold bonds.[66]

Out of these early Depression-era *Our Gang* shorts emerged one child who best embodied the heroic underdog to audiences. He was Stymie Beard, the resilient, witty, and ever-resourceful rascal of the group. Like the other kids, he may have been down on his luck, scrabbling around for pennies or some food to eat. But Stymie always had a funny quip or clever scheme to lighten the mood and, more importantly, get what he wanted. If Farina was Everyman for the 1920s, Stymie was Everyman for the early 1930s. Where Farina was "Fate's football," a slapstick victim of cream pies and banana peels, Stymie was no such sucker. Stymie kicked Fate right back. More often than not, Stymie was the one doing the conning, rather than the one being conned. Some of the most memorable lines from *Our Gang* came out of Stymie's mouth: "It might've choked Artie, but it ain't gonna choke Stymie," or "He fell in the well. Well, well, well."[67] The lines weren't double entendres in the risqué sense—this wasn't Mae West purring about a gun in the pocket—but they showed wit and spirit. Stymie was the wise guy, smarter than the other kids, smarter even than the adults around him. Dickie Moore would go on to play Oliver Twist, but Stymie was already the Artful Dodger.

He was also a new representation of the Negro child. Since its inception, *Our Gang* had based its black characters on the pickaninny caricature. Farina, with his ribboned braids, oversized

shoes, and ragged clothes, had been its iconic example. Yet by the 1930s, the pickaninny, with its origins in the antebellum South and the nineteenth-century tradition of blackface minstrelsy, was seeming a bit threadbare. *Our Gang* traded in nostalgia, but audiences of the 1930s were finding themselves further and further removed from the agrarian past from which it drew. The Great Migration had visibly changed the racial demographics of cities in the North and Midwest. The Harlem Renaissance had popularized African American arts and literature and promulgated the image of the New Negro. Perhaps this filtered down to the writers who created Stymie's character. Perhaps they wanted to "update" a nineteenth-century stereotype for the 1930s. Or perhaps they simply wanted to distinguish Stymie from his predecessor, Farina.

Whatever the reason, Stymie was different. Where Farina had been known for his long hair, sometimes tied in pigtails, other times done in one long braid, Stymie was kept bald. Where Farina wore tattered clothing and minstrel shoes, Stymie wore a smart derby and an oversized vest. Farina's gender had been the source of confusion from the beginning. Stymie, who first appeared under the name "Hercules," was always clearly a boy. Farina was a creation of the plantation South and often played the gullible, unsophisticated Sambo. In *Little Daddy* (1931), he was the pigtailed and earnest elder, distraught that his young friend was about to be shipped off to an orphanage. Stymie, on the other hand, was a creature of the urban North, tough and unsentimental. In *Little Daddy,* he was the sharp-witted sidekick, teasing Farina for being maudlin and purposely not inviting his friends to his farewell party so he could enjoy the lavish spread himself. According to writer John Strasbaugh, scenes like this demonstrated Stymie was "more slick and streetwise, a ragged Zip Coon."[68] Yet even the Zip Coon stereotype wasn't quite accurate. Stymie was an urban black child, but he did not put on airs, or comically imitate white people, or get into street fights. His strategies were much more subtle. In his repartee with white adults or children, he was the one who often wielded the intellectual and verbal upper hand. He seemed to emerge not from the tradition of blackface minstrelsy, but from an alternate tradition, that of African American oral folklore. He was a trickster.

Scholars such as Henry Louis Gates Jr. have traced the Af-

rican American trickster figure to its roots in figures such as Esu-Elegbara, a Yoruba deity, and the Signifying Monkey, his "first cousin, if not his American heir," who uses his wiles to outwit physically stronger opponents such as the Lion or the Elephant.[69] Other possible African forebears include the trickster Hare and the trickster Spider, known as Anansi. These folk tales, transmitted orally through generations of slaves transplanted to the New World, were simultaneously amusing and cathartic, demonstrating how the weak could overcome the strong. For slaves, dispossessed of power, homeland, and the very ownership of their bodies, the trickster was a hero and an alter ego.[70]

It was a white man, however, who popularized African American trickster stories to a wider audience. In 1880, Joel Chandler Harris, a journalist with the *Atlanta Constitution,* published *Uncle Remus: His Songs and His Sayings,* a collection of folk stories and songs narrated by the fictional Uncle Remus, a Negro storyteller and former slave who spoke in a broad Southern Gullah dialect. Harris had first heard the stories collected in *Uncle Remus* as a child growing up in antebellum Georgia, listening to the yarns of plantation slaves. Several of the tales featured the trickster figure Br'er Rabbit outsmarting opponents like Br'er Fox and Br'er Bear. *Uncle Remus* sold ten thousand copies in four months and spawned five other collections of Uncle Remus stories. Among its fans was Mark Twain, who read the stories to his children. (In his 1883 memoir, *Life on the Mississippi,* Twain recalled the disappointment of a group of children who had gathered to meet Harris. "Why, he's white!" they cried, crestfallen.)

The Uncle Remus stories were tremendously popular among children and their parents well into the twentieth century. But like Helen Bannerman's *Little Black Sambo,* another familiar children's book of the period, the Uncle Remus stories perpetuated recognizable racial stereotypes. Little Black Sambo was a happy pickaninny; Uncle Remus was a happy darky. Both were part of the picturesque scenery of the antebellum South.[71] Like blackface minstrelsy before it, *Little Black Sambo* and *Uncle Remus* were white America's sentimentalized and distorted take on African American culture. Nonetheless, the Br'er Rabbit stories, though mediated by Harris, did much to familiarize the general public with the trickster hero of African American folk

tradition. Among children, Br'er Rabbit was an appealing character, spunky and mischievous, a predecessor to other anthropomorphized kiddie heroes like Mickey Mouse or Bugs Bunny. The critic Hugh Keenan writes, "Remus tells the stories to show how the weak in body and inferior in power (like the child and others) can use their wits to overcome their enemies and their subservient condition."[72] Br'er Rabbit, in other words, was one of the original little rascals.

Was Stymie a descendant of Br'er Rabbit or the African American trickster figure? It's hard to know for sure, but if we see in *Our Gang* traces of American juvenile popular culture, from Huck Finn and Tom Sawyer to blackface minstrelsy to Little Black Sambo, then Br'er Rabbit, too, must be part of the conversation. Rascal, pickaninny, Sambo, Zip Coon, con artist, trickster: Stymie was the patchwork descendant of all of these.

The Gang filmed its 110th short in August 1931. By now, what had initially appeared to be a mild recession had hardened into a major depression. A wave of bank failures a few months earlier had eroded consumer confidence and created an atmosphere of cynicism and even panic. Soup kitchens and breadlines were overwhelmed with those seeking food relief. In some cities, desperate adults and children dug through garbage dumps for something to eat. Those who had lost their homes settled in makeshift shantytowns snidely referred to as "Hoovervilles," after a president who was increasingly seen as clueless and out of touch. Family life fell apart under the financial and emotional strain. Some men deserted their families. Others took to the road, hitchhiking or jumping trains in search of work.

The children assembled for work on August 12—driving past the unemployed crewmembers around the gate, entering the bubble of *Our Gang*. As usual, Stymie's first stop was the studio barbershop, where his head was freshly shaved. He changed into his familiar outfit of bowler hat, checked shirt, and oversized vest. Uncle Bob gathered the children around to explain the week's script, entitled *Dogs Is Dogs*. Wheezer and Dorothy were to star as siblings, forced to live with their mean stepmother and spoiled stepbrother, played by Sherwood "Spud" Bailey. The plot would pit Wheezer and his mutt Petie against Sherwood and his pedigreed dog Nero, a classic good versus bad guy setup.

Stymie was to star as Wheezer's neighborhood ally and comic partner.

On a sound stage on the studio lot, designed to look like the interior of a modest home, Wheezer, dressed in an old nightshirt, snuggles with Petie, whom he has smuggled into his bed. Sherwood, dressed in fancy silk pajamas, tattles on his stepbrother, earning Wheezer a licking by his stepmother, played by the six-foot-three scowling giantess Blanche Payson. The premise is as familiar as an old fairy tale: Dorothy and Wheezer are the unloved stepchildren, seemingly abandoned by their father and abused by their mother. Sherwood is the coddled favored child, dressed like Little Lord Fauntleroy. Wheezer weeps, Sherwood bullies, and Dorothy tries to comfort her brother.

The real laughs begin once Dorothy and Wheezer's stepmother leaves on a shopping trip and the children are left to their own devices. On cue, Stymie sidles up to the kitchen door, eager for something to eat. Like Dorothy and Wheezer, Stymie doesn't know where his father is—"I guess my Pap's in jail again; he didn't show up last night," he muses to Petie earlier—and like Dorothy and Wheezer, he is tantalized by the smell of Sherwood's decadent breakfast of ham and eggs.

Wheezer greets Stymie with a hearty hello, but Sherwood is not so welcoming: "You can't come in here—mother said so!"

Stymie is nonplussed. "Calm yourself, brother," he says, raising his hand in peace, "I ain't coming in. I'm just gonna stand right here and smell."

Of course, Stymie is soon ensconced at the breakfast table and eyeing a slab of uncooked ham and platter of eggs in the icebox. His eyes brighten, and he turns to Sherwood.

"Hey Spud, did you ever know ham and eggs could talk?"

"Aw, whoever heard of such a thing?" Sherwood sneers.

"Well, I heard 'em talking this morning," Stymie insists.

Wheezer, with a knowing wink, gets in on the joke.

"What'd they say?" he asks Stymie, grinning from ear to ear.

"Well, the ham said to the eggs, 'Move over there, white boy, you's crowding me.'"

"Then what'd the eggs say?" Wheezer asks.

"Ham, I ain't crowding nobody. I'm just nibblin' around in this here grease."

Sherwood is unconvinced. He retrieves the ham and eggs from the icebox and waits intently for them to talk. When nothing happens, Stymie tells him he needs to put them in a frying pan, then "kinda turn 'em over, shuffle 'em around a little bit." Still nothing. Disgusted, Sherwood exits the house with his dog, leaving Wheezer, Dorothy, and Stymie to enjoy a sumptuous, piping hot breakfast.

As they devour their meal, Wheezer admiringly asks, "Stymie, where'd you ever get that idea?"

"I'm full of ideas when I'm hungry," Stymie says.

Dorothy protests, "I knew ham and eggs couldn't talk!"

"Well," Stymie answers, "they're saying hello to my stomach right now!"

The ham and eggs joke is classic Stymie. Using his wits, sharpened by hunger and poverty, he manages to do what Wheezer and Dorothy cannot—outsmart Sherwood and secure a square meal. The camaraderie between Wheezer and Stymie is contrasted with the enmity between Sherwood and Stymie. Wheezer and Stymie are of different races, but they are essentially "in the same boat": hungry, disempowered, and fatherless. Sherwood, on the other hand, sees Stymie as an interloper and outsider—someone not even allowed in the house, much like Petie, the dog.

H. M. "Beanie" Walker was credited with the dialogue in this episode, and he wove in some tongue-in-cheek racial puns. The eggs are described as the "white boy" crowding out the ham in the frying pan. The ham, by extension, is a pun on the biblical Ham, son of Noah and supposedly the forefather of black Africans. Stymie's joke becomes a miniallegory of race relations, eggs jostling ham, ham jostling back, yet both undeniably more enjoyable when paired together.

Stymie and Wheezer might have gotten along like a comedic ham and eggs, but in the real world, race relations were rapidly deteriorating along with the nation's economic fortunes. The decade's most infamous episode of racial injustice was just then unfolding in Alabama, a state riven by poverty and unemployment. In March of that year, a group of black and white youths hoboing for work got into a fight aboard a Southern Railroad freight train. The train was stopped, and a posse led by the sheriff and armed with shotguns, pistols, and pieces of rope arrested nine black

teenagers for assault. Soon rape charges were added, based on the false testimony of two white women also on the train. Racial hysteria exploded. A lynch mob gathered at the Scottsboro jail, where the nine boys were being held, and the National Guard was called in for emergency protection. Within a matter of days, the trial was under way. Two hundred national guardsman guarded the Scottsboro courthouse as a mob of thousands, some coming from as far away as Georgia and Tennessee and many armed with shotguns, gathered in the town square. A brass band added to the circus-like atmosphere, playing "Dixie" and "Hail, hail, the gang's all here" to the gathered crowd.

Southern justice was swift and brutal. An all-white jury tried and convicted all nine of "the Scottsboro Boys," as they were called. Eight were sentenced to death. The youngest, who was only twelve, was given a sentence of life imprisonment. Outside, the assembled mob cheered at the verdicts. The case became a national and international cause célèbre, drawing in the NAACP and Communist Party and eventually going through several tortuous years of appeals and retrials. Twice, the case went all the way to the Supreme Court, which ruled that the Scottsboro Boys' right to due process and a jury of their peers had been violated. Still, Alabama juries continued to convict the boys time and time again, in flagrant disregard of legal procedure and the very facts of the case.

For much of the 1930s, the legal travails of the Scottsboro Boys formed the sensational backdrop to any discussion of race relations in the country. The sheer youth of the accused, the hastiness of their trial, and the severity of their punishment shocked the public. In a poem inspired by the plight of the Scottsboro Boys, Langston Hughes caustically wrote:

> That Justice is a blind goddess
> Is a thing to which we black are wise.
> Her bandage hides two festering sores
> That once perhaps were eyes.[73]

Hollace Ransdell, an investigator for the American Civil Liberties Union, was more blunt. "It is no exaggeration certainly to call this a legal lynching," he wrote.[74]

Los Angeles was a long way from Scottsboro, Hal Roach

Studios a long way from an Alabama courtroom. But for a young black boy growing up in the 1930s—even one who was a film star— the plight of the Scottsboro Boys made clear that American racial attitudes had made little progress. Despite *Our Gang*'s more tolerant racial worldview, it too was not impervious to prevailing stereotypes. As often as Stymie proved himself to be the most canny and urbane member of the Gang, he was still stuck with many of the same stereotypes that had dogged his predecessors—the unfunny minstrel jokes about watermelon and black criminality. *A Lad an' a Lamp,* released in December 1932 and exploiting the supposed similarity between black people and monkeys, is a particularly egregious example. Starring Stymie and his brother Bobbie "Cotton" Beard, the film opens with the Gang feverishly rubbing an assortment of lamps big and small, hoping to extract a wish from a genie. Stymie alternately wishes for his pappy to get out of jail and for a watermelon. Spanky, the ascendant star of the Gang, wishes Cotton would turn into a monkey; after all, he surmises, "all he needs is a tail." In a comic mix-up, a chimpanzee from the local vaudeville troop swaps places with Cotton and embarks on a series of comic misadventures.

The interchangeability of black people and monkeys is mocked throughout the film, in visual gags that tastelessly burlesque black sexuality and primitivism. At a lunch counter, a black cook and his girlfriend flirt with each other. The chimp insinuates himself between the two, nibbling on the man's ear and draping his arm around the woman. Neither notices the difference, at first—the chimp's big lips and hairy arm being credible proxies for their black counterpart. When each lover suddenly discovers the mix-up, the chimp curls his lips in grotesque minstrel fashion, and both man and woman run away in a panic. Later, Stymie asks a policeman for help in finding his chimp brother. When asked what his brother looks like, Stymie answers, "He used to look like me, but now he looks like Ingagi!"

"Ingagi" was a reference to the pre-Code exploitation film of the same name, released the previous year and depicting decidedly un–family friendly fare. Like *King Kong,* its more famous successor, *Ingagi* played on stereotypes of black sexuality and bestiality, casting "Central Avenue Negroes" (as the *Los Angeles Examiner* put it) as gorillas who sexually enslave native African women.

Marketing itself as "the most sensational picture ever filmed!" *Ingagi* immediately ran afoul of censors but was a box-office hit, referred to in the papers as "the gorilla 'sex' picture."[75] The movie critic Robert Sherwood was one of the few who found the film less than impressive, sardonically noting that the pygmies "look exactly like Negro children—like Farina, for instance, or others of Our Gang."[76]

The actual *Our Gang* comedies were supposed to be the antithesis to *Ingagi,* but that didn't mean McGowan and his writers couldn't allude to the controversy in their scripts—or even create their own sanitized parody of the film. Transforming Cotton into a monkey was another version of *Ingagi*'s cross-species casting, and having a chimpanzee pucker up to a black woman was a G-rated version of *Ingagi*'s gorilla-woman sexual plotline. In *The Kid from Borneo,* another famous *Our Gang* short from the early 1930s, black savagery is again mocked in the character of Bumbo, the circus sideshow "wild man" who wears an animal pelt and face paint and terrorizes the Gangsters with his cannibalistic cry, "Yum, yum, eat 'em up, eat 'em up!" Played by the African American actor John Lester Johnson, Bumbo is a campy parody of the African savage, more animal than human. (Stymie even cries, "He looks like a gorilla ape!") In later years, Dickie Moore winced at the racial humor in this episode and others, once broaching the topic with Stymie, who magnanimously waved off his concerns with the explanation that they were just "being kids" and having fun.[77]

In more unguarded moments, however, Stymie was clearly pained by these examples of racial humor. He specifically remembered lines like "Mah pappy was a crap-shootin' fool,"[78] taken from the 1931 short *Bargain Day,* in which Stymie played the chauffeur's son opposite Shirley Jean Rickert, a lonely little rich girl. "That don't rub me too good today," he admitted as an adult.[79] It was the Depression, however, and Stymie knew that delivering such lines helped support an ever-growing family. In a poignant example of how one line could generate such drastically different memories, Rickert recalled how "One-Take Stymie" initially muffed the line as, "My daddy's just a crappin' fool!" causing the whole set to burst into laughter. According to Maltin and Bann, Roach was so tickled that he held on to the outtake to show as a

gag reel.[80] At six years old, Stymie was already experiencing the contradictory pull of double consciousness. He was a young black child surrounded by white children and adults, performing a racial role that got big laughs but that would haunt him well into adulthood.

By 1933, the series was at a turning point. Spanky was now the indisputable star of the comedies, a pint-size dynamo in his tam-o'-shanter (later replaced by his famous beanie). He was precocious, droll, and unflappable, charming directors and fans alike. He was also only five years old, his career stretching promisingly before him. Wheezer, who had joined the series at the age of two, was now eight years old and had aged out of the series.[81] Dorothy DeBorba, who was also eight, retired at the same time. Dickie Moore left that year for a career in feature films. And Jackie Cooper was long gone, having been lured away by Paramount.

By far the most significant departure, however, was that of Bob McGowan, who had been with the series from its humble beginnings twelve years earlier. Broken down by years of wrangling kids and their stage parents, McGowan, in Roach's words, was "an ill man."[82] In a valedictory article in the *Los Angeles Times,* McGowan spoke with fatherly affection of his little charges. "When they begin to grow up," he wrote, "I feel about like a man does who sees his children getting to be young men and women."[83] By his count, he had seen "three complete changes in personnel of Our Gang"—the equivalent of three generations, compressed into little more than a decade. Uncle Bob, in other words, was a grandfather many times over. He moved over to Paramount Pictures, where he directed a series of feature films, before returning to the Gang one last time to film the 1936 two-reeler *Divot Diggers.* The heyday of his career, however, was over.

The nation, too, was at a critical juncture. Franklin D. Roosevelt was now in office, having defeated Hoover in a landslide and pushed through, in his first hundred days, a New Deal agenda that promised to restore the country to economic health. His campaign theme, based on a rollicking popular song, was "Happy Days Are Here Again." The African American community, battered by the Depression, watched and waited. Most had voted for Hoover out of a historic allegiance to the Republican party—the

party of Lincoln, after all. But now, leaders such as Robert Vann, publisher of the *Pittsburgh Courier,* admonished the community to give Roosevelt a chance. "My friends," Vann exhorted, "go turn Lincoln's picture to the wall. That debt has been paid in full."[84] In the pages of the *Baltimore Afro-American,* readers expressed their hopes that Roosevelt might provide greater racial as well as economic leadership. "[He] is for the Negro race as well as white," one woman wrote. Another optimistically predicted, "I do believe he will stop Jim Crow law."[85]

The good old days were over. But perhaps, happy days were here again.

7

Movie-Made Children

On January 1, 1934, Stymie turned nine years old. His best friend Dickie was gone, and so was his beloved director, Uncle Bob. Scotty Beckett, a dark-haired ringer for Dickie, joined the cast, eventually settling into his trademark role as Spanky's comic sidekick. Wally Albright, Tommy Bond, and Leonard Kibrick rounded out the group. Looking around, Stymie couldn't help but notice he was one of the oldest and tallest of his costars. Hal Roach and his staff had also noticed. That year, Roach began to stage regular, monthly talent contests at the Lincoln Theater on Central Avenue in Los Angeles. From the hundreds of children who attended the tryouts, Roach selected four each month to bring back to the studio for further screen tests. A few made it onto the *Our Gang* set in bit parts, including Stymie's younger siblings Bobbie and Carlena. Stymie still retained top billing, but his successor, yet unchosen, waited in the wings.[1]

Gus Meins had stepped in as McGowan's successor. Born Gustave Peter Ludwig Luley in Frankurt, Germany, Meins started out as a cartoonist for the *Los Angeles Evening Herald* and a Mack Sennett gagman before making his name directing the Buster Brown silent comedies. He joined Hal Roach Studios in 1932, working with Charley Chase, Thelma Todd, ZaSu Pitts, and Patsy Kelly and codirecting the Laurel and Hardy feature *Babes in Toyland*. From McGowan, Meins learned how best to gain the

trust of his young stars.[2] He was small and scholarly looking, with round spectacles and thinning hair, and he shared with McGowan a gentle, disarming manner. Jackie Lynn Taylor, who appeared in a handful of *Our Gang* shorts, remembered him as a delightful and loving "foster father," while the studio pressbook described him as "short of stature and always wearing a beaming smile."[3] When auditioning potential actors, he put them at ease by letting them guide the conversation and fending off any overbearing stage parents. His *Our Gang* films were, in the words of Richard Bann and Leonard Maltin, "witty, tasteful, stylish, and skillfully constructed."[4] Unlike McGowan, Meins stuck more closely to the official script and relied less on improvised gags, lending his films a more polished, crafted feel.

Filming began late that season, due to the unavailability of Spanky, whose work permit had been suspended. During his hiatus from *Our Gang* the previous year, Spanky had been loaned to Paramount to appear in the feature film *Miss Fane's Baby Is Stolen*, during which he caught whooping cough. Rather than keeping him home to recover, Spanky's parents allowed him to work while sick, thus passing along the disease to Spanky's young costar, Baby LeRoy. As punishment, the Los Angeles Board of Education suspended Spanky's work permit for ninety days. In the past, production might have continued without him, with the rest of the ensemble covering his absence. But *Our Gang* was now a star vehicle for Spanky, with the rest of the Gang mere supporting actors. Without Spanky, the show could not go on. Scheduling was rejiggered to accommodate Spanky's availability, with the result that the 1934 season was truncated.

For Pete's Sake!, the second short released that season, is notable for several reasons. For one, it introduces the character of Buckwheat—but not the Buckwheat fans would later become familiar with. This Buckwheat was a girl, played by Stymie's younger sister Carlena.[5] Billie Thomas, who would later take over as the "real" Buckwheat the following season, appears in a small, nonspeaking role. Tightly shot and written, the short also departs from the looser, improvisational style of McGowan. The short has a beginning, a middle, and an end; in Maltin and Bann's estimation, it is "perfectly paced and conceived so that every scene fits into place, framed by a running gag."[6] Yet beneath

its classic plot of Gang versus neighborhood bully (here played by Leonard Kibrick), there is a harder, more violent edge, one that marks it as a serious departure from the shorts that preceded and followed it. In this *Our Gang* short, coded in the antics of children, is an unexpected commentary on race and violence in 1930s America.

The film opens with the Gang gathered around Wally Albright, who stands outside sick Marianne's window, repairing her headless doll by pouring sawdust into its body. Much to Spanky and Scotty's amusement, Wally doesn't realize that the dust is pouring out the doll's leg, into his own trousers, and out his own leg. Once he realizes his mistake, Wally elicits Stymie's help, and the two work assiduously to fix Marianne's doll. Meanwhile, red-haired, freckle-faced Leonard suddenly appears over the wooden fence, rope in hand. As Wally hands Marianne her repaired doll, head safely back on and legs bound with string, Leonard lassos the doll around its neck and yanks it into the street, where a passing car wincingly crunches over its head.

"You shouldn't have done that!" Wally berates Leonard, who sneers, "Aw, it was only an old rag doll!" Wally and Leonard appear ready to fight when Leonard is conveniently called away by his mother. Marianne is left tearful and heartbroken, prompting Wally to vow to get her a new doll by the end of the day, a promise the Gang enthusiastically seconds. As they disperse from Marianne's window, Carlena Beard, wearing a checked dress with her hair in white ribboned pigtails, is left behind, hanging from the sill.

"Hey Stymie," Spanky yells, pointing to Carlena. "You forgot something!" Stymie dutifully trots back and unhooks his sister from the window.

The next scene opens with the kids clustered in front of a toy store, peering at the dolls displayed in the window. It turns out the store is owned by Leonard's father, a tall, humorless man in suit and glasses who brusquely shoos them away.

"Hey mister, how much is that doll worth?" Wally asks.

"It's worth a lot of money. Go on, now!" Leonard's dad snaps.

"But how much does it cost?" Wally persists.

"It costs a dollar and twenty-five cents!" Leonard's dad answers.

Leonard and his father offer to barter the doll for the Gang's dog Pete, but Wally is indignant. "I wouldn't trade that dog for your whole darn store!" he cries.

The Gang sets off to raise the money they need to purchase the doll. They pass a bickering couple on the lawn in front of their house. The husband, dressed in his vest and shirtsleeves, has been tasked to beat the carpets while his wife goes on a shopping trip.

"Why couldn't we hire it done?" the husband complains. "You can get a man cheap!"

"There you go, always wanting to spend money," his wife responds.

"Yes, but you're going shopping," he protests.

"Well, I'm going to *save* money," she answers.

The Gang, seeing an opportunity to make some cash, offers up its services. For ten cents each, they agree to clean the rugs and mow the lawn while the husband kicks back on a hammock and takes a nap.

Wally, Stymie, and Tommy struggle to drape a large rug on a clothesline while Spanky and Scotty supervise, sprawled on their stomachs on the grass. "Hey Wally!" Spanky yells and points to Carlena, who has somehow gotten tangled onto the clothesline and is hanging from her neck.

"Why don't you tie her up?" Wally asks Stymie. Stymie complies, finding a piece of rope and lassoing it around Carlena and a nearby tree.

Meanwhile, Spanky and Scotty have come up with the bright idea to harness Pete to the lawnmower like a horse. A passing cat causes Pete to go haywire, dragging the lawnmover right over a rug. The Gang tries to glue the rug back together, but Carlena, who has started yanking on her rope to get apples to fall off the tree, accidentally wakes up the napping husband. Seeing the Gang's wanton destruction, he shoos them away. The Gang splits, with Spanky, Scotty, and Pete the Pup sporting carpet-pile shoes. In their haste, the Gang has completely forgotten about Carlena, who appears a few beats later, munching an apple and still tied to a tree branch.

Time is running out and Wally decides he has no choice but to trade Pete for a new doll. The Gang returns to the toy shop to complete the exchange, and Leonard's father hands Pete's leash

to Leonard. Immediately, Leonard wrenches the leash over the counter, throttling Pete.

"Hey! That's no way to treat him!" Wally protests.

"Well, he's my dog now, isn't he?" Leonard retorts.

As Wally leaves the toy shop with the doll, Spanky again calls out, "Hey Stymie! She's at it again." Inside, suspended in the air by some apparatus and kicking wildly, is Carlena.

"This is getting monopolous," Stymie complains. He returns to retrieve his sister but accidentally knocks over some vases, leading Leonard's father to demand the Gang return the doll and pay him three dollars for damages. Pete, however, has had enough and begins rampaging around the store, tearing the seat of Leonard's father's pants and forcing Leonard to scramble onto a shelf to get out of his way. Frantic, Leonard's father begs Wally to take his dog back and agrees to include the doll as well. When the Gang returns to Marianne's house, however, they discover that the doll is a black Topsy doll, with braided hair and a gingham dress.

"That can't be right!" Stymie says.

Pete sprints back to the store, dragging Spanky and Scotty with him. Leonard and his father are just closing up. They panic, climbing up to the chandelier as Pete jumps into the store window and retrieves the correct, white doll. Pete makes a mad dash back to Marianne's house, again dragging Spanky and Scotty behind him. They upset a ladder, leaving a painter dangling from the eaves of a theater awning. Back at the house, Pete climbs a crate and delivers the new doll to Marianne, who hugs it happily. The short ends with a shot of Carlena, again hanging from a clothesline, clutching the discarded Topsy doll.

Originally titled "Doll Diggers of 1934," a pun on the popular pre-Code Warner Brothers musical film *Gold Diggers of 1933, For Pete's Sake!* betrays a more cynical attitude toward the Depression than in previous shorts. Whereas before, the Gang defends Grandma from creditors or unscrupulous relatives, here the enemy seems to be capitalism itself. Leonard Kibrick is the venal "rich kid" in this script, but unlike spoiled Sherwood in *Dogs Is Dogs*—another film that pits a rich bully against Pete the Pup—Leonard is the son of a bourgeois shopkeeper who places a price on everything, from dolls to dogs. In Leonard and his father's worldview, everything is a commodity, meant to be traded or exploited. Thus, when Wally protests at Leonard's cruel treat-

ment of Pete, Leonard's response is that ownership gives him that privilege: "Well, he's my dog now, isn't he?" Even human beings have a price, as the hapless husband tells his wife when complaining about cleaning the rugs: "You can get a man cheap." As the Depression had made clear, with unemployment rampant, human labor *was* cheap.

If human labor was cheap, so was human life. Throughout the film, this is conveyed in two ways: first, by the queasy parallelism between human and doll, and second, by the repeated motif of lynching. The little white girl, Marianne, owns a little white doll; the little black girl, Carlena, eventually ends up with a little black doll (and is herself so emotionless, she could be a doll). In the opening scenes, Wally, too, is paralleled with Marianne's headless doll—the sawdust pouring out of the doll's leg ends up pouring out of Wally's trouser leg. And when the car crunches over Marianne's doll's head, we instinctively recoil at the sound, imagining an actual human skull crushed under the tires. That coded violence is perpetuated by the many bizarre sight gags of Carlena Beard hanging from or tied to various structures: a window sill, a clothesline, a tree, a hook. A white child dangling from a hook was one thing; a black child was another.[7] Given the prominence of lynching in the public consciousness in the 1930s, the image was fraught with violence.[8]

The hanging motif is everywhere—in the dolls and puppets hanging in the toy store, in the painter hanging from the theater awning—but it is most chillingly reinforced in the repeated close-up shots of Leonard strangling Pete with his rope leash. Paralleling the earlier shot of Leonard lassoing Marianne's doll around the neck and hurling it into the street, Leonard's barbarity is heightened by his willingness to torture living or lifelike things. His excuses—"Well, he's my dog now, isn't he?" and "Aw, it was only an old rag doll"—suggest a troubling disregard for life in general. Pete is a canine and the doll a simulacrum of a human, but both are stand-ins for actual humans: Pete for his fellow members of the Gang, and the doll for Marianne. Leonard and his father, however, see the two as the same thing: objects of exchange. "I'll trade you *that* doll for *your* dog," Leonard's father explicitly states, to which Wally reacts with horror: "Hey! I wouldn't trade that dog for your whole darn store!"

What were Meins and his team of gag writers trying to say?

The *Our Gang* shorts had always incorporated contemporaneous events, from the Depression to the World Series to recent Hollywood films. But the films rarely engaged in anything overtly political, in keeping with its reputation for wholesome, inoffensive fun. When a film *did* refer to a potentially divisive topic, as it did when caricaturing the Ku Klux Klan in *Lodge Night,* it maintained a tone of levity throughout. The outlandish costumes and rituals of the Klan were mocked, as well as its policy of monoracial purity, but the film steered clear of more problematic Klan vigilantism and violence. *For Pete's Sake!* likewise avoids directly confronting issues of lynch law, cloaking it in the tale of a neighborhood bully versus the Gang. And yet the film's use of such freighted imagery, its attention to race, and its thinly concealed violence seem to gesture provocatively to the racial climate of the time.

For Pete's Sake! was written and filmed at the same time that the NAACP, under the leadership of Walter White, was attempting to build an interracial coalition of support for a federal antilynching law. With FDR in office, African Americans were hopeful that they had a political ally in the president. Many sent handwritten letters to the White House, describing the terrors of lynch law and begging for protection. That year, Senators Edward Costigan and Robert Wagner introduced an antilynching bill to Congress, drawing renewed national attention to the cause. Figures like H. L. Mencken, Sherwood Anderson, and Eleanor Roosevelt publicly lent their support. At the same time, the Scottsboro Boys continued to dominate headlines with their case's protracted journey through the justice system. The International Labor Defense, the legal arm of the Communist Party of the United States, had taken over the defense, hiring the attorney Samuel Leibowitz to argue the case in front of a new jury. Since the late 1920s, the Communist Party had plunged into the battle over black rights, arguing for an interracial alliance of the proletariat against a racist and classist system of capitalism. The party platform, codified at the Sixth World Congress of the Communist International in 1928, called upon white workers to join the struggle against Jim Crow law, which it linked to a "bourgeois slave market mentality." More so than any other white organization of the 1930s, the Communists publicized racial injustice and preached the benefits of integration.[9]

The Gang had always been figured as a miniaturized democracy, a prototype of the nation as a whole. But now it seemed to toy with socialism, where the Gang, comprised of poor black and white kids and even a black-and-white dog, unite against an avaricious storeowner and his son, redistributing wealth by destroying their wares and replacing Marianne's doll. In fact, even the film's improbably neat ending, with Marianne clutching her new white doll and Carlena clutching her new black doll, suggests that both white and black child benefit materially from this interracial (and interspecies) alliance: Marianne receives a new doll in the place of the one so wantonly destroyed by Leonard, and Carlena, who never had a doll to begin with, now has her own. Like the other *Our Gang* shorts, *For Pete's Sake!* becomes an allegory of race relations. The Gang's victory over the Kibricks suggests that a black and white (and canine) coalition of the proletariat could overcome the oppressive bourgeois class and secure a better deal for all.

The historical record is silent on the political sympathies of Meins and his writers. Certainly there existed in the 1930s a group of Left-leaning intellectuals and artists in Hollywood. The establishment of the Screen Writers Guild, a labor union created in 1933 to defend the interests of writers against the studios, meant that issues of equitable pay and screen credit were circulating among the creative class. Within the gates of Hal Roach Studios, Stan Laurel was in the midst of his own acrimonious conflict with Roach over issues of creative control and fair compensation. Brash and endlessly self-confident, Roach was accustomed to having the last say in creative decisions, a stance that increasingly clashed with Laurel's desire for creative autonomy. Things came to a head with the Meins-directed *Babes in Toyland*. As Henry Brandon, who played the film's villain, recalled, "Roach and Laurel were arguing constantly while it was being made. Roach would tell Laurel his suggestions on the comedy scenes and they'd go into Roach's office and yell at each other. It was a real battle of egos."[10] According to Laurel and Hardy expert Randy Skretvedt, the problem lay in the fact that Laurel was an artist and Roach a businessman: "The troubles arose when Stan, a salaried employee, tried to assume more control over films Roach was financing."[11] Theirs was the struggle of the artist-worker against the

capitalist-producer, fought publicly on the studio lot.[12] Were Meins and his writers, many of whom knew Laurel or had worked with him, mounting a critique of Roach and the studio system? Were they making a statement about lynching and the devaluation of human life and labor? Was this a socialist manifesto, coded in comedy? Whatever the case, *For Pete's Sake!* appears an idiosyncratic one-off. Subsequent Meins films refrained from any controversial statements, coded or not.

Meanwhile, the film's fantasy of an interracial working-class coalition proved just that—a fantasy. In reality, the Communist Party encountered difficulty convincing white workers, especially in the South, to overcome racial prejudice and unite with their fellow black workers. The party's defense of the Scottsboro Boys also foundered against an intractably racist Southern justice system. Each time the case was sent back to the Alabama courts for a retrial, the results were the same: quick conviction. Among black leaders, the Communist Party was praised for its support of integration and social equality, gaining some highly visible members like Paul Robeson and Langston Hughes. Yet Communism never made great inroads in the larger black community, most of whom wanted a fair shake at American capitalism, not the overthrow of the entire system.[13]

The interracial quest to end lynching also encountered obstacles. With the support of the NAACP, Senators Costigan and Wagner had introduced a federal antilynching law in 1934, but President Roosevelt continued to drag his feet. Black Americans, terrorized by the lynchings occurring in their own backyard, joined the campaign, sending handwritten letters to the White House appealing for his help. Walter White, executive secretary of the NAACP, personally met with Roosevelt to plead the case and demonstrate the bill's broad, interracial support. But the president, reluctant to alienate Southern Democrats and risk his legislative agenda, refused to throw full support behind the bill. In October 1934, Claude Neal, a young black man accused of raping and murdering a white woman, was horrifically lynched in Florida. The mob tortured Neal, cut off his fingers and toes, castrated him and forced him to eat his genitals, burned him with hot irons, and hanged him. The NAACP used the Neal case to press for action on the Costigan-Wagner Bill. Again, the bill failed to

come to a vote. Year after year for the rest of the decade, the NAACP continued its battle for antilynching legislation, only to be thwarted each time by Congress's Southern bloc.[14]

At Hal Roach Studios, the friction between Laurel and Roach continued, with the two men butting heads during contract negotiations and Roach even threatening to replace his star. But the two men also needed each other, Roach because Laurel was a proven box-office draw, and Laurel because Roach could finance his costly productions. The independent short film, on which Hal Roach had built his reputation, was on its way out. Double features had become so popular among audiences that there was less time and money left to screen short films. Sennett, Christie, and Educational, Hal Roach's rival independent short comedy producers, all failed to survive the 1930s. Roach clung on by aggressively moving out of short films and into features. The Todd-Kelly series was brought to an end with the mysterious death of Thelma Todd by carbon monoxide poisoning in December 1934. Charley Chase, whose short series had been one of Roach's early hits, amicably parted with the studio in 1936. And Laurel and Hardy, whose short films were the studio's bread and butter, had made the transition to features by the mid-1930s. Only *Our Gang* remained of the Roach stable of short comedies, but even this studio workhorse was compressed to half its previous length, to a single, ten-minute reel.

Stymie, who was now ten, began to get a "kind of funny feeling." On the *Our Gang* set, he watched first one, then another black child appear as his younger brother or sister. Willie Mae Taylor appeared in a few shorts, replacing Carlena as Buckwheat. By the beginning of the 1935 season, Buckwheat had morphed into a boy, played by the three-year-old Billie Thomas. "I wasn't going to the barbershop regular anymore, getting my head shaved," Stymie remembered. "You could see it in some of the later comedies. And I was getting pretty tall. I outgrew the other kids and that didn't work."[15] Sure enough, the studio dropped Stymie from the *Our Gang* cast midway through the 1935 season. And though Stymie suspected what was happening, suspected he was getting too old and too big, the reality was a shock. "I felt very bad, 'cause nobody explained to me what happened," he said. "They'd brought Buckwheat in when I started getting too large

just as they had brought me in when Farina started getting too large; and I knew that Farina had had the same feeling when I took his place."[16] Stymie's last short, *Teacher's Beau,* was notable mostly for Stymie's almost complete lack of dialogue and the brief appearance of Dorothy Dandridge. The scene-stealer now practically blended into the background.

Despite his persona as the Gang's unflappable wise guy and con artist, Stymie was ultimately a child, with a child's sensitive soul. He knew he had outlived his usefulness and been replaced, and the truth stung the young boy. The period of retrenchment at Hal Roach Studios only reaffirmed the fact that Hollywood, despite its trafficking in fantasy, was ultimately a business. As Diana Cary, the child star known as Baby Peggy, put it, "Our only value lay in our youth, like a bonsai tree which is only valuable because it looks like a mighty oak, but it is only three inches tall. We were all bonsai. The entire 'Our Gang' was nothing but a bonsai forest."[17] Stymie was now a "big boy," too big for *Our Gang,* his value dissipated. But in many ways, he remained the bonsai tree, stunted emotionally if not physically. Raised within the safe confines of the studio, he knew nothing about the so-called real world. He had thrived in this little Eden, this cultivated and rarified world of fantasy and celebrity.

"I heard the footsteps," he remembered, "but I didn't want to go."[18]

Stymie's retirement coincided with the rise of the Depression era's most durable child star, Shirley Temple. Born in Santa Monica, California, in 1928, Temple got her start on Educational Pictures' rival kid series, *Baby Burlesks,* playing an infantine version of Mae West and Marlene Dietrich in campy parodies of popular films. According to Hal Roach, Temple tried several times to land a spot on *Our Gang.* "Her mother brought her in five or six times I understand, and nobody'd let her get beyond the outer office," Roach recalled. "But bear in mind there would usually be dozens of kids out there every single day. You couldn't see them all, and the casting director apparently didn't think Shirley Temple had anything to offer the gang. So she didn't get chosen."[19] Bob McGowan apparently did recall seeing Temple and thinking she had promise, but wouldn't give her star billing on *Our Gang,* as

her mother wished. "Who else but *me* would turn down Shirley Temple?" he would later joke.[20]

Temple's career would take off in 1934, when she began to appear in features for Fox and Paramount. With her spunk and optimism, Temple was considered an ideal protagonist for the Depression, singing and tap-dancing her way out of the most difficult situations. "As long as our country has Shirley Temple, we will be all right," FDR famously said. "During this Depression, when the spirit of the people is lower than at any other time, it is a splendid thing that for just 15 cents an American can go to a movie and look at the smiling face of a baby and forget his troubles."[21] In 1935, Temple appeared in two Civil War–themed films, *The Little Colonel* and *The Littlest Rebel,* dancing alongside Billy "Bojangles" Robinson. As Temple wrote in her autobiography, the pairing was inspired by a note D. W. Griffith had written to a Fox executive, stating that "there is nothing, absolutely nothing, calculated to raise the goose-flesh on the back of an audience more than that of a white girl in relations to Negroes."[22] Griffith was speaking of the fear of miscegenation, which his own *Birth of a Nation* had so spectacularly exploited. But the partnership of Temple and Robinson safely defused that threat by making Robinson an Uncle Tom figure—faithful, dutiful, and childlike. Temple even called him "Uncle Billy" off screen.[23]

Polished and professional, with her perfect ringlets and smile, Temple was the most popular film star of the Depression era, eclipsing adult stars like Clark Gable and Greta Garbo. With her years of dance and voice lessons and her ever-present stage mother, she was also closer to the "trained seal" that Roach had derided when first casting *Our Gang* in the 1920s. The natural, rough-around-the-edges quality of the Gang, which had been the key to its appeal from its inception, was becoming less fashionable. Whereas earlier in the decade, audiences had gravitated toward grittier, more realistic cinematic fare, now they craved its opposite—slick fantasies, preferably set in some idealized past, that offered an escape from the realities of contemporary life. Stymie Beard was a scrappy hero of the Depression's early years, dressed in secondhand clothes and surviving by his wits. Shirley Temple was the face of the New Deal, whose angelic smile assured audiences that the nation had turned a corner.

The shift in audience taste reflected the more optimistic mood of the country, but it also reflected a convergence in values among politicians and studio heads. The New Deal administration was eager to restore national morale and promote patriotism, unity, and other traditional American values. The studios, meanwhile, saw the economic benefits of providing audiences the more comforting, old-fashioned, escapist fare they craved. All of this was compounded by the debate over movie morals that came to a head in the middle of the Depression. The establishment of the Breen Office in 1934 meant that films were now seriously limited in what they could depict on screen. Sex and violence, which had helped keep the studios afloat during the worst years of the Depression, were now verboten. Glamour and romance, on the other hand, were not only acceptable but desirable, painting an idealized picture of American society and its values.[24] Shirley Temple united in her one person the combined desires of politicians, studio heads, and censors for a child savior to lead the nation out of psychological, economic, and moral darkness.[25]

From the motion-picture industry's beginnings, moral watchdogs believed movies to be unsavory and corrupting, a threatening new form of technology, housed in seedy nickelodeons and dangerously seductive to young minds. One doctor, testifying in a Chicago censorship trial in 1919, linked moviegoing to a greater incidence of neurosis, St. Vitus' dance, nearsightedness, and sleep deprivation. In the early 1920s, the Fatty Arbuckle sex scandal and the murder of director William Desmond Taylor provided further ammunition to critics convinced of the film industry's moral dissoluteness. Politicians across the nation began introducing movie censorship bills, alarming the major studios. In response, movie moguls founded the Motion Pictures Producers and Distributors of America (MPPDA), a trade organization meant to promote public relations and uphold the moral probity of Hollywood. For the MPPDA's first president, the studios appointed William H. Hays, a former chairman of the Republican National Committee and postmaster general for the Harding administration.[26] A master lobbyist, Hays managed to kill most of the censorship bills making their way through state legislatures. He also rebranded the movie industry, promoting films as an instrument of democracy and mutual understanding. Censorship,

by implication, was un-American, a suppression of free speech and democratic values.

Hal Roach, who created *Our Gang* just as the MPPDA was founded, capitalized on circulating anxieties about movies when he first began to market his new juvenile comedies. Parents could rest easy letting their child watch an *Our Gang* short, because *Our Gang* was irreproachable family fare. Over and over, exhibitors extolled how "clean" the pictures were, how "wholesome" and funny.[27] Watching *Our Gang* was practically the next best thing to playing outdoors with your own friends. There was nothing risqué about these kids—no nudity or violence or other moral perversity. In a tongue-in-cheek acknowledgment of the comedies' reputation, Pathécomedy released a lobby card advertising the 1925 short *Better Movies* in which the Gang, dressed in outlandish exotic costumes, is depicted making a homemade movie. The caption below reads: "The Gang—They decided to organize their own motion picture company—More responsibility for Will H. Hays."[28] The joke was that whatever mayhem the Gang created, Hays could breathe a sigh of relief, for it was sure to be good, clean fun.

With the advent of sound, Hays adopted a new set of moral guidelines, officially known as the Motion Picture Production Code (colloquially referred to as the Hays Code). The Production Code banned the use of profanities, obscene words or gestures, "excessive or lustful kissing," and nudity. It explicitly forbade miscegenation ("sex relationship between the white and black races"), which it placed in the same category as other taboo subjects such as incest, abortion, and homosexuality (which it termed "sex perversion"). Enforcement, however, temporarily took a back seat to the exigencies of the Depression and a plummeting box office. Sex and crime pictures helped keep the industry afloat, and the Hays Office tacitly looked the other way. Religious leaders grumbled that movies continued to exert a baneful influence on young minds. Even Stymie's father, a minister, was convinced that most movies were "sinful" and "never set foot in a studio."[29]

Censors received a powerful boost from the publication of Henry James Forman's *Our Movie Made Children* in 1933. Forman, a journalist and editor, deftly summarized the findings of the Payne Fund Studies, a series of research experiments conducted

in the late 1920s and early 1930s to systematically study the impact of motion pictures on young children. With sensationalist flair, Forman depicted movies as a training ground in debauchery, not democracy. Here are "Mary and Johnny, aged somewhere between seven and thirteen, but recently initiated into the independence and thrill of going alone to the movies, who we may see electrified, excited, scarcely able to hold their seats. With large and eager eyes through the murk of the often stuffy theatre, watching the unfoldment on the screen of the ubiquitous themes—love, sex, and crime."[30] The theater, he insinuated, was little better than a whorehouse. Children's minds, previously described by Hays as "that clean, virgin thing, the unmarked slate," were being sullied right under their parents' noses.[31]

Forman tapped into a potent fear that American society itself was being undermined by the decadence of pictures. Children, exposed to the "vast haphazard, promiscuous" output of pictures, would then develop a "haphazard, promiscuous and undesirable national consciousness."[32] Whereas Hays had implied that censorship undermined American values, Forman now suggested that censorship did the opposite—that it prevented their erosion. Energized by these findings, the Legion of Decency, a national organization sponsored by Roman Catholic bishops, called for a boycott of movies that the church considered indecent. Desperate to protect their precarious box-office returns, the studios agreed to a new enforcement agency, the Production Code Administration, headed by Joseph Breen. The Code, in other words, suddenly had teeth. Films released after July 1, 1934, required a certificate of approval from the Breen Office. The nudity, sex, and violence that had characterized pre-Code films were no longer acceptable and were ruthlessly edited from scripts and the screen.

Lost in the uproar was how movies also had a tremendous power to shape racial perception. Children's minds, it turns out, were remarkably impressionable not just when it came to sex and violence, but also when it came to skin color. Many of the children interviewed by the Payne Fund, for example, expressed a deep fear of the Chinese, typically depicted in movies as crooks and heathens, the so-called yellow menace. One white girl admitted, "I never pass by our Chinese laundry without increasing speed." And a "Negro high-school boy, himself a member of a race suffering

under prejudice," had a similar reaction: "I think all Chinamen are crooks because I have seen them in the underworld of pictures so often. . . . [I am afraid] of Chinamen."[33] And yet racial perception could just as easily be changed, so responsive were children's minds to the images on screen. In a study of "inter-racial contacts," two researchers investigated whether anti-Chinese prejudice among white children could be reversed by screening a film that depicted the "admirable," "fine," and "attractive" Chinese protagonist, Sam Lee. The following morning, the children were tested for their attitude toward the Chinese, and the results were remarkable: just as many children who had previously deemed the Chinese "yellow devils" now had a favorable impression of them. Still more, this favorable attitude lasted even nineteen months later, when researchers again tested the children.[34]

The researchers then ran a more chilling permutation of this study, this time testing for children's attitudes toward "Negroes." They chose as their test site a small town in Illinois with a homogeneous white population. The investigators interviewed more than four hundred schoolchildren ranging in age from eleven to eighteen and discovered their subjects had a "pronounced liberality toward the Negro race," with a large majority agreeing with statements like "I believe that the Negro deserves the same social privileges as the white man" and "by nature the Negro and white man are equal." The next step was to screen *The Birth of a Nation*, which had recently been revived with sound. The day after the screening, the children's attitudes toward the Negro race and interracial equality had shifted dramatically. "One wishes the reader could see the curve of graphs plotted by the psychologists on the before and after readings," Forman writes. "If you compared the 'before' readings to a peak, then the 'after' readings sink almost to a crater. . . . The unmarked slates, in other words, now bear definite record of a shift toward anti-Negro prejudice." More troublingly, the effects lasted months after the study, despite no further exposure to anti-Negro propaganda. "The motion picture," Forman concludes, "which can be a tremendous power for good, can as obviously be a powerful force for evil, depending upon its content and use."[35]

While the Payne Fund Studies were later criticized for their methodology, they were the first comprehensive investigation of

the effects of mass media on children.[36] And they simply confirmed what the African American community already suspected: that the motion picture was a powerful propagandistic tool when it came to racial perceptions. This was why the NAACP had so vigorously denounced revivals of *The Birth of a Nation* and why actors like Sunshine Sammy and Farina Hoskins were embraced by the community as positive role models despite their stereotypical pickaninny roles. For white children with little exposure to "the Negro race," *Our Gang* films offered a comparatively favorable depiction of black children. When it came to depictions of the Chinese, *Our Gang* likewise used stereotypical but comparatively positive images. In the 1934 short *Washee Ironee*, the Gang makes an emergency stop at "Yun Wong Laundry," where Stymie first uses broken English to communicate to a young Chinese boy. "You wash-ee clothes-ee?" he asks, but the Chinese boy looks at him blankly. "Well, maybe he don't understand Chinese," Stymie concludes, but Spanky then tries pig Latin, "Oo-yay ash-way othes-clay." This the Chinese boy understands, responding "wash-ee clothes-ee! Wash-ee clothes-ee!" while running the washer. The role is undeniably stereotypical, perpetuating the image of Chinese as foreigner and laundryman. But compared to the ubiquitous images of Chinese heathens and criminals, *Washee Ironee* at least depicts the Chinese boy as a sympathetic ally, rather than enemy, of the Gang.

The black newspapers heralded Billie Thomas's ascension to *Our Gang* main player with uncontained excitement. "Taking up the royal film scepter handed down by Sunshine Sammy, Farina and Stymie, little Billie Thomas, known to screen fans as 'Buckwheat' is now an important member of the Our Gang comedy crew," trumpeted the *Atlanta Daily World*.[37] "'Buckwheat' Is Now New King of 'Our Gang,'" shouted a headline from the *Norfolk New Journal and Guide*.[38] The *Chicago Defender* called him a part of "the sepia gentry here in Hollywood" and the latest "heir of the throne once occupied by Sunshine Sammy."[39] An only child, Billie Thomas was regarded with awe by the members of the Los Angeles black community, who saw him plucked from obscurity and inducted into *Our Gang* royalty. When he was first cast in the series, his family lived off Central Avenue, between Vernon and

Slauson, not too far from the Lincoln Theater, where Roach had held his open calls.[40] Soon after, Billie's family moved fifty blocks south, to the area that would become known as Watts. A neighbor recalled, "[he] lived on 108th between Central and Compton Avenues. . . . [He was] very, very protected. We would watch him from the playground. As far as conversation, there wasn't any conversation with him at all. We weren't allowed anywhere near inside his house."[41] Like Stymie before him, Buckwheat was kept in a bubble, cosseted and protected from the real world. His father, Will, worked as a janitor at the Wilton Apartments in Hollywood, and his mother, Mattie, was his on-set chaperone. Strong-willed and protective, it was Mattie who managed her son's film career. Every morning, she woke her son up early for the long drive down Washington Boulevard to the studio. They were never late. "Every new toy that came along, I wanted and I had," Billie later recalled. "My father bought me anything I wanted. I took my toys with me in the car, and I sometimes ate ice cream along the way."[42]

Billie Thomas's discovery story followed the familiar narrative of amazing luck against stupefying odds. According to studio statistics, by 1938, more than 140,000 children had auditioned for *Our Gang*, with only forty-one receiving contracts—placing the odds at a mind-boggling 3,400 to 1.[43] A person was more likely to be hit by lightning than to be cast as a star in *Our Gang*.[44] So desperate were stage mothers to get their children in the comedies that they proved easy marks for con men posing as official Hal Roach representatives. Several showed up unannounced at the studio gates, having traveled all the way from Texas and Oklahoma, claiming that their children had won contests entitling them to *Our Gang* contracts.[45] Billie, luckily, entered through authorized channels. "I started out when I was three years old," he later remembered. "My mother took me out to the studio on a regular interview day, and they needed a person, and that was it."[46] Cast in a bit part, Billie was so overwhelmed at first that he refused to take direction and burst into tears when anyone spoke to him. Given a second chance, he acquitted himself so well that he earned a long-term contract starting at $40 a week—more than his father was making at the time.[47] According to his official studio biography, Billie was born in Los Angeles on March 12, 1932, stood three feet tall, and weighed thirty-one pounds.

He possessed a "coal-black complexion with wide, luminous eyes and kinky hair," and he loved tinkering with toy automobiles, spending his free time taking them apart and putting them back together.

Billie Thomas's biography notwithstanding, the genesis of Buckwheat as a character was a remarkable piece of déjà vu. With his breakfast food nickname (his son surmises it was taken from the popular Aunt Jemima Buckwheat Pancake Mix), his indeterminate gender, his pigtails and costume of ragged dresses and oversized shoes, he was the second coming of Farina Hoskins.[48] Like Sonny before him, Billie apparently hated wearing girls' clothing and tore off his dresses as soon as filming ended.[49] He, too, could cry on cue. Even Mrs. Thomas's responses to reporters regarding her son's gender were a nearly verbatim echo of Mrs. Hoskins's responses to reporters ten years earlier. "'He is a boy and not a girl,' Mrs. Mattie Thomas, his mother, said emphatically" to the *Chicago Defender*.[50] The black newspapers too made the connection in their headlines, calling Buckwheat a "Great Double for Farina" or describing him as "Filling Farina's Shoes Nicely."[51] If the black children in *Our Gang* formed their very own dynasty, then Buckwheat was Farina II.

Why had Hal Roach "gone back to the archives," as it were? Why recycle a character from the 1920s, rather than develop a new black character, as the studio had done with Stymie? Why, in fact, resurrect the pickaninny, an already tired caricature, at all? Hal Roach gave a hint of the answer when publicizing the 1935 *Our Gang* short *Shrimps for a Day*. Describing theatergoers as tired of pre-Code "sex plays, murder mysteries, melodramas and the like," he declared that light screen comedies would once again rule. "People are emerging from the depression with a smile and they want to forget all of the unhappiness and sorrows of the past few years," he said. "There is no greater medium for bringing this condition about than cheerful motion pictures—films which will bring sunshine and laughter to [the] soul—and it is my sincere endeavor to produce the best of this character of screen entertainment."[52] Resurrecting Farina was to resurrect the good old days of *Our Gang*'s beginnings and the classic silent film comedies of the 1920s. It would remind longtime *Our Gang* fans—now ten or fifteen years older—of one of their favorite childhood stars. And

it would also establish *Our Gang* as a powerful and stable brand, reassuringly constant despite the passing years.

Frequently lauded as "the oldest single unit in motion pictures," *Our Gang* had proven its durability. To commemorate the fifteenth anniversary of the series, the studio invited members of the original Gang to meet what was now the fourth generation of their successors. Now in their late teens and early twenties, Farina Hoskins, Joe Cobb, Mary Kornman, Johnny Downs, and Jackie Condon all showed up, along with former directors Bob McGowan and Gus Meins, and the latest director, Fred Newmeyer. Hal Roach was unavailable, but his son, Hal Jr., recently graduated from military school and learning the family business, was on hand to represent his father. Miss Fern Carter, who still taught the studio school, served as toastmistress. Over a luncheon of watermelon, ice cream, and cake in the *Our Gang* cafe, the old and new Gangs mingled. In a studio photograph of the occasion, Farina, Joe, Mary, John, and Jackie, dressed in their Sunday best, stood in a row, waving gaily at the camera. Posed in front of them, as if in a family photo, were Billie "Buckwheat" Thomas, Baby Patsy, George "Spanky" McFarland, Carl "Alfalfa" Switzer, Darla Hood, and even Pete the Pup, great-grandson of the first *Our Gang* dog. The symbolism was clear. Buckwheat was Farina's progeny and protégé, just as Spanky was Joe's, and Darla was Mary's, and even Hal Jr. was Hal Sr.'s. "Our Gang—Past and Present," read the headline. Times would change, cast members would grow up and retire, but *Our Gang* represented continuity and consistency. The Gang today was essentially the same as the Gang of yesterday.[53]

In the case of Farina and Buckwheat, however, it was yet another retreat into the pickaninny, that calcified symbol of reassuring sameness. To recycle the fat boy character was one thing, but to recycle the pickaninny was to recycle a whole century of racial caricature. Whereas the other children wore pinafores and sweaters, beanies and suspenders—the typical uniform of copacetic 1930s childhood—Buckwheat wore repurposed flour sack dresses and minstrel shoes, looking like a refugee from a time machine. The gags, too, seemed a throwback to an earlier time. In *Anniversary Trouble* (1935), Buckwheat, whose mother is a maid played by Hattie McDaniel, switches outfits with Spanky

so the latter can sneak past the Gang. His face unevenly covered in black paint and his hair covered by a black cap dotted with pickaninny ribbons, Spanky makes a wholly unconvincing black-face Buckwheat, down to his clumsy plantation dialect. In *Little Sinner* (1935), Spanky, Porky, and Buckwheat play hooky from Sunday school and stumble across a black baptism scene, full of portentous chanting and shouting. Two white-gowned congregants, looking like extras from King Vidor's 1929 talkie *Hallelujah!*, stagger toward Spanky and Buckwheat, gesticulating wildly and jumping in the air, causing Buckwheat's pigtails to stand on end.[54] And in *Our Gang Follies of 1936*, the Gang stages a musical revue and invites a crowd of neighborhood kids. As the lights dim, a group of black kids disappears into darkness, their eyes glowing white. The series, like the character of Buckwheat, was going through a bad case of déjà vu.

The Gang had settled into its current configuration: Spanky, the stout, bossy ringleader; Alfalfa, the hayseed with the cracked singing voice and cowlick; Darla, the Gang's sweetheart; Buckwheat, the junior tagalong; and Porky, his chubby sidekick. Later, Tommy Bond would rejoin the cast as "Butch," taking over the role of neighborhood bully from Leonard Kibrick. Sidney Kibrick, Leonard's brother, would be cast as Tommy's sidekick, "The Woim." Pared down to a single, ten-minute reel, *Our Gang* was now directed by Gordon Douglas, who had worked his way through multiple jobs at Hal Roach Studios, from the casting office to the prop room to the position of assistant director on *Babes in Toyland*. *Our Gang* had barely survived the studio's transition to feature-length production that year. Despite the shorts' continued popularity, competition from double features continued to shrink the series' profit margins. Roach, who was ultimately a businessman, contemplated shuttering the series, but Louis B. Mayer of MGM convinced him to continue by agreeing to distribute the one-reel episodes, as well as to distribute a special *Our Gang* feature.[55] Before the 1936–37 season, Hal Roach Studios issued a press release announcing the new single-reelers, claiming "the public just couldn't stand for a discontinuance of *Our Gang*. Might as well abolish baseball!"[56] In *Film Daily*, MGM further touted the series' hold on the American imagination, recounting the legend of "famed comedy producer" Hal Roach, who "collect-

ed a flock of assorted kids" to create what was now, in effect, an American institution: "The Gang is as American as baseball and the circus, and there's no age limit to its enjoyment."[57]

Even Roach, the veteran Hollywood producer and avowed pragmatist, betrayed a sentimental streak when it came to the series. "If urged, [Roach] will proudly pull out photographs of Buckwheat, four-year-old pickaninny of 'Our Gang,'" a reporter noted.[58] Buckwheat was a good-luck charm, a symbol of continuity and durability, a link to the studio's past and perhaps a key to its future. His character was based on the pickaninny, itself an emblem of constancy to Southern apologists, and he performed a similar role in the life of the series. Depicting Buckwheat as a latter-day Farina was to suggest that despite the lapse of fifteen years, nothing much had changed in the world of *Our Gang*. Even Buckwheat's earliest appearances seemed to suggest a virtual rewinding of the clock. Like a silent film comedian plopped into a talkie film, Buckwheat was practically mute—all wide eyes and beaming smile. Spanky and Alfalfa did all the chattering, hatched all the plans, did all the lousy performing. Buckwheat was the silent onlooker, the good-natured soldier, the one who registered the greatest surprise and the greatest innocence. He was an immediate favorite among fans, described by Maltin and Bann as among the "most durable of all *Little Rascals*."[59] Precisely because he was such a cipher, anyone could relate to him. He wasn't cheeky, like Spanky, or vain, like Alfalfa. He just wanted to play.

Hal Roach attempted to transition *Our Gang* into features, using Spanky as its juvenile headliner. Eyeing Shirley Temple's success with her Civil War–themed features, *The Little Colonel* and *The Littlest Rebel,* he produced a burlesque melodrama about the Old South called *General Spanky*, featuring his young star as a pint-sized Confederate general, Buckwheat as a runaway slave, and Alfalfa as a fellow Confederate sympathizer. Louise Beavers, fresh off her role alongside Claudette Colbert in *Imitation of Life,* was cast as a housemaid; Willie Best (also known as "Sleep 'n' Eat" and marketed by Hollywood as a new Stepin Fetchit) played a house slave. Like the Temple features on which it was based, *General Spanky* capitalized on the public's renewed appetite for costume dramas and romanticized depictions of the antebellum

South, an appetite that would reach its zenith in the 1939 film *Gone with the Wind*. Full of slave spirituals, picturesque plantations, humorous mammies and Sambos, and Southern plantocrats, *General Spanky* was a nostalgic vehicle for a series that had become practically synonymous with nostalgia.

One of the film's central comic premises is Buckwheat's status as an "accidental" runaway slave. Although he was described as a pickaninny in the script, Buckwheat was allowed to shed his retro pigtails and dress and appear in the striped shirt and suspenders that would eventually become his trademark. Inadvertently separated from his overseer on a riverboat headed down the Mississippi, Buckwheat overhears two white men discussing the Civil War, which has just broken out. Both men agree that slavery is the war's main cause, with one man complaining, "Slaves have to be kept in tow. Every slave has to have a master," and the other agreeing, "And any slave that doesn't have a master ought to be shot." Panicked, Buckwheat bumps into Spanky, who is shining shoes on the boat. "Will you be my massa?" Buckwheat asks. "Huh?" Spanky answers. "Will you be my massa?" he repeats. "I don't want to be your master," Spanky says. "You wouldn't be any help to me. You're too small."

The boys bicker over whether Buckwheat is too small or not, until Spanky sighs, "business ain't so good." The two of them hatch a classic *Our Gang* plan, one first demonstrated by Sunshine Sammy and Farina in the 1923 silent short *A Pleasant Journey*. To drum up more business, Buckwheat will surreptitiously whitewash shoes, and Spanky will follow up with an offer of a shoeshine. Later, tossed off the riverboat and abandoned in the South, the two will join the war effort, an interracial army of two. Bumping into Alfalfa and a gang of other kids, they're surrounded and accused of being Yankees. "I'm no Yankee!" Spanky protests. "How you gonna prove it?" Alfalfa responds. "Well—I've got a slave!" Spanky answers, urging Buckwheat to identify himself. "I'se his slave!" Buckwheat pipes up. Alfalfa, his suspicions allayed, joins the army as a "second general," and the boys continue to get into comic mishaps, this time with actual Union soldiers. A secondary plotline depicts a romance between a Southern belle and her suitor, a reluctant Confederate soldier whose life is eventually saved by the intrepid Spanky. Louise Beavers and

Willie Best round out the film, providing additional comic relief as "happy darkies."[60]

General Spanky is a far cry from the more contemporaneous, grittier *Our Gang* shorts of just a few years earlier. While certain Gang trademarks remain—the interracial camaraderie, the pranks, the comic scuffles with adults—the film's historical and geographic setting is at odds with the Gang's usual backdrop of contemporary Anytown, USA. Faced with the historical reality of slavery, the Gang tries to sidestep its seriousness through comedy. Spanky is unwilling to "enslave" Buckwheat, not because of any lofty notions of social equality but because Buckwheat is "too small" and unhelpful. The two instead work out a shoeshine partnership and later mount their own quixotic army, albeit one that professes Confederate sympathies and that requires Spanky and Buckwheat to pretend to be master and slave. Such moments of friction might partially explain the film's lack of success with audiences. Shirley Temple and Billy "Bojangles" Robinson, recently partnered and separated by a vast gulf in age as well as race, had never been figured as true equals. The *Our Gang* kids, though, had a fifteen-year history of interracial equality, a history that played awkwardly against the film's Civil War setting.

Although *Film Daily* gave *General Spanky* a positive review, calling it a "grand picture" that managed to handle the Civil War "in such good taste that under no circumstances could either side have reason for offense," the movie was a box-office failure.[61] Along with its tricky subject matter, the film had stretched a typical ten- or twenty-minute *Our Gang* short into a seventy-one-minute feature, revealing weaknesses in comedic pacing and story line. Roach would give up on any further attempts to produce *Our Gang* features, leaving Douglas to hone the short, punchy *Our Gang* one-reeler. Douglas's very first contribution to the series, *Bored of Education,* won the 1936 Academy Award for Live Action Short Film, the only *Our Gang* entry ever to win the award and perhaps some consolation for the disappointment of *General Spanky.* Loosely based on McGowan's 1930 short *Teacher's Pet,* *Bored of Education* was a minor effort featuring Alfalfa faking a toothache and wheezing his way through another cracked singing performance.

Over the next two years, Douglas continued to direct eco-

nomical, tightly plotted one-reelers, stripped of the extraneous gags or tangents that had characterized McGowan's baggier, more improvisational style. The results were still charming, but also more streamlined and professional. Cary Grant, who was filming *Topper* on the Roach lot, would sometimes wander over and watch the kids, marveling at their acting skill.[62] Like Farina before him, Buckwheat was gradually allowed to ditch the pickaninny dresses and adopt a costume of suspenders and striped shirts. His hair was taken out of pigtails and allowed to grow into an afro. As he grew older, he was also given more lines, though a childhood speech impediment kept him from being understood much of the time. He was often paired with Eugene "Porky" Lee as the Gang's junior tagalongs, the two boys forming an interracial partnership that recalled the earlier friendship between Stymie and Dickie. With their trademark quip, "O-tay!" the two boys were united against the older kids and seemed to communicate in their own incomprehensible secret language. The series continued to recycle racial gags, like the monkey/black child mix-up and the white spots on black face, both of which appear in *Three Smart Boys* (1937). But it also cast Buckwheat in more contemporary roles, as in *Our Gang Follies of 1938*, where he plays "Cab Buckwheat," a junior version of Cab Calloway, the famous jazz singer and bandleader. Spanky is a nightclub impresario, running his own version of the Cotton Club, and Buckwheat is a "Harlem dandy," dressed sharply in white tails and a hat, dripping in diamonds.[63]

In other ways, however, things remained dispiritingly the same. Embarking on a national publicity tour with the rest of the members of the Gang, Billie Thomas was relegated to a colored hotel in Detroit while his white costars stayed in a fancy hotel downtown. The *Chicago Defender* reported, "The policy of not permitting Buckwheat to stay with the rest of the gang is not the wish of the other youngsters nor their parents but the jim crow policies of the theatre owners and the local sponsors of their appearance." In an ironic twist, Billie's segregation from his costars ended up being a protective form of quarantine. "Now six of the seven [Our Gang stars] who stopped in the exclusive hotel that was too good for Buckwheat are down with the measles while Thomas roams the streets," the *Defender* gleefully noted. Billie's mother discreetly refused to comment on the situation,

although she did allow that "she was glad Buckwheat had escaped the attack."[64]

Following in Farina's footsteps, Billie, too, was anointed a race leader, his career followed by black newspapers. During the Gang's tour of Chicago, he was feted by the *Defender*'s Billiken Club and allowed to play around on the newspaper's typewriters and telephone. Interviewed by David Kellum, still the club's editor, Billie announced, "I'm going to be a doctor, a cameraman, and a newspaper reporter when I grow up." He professed a fondness for Joe Louis, spinach, hamburgers and hotdogs, chicken, and ice cream, but was less than crazy about pork chops. Taken on a tour of Chicago's South Side, he was "favorable impressed," but admitted finding the city's "cool weather too much for him."[65] The paper photographed him getting ready backstage for an appearance at a local theater, his mother styling his hair into his pigtails. In another shot, Billie waves farewell to Chicago, dressed in his *Our Gang* costume, an enormous piece of luggage in hand.[66]

Later that year, Bernice Patton, a reporter at the *Pittsburgh Courier*, made a trip out to Los Angeles to visit Billie, who was in the middle of shooting *General Spanky*. Roach apparently insisted to Patton that Billie was "much too valuable to be typed in taboo pickaninny roles."[67] What Roach meant is unclear. Did he mean Billie was too valuable to remain in his floursack costume and pigtails? That *General Spanky* would offer Billie more dramatic latitude than a typical Old South feature? That the character of Buckwheat would eventually evolve into a more complex figure? Among members of the black community, there was a growing weariness with the unrelenting sameness of racial representations in Hollywood, with some critics, mostly from the East Coast, enjoining their Hollywood brethren to demand more progressive portrayals of the race. Loren Miller, an editor at the *California Eagle*, noted, "The Negro's place on stage and screen has been fixed for so many years that the tradition sways the judgment of Negroes themselves and honest whites."[68] The white movie critic Archer Winsten complained that Negroes inevitably played clowns, "dullard and menial," and criticized recent roles by Louise Beavers, Stepin Fetchit, Hattie McDaniel, and even Billie himself in *General Spanky*.[69] Defenders of Hollywood argued that movies were simply providing the racial pablum that white audiences

wanted and that to do otherwise would "raise hell in Southern box office."[70] For black Hollywood, the prevailing opinion was that such roles, however stereotypical, not only put bread on the table but also contributed to racial uplift and social progress by assuaging white fears.[71] The singer Etta James, who was born in Los Angeles in the 1930s, recalled, "In the Central Avenue of my childhood, the black actors were heroes. They might play fools on the screen, but the folks in the neighborhood knew it took more than a fool to break into lily-white Hollywood."[72]

If Roach had plans for Billie and the rest of the Gang, they never came to fruition. In 1938, faced with dwindling profits and bookings on his *Our Gang* shorts, and presented with an attractive distribution contract by United Artists, Hal Roach gave up. He sold the entire *Our Gang* production, "lock, stock, and barrel," to MGM, located just a few blocks west on Washington Boulevard.[73] It was the end of an era. Though the *Our Gang* kids and their director, Gordon Douglas, would only be moving down the street, MGM was a world apart from Hal Roach Studios. If Hal Roach was Hollywood's scrappy, independent studio, MGM was the industry behemoth. Vast and industrial, covering more than forty acres and employing thousands of employees, MGM pumped out fifty pictures a year and boasted a roster of stars that included Norma Shearer, Jeanette MacDonald, Joan Crawford, Greta Garbo, Clark Gable, Spencer Tracy, and Jean Harlow. Its films were lavish and slick, its production values high, its machinery well oiled. At Hal Roach, everyone knew each other and treated each other like family, with the *Our Gang* unit regarded with special fondness as the studio's longest-running single production. On the MGM lot, the *Our Gang* unit was just one of many units churning out product and managed by a seemingly endless parade of studio executives.

To be sure, the central cast remained the same, offering the illusion of continuity and consistency, and the *Our Gang* brand was still very much alive to exhibitors and audiences. Roach, too, maintained to the trades that *Our Gang* would retain the "Roach imprint," that the move to MGM was "in no sense equivalent to being sold down, or up, the river" (an ironic choice of words, especially after *General Spanky*).[74] But for the kids themselves, the immediate world around them—the world of prop men and

cameramen and producers—had changed. Transplanted to a new studio, with a new culture and a new crew, the series was undergoing a "rejuvenation" from without, this time, not within. The kids were moving away from "home," as it were, away from the intimate and the familiar. In a publicity still chronicling the move, Darla, Porky, Buckwheat, and Alfalfa stride jauntily through the MGM studio gates, looking like college freshmen stepping onto campus for the first time. Dressed sharply, personalized suitcases in hand, the Gang looks confident and eager for this next stage of their professional lives.

In reality, however, all of the kids felt a sense of displacement and loss. Porky described the moment as "traumatic": "We were leaving a friendly home, the Roach studio, and entering a huge factory, to *work*."[75] Tommy Bond described MGM as more "impersonal" and "business-like," concluding, "This was definitely NOT 'The Lot of Fun.'"[76] Darla echoed his sentiments. "We knew something had changed. I mean even the kids felt it, and I remember Spanky and Alfalfa particularly sensed it. Instead of playing, having fun under a director's supervision, as we'd done on the Roach lot, we suddenly became aware that we were supposed to be performing. After a few M-G-M shorts, I knew what I was doing. I knew I was acting; before I didn't know it."[77]

The "good old days" of Hal Roach were over; the MGM days had begun.

8

The Good Soldier

As America emerged from the Depression, Adolf Hitler and the Nazi Party were consolidating power in Germany, embarking on a period of rapid militarization and mass indoctrination. The 1936 Olympics, held in Berlin, were to be Hitler's coming-out party to the world, a chance for him to showcase the nation's ideology of Aryan superiority. An enormous new sports complex was built and the city festooned with Olympic flags and swastikas. Posters were issued linking Nazi Germany to ancient Greece and promoting an Aryan racial ideal. Berlin was swept clean of the resident Roma population, and anti-Jewish signs were temporarily removed. Watching newsreel footage at home, Americans were transfixed by the pageantry of the Games—of Hitler and his entourage entering the Olympic Stadium to a chorus of three thousand Germans singing "Horst Wessel Lied," the Nazi anthem; of the airship *Hindenburg*, emblazoned with the Olympic rings, swooping over the stadium; of the spectators in the stadium—all one hundred thousand of them—raising their arms in the Nazi salute.

Against this orgiastic display of propaganda stepped twenty-two-year-old Jesse Owens, the Ohio State University track-and-field star known as the "Buckeye Bullet." Born in Alabama in 1913, Owens was the son of a sharecropper who joined the Great

Migration in the years after World War I, settling his family in Cleveland, Ohio. Along with Joe Louis, Owens was one of the most famous African American athletes of the 1930s, renowned for his sportsmanship as well as his speed. Quietly but devastatingly, the lanky Owens dismantled what Hitler's propaganda machine had so strenuously constructed—the myth of white racial superiority. In one event, and then another, and then another, he triumphed over his German competitors, collecting four gold medals in all. The American press reveled in his victories, calling it a rebuke of Nazi ideology and interpreting Hitler's absence at Owens's medals ceremony as a personal "snub."[1] Owens returned to America a national hero, the guest of honor at ticker-tape parades and receptions around the country. In the midst of all the celebration, however, one well-wisher remained conspicuously silent. Years later, Owens recalled, "Hitler didn't snub me—it was our president who snubbed me. The president didn't even send me a telegram."[2]

Roosevelt's "snub" was emblematic of the growing chasm between America's rhetoric of democracy abroad and its practice of democracy at home. How could a nation that decried the rise of Fascism and anti-Semitism in Europe condone the treatment of African Americans in its own backyard? The black community had rallied behind the nation during World War I, heeding Woodrow Wilson's cry to make the world "safe for democracy" and sending nearly four hundred thousand of its young men into the armed forces. Honorable service, they hoped, would confirm their loyalty to the nation and help pave the way to full citizenship rights. Instead, black soldiers returned home to a wave of racial violence and discrimination, to riots and lynchings and the continued indignities of Jim Crow. FDR's presidency had also proven a disappointment when it came to advancing civil rights, with the snub of Jesse Owens further evidence that the president remained fettered to the Southern Democrat wing of his party. Disillusioned, African Americans greeted calls to band against the ascendant Axis powers with considerable cynicism. As the political situation in Europe deteriorated, the *Crisis* published a series of articles detailing the history of Jim Crow in the military and quoting Charles Houston, an NAACP attorney, who pointedly

noted, "The army cannot ignore and reject the Negro in time of peace and expect him to function with one hundred per cent efficiency in time of war."[3]

A pall of cynicism had also descended on *Our Gang*. Gordon Douglas, who had made the move to MGM with the cast, quickly returned to Hal Roach Studios after finding his new workplace something of a culture shock. MGM was a factory, with all the fanciest sets and top technical experts. The whole production process—writing, budgeting, shooting, and editing—was minutely regimented and supervised. Scripts were refined and rehearsed to the tiniest detail. But while the shorts may have *looked* great, they were becoming a shiny shell of their former selves. For Douglas, part of the problem was that MGM didn't seem to "get" the spirit of *Our Gang*. MGM "involved the kids in adult problems [in the films], and I think it was a mistake," he said. He also recalled a kind of mean-spiritedness, claiming, "We never made fun in the Roach days of any physical deformities, and Metro did, in a few pictures I remember."[4] Douglas was lucky. When he got homesick for Roach, the studio was there to take him back. The kids, however, were stuck. As much as they might miss their old stomping ground, there was no going back.

George Sidney was hired to take Douglas's place. Only twenty-one years old, Sidney was the son of a vaudeville actress and a theater producer and had even briefly been a child actor before working his way up at MGM. For Sidney, directing *Our Gang* was an obligatory apprenticeship until he graduated to MGM features—he would later direct *Annie Get Your Gun* and *Show Boat*. Not much older than the *Our Gang* cast, Sidney chafed at the onerous production process and the pressures of wrangling so many kids and their stage parents. "It is very possible that doing that series conditioned me to hate all kids," he later recalled.[5] To be fair, the kids he was left with *were* a handful. Spanky, who had left *Our Gang* just before the MGM move, was rehired by MGM shortly thereafter. There, his rivalry with Alfalfa continued unabated, fanned by their fathers, who jockeyed aggressively for more screen time for their sons. Mercurial and defiant, Alfalfa terrorized the lot, retaliating for any perceived slights. When a cameraman got mad at him, Alfalfa responded by shoving a huge wad of gum into his camera. When a director re-

proved him, Alfalfa urinated all over the floor lights. Once, in a fit of pique, Alfalfa forced thirty-two takes of a scene with the Gang hanging onto the back of a truck. (The only reason there wasn't a thirty-third was because Darla passed out from the exhaust fumes and had to be rushed to the hospital.)[6]

MGM released a publicity photo of Billie in character as Buckwheat, beaming over a head-shot of his favorite MGM star, Clark Gable, soon to appear as Rhett Butler in the blockbuster *Gone with the Wind*. Buckwheat, the studio seemed to suggest, was simply tickled to be on the same lot as his matinee idol; the two actors even seemed to grin in unison. In other ways, however, the two could not have been more different. Billie was dressed in his *Our Gang* costume of striped shirt, ragged pants, and oversized shoes, his hair in an unbrushed afro. Clark Gable was dressed in a tuxedo, his hair slicked back with pomade and his mustache neatly trimmed. They were the pickaninny and the leading man, under contract at the same studio but separated by a vast gulf of age, race, and available roles. Billie might have been part of the MGM "family," but he would never grow up to be Clark Gable.

"Family" meant something different at MGM than at Hal Roach Studios. At Roach, it meant you were part of a close-knit group that worked together on gags, ate together at the *Our Gang* commissary, and often socialized together after hours. Hal Roach was the genial studio head, at ease with everyone from the studio carpenter to the star talent. While Roach ran his studio like a democracy, Louis B. Mayer ran MGM like a monarchy. As the actor Turhan Bey remembered, "MGM had a caste system, just like India."[7] The studio was strictly hierarchical, with no mixing of employees of higher and lower status. When Mayer, a volatile and intimidating figure, crossed through the cafeteria on his way to his private dining room, everyone stood up.[8] A star like Clark Gable was part of the elite at MGM. He was "the rock upon which MGM was built" and one of the highest paid actors in Hollywood.[9] Billie, in contrast, was nobody.

The studio executives at MGM didn't help matters, treating Billie as a second-class citizen. Sidney remembered how they rushed into his office one day, demanding that he reshoot the previous day's scenes. The problem? "You had the black boy standing next to a white girl," they complained. In the end, Sidney

reworked the entire scene rather than simply moving Billie away from Darla. "I wasn't going to have a lovely boy like Billie Thomas, nine years old, be told they had to reshoot something on account of that," Sidney said.[10] During promotional tours, Billie found himself overlooked by the MGM writers, given nonspeaking roles, and thrust into the background. Mattie would not have it—Spanky and Alfalfa weren't the only ones with stage parents, after all! Pulling her son aside, she announced, "I'm tired of you having to stand around in the background like a dummy. We're going to make up your own routines."[11] The two came up with their own comedy bits and successfully tried them out at the Gang's next appearance. Gradually, the MGM writers began to give Billie bigger parts.

At home, the cast was undergoing another shift, adding to the sense of upheaval. Porky, Billie's partner in crime, had shot up several inches in height and was abruptly retired at the age of seven. Mickey Gubitosi, later known as Robert Blake, took his place. Sidney "The Woim" Kibrick retired a few months later, followed by Tommy Bond. Alfalfa, who was now twelve and had clearly outgrown the series, retired at the end of 1940. Billy "Froggy" Laughlin, who had been introduced earlier that year in a supporting role, was promoted to a main cast member. Director George Sidney was long gone, having lasted little more than a year with the Gang and presumably more than happy to leave the kids behind. Edward Cahn, who would later go on to a career directing B movies, took his place, helming the series for the next four years.

Billie, Spanky, and Darla were now the only holdovers from the Hal Roach days, a process of natural attrition that reaffirmed that the series was now essentially an MGM product. Exhibitors wrote into the trade magazines, complaining that the comedies were falling off in quality and popularity. "Any time they want to stop these Gang comedies it will be all right with us. They do not have the Gang Hal Roach used to have," wrote one theater owner.[12] Another complained, "It is a shame to let these Gang comedies peter out as Metro is doing. They need the Hal Roach touch and new talent."[13] Part of the problem was that the stories were becoming increasingly contrived and the acting increasingly stilted. MGM's heavy-handedness when it came to production

Matthew "Stymie" Beard wearing his signature derby, reportedly a gift from comedian Stan Laurel, circa 1932. Author's collection.

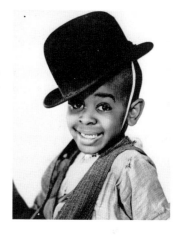

Best friends Stymie Beard and Dickie Moore, circa 1932. Stymie later told Dickie: "I have to say it, man, you were my favorite when I was a child, Dickie Moore. You never called me 'nigger.'" Courtesy of Marc Wanamaker/Bison Archives.

Our Gang, 1932. From left to right: George "Spanky" McFarland, Bobby "Wheezer" Hutchins, Dorothy DeBorba, "Breezy Brisbane" McComas, Sherwood "Spud" Bailey, Matthew "Stymie" Beard, and Pete the Pup. The kids in *Our Gang* now saw each other more as rivals than as friends. Author's collection.

Stymie Beard, 1932. With his dapper suit and hat, Stymie was a departure from the stereotypical "pickaninny" caricature of *Our Gang*'s silent years. Author's collection.

MGM advertises Hal Roach shorts, 1933. Roach left Pathé for MGM in 1927 to take advantage of "block booking" with MGM features. Courtesy of Media History Digital Library.

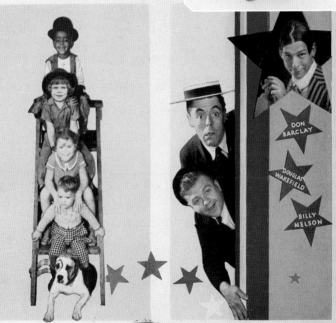

6 OUR GANG

TWO REEL COMEDIES

"This Hal Roach fellow is a genius. He has a marvelous idea for the NEW SERIES of Our Gang—says it came as an inspiration while flying cross-country in an aeroplane. And what an idea it is! Look for something entirely new — sure-fire in its audience appeal. Spanky, the youngster that made such a hit last year will be right up front — the rest of Our Gang, too. The public will get a brand new kick out of the NEW 'OUR GANG'."

8 HAL ROACH ALL STAR

TWO REEL COMEDIES

"Imagine touring the world for an idea! Hal Roach did it! Toured all Europe looking for big-time talent— found it in England in Douglas Wakefield and Billy Nelson. Then Hal (everybody calls him Hal) raids Broadway and signs up Don Barclay, sensational comedy favorite of revue spectacles. Supported by a flock of other talent, action will stick out all over this series. It was Hal Roach All Star series such as this that developed stars like Harold Lloyd, Bebe Daniels, Laurel and Hardy and others. History repeats!"

M-G-M FEATURE STRENGTH SHORTS

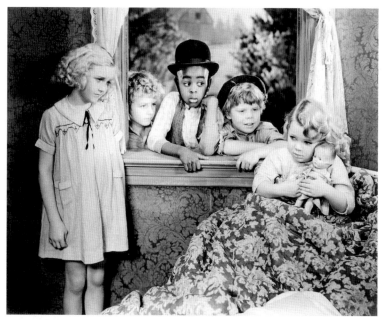

Stymie Beard in *For Pete's Sake!*, 1934. Bob McGowan had retired, and Gus Meins was now directing *Our Gang*. Author's collection.

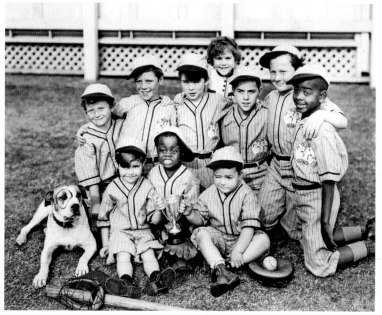

Our Gang's integrated baseball team, 1935. Stymie would soon age out and be replaced by Billie "Buckwheat" Thomas. Author's collection.

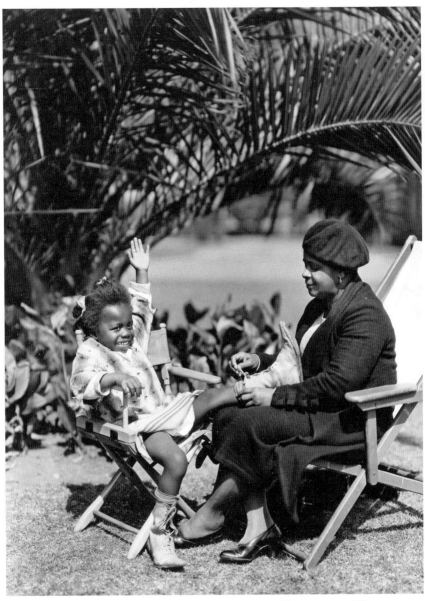

Billie "Buckwheat" Thomas and his mother, Mattie Thomas, 1935. Wearing his hair in pigtails and dressed in a floursack dress and oversized shoes, Buckwheat marked the return of the pickaninny stereotype. Photograph courtesy of William Thomas Jr. and David W. Menefee from *"Otay!": The Billy "Buckwheat" Thomas Story* (Albany, Ga.: BearManor Media, 2010).

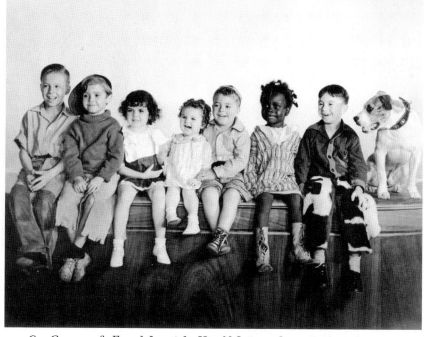

Our Gang, 1936. *From left to right:* Harold Switzer, Scotty Beckett, Darla Hood, "Baby Patsy" Dittemore, George "Spanky" McFarland, Billie "Buckwheat" Thomas, Carl "Alfalfa" Switzer, and Pete the Pup. Author's collection.

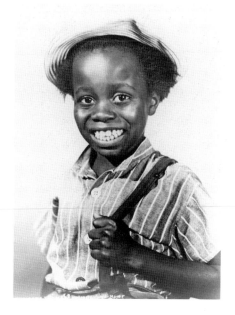

Billie "Buckwheat" Thomas, 1936. Buckwheat's costume eventually settled on a striped shirt, suspenders, and straw hat. Author's collection.

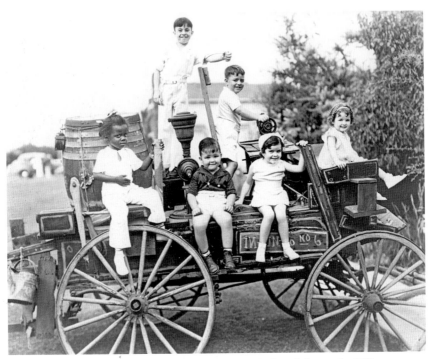

The Gang on a makeshift fire engine, circa 1936. *From left to right:* Billie "Buckwheat" Thomas, Carl "Alfalfa" Switzer, Eugene "Porky" Lee, George "Spanky" McFarland, Darla Hood, and "Baby Patsy" Dittemore. Porky and Buckwheat, the Gang's junior tagalongs, were best known for their signature expression, "Otay!"—the result of a speech impediment. Author's collection.

Hal Roach and the Gang, circa 1937. Faced with declining profits, Roach aggressively moved into feature production and slashed *Our Gang* to one reel. Notice Spanky aiming his toy pistol at Roach. Photograph courtesy of Photofest.

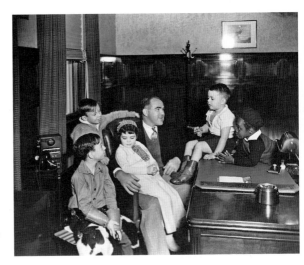

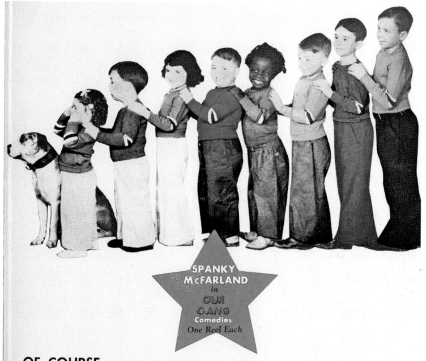

SPANKY McFARLAND in *OUR GANG* Comedies One Reel Each

OF COURSE SPANKY will continue to star in "Our Gang" comedies now being made by as spry a troupe of youngters as ever gathered under the Klieg lights. The "Our Gang" Comedies are in 1-reel each now and definitely a bright spot on any program.

ALFALFA! Certainly, there he is in the photo above, second from the right. It sure had to be *trick* photography to remove his freckles from the photograph and to re-arrange those eyes! But on the screen he's got all those things that make folks chuckle and a weirder voice than ever!

NATURALLY Hal Roach will continue to make "Our Gang" Comedies in single reels in addition to his new Feature Production enterprise. The public just wouldn't stand for a discontinuance of "Our Gang". Might as well abolish baseball!

"OUR GANG FOLLIES OF 1937" The first one was such a joy that it's good business all around to have another in the new season. Based on the experience with last season's Gang Follies, they've developed some new Gang gags that are positively marvelous. Wait!

Certainly, in addition to his FEATURES, there will be
12 HAL ROACH-OUR GANG COMEDIES
in *One Reel Each*
(*Last Page over there* ☞)

Our Gang advertisement, 1936. Spanky and Alfalfa were now the stars of the series. Courtesy Media History Digital Library.

Alfalfa, Buckwheat, and Spanky in *General Spanky,* 1936. Alfalfa and Spanky played Confederate generals, and Buckwheat played an "accidental" runaway slave. The film was Roach's sole attempt at an *Our Gang* feature and did poorly at the box office. Soon after, Roach sold the series "lock, stock, and barrel" to MGM. Author's collection.

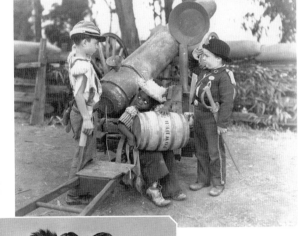

Buckwheat, Alfalfa, Darla, and Porky reading their first script at MGM, 1938. Eugene "Porky" Lee later recalled the move as "traumatic": "We were leaving a friendly home, the Roach studio, and entering a huge factory, to *work*." Courtesy of Marc Wanamaker/ Bison Archives.

MGM studio boss Louis B. Mayer with the *Our Gang* cast in a patriotic publicity shoot, circa 1941. Photograph courtesy of William Thomas Jr. and David W. Menefee from *"Otay!": The Billy "Buckwheat" Thomas Story* (Albany, Ga.: BearManor Media, 2010).

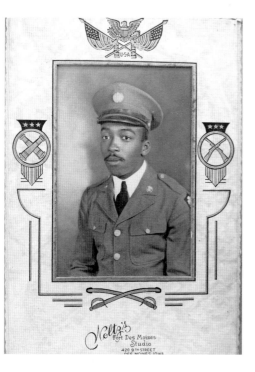

Private Allen C. Hoskins of Company D, Forty-seventh Quartermaster Regiment, 1941. Allen later told his son that it wasn't until he joined the army that he experienced "outright racism." Courtesy of Michael Hoskins/Allen Clayton Hoskins Papers.

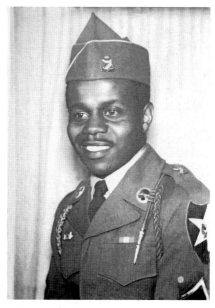

Private First Class Billie Thomas, Thirty-eighth Infantry, circa 1954. In 1948, President Truman signed Executive Order 9981, which integrated the armed forces. Billie joined a fully integrated army and served in Korea. He received a National Defense Service Medal and a Good Conduct Medal and was honorably discharged in 1962. Photograph courtesy of William Thomas Jr. and David W. Menefee from *"Otay!": The Billy "Buckwheat" Thomas Story* (Albany, Ga.: BearManor Media, 2010).

Stymie Beard, circa 1934 and 1975. After years of drug abuse and time in prison, Stymie made a comeback in the 1970s, appearing in *Good Times, The Jeffersons,* and *Sanford and Son.* The photograph is addressed to Huey Newton and signed, "To Huey, Power to the People, Stymie." Photograph courtesy of Dr. Huey P. Newton Foundation Inc. Collection, Special Collections and University Archives, Stanford University.

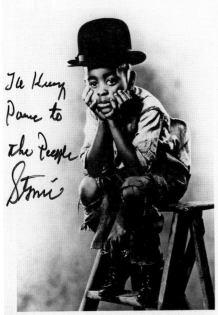
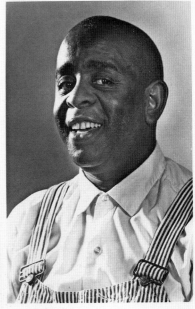

STYMIE BEARD

Allen C. Hoskins with visiting Japanese educators at his training workshop for the intellectually and developmentally disabled in California, 1970. Originally published in the Hayward, California, *Daily Review,* April 2, 1970. Photograph by Jim Chapman. Reprinted with permission of *Daily Review.* Copyright 2015; all rights reserved.

Eddie Murphy as "Buckwheat" on *Saturday Night Live*, 1981. Billie Thomas had recently passed away, and his son, Bill Jr., was hurt by the impersonation.

Billie Thomas stands in front of a photograph of "Buckwheat," 1981. Billie worked for many years as a Technicolor lab technician for MGM but expressed no desire to return to the screen. William Thomas Jr. and David W. Menefee from *"Otay!": The Billy "Buckwheat" Thomas Story* (Albany, Ga.: BearManor Media, 2010).

Al Hoskins died in 1980, just before his sixtieth birthday. Hal Roach, who was eighty-eight years old, sent this condolence card and flowers. Courtesy of Michael Hoskins/Allen Clayton Hoskins Papers.

Deepest Sympathy

To my favorite actor.

Hal Roach..

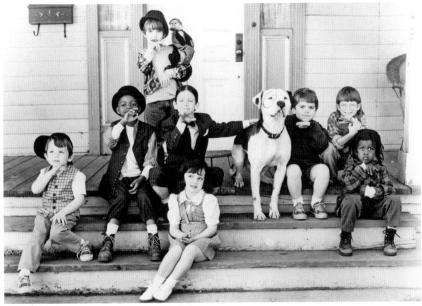

The Little Rascals, directed by Penelope Spheeris, 1994. "Stymie" and "Buckwheat" were updated to eliminate racial stereotypes like plantation dialect, pickaninny clothes, and wild hair. Author's collection.

oversight and procedure seemed to spill over onto the screen. The Gang now lived in Greenpoint, a town as insipid as its name. In films like *Dog Daze* (1939), stagey close-ups made the kids appear less and less natural. Parts were now so heavily scripted that the kids were more consumed with getting their lines exactly right than about delivering them in an unaffected way. Worst of all, MGM changed the very spirit of the series. Instead of letting the kids be kids, as Roach did, MGM tried to make them grow up. The comedies morphed into morality plays and educational films, full of "adult" lessons. Presented with such leaden fare, audiences—young and old—rebelled. To borrow the title of *Our Gang*'s Oscar-winning entry, they were "bored of education."

It was a terrible misfire. While the Roach films had also imparted lessons in citizenship and fair play, they were leavened with enough mischief and unruliness to make the lessons delightful rather than didactic. The MGM shorts, in contrast, were humorless. Adding to audience discontent was the fact that MGM retained stars like Alfalfa and Spanky well into awkward adolescence. Roach had always maintained the youthfulness of his series by gradually introducing new, younger cast members as the older ones aged out. Farina, his longest-running star, was only ten years old when he "retired." Alfalfa, meanwhile, was nearly thirteen when MGM finally ended his tenure on the series. Spanky, who was practically the same age, lingered on, saved by the fact that he remained short. Billie and Darla, who were both around ten years old, were also retained, despite being near the end of their viability as "child" stars. *Our Gang* was becoming a fossil, its actors past their prime, its plots stale. MGM didn't seem to care. For the studio, there was little incentive to improve the product because they had a captive consumer base—if exhibitors wanted to screen MGM features, they had to buy the whole MGM "bundle," shorts included. In May 1939, C. L. Niles, a theater owner in Anamosa, Iowa, complained to the *Motion Picture Herald*, "These Gangs are slipping. Need new characters, better stories, and better direction."[14] Two years later, he was even more succinct: "These Gangs have gone to pot."[15]

By mid-1940, with Europe now fully embroiled in war, the rhetoric of democracy had reached a new level of urgency across the

Atlantic. It seemed only a matter of time before America, too, would be drawn into the conflict. Under pressure from African Americans to put an end to racial discrimination in the armed forces, FDR presented what the NAACP snidely referred to as the "White House Jim Crow plan." While Roosevelt promised Negro representation in all branches of the military and equal opportunity for employment at military facilities, he stopped short of desegregating the armed forces. "The policy of the War Department is not to intermingle colored and white enlisted personnel in the same regimental organizations," the White House memo blandly stated. "This policy has been proven satisfactory over a long period of years, and to make changes would produce situations destructive to morale and detrimental to the preparation for national defense." The *Crisis* responded with a howl. Destructive to morale? Detrimental to the preparation for national defense? The magazine pointed out that the continued segregation of the military, on top of the latest failure to pass a federal antilynching bill, had alienated the African American community and undercut the nation's call for loyalty and democracy. The *Crisis* tersely noted, "It is being said that the strongest defense of democracy lies in the unity of all groups in the nation and a conviction that each has a stake in a democratic government." The far graver threat to morale and national preparedness, it argued, was the exclusion of African Americans from this democratic promise.[16]

With the bombing of Pearl Harbor in December 1941, this question was no longer academic. America was at war, and the nation needed the support of all its citizens, whatever their color. The Office of War Information (OWI) was created the following June to marshal the forces of media—the press, radio, and motion picture—on behalf of the war effort. Essentially a propaganda agency for the U.S. government, OWI was particularly concerned about the allegiance of African Americans. Internal polls revealed that while the black community disapproved of the Nazis and their racist ideology—having had ample experience with "minor Hitlers" at home—they were nonetheless conflicted in their support of the war. Years of racial injustice at home had eroded their faith in the American government, and some even felt that the Japanese, as fellow people of color, might offer a better lot in the future. In a survey of Harlem blacks conducted in early 1942,

48 percent of those interviewed believed they would be no worse off if Japan won the war, and 18 percent thought they would actually be better off.[17]

Despite these dismal numbers, most African Americans were fundamentally patriots, eager for the reform of the nation, not its overthrow. Black newspapers like the *Pittsburgh Courier* launched a "double V campaign," calling for victory against Fascism abroad and Jim Crow at home. Dr. Benjamin Mays, president of Morehouse College, echoed the *Courier*'s cry in the pages of the *Crisis*, describing how the Negro "must fight on two fronts."[18] To those who expressed sympathy for Japan, he warned, "Japan has no particular love or interest in the darker peoples of the earth. Japan is for Japan." Indeed, he continued, as bad as the American situation was, it would be far worse under Hitler, with Negroes treated even worse than Jews.[19] Walter White, head of the NAACP, called on black Americans to "fight for the right to fight." Along with civil rights activists A. Philip Randolph and Bayard Rustin, he proposed a march on Washington to protest the segregation of the armed forces. Yielding to their pressure, FDR signed Executive Order 8802, banning racial discrimination in the national defense industries, though segregation within the military remained intact.

At OWI, Philleo Nash, a special assistant to the director, suggested another way to secure the loyalties of black Americans. Why not promote "the metaphor of 'Uncle Sam's family,'" where Americans of varied racial and ethnic backgrounds were figured as equal members of a family, united in their resistance to the Axis powers? Gardner Cowles, publisher of *Look* magazine, put it another way: "unless the Negro is made to *feel* he is part of America we cannot expect him to be a good American."[20] The agency turned to the movie industry to help disseminate a message of unity by filming combat units comprised of multiethnic coalitions of Americans—never mind that this was literally a fantasy, since the military remained segregated. OWI also tried, with less success, to eliminate stereotypical images of blacks in film, which they felt not only alienated black Americans at home but also undermined the image of American democracy abroad. Some films, like the combat pictures *Crash Dive* (1943) and *Sahara* (1943), depicted African Americans in heroic roles and allowed

them some measure of equality and dignity on screen. Most films, however, still depicted African Americans in stereotypical guise as clowns and entertainers—a race apart. Movie musicals were especially problematic, exploiting popular conceptions of African Americans as superstitious, comic, high-spirited singers and dancers. In 1945, a Columbia University study found that a vast majority of black appearances in wartime films perpetuated racial stereotypes.[21]

When it came to representing black characters with greater dignity, MGM's record during the war was decidedly mixed. On the one hand, in films like *Bataan* (1943), the studio appeared to heed OWI's call for cinematic diversity by casting Kenneth Spencer as a loyal and heroic black soldier. In others, however, the studio was notably recalcitrant and tone-deaf. Around the same time, the studio began work on a film called *The Man on America's Conscience,* a historical costume drama about President Andrew Jackson that whitewashed his dismal record on black rights and painted a historically inaccurate picture of Reconstruction. OWI's Bureau of Motion Pictures joined forces with Walter White and others to protest the film, believing it would further estrange the black community when it was critical to bring them into the fold. MGM responded by accusing the bureau of allowing a "minority in the country" to dictate what appeared on screen. In the end, MGM grudgingly allowed reshoots and renamed the film the more anodyne *Tennessee Johnson.*[22]

Magnifying the stakes for OWI was the wave of race riots breaking out across the country. Not since the Red Summer of 1919 had there been such a concentrated period of racial discord erupting into mass violence. In New York and California, Alabama and Texas, racial strife was undermining the rhetoric of national unity and—worse yet—providing powerful ammunition to the Axis propaganda machine.[23] In June 1943, the worst of these riots erupted in Detroit, the main production center of the war effort and the so-called arsenal of democracy. Like the Chicago Race Riot more than twenty years earlier, the Detroit Race Riot was the violent expression of tensions over housing discrimination and a changing racial and industrial landscape. Federal troops were called in to quell the unrest, but the damage was already done. Not only was there the loss of human life and property—

nearly forty people killed, most of them African American, and nearly two million dollars worth of property damage—but the riot was eagerly taken up by the Axis Powers as evidence of a weak American nation, riven by race hatred, social injustice, and class warfare. Now, more than ever, OWI was fighting its own propaganda war against the Nazis, and it needed Hollywood on its side.

At first, *Our Gang* might have seemed an unlikely soldier in OWI's efforts. It was a children's comedy series more concerned with pranks and playing hooky than about an international war against Fascism. On closer look, however, the comedies were a perfect fit. Here was a group of kids who *already* represented Philleo Nash's "metaphor of 'Uncle Sam's family'"—who *already* depicted black members united with white members in an allegory of American democracy. Sure, the enemies were Butch or his successor, Freddy "Slicker" Walburn, but what were Butch and Slicker but mini-Fascists, dictators of the playground and neighborhood? Even MGM's style of heavy-handed moralizing was a perfect fit for the heavy-handed messaging of war propaganda. In a film like *Helping Hands* (1941), Spanky gets a letter from his older brother, who has just been drafted, instructing him to "take care of things" while he is away. In response, the kids mount their own *Our Gang* army, a multicultural unit that would have made OWI proud. Eagerly waiting in line to be drafted are Lee Wong, Jose Gonzalez, Herb Schwartz, and Nicolas Pappas, a rainbow panoply of loyal Americans. When a U.S. Army major interrupts their drills to suggest they redirect their efforts to the local Civilian Defense Council, Spanky and his gang throw themselves into activities like clearing the streets of refuse and other "fire dangers," collecting pots and pans to help build warplanes, and buying defense savings stamps. In *Calling All Kids* (1943), any plot is dispensed with altogether, with the Gang simply staging a patriotic revue. Opening with Janet Burston singing an homage to the U.S. military ("We don't mind working hard and paying taxes, / If they can get rid of the Japs and Axis"), the show includes a chorus line of kids in uniform, a recruiting skit by Mickey and Froggy (Froggy: "I've got an axis to grind!"), and a skit where Buckwheat imitates Eddie "Rochester" Anderson from the Jack Benny feature *Love Thy Neighbor* (1940).

In other films, like *Baby Blues* (1941), the Gang's perennial

message of racial tolerance is made excruciatingly explicit, in keeping with its new propagandistic mission. Mickey's parents are expecting their fourth child, and Mickey, after reading some statistic that one in four children is born Chinese, assumes that his new sibling will also be Chinese. Despondent, he goes to the zoo to speak to the stork and ask for "an American baby like me." Meanwhile, neighborhood bullies are taunting Lee Wong, singing "Ching-Chang-Chinaman, Sitting on a Rail" and asking him, "Where's your pigtail?" to which Lee Wong responds, "We don't wear pigtails anymore." Spanky steps in to defend his Chinese friend with the moralistic battle cry, "It doesn't matter if a kid is a Chinaman or anythin' else. If he's a good kid, he's ok!" (to which Mickey mopes, "Looks like I'll be fighting all the time to help save my brother!"). In gratitude, Lee Wong invites the Gang back to his house for lunch. Mickey is worried they'll have to eat birds' nests, and Buckwheat thinks they'll be served rats' tails. Instead, Mrs. Wong serves a delicious and eminently American meal of ham and eggs. Stuffed, Mickey concedes that having a Chinese brother might not be such a bad thing after all, especially if that brother is "as nice as Lee Wong"—only to come home to discover his mother has given birth to (ba-dum-bump!) twin girls.

Baby Blues still clings to racial stereotypes—Lee Wong's father runs a laundry, and the script is studded with references to "Confucius say"—but the film's strident message of tolerance and its expansion of what it meant to be "American" was a significant step, given the film industry's long history of demonizing "Chinamen."[24] This was Uncle Sam's family—Spanky, Mickey, Buckwheat, and even Lee Wong—united by American values and American cuisine. In the realm of wartime propaganda, racial demonization was now directed at that other Asian race, the Japanese, who were endowed with the barbaric, subhuman, and violent tendencies so long ascribed to African Americans and the Chinese. *Our Gang* itself refrained from caricaturing the Japanese, drawing the line at warbling against the "Japs" in song or invoking them in vaudeville patter.[25] To do more would be to puncture the image of racial amity and childhood innocence so associated with the series.[26] Blatant racial intolerance, even during wartime, was something the Gang avoided.

When it came to Billie "Buckwheat" Thomas, he remained

the consummate good soldier. Already a long-standing and loyal member of the Gang, he was proving himself an equally good patriot, participating in the filmed revues as the representative African American and joining his castmates off the screen in war bond drives and patriotic photo shoots with studio boss Louis B. Mayer. But as Billie and his mother had noted during their promotional tours, MGM and its writers seemed to take him for granted. Whether it was laziness or racism or a combination of both, screenwriters Hal Law and Robert A. McGowan (not Uncle Bob, but his nephew of the same name) often resorted to casting Buckwheat in default caricatured roles, even as they exploited his usefulness to the war effort. In the countless treatments and script revisions to a comedy like *Unexpected Riches* (1942), we can see how the MGM writers incrementally amplified the racial stereotyping until the result was practically an orgy of caricature. Fantasizing of returning home to the Black Belt a rich man, Buckwheat is initially described being chauffeured down the street in a "fancy big limousine" heaped with watermelon. In a script revision a month later, the limousine has now turned into a three-car motorcade, the first car a "7-seat Rolls-Royce touring car with the top down" filled with "six colored musicians" and their instruments. A week later, the six colored musicians had become a full-blown minstrel band called "MR. BUCKWHEAT'S DIXIE TOOTERS," and the motorcade not only carried piles of watermelon but also huge platters of fried chicken legs. Buckwheat's dandy attire went through a similar process of augmentation and exaggeration, from "a very loud, fancy suit" and "straw hat with loud band" to "an exaggerated English walking-suit made of loud checkerboard-effect material, a silk hat, his 'Our Gang' shoes, off-white spats, white gloves and . . . walking stick. His shirt studs, cuff links, rings and the head of his walking stick are huge diamond-like rhinestones."[27] What was meant to be Buckwheat's fantasy of the high life became the MGM writers' fantasy of uppity blackness.

Even the minstrel show, that hundred-year-old theatrical form, was revived with a vengeance during the war, updated as a particularly patriotic, American brand of entertainment. In *Ye Olde Minstrels* (1941), Froggy's uncle, played by Walter Wills, suggests the Gang put on a minstrel show to help raise money

for the Red Cross. All the kids think it's a great idea—all, that is, except Buckwheat. The script further emphasizes this by high-lighting Buckwheat's response in bold letters:

> All the kids **excepting Buckwheat** smile and react highly elated [to Mr. Wills's suggestion of mounting a minstrel show]. Buckwheat reacts with a worried frown.

> KIDS (elated, to Froggy's uncle): That's swell—oh Boy!—Thanks!—Goodbye Mr. Wills!

> The kids, **excepting Buckwheat** wave their hands at Froggy's uncle as they say "Goodbye" and start to exit. . . . Froggy's uncle waves back at the kids, who with the **exception of Buckwheat,** are all smiling. Buckwheat still reacts in a worried manner.

> BUCKWHEAT (to Spanky, greatly worried as they walk for-ward): Look Spanky, don't you gotta put on a blackface makeup, when you do a Minstrel Show?
> SPANKY (to Buckwheat, disgustedly): WELL—what are YOU worried about?

What *was* Buckwheat worried about? That the minstrel show was a racist form in which he'd rather not take part? That he'd be left out of the production because he was already black? Spanky brushes aside any of Buckwheat's concerns as silly or overblown—of *course* he will participate in the minstrel show, of *course* he won't let racial concerns spoil the fun. Buckwheat gamely follows along, appearing at the top of a pyramid of children dressed in flashy, satin minstrel outfits, singing the popular minstrel tune "Carry Me Back to Old Virginny." Spanky plays the interlocutor, Froggy and Mickey are the end men, and Walter Wills, imitating the nineteenth-century blackface minstrel George Primrose, per-forms a tap-dance routine to the Laurel and Hardy tune "Lazy Moon." In a shocking screen edit, Wills and his chorus line of kid minstrels suddenly appear in blackface, an effect compounded by the appearance of Buckwheat, who now appears in whiteface. This awkward cross-racial masquerade ends quickly, as the white children and Buckwheat just as abruptly revert back to their orig-

inal shade and the show ends with a rousing rendition of "Auld Lang Syne."

Buckwheat remained a loyal member of the Gang to the end, outlasting Darla, who retired in 1941 at the age of ten, and Spanky, who retired a year later at the ripe old age of fourteen. Edward Cahn had more or less left the series in 1942, handing over the reigns to Herbert Glazer and then Cyril Endfield.[28] When MGM finally pulled the plug on the series in April 1944, it was a shadow of its former self. The comedies were corny, sanctimonious, and, worst of all, unprofitable. According to the studio's books, five of the final seven releases of *Our Gang* lost money. MGM did not wait to see if the eighth release, *Home Front Commandoes*, would prove otherwise, cancelling the production midway through. With that, twenty-two years of *Our Gang* comedies reached an unceremonious end. There were no parties, no celebrations, no public retrospectives; the Gang was simply disbanded. Audiences did not seem to notice. The war was at a critical turning point, and the escapades of overgrown children must have seemed unbearably trite compared to the drama across the ocean.

Billie was thirteen years old, practically geriatric for a child star. If the racial gags on the comedies bothered him, Billie never let the others know. He was well liked on the set, a team player, the only one, in the colorful words of Robert Blake, who "had his [expletive] together."[29] He had his moments of intense race pride, as when his idol, Joe Louis, beat Max Schmeling for the World Heavyweight Title in 1938, a victory that was seen as a symbolic defeat of Germany and its Nazi ideology. "On that day, you had to stay out of his territory," Gordon Douglas remembered, "because he was really fired up with pride, as we all were."[30] Later, Louis had enlisted in the army over the objections of fellow African Americans, who complained, "It's a white man's Army, Joe, it ain't a black man's Army." Louis's answer was simple. "Lots of things wrong with America, but Hitler ain't going to fix them."[31] Like his hero, Billie was proud to be black and proud to be American. He was part of Our Gang's family and Uncle Sam's. He was a real trouper and a real trooper.

Down the street, Hal Roach Studios had been turned into "Fort Roach," taken over by the army and air force to produce military

training and propaganda films starring actors like Ronald Reagan and Alan Ladd. (Ironically, several years earlier, Roach had partnered with Vittorio Mussolini, son of the Fascist dictator, on an abortive business venture, a production company called "R. A. M." for "Roach and Mussolini." The venture was scrapped after protests by MGM and Hollywood anti-Nazi activists, who recoiled when Roach welcomed Mussolini to town, hosted a party in his honor, and took him on a tour of the lot, where he posed with the *Our Gang* kids. Roach, ever the contrarian, remained stubbornly unapologetic about the endeavor.) Drafted in 1942, Roach initially requested deferment based on his age (nearly fifty) and his critical role in running the studio. When those requests were denied, "Major Hal" reported for duty, overweight and dressed in a costume uniform "a Ziegfeld chorus boy wouldn't wear." He was sent to the Signal Corps in Astoria, New York, where a colonel took one look at his garish uniform, with its pleated, scalloped pockets, and groaned, "Roach, do me a favor. Act like you've never been here before and go over to Macy's and get yourself a suit of cotton clothes and come back."[32] Roach thought it was a great joke—made even more so when, due to wartime rationing, he got to continue wearing his gag uniform around the facility.

Roach wasn't the only one entertaining folks. Ernie "Sunshine Sammy" Morrison, now in his thirties, served as a USO entertainer in the South Pacific. After retiring from *Our Gang,* he had embarked on a decade-long vaudeville career, returning to Hollywood in 1940 to star in *Fugitive from a Prison Camp,* a Columbia feature.[33] Ernie was then cast as "Scruno" in Monogram Pictures' *East Side Kids*. Starring another former *Our Gang* player, Donald Haines, *East Side Kids* was a cheaply produced series of films that revolved around a gang of tough-talking adolescents. It was *Our Gang* grown up, urbanized, and melodramatized. Along with most of the cast, Ernie was drafted during the war. Uncle Sam needed him, not to fight on the front lines but to boost morale among troops scattered across the world. "Entertainment is always a national asset," FDR had declared in 1943. "Invaluable in times of peace, it is indispensable in wartime."[34] Ernie joined stars like George Burns, Gracie Allen, and Jack Benny, performing in camp shows on military bases and providing a diversion from the boredom, homesickness, and fear that characterized military life.[35]

His former *Our Gang* sidekick, Sonny "Farina" Hoskins, was now in his early twenties. After leaving the Gang, he had done some vaudeville and appeared in a few more films, but by his teens, he had mostly retired from show business, though he remained interested in behind-the-scenes work like "directing and lighting."[36] Now going by the more grown-up "Allen," he had attended William McKinley Junior High and Thomas Jefferson High School in Los Angeles, where he was a popular student, a member of the camera club, and an all-around "good guy," in the words of a classmate. McKinley and Jefferson were racially integrated schools, where Allen took classes alongside white, Latino, and Asian students. His school yearbook, bristling with autographs, attests not only to his popularity, but also to the diversity of his friendships. Along with the Ella Moores and the Carl Joneses are names like Midori Hasama, Alberto Contreras, Henry Ramirez, Grace Chin, and Tom Kajiyama.[37]

Allen was drafted in 1941 and joined Company D of the Forty-seventh Quartermaster Regiment, based out of Ford Ord in Monterey Bay, Northern California. The press made much of his enlistment, reading it as another marker of his manhood. Farina hadn't just grown up, he'd become a soldier, a "real" man. *Time* magazine, in a special war section called "Warriors and Defenders," published "then and now" photos of Allen, juxtaposing an old *Our Gang* still with a recent photo of the now mustached, uniformed soldier. "Farina, the spindly, pigtailed pickaninny of the old 'Our Gang' comedies, turned up in the Army as husky, close-cropped Alan [*sic*] Clay Hoskins," the caption read.[38] A black newspaper in Virginia put a photograph of Private Hoskins on its front page. "Remember Farina, the little 'girl' of the old 'Our Gang' comedies? Well, 'she'"s in the Army now."[39] Allen grinned for the camera, caught in the middle of changing a tire on an army truck, a manly man instead of the girl-boy of the past.

Especially bittersweet was a story issued by the Associated Press, which depicted Allen as a war-weary soldier instead of the innocent he once was. Stationed at the Monterey Presidio, the Associated Press reported, Allen was standing on a corner when a beautiful lady stopped at a red light, honked, and leaned out of her window. "Say—don't I know you?" she asked the young soldier, who replied, "I'm Private Allan [*sic*] Hoskins, Company D, 47th Quartermaster Regiment." The woman was Claudette

Colbert, and when she drove on, a fellow soldier asked Allen why he hadn't identified himself as Farina from *Our Gang*. Allen "wistfully" replied, "Well, Farina was the name of that other guy she was thinking of—a little guy in a white dress whose contract called for more money in a week than I now make in a year. Farina's grown up. I'd rather she remembered me as I used to be, before the world lost its sense of humor."[40]

In reality, it was the army, not the war, that precipitated Allen Hoskins's loss of innocence. As a child, he'd been sheltered from racial prejudice by his fame and by the comparatively integrated environment of his junior high and high schools. It wasn't until he got into the army that Allen experienced "outright racism."[41] The Quartermaster Corps, where he was assigned, was a segregated unit, responsible for providing combat troops with food, clothes, munitions, fuel, and other supplies. Although the White House had promised African American representation in all branches of the military, in reality most black servicemen were shunted into labor and supply units like the Quartermasters, Engineering, and Transportation. They performed so-called black work—menial, physical jobs like digging ditches, cleaning latrines, peeling potatoes, fixing trucks. Even those soldiers assigned to other units, like the air force, were not flying planes; they were relegated to performing labor and maintenance.[42]

The army was full of other indignities. Black soldiers were forced to take segregated buses, use segregated bathrooms, shop at segregated post-exchanges, and amuse themselves at segregated service clubs. Accommodations and other facilities were overcrowded and inferior. One soldier, writing to a black newspaper from his base in Texas, reported, "We are discriminated against in everything we do or take part in. The post theatre is divided off for [my squadron]. Government buildings also. In the hospital when we are improving from our ailments, we are used as K.P.'s [kitchen patrol] there until released. In the Gym we are segregated even for a Colored U.S.O. show."[43] The military enforced Jim Crow policies even when the surrounding town did not. A soldier based near La Junta, Colorado, reported that the base theater had cordoned off four rows of seats for black soldiers and stationed military police officers to ensure compliance. Rather than suffer such humiliation, soldiers chose to boycott the base theater and attend

one of two integrated theaters in the nearby town.[44] Particularly galling was the treatment of German POWs, who were handled with greater respect than the army's own black troops. Writing from Camp Barkeley, Texas, Private Bert Babero described his shock at seeing a Jim Crow latrine in the German POW camp. "Seeing this was honestly disheartening," he wrote. "It made me feel, here, the tyrant is actually placed over the liberator."[45]

Fort Ord, where Allen was initially stationed, was no different. Black soldiers were segregated by unit and forced to use only "colored" USO facilities. Their barracks were on the site of a former Civilian Conservation Corps (CCC) camp inauspiciously known as "the Dust Bowl." Family housing, too, was segregated, and training was substandard and rushed.[46] When Allen deployed overseas to Australia, the army's Jim Crow policies followed. Now known as Corporal Hoskins, Allen was a company clerk for the Quartermaster Corps in Port Moresby, a key staging point for the Allies' Japanese offensive. Located on an island off the coast of Australia in what is now Papua New Guinea, Port Moresby was so isolated that Australian aborigines, seeing black soldiers for the first time, fled from them in terror. With no recreational facilities available to them, black soldiers resorted to hunting wild turkey and kangaroos, followed by a barbecue and "beer bust." The establishment of an American Red Cross club serving Negro troops stationed in Australia and New Guinea was cause for celebration—now, for the first time, black troops had "a club of their own," a place where they could live and entertain themselves while on leave.[47]

This was where the *Pittsburgh Courier* caught up with Allen in May 1943, apparently safe and sound. The previous year, a rumor had circulated that "Farina" had been killed in action in Australia. Harry Levette of the *California Eagle* reported, "Unofficial talk was that [Allen Hoskins] was one of a tank crew that made the great sacrifice when Axis bombers swooped down on their marching column."[48] Readers waited anxiously for confirmation that their "Little Farina" was alive. The next month, Levette offered some hope with the following bit of gossip: "No official report from the government that Allan [sic] Hoskins, 'Little Farina,' is among the missing in Australia. His mother states that she heard from him recently."[49] His readers breathed a sigh of relief.

Allen Hoskins was their son as much as his mother's. His fate was symbolic of the fate of all "Uncle Sam's negro boys."

While "Sunshine Sammy" was entertaining the troops and "Little Farina" was being hailed as a war hero, Matthew "Stymie" Beard, now eighteen years old, was in jail. The Gang's wisecracking trickster had found post-Gang life a difficult road. Film parts dried up as he entered his awkward teenage years.[50] His parents were accused of "charity chiseling"—accepting relief despite their son's supposedly lavish paychecks—and Stymie was called upon to testify against them.[51] Worst of all, the formerly sheltered star was now thrust into the cruel world of adolescence, where he was taunted by his peers for his Hollywood past and found himself desperate to fit in. "I just wanted to see how other people lived," he later recalled. "I guess I wanted to live the high life."[52] Stymie started smoking marijuana at the age of sixteen and began stealing to pay for his habit. At the age of eighteen, he was arrested and sentenced to sixty days in jail. Instead of rehabilitating him, jail just made things worse. "You know in there, you could get any type of dope you wanted," he said.[53] "I heard the big boys talk about how good heroin was and I thought I'd like to try it."[54] Stymie quickly became addicted and continued his precipitous descent into drugs, later serving six years in prison for selling heroin. He was arrested so often for petty thievery—creeping around to steal money out of cash registers and swipe valuables from people—that the local cops gave him a nickname. "One-Take Stymie" was now better known as "Stymie, the Creep."[55]

With the war's end in September 1945, the nation entered a period of tectonic economic, social, and political change. Millions of soldiers returned home and were reintegrated into civilian life with the help of the G.I. Bill, which paid for college tuition and living expenses, provided zero down-payment, low-interest home loans, and offered unemployment compensation. Returning veterans began to start families, triggering the demographic bulge known as the baby boom. In 1946, the first year of the boom, there were over 3.3 million live births, a number that would mushroom to 4.3 million in 1957, the peak year of the boom.[56] Families began to move to the suburbs, buying up new homes in planned communities. Having weathered the shortages and rationing of the

Depression and war years, Americans were now eager to spend. By the end of the decade, with the economy thriving and the mood optimistic, Americans bought cars, appliances, furniture, clothes; they spent money on entertainment and vacations, on personal services and home amenities.

At the same time, however, African Americans found themselves shut out of this dream of prosperity. Having fought for freedom overseas, black veterans returned home to find they were still not free. Despite the demographic shift achieved through the Great Migration, the majority of African Americans still lived in the South, where Jim Crow continued to terrorize daily life. In 1946, just hours after being honorably discharged from the army, Isaac Woodward, an African American war veteran, was dragged from a Greyhound Bus outside Aiken, South Carolina, and ferociously beaten by the local police, his eyes gouged out with billy clubs. Under pressure from the NAACP, President Truman pushed the Department of Justice to open an investigation, but the resulting trial was a farce on par with the case of the Scottsboro Boys. After thirty minutes of deliberation, the all-white jury acquitted the white police officers of all charges. That same year, George Dorsey, a black war veteran with five years of service in the army, was lynched with his wife and another black couple by a white mob in Georgia. Their bodies were discovered near a bridge spanning the Apalachee River, riddled with over sixty bullets. A grand jury investigation came up empty-handed.

The African American community rose up in protest, sending letters to the White House and organizing marches. The NAACP, now boasting a membership in the hundreds of thousands, challenged Jim Crow laws in federal courts and continued to press Truman to pass civil rights legislation. In December 1946, horrified by the Woodward case and other acts of racial violence, Truman established an interracial Civil Rights Commission. The following year, he delivered a speech to the NAACP from the steps of the Lincoln Memorial, a speech that was broadcast live on four major radio networks. In it, Truman claimed that the nation had reached "a turning point" in its long and uneven efforts to ensure the freedom and equality of all its citizens. "Recent events in the United States and abroad have made us realize that it is more important today than ever before to insure that all

Americans enjoy these rights," Truman declared. "And when I say all Americans—I mean all Americans."[57] Truman's support for civil rights was personal, but it was also political. He was courting the African American vote, now a substantial portion of the electorate in the North. He was also acutely aware of how Jim Crow was undermining the nation's image as the leader of the "free world" in the early years of the Cold War.[58]

Under the leadership of civil rights reformer A. Philip Randolph, African Americans urged Truman to end discrimination in the armed forces, vowing to resist his peacetime draft law unless segregation was formally banned. In July 1948, yielding to the threat of mass black resistance and the growing political power of the black electorate, Truman signed Executive Order 9980, which integrated the federal government, and Executive Order 9981, which integrated the armed forces. Two years later, with the start of the Korean War, the nation's commitment to military desegregation was put to the test. Integration took place gradually, aided by the need for manpower replacements and the proven effectiveness of integrated combat units. By the end of the war in 1953, 90 percent of black soldiers served in integrated units. Billie Thomas, now in his early twenties, enlisted in a completely integrated army in 1954 and served for nearly two years, most notably with the Thirty-eighth Infantry. After he was released from active military duty, he spent another eight years in the Army Reserve, receiving an honorable discharge in 1962, the recipient of a National Defense Service Medal and a Good Conduct Medal.[59]

Another revolution—this one technological—was taking place that would intersect with the vast social and economic changes of the postwar period. Beginning in 1946, the first affordable television set—the RCA 630-TS—began rolling off the assembly line.[60] Besotted by this new medium and eager to spend, Americans snapped up millions of television sets over the next decade.[61] By 1955, two-thirds of the nation's homes owned a television. By 1960, the number was almost 90 percent.[62] Almost immediately, this new technology reordered people's lives. Schedules were upended, leisure time reconfigured. Television was described as a home invader—"a loud-mouthed, sometimes delightful, often shocking, thoroughly unpredictable guest."[63] Children gravitated to the new Pied Piper, watching hours of television per week as

their mothers tended to chores and made dinner. In a 1952 study in Columbus, Ohio, kids in kindergarten through second grade watched more than two hours of television on weeknights; kids in fourth through eighth grade watched closer to three hours.[64] Households with children watched more television across all time periods than childless households.[65]

For Hollywood, the arrival of television coincided with its cultural decline.[66] By 1951, movie attendance had dropped 20 to 40 percent in cities with a commercial TV station. According to broadcast historian Erik Barnouw, "Areas well provided with television reported movie theater closings in waves: 70 closings in eastern Pennsylvania, 134 in southern California, 61 in Massachusetts, 64 in the Chicago area, 55 in metropolitan New York."[67] Like radio before it, television was characterized as a cozy, intimate form of entertainment, a home theater in your living room. Families could gather around this "electronic hearth" in domestic harmony, reveling in their togetherness.[68] At the same time, television provoked the same anxieties that had greeted film in its early years. Critics tied television viewing to juvenile delinquency, nervousness, sleep problems, and eyestrain. They worried that children would eschew schoolwork and healthy play, instead absorbing the questionable values conveyed by cowboy films, detective thrillers, and soap operas. In newspapers and magazines, parents read lurid tales of children imitating things they'd seen done on television, from mixing ground glass into a pot of stew, to strangling a baby in her sleep.[69] Still worse, television was nearly impossible to restrict. It didn't require the price of a ticket or a trip to the local theater—it was right there in the living room, accessible with the flip of a knob. The furor over "TV-made children" now supplanted earlier decades' anxieties over "movie-made children."[70]

While educators and politicians fretted about television's deleterious effects on young minds, the African American press was more optimistic about this new form of technology, seeing it as a more democratic, integrated space that might offer a respite from the minstrel-inspired stereotypes that inhabited film and radio. *Ebony* magazine envisioned a bright future for black performers on television, one that was "free of racial barriers" and offered better and more plentiful roles.[71] The *Pittsburgh Courier*

argued that television would "contribute to a better understanding of the American Negro" and provide "favorable publicity."[72] Their optimism was bolstered by the support of industry trade groups and influential television personalities. Aware that African Americans, too, bought television sets and were a profitable consumer demographic for advertisers, the National Association of Radio and Television Broadcasters approved a television code that banned ridicule of "racial or nationality types."[73] Ed Sullivan, who practiced race-blind casting on his variety show, predicted nothing less than a revolution in American race relations. Through television, Sullivan argued, "the Negro" could bring his crusade for equal rights into people's living rooms, becoming "a welcome visitor, not only to the white adult, but to the white children, who finally will put Jim Crow to rest."[74] By broadcasting images of African Americans into households that would never admit an actual African American visitor, television had the capacity to radically transform racial worldviews.[75]

Hal Roach, who had returned to Los Angeles after the war and resumed control over his studio, quickly felt the effects of the dramatically shifting media landscape. At first, he plunged back into movie production, creating so-called streamliners, featurette comedy films that ran for about fifty minutes. Hoping to recapture the success of *Our Gang,* he proposed another kid film featuring a mixed-race cast, but MGM initially balked, claiming it might want to resurrect *Our Gang* itself one day. In the end, the studio allowed Roach to go ahead, so long as he did not use the name "Our Gang" or draw any connections between his new streamliners and his old short films.[76] *Curley* was released in 1946, featuring an all-new cast of kids, including René Beard, Stymie's little brother. The film did poorly at the box office and also raised the ire of the Memphis, Tennessee, board of censors, which banned the film for its scenes of integration. "The South does not permit Negroes in white schools nor recognize the social equality between the races even in children," the board wrote to United Artists, *Curley*'s distributor. Although Roach, United Artists, and the Motion Picture Association of America filed a lawsuit, claiming violation of free speech and due process, the Tennessee courts upheld the ban.[77]

Reflective of the way Southern exhibitors could simply re-

fuse to book films they believed transgressed local Jim Crow codes, the Memphis ban of *Curley* was the first time Roach encountered wholesale resistance to his films' integrated casting. In the past, individual exhibitors had complained to the trades about *Our Gang*'s use of "Sambo," but the complaints had not translated to official boycotts or significant lost revenue. The *Our Gang* shorts were, well, short and later packaged with MGM features, making it difficult for reluctant exhibitors to declare a ban on the whole package. *Curley* and its sequel *Who Killed Doc Robbin?* had no such protective packaging. They also lacked the charm of the original *Our Gang* shorts, whether because of poor casting, limp plotting, or the awkward streamliner length. Hal Roach found his studio teetering on the edge of bankruptcy, its streamliners a bust, the whole film industry contracting, no surefire film stars or series in its stable. Desperate, Roach approached the Air Force with an offer to sell them the studio and all its equipment. The Air Force declined.

Ever the risk-taker, Roach decided to make the leap to television. He reconfigured the studio for television production and sent his son, Hal Jr., to New York to drum up publicity. The gamble would pay off handsomely. By 1951, *Time* reported that Hal Roach Studios was "well in the black," producing 1,500 hours of television content a year, or nearly three times Hollywood's total annual output of feature films.[78] Over the next several years, the studio would enter a second golden age, producing or leasing space on its lot to television series like *Racket Squad, Mystery Theater, Amos 'n' Andy, My Little Margie, The Lone Ranger, Abbot and Costello,* and *Beulah*.[79] In 1949, Roach also repurchased his old *Our Gang* silent and talking shorts from MGM, agreeing to forfeit the right to the "Our Gang" name and repackaging the eighty sound shorts as *The Little Rascals*. The films were reissued to theaters by Monogram Pictures, where they did a brisk business among fans who remembered seeing the films in the 1920s and 1930s.[80] Two years later, *Variety* reported that Roach had sold the TV rights to *The Little Rascals* for $200,000.[81] The sale helped save the studio at a critical moment, allowing it to settle some debts and regain its footing as it moved into the television era.[82] Little did Roach know that the sale would help launch *Our Gang*'s second golden age, as well.

9

The Little Rascals

In July 1955, Emmett Till turned fourteen years old. He and his
mother, Mamie, lived on Chicago's South Side, where Emmett
attended integrated schools and was known by his childhood nick-
name, "Bobo." Emmett's father, Louis Till, had died serving in
World War II, leaving behind a gold signet ring emblazoned with
his initials, "L. T." Emmett had taken to wearing it on his finger,
packing it with tape to keep it from falling off. He was a round-
faced, chubby kid, with large eyes and a friendly smile. Despite a
persistent stutter, the vestige of a childhood bout of polio, Em-
mett was a popular child, always at the center of things, a natural
leader and jokester. A neighbor remembered, "He never bothered
with grown-ups—only with boys, baseball, basketball." As a prank,
he once put a pair of underwear on a sleeping friend's head. In
his free time, he devoured comic books like "Little Lulu," "Su-
perman," and "Space Patrol." Asked by his mother to paint the
garage, Emmett would paint a little, then run over to a friend's
place to play ball, then run back to paint some more. "He surely
wanted to be painting when his Mama showed up from work,"
a neighbor recalled. On paper, Emmett sounded like any other
schoolboy, mischievous and full of energy. Except Emmett wasn't
a white boy living in antebellum Hannibal, Missouri, or in turn-
of-the-century upstate New York. He was a black boy who was
about to spend part of August in the 1950s Mississippi Delta, the

heart of cotton country, a region as famous for its poverty and racism as for its fertile soil.[1]

Before Emmett left for Mississippi, Mamie Till warned him to abide by the rules of Jim Crow. "We went through the drill," she said. "Chicago and Mississippi were two very different places, and white people down South could be very mean to blacks, even to black kids." She told Emmett to say "yes, ma'am" and "no, ma'am" and to get off the sidewalk and drop his head if a white woman walked down the street. "Don't look her in the eye," Mamie said. "Wait until she passes by, then get back on the sidewalk, keep going, don't look back."[2] Since the Supreme Court had struck down school segregation in *Brown v. Board of Education* the previous year, the racial climate in the Deep South had turned combustible. Earlier that year, two black men who had helped register black voters in Mississippi were killed. Emmett, with the brash overconfidence of youth, brushed aside his mother's concerns. Along with his cousin Wheeler Parker, he took the sixteen-hour train ride from Chicago to the Mississippi Delta, arriving near the start of cotton-picking season. The two boys were in heaven. Half the day they spent picking cotton, the other half swimming and fishing and running the snakes out of the river. "We had a lot of fun," Wheeler remembered. They stayed with Mamie's uncle, Moses Wright, a sharecropper and preacher who lived in a tiny, three-room home outside the whistle-stop town of Money, Mississippi.

One day in late August, after picking cotton in the morning, Emmett and a bunch of his friends clambered into his great-uncle's Ford and drove into town to buy candy at Bryant's Grocery store. What happened next was unclear. Emmett ordered some bubblegum, and some said that on his way out, perhaps on a dare, he wolf-whistled at Carolyn Bryant, the white owner. Later, Mamie Till speculated that her son had stuttered while ordering his candy, whistling to overcome his speech impediment. Whatever the case, Carolyn Bryant stormed out. "We all got a-scared," Wheeler remembered, "and someone said, 'She's going to get a pistol.'" The boys jumped back into the car and fled. They agreed not to mention the incident to Moses Wright and soon forgot all about it. A few nights later, however, Carolyn Bryant's husband, Roy, and his half brother J. W. Milam showed up on Moses

Wright's doorstep, demanding to see the boy who had insulted Mrs. Bryant. Wright pleaded with the men, telling them Emmett was just fourteen and a visitor from Chicago, ignorant of the ways of the South. "Why not give the boy a whipping and leave it at that?" Wright begged. The men ignored him and dragged Emmett from his bed. Three days later, his body was found, caught on a tree root in the swirling brown waters of the nearby Tallahatchie River. A seventy-five-pound gin fan had been tied to his neck with barbed wire in order to weigh his body down. He was so badly beaten that Moses Wright could only identify him by his father's signet ring.[3]

At Emmett's funeral in Chicago, Mamie Till insisted on having an open casket in order to show the world what had happened to her son. In her own words, "the right eye was lying on midway his cheek" and "his nose had been broken like somebody took a meat chopper and chopped his nose in several places. As I kept looking, I saw a hole, which I presumed, was a bullet hole and I could look through that hole and see daylight on the other side."[4] *Jet* and the *Chicago Defender* published photos of Emmett's disfigured face, a sight so ghastly that it haunted and shocked viewers with the brutality of lynch law. Muhammad Ali, then just a kid from Kentucky named Cassius Clay, remembered "stand[ing] on the corner with a gang of boys," staring at before and after photos of Emmett's face. "In one, he was laughing and happy. In the other, his head was swollen and bashed in, his eyes bulging out of their sockets and his mouth twisted and broken," Ali said. "I felt a deep kinship with him when I learned he was born the same year and day I was."[5] The writer John Edgar Wideman, who was also fourteen that summer, remembered seeing Emmett's face, "a mottled, grayish something resembling an aerial shot of a landscape cratered by bombs or ravaged by natural disaster," something one could only "glance at and glance away."[6] The death of Emmett Till resonated among all black boys in America. Emmett could have been any one of them.

Three weeks after Emmett's body was fished out of the river, Bryant and Milam were brought to trial in Sumner, Mississippi, a five-hundred-person town that was advertised on billboards as "a good place to raise a boy." By now, the case had become front-page news around the nation and even the world. Newspaper reporters besieged the town, and all three national news networks sent cor-

respondents. Defying threats against his life, Moses Wright took the stand and pointed to Bryant and Milam as the men who had kidnapped his great-nephew. After testifying, he escaped north to Chicago, abandoning his truck at the train station and leaving his cotton to die in the fields. It made no difference. It took the all-white jury little more than an hour to acquit Bryant and Milam of murder—in fact, it would have taken even less time if the jury hadn't taken a break to drink soda pop. Mamie Till, who was sitting in the courthouse, remembered, "You could hear guns firing. I mean it was almost like a 4th of July celebration, or it was almost as if the White Sox had won the pennant in the city of Chicago. It was just it just—oh, it—it was a mess."[7] Although Mamie Till and her supporters urged the federal government to reopen the case, neither President Eisenhower nor FBI director J. Edgar Hoover heeded their calls. A few months later, *Look* magazine paid Bryant and Milam, now protected from further prosecution, four thousand dollars for their side of the story. The two men confessed to kidnapping and torturing Emmett, shooting him in the head, and dumping his body in the river. Afterwards, they incinerated his clothing in a bonfire, complaining how hard it was to burn his crepe-soled shoes.[8]

Bryant and Milam might have been chillingly unrepentant, but for the rest of the world, the murder of Emmett Till unleashed a fury of emotion. Emmett's youth, the triviality of his "offense," the grotesqueness of his punishment—all exposed the inhumanity of Jim Crow. The national and international press assailed the verdict, calling it a travesty of justice and democracy. One German paper published the headline, "The Life of a Negro Isn't Worth a Whistle."[9] It was, according to historian David Halberstam, "the first great media event of the civil rights movement."[10] For many, the murder of Emmett Till now took on symbolic weight. He was a martyr, a "sacrificial lamb," the innocent child whose death would end up galvanizing the incipient civil rights movement.[11] One hundred days after his death, Rosa Parks would refuse to give up her seat on a city bus, and the Montgomery bus boycotts would begin.

In 1955, Hal Roach's original *Our Gang* talkies were quietly syndicated to television by Interstate Television, the video arm of Allied Artists (formerly Monogram Pictures). The series was now

decades old, and no one knew how audiences would respond to these so-called museum pieces.[12] Almost immediately, however, the series was declared a phenomenal success. After just three weeks on WPIX in New York, *The Little Rascals* was pulling in comparable ratings to the NBC kid series *Howdy Doody*, with which it competed across the board.[13] After four months, it had become the top-rated afternoon kids' show in the New York area, watched by more than a million viewers.[14] Across the country, in places like Detroit, Seattle, Denver, and Philadelphia, it was performing similarly well.[15] The *Los Angeles Times* ran the headline, "Old 'Our Gang' Films Swamp TV Opposition," describing how the kids easily trounced even an "NBC evening spectacular."[16] *Billboard* wrote, "[*The Little Rascals'*] success underscores once again the fact that films initially shot for theaters and already seen by audiences of millions can still pack a tremendous wallop when aired on TV."[17] Witnessing the popularity of *The Little Rascals*, MGM syndicated its own *Our Gang* shorts the following year.[18] The Pathé silent films also made their way to television, known alternately as *The Mischief Makers* and *Those Lovable Scallawags with Their Gangs*.[19]

TV Guide, still only in its third year of publication, covered *The Little Rascals* television phenomenon, using it as a chance to catch up with the now grown-up cast. The magazine posed members from different seasons in front of cardboard cutouts of their younger selves: Carl "Alfalfa" Switzer, Mary Ann Jackson, Joe Cobb, Jackie Condon, Darla Hood, Tommy Bond, and Mary Kornman. Conspicuously absent were George "Spanky" McFarland and all the African American members of the Gang; it is unclear whether they declined to attend the photo shoot or were not even invited. Farina did appear in a smaller inset photograph, juxtaposed with a photograph of his adult self. He had reportedly auditioned for a role in TV's *Amos 'n' Andy* and was now "touring with his own review." Most of the kids had transitioned out of show business altogether. Mary Ann Jackson and Mary Kornman were now housewives, Joe Cobb an assembler at the North American Aviation Plant in Inglewood, California, and Jackie Condon a file clerk for the IRS in Los Angeles. Spanky, the magazine reported, "followed an erratic career in California as a gas station operator and hotdog vendor, [and] is now an oil promoter in Dal-

las." Those who had stayed in the industry were forced to hustle or evolve. Alfalfa supplemented his acting income by tending bar and working as a hunting and fishing guide in Northern California. Tommy Bond transitioned from acting to working behind the camera and was now the head prop man at KTTV-Los Angeles. Darla Hood was working as a nightclub singer. *TV Guide* did not offer updates of Stymie or Buckwheat. And "of 'Sunshine Sammy' Morrison," the magazine wrote, "little is known."[20]

Several original members of the Gang had actually reunited on television just a few years before on *You Asked for It,* a popular human-interest show hosted by the hokey Art Baker. In a testament to the series' continued hold on the public imagination, a viewer from Pittsburgh, Pennsylvania, wrote in, asking for an update on the *Our Gang* kids:

> Dear Art Baker,
>
> Long ago, I used to take my children to any theater that advertised an *Our Gang* comedy with those cute kids Fatty and Freckles and Johnny and Farina and all the others. But it seems like twenty-five years ago—could that be possible? I am curious to see what they look like now.
>
> Sincerely,
> *Mrs. Irma McCann*

After refreshing his viewers' memories with old photo stills of the Gang, Art Baker announced, with a dramatic flourish, "That is how they looked twenty-five years ago, my friends . . . and here is how they look today!" The camera dissolved to Jackie Condon, Joe Cobb, Mickey Daniels, Johnny Downs, and Allen Hoskins all perched on a wooden wagon, dressed in beanies and short pants. The band struck up the tune "Hail, Hail, the Gang's All Here!" and the studio audience erupted into applause as Baker shook hands with each actor.[21]

Through the marvels of live television, viewers could see and hear their favorite stars in real time. Baker briefly interviewed each star, beginning with Allen Hoskins. "This is Farina!" Baker announced, then exclaimed, "I always thought you were a little girl! You had pigtails . . . where did the pigtails go?" If Allen found the question tiresome after so many years, he never let it

show. Now in his early thirties, a wiry man with a mustache and close-cropped hair, Allen gamely played along, pretending to feel around for his missing pigtails. "They kinda went," he joked. Asked by Baker if he was still in show business, Allen deadpanned, "I was for a while, but about four years ago, I decided I like to eat regular." The audience roared. Asked about his family life, Allen's face lit up. "Yeah, I got a little boy now!" he answered, bursting with pride.[22]

All the kids had grown up. Johnny Downs was MCing a television show and had a wife and four kids. "Freckles"—Mickey Daniels—no longer had freckles, but still had an enormous, gap-toothed smile and a huge, whinnying laugh. "What a big boy you grew up to be, brother!" Baker exclaimed, looking startled. Moving on to the soft-spoken Joe Cobb, Baker asked, "Fatty, have you lost much weight?" Joe jokingly rubbed his still ample belly, then informed Baker that he now worked "in plastics" and liked it very much, thank you. Jackie Condon was the last to be interviewed, a handsome young man who still sported a cleft chin but no longer had the wild hair that looked like it had been combed with an eggbeater.

The reunion wasn't over. As a surprise, Baker had brought in longtime *Our Gang* teacher Fern Carter, cameraman Art Lloyd, and director Bob McGowan. The three were now quite old—Mrs. Carter white-haired, Lloyd frail and in a wheelchair, and McGowan bespectacled and nearly bald. The "children" gathered around their former mentors, shaking hands and exclaiming with joy. Uncle Bob, looking shy and uncomfortable in front of the camera, was given the honor of cutting the cake brought in for the reunion. "WELCOME HOME, GANG," it read in icing. Baker closed the segment with the observation, "I like reunions, doggone. There's something about it. Seeing someone you haven't seen for a long time." Corny as he was, Baker was right. It was a reunion for audiences at home, who hadn't seen the shorts for a while and who wondered how the kids had turned out. But it was also a reunion for the original cast, who had drifted away from each other, who now had children themselves and held jobs in different industries and cities. For Allen, Johnny, Mickey, Joe, and Jackie, it would also turn out to be one of the last times they saw Lloyd and McGowan. Both men passed away a few years lat-

er, Lloyd in November 1954, and McGowan two months later, in January 1955.

Uncle Bob would pass away before learning of the phenomenal television success of his old films. Perhaps he wouldn't have been surprised—after all, he had always had a soft spot for the kids. So did Mrs. Irma McCann, the viewer who had written in to *You Asked for It*. So had a generation of nostalgic adults who had originally seen the films in theaters. John Crosby, a radio and TV columnist in the 1950s, joked that the series allowed "old fuddy-duddies like me [to relive] our childhood."[23] On top of that, there were millions of kids for whom the series was brand-new and newly funny. One reporter speculated, "Perhaps modern children, like those of another generation, find elaborately organized mischief appealing."[24] Whether born in the 1920s or in the 1950s, raised during the Depression or during the Atomic Age, kids found *Our Gang* and its gags to be timeless.

In another twist of fate, *Our Gang*'s original one- and two-reel format, which had led to its demise in Hollywood, actually lent itself to television's thirty-minute time slots. Its large library of "episodes" could also be "strip-programmed," or given a regular slot or "strip" across the weekly television schedule. Quickly, *The Little Rascals* became a part of the daily routine. Every day— usually after school, between 4:00 and 7:00 p.m.—audiences could be sure to catch the Gang. While mom (and it was usually mom) made dinner, the kids could watch the latest antics of Spanky and Alfalfa and Buckwheat. Sometimes mom might even join in watching the episode, laughing alongside her kids and reassured that it was the same good, clean fun she had enjoyed as a little girl. After the kids were put to bed, mom and dad might both collapse on the couch and catch the 10:30 p.m. showing of *The Little Rascals*, collectively indulging in nostalgia for their own childhoods.[25]

As it had in its film days, *The Little Rascals* appealed to both adults and children and assuaged moral anxieties over the effects of new media on young minds. Parents could rest easy knowing their kids were watching comedies they themselves had enjoyed as kids. Adults who worried that children might imitate the antics on screen—say, by heisting a car or tearing a house apart—were mollified by the presence of television hosts like "Officer Joe" on

WPIX-New York, a friendly cop who counterbalanced the televised mayhem with an element of law-abiding propriety. Officer Joe had even received a citation from the Police Athletic League, giving the "Clubhouse Gang," as the afternoon show was billed, its seal of approval as "a good influence on the children who watch it." The *New York Times* joked, "The kids now have the law on their side and unless they can be bribed with new pogo sticks or other diversionary attractions, it's going to be harder than ever to keep them away from 'Clubhouse Gang.'"[26]

Endorsed by parents and even the police, the series likewise promoted a sense of cross-generational continuity and unity. The whole family could watch the show together, in a vision of postwar harmony and domestic bliss. Some even argued that *The Little Rascals* was educational—that it could teach social skills and "how to play" with one another. *Sponsor* magazine, citing a child expert, wrote, "With parents deploring the lack of ingenuity in the play activities of children, there is a need for programs about group play, like the old 'Our Gang' comedies, now shown on tv under the title 'Little Rascals.'"[27] John Crosby, the film and TV columnist, considered the series a vast improvement over the violence of other kiddie fare, praising its "gentle, instructive" quality and its evocation of simpler times. "Spanky, Baby Jean, Alfalfa, and Farina were mischievous youngsters," he conceded, "but swiping cookies and throwing mud pies was about as far as they ever went. There wasn't an atomic disintegrator in the crowd."[28] Children, meanwhile, couldn't have cared less whether *The Little Rascals* was parent- or expert-approved. For them, the series was simply funny. In a tongue-in-cheek article in a trade magazine, *The Little Rascals* was called "the show recommended by children for adults."[29] Industry polls of viewership seemed to confirm that significant numbers of adults as well as children were tuning in to watch *The Little Rascals*.[30] In the words of an Interstate Television advertisement, "The Amazing Rascals Combine Solid Entertainment with Full Family Acceptance!"[31]

Where children flocked, advertisers followed. Among the sponsors of *The Little Rascals* were Wishbone salad dressing and Ruffles potato chips.[32] The show was often scheduled in a block with other cartoons and kiddie series and MCed by a clown to create an afternoon children's hour, the better to keep kids captive to

a single channel and its sponsors. Children, moreover, turned out to be an endlessly renewable resource. As one set of kids outgrew the *Rascals,* another group was there to take its place, part of the extended tail of the baby boom. In 1961, six years after *The Little Rascals* was first syndicated to television, the series was still going strong, its durability ascribed to a "new small-fry audience that grow up every two to three years."[33] *The Little Rascals,* it seemed, had discovered the fountain of youth. What had been *Our Gang'*s curse—that child stars grew up and were replaced by younger stars—was now its charm. New tots replaced old tots among the audience members, an endlessly rejuvenating demographic for television stations and the advertisers they courted.

Given the impassioned struggle for integration that was heating up even as *The Little Rascals* was first televised, how did television stations and audiences—especially those in the South—respond to the series' scenes of racial friendship? Television, much like film before it, was slower to make inroads in the South. And from the beginning, Southern legislators were suspicious of network television's integrationist gestures. In 1952, Governor Herman Talmadge of Georgia wrote an editorial in the *Statesman,* objecting to images of white and black performers—including black and white children—dancing together and talking to one another "on a purely equal social basis." He protested the "complete abolition of segregation customs in these shows which are beamed in states of the south." Threatening a mass boycott on products sold by the sponsors of these shows, Talmadge called on the networks to avoid offering programs so offensive to any large group in the nation. "Television," he complained, "is just about equivalent to visiting somebody in his home."[34] When asked for comment, the networks brushed off the governor's criticisms. A few years later, Louisiana legislators accused the industry of "the communist technique of brainwashing for racial integration by bringing into private homes in this state harmful programs designed to affect the minds and attitudes of juveniles." They too called for the prohibition of any televised entertainment that demonstrated "social contacts between members of both races."[35]

Despite such protests by Southern lawmakers, the television networks ultimately had the upper hand. Local stations couldn't preview and censor live broadcasts, nor could they simply stop

the network feed and forfeit the advertising dollars. As historian Thomas Doherty writes, "Trapped by technology and commerce, station managers in the Deep South telecast images of interracial amity they would never have countenanced in their hometown newspapers or at the local Bijou."[36] Reluctantly, Southern audiences let "the Negro" into their homes. When it came to local television programming, however, stations *could* simply choose not to purchase *The Little Rascals* syndication package. Dick Feiner, a syndication salesman in the 1950s and 1960s, remembered the resistance he encountered among Southern television stations: "[We] couldn't sell the Zane Grey series in the South because they wouldn't play the Sammy Davis, Jr., one. That was true all over the South. They even cut the black kids out of 'Li'l Rascals.'"[37] It's hard to imagine how they could have done so—Sammy, Farina, Stymie, and Buckwheat were so much a part of *The Little Rascals* that to cut them out would be to cut out the very heart of the series.[38] Despite such resistance, *The Little Rascals* still managed to find an audience—a large one—in some parts of the South during its first few years of syndication. The series was advertised as the #1 show on WLBT-Channel 3 in Jackson, Mississippi, in 1956.[39] And in 1958, it was advertised as one of the top ten shows in New Orleans, Louisiana.[40]

The Little Rascals' reception by the black community was likewise inconsistent. The series was popular in cities with substantial African American populations, and newspapers like the *Chicago Defender* still occasionally printed short interest articles about the films' television success.[41] The shocking death of the thirty-one-year-old Carl "Alfalfa" Switzer in 1958 (he was shot to death by an ex-partner over fifty dollars) prompted a brief retrospective of *Our Gang's* interracial cast and the post-Gang careers of Sunshine Sammy, Farina Hoskins, and Pineapple Jackson. (Stymie and Buckwheat were not mentioned, perhaps because their film careers ended with *Our Gang.*) The article then ended with a paean to Switzer's openness regarding integrated casting: "As one producer-director once said, 'you can employ "Alfalfa" in any role, interracial or otherwise. Makes no difference to him [or] to his cast opposite him. Nor will he, as some do, shy away from a role because the vehicle is too interracial.'"[42] In another brief article, the *Defender* covered a legal skirmish between film

and television distributors over the use of the name "Our Gang Comedies," citing it as proof that Farina and Sunshine Sammy were "Still Best Seller Aces."[43]

Other black newspapers, however, reported growing opposition to *The Little Rascals*. In 1958, Al Sweeney, city editor for the *Cleveland Call and Post*, spoke out against the series in his weekly column, specifically naming Buckwheat and Farina as "objectionable characterizations with the kinky hair, bucking eyes, and down-home drawl." Such caricatures, Sweeney argued, should be removed from television, not least because they "stereotype[d] Negro youngsters in the minds of white youth, who don't have interracial associations."[44] The following year, the NAACP issued letters to three Pittsburgh-area television stations, seeking to pull *The Little Rascals* from the air. The films were not only "extremely offensive to the Negro audience" but were also "holdovers from a period when Negro Americans were depicted as dull, superstitious, stupid, ignorant, naturally comical, lazy, criminal, and descendants of the worst aspects of slavery and oppression." Viewers of all races, the NAACP feared, would start to believe "there is superiority for all white persons irrespective of education, culture, moral and spiritual qualities, and racial inferiority for all Negroes simply because of their race or color."[45]

The uneven response to *The Little Rascals* among African Americans could find some precedent in the response to the television series *Amos 'n' Andy*. Although the show debuted to high ratings in 1951, it almost immediately came under attack by the NAACP, whose annual convention was held the very week of *Amos 'n' Andy*'s premiere. The NAACP swiftly voted to censure the series, with Roy Wilkins, the national administrator, fretting about its tremendous visual impact: "The television brings these people to life—they are no longer merely voices and they say to millions of white Americans who know nothing about Negroes, and to millions of white children who are learning about life, that this is the way Negroes are."[46] Not everyone agreed with Wilkins, however. Billy Rowe of the *Pittsburgh Courier* defended the show as "cute and amusing," a sentiment shared by many other African Americans, who responded to the NAACP's protest with indifference or even disapproval.[47] Some thought the series was innocuous fun, not reflective of real life. Others were delighted

there were black actors on television at all.[48] Still others thought there were more important social issues to confront than a trivial television show. Despite the differences of opinion, CBS eventually caved to the NAACP's pressure and canceled the series in 1953.

Perhaps witnessing the NAACP's successful campaign against *Amos 'n' Andy,* some members and supporters mounted a similar protest against *The Little Rascals,* pointing to the offensive racial stereotypes and the series' outdated origins in the 1920s. For many reasons, however, their attempts gained little traction in the 1950s. Like *Amos 'n' Andy, The Little Rascals* still had its fans in the black community, those who thought of the series as harmless fantasy or a rare example of diversity on television. In addition, the dispersive nature of television syndication made it much more difficult to wage a successful campaign. National networks were more susceptible—and sensitive—to black protest, wary of losing national sponsorship. All three national networks maintained a policy of interracial casting, despite the complaints of segregationists like Governor Talmadge. So concerned was NBC about offending the black community that it even went so far as to cut from old film features any images that contained offensive racial stereotyping—including, among other things, "a picture of 'Farina' of the old 'Our Gang' comedies."[49]

Local television stations, on the other hand, were only beholden to local sponsors and local cultural mores. And it was the local station—not a national television network—that purchased *The Little Rascals* package. As a result, to remove *The Little Rascals* from the air would have required a campaign in every local market in which *The Little Rascals* was broadcast. The NAACP might have protested the series among Pittsburgh-area television stations, but had it succeeded in pulling the show from the air, *The Little Rascals* would have continued to be broadcast in Philadelphia and other surrounding cities. *Amos 'n' Andy* had faced a similar predicament. Once CBS canceled the series, the series lived on in television syndication, broadcast by local television stations for the next decade. The NAACP could do no more. To wage individual campaigns in dozens of cities was simply impractical.[50]

Ironically, thirty years earlier, the NAACP had been among *Our Gang*'s most vociferous fans. W. E. B. Du Bois, one of the organization's founders, had highlighted Sunshine Sammy in the

pages of the *Brownies' Book* and had posed with the young star in the *Crisis*. Both Sammy and "Little Farina" had appeared several times in the magazine during the 1920s. William Pickens, a founding member and field secretary, had visited Sonny Hoskins on the Hal Roach lot and hung out with the *Our Gang* cast. Sonny himself had made an appearance at the 1928 NAACP convention in Los Angeles. Perhaps recalling the organization's long-standing support of the series, Ursula Halloran, a press agent for WPIX's "Clubhouse Gang," appealed to the NAACP for an "award or citation" just months after the series' television debut. The comedies, Halloran argued, were the first to show black and white children playing together as social equals and did not relegate characters like Stymie and Farina to "menial, subservient roles" or to "comic-opera foils." Halloran closed with her public relations pitch: "We believe this absolute equality exemplifies the fine ideals of your association, and that an award to the program would bring this ideal before the public eye in a graphic manner."[51]

The NAACP, however, was not the Police Athletic League and was uninterested in giving its stamp of approval. Instead, the organization now seemed to lead the charge against the series, to denounce it as antithetical to its mission of racial equality. What had happened in the intervening years? For one thing, the NAACP was reaching maturity as an organization. From a membership of 90,000 in 1919, it now boasted a membership of more than 600,000 in 1946.[52] For another, its strategy of attacking Jim Crow through the nation's courts was, at long last, bearing fruit— as proven in the NAACP-sponsored case of *Brown v. Board of Education*. With its growing political clout, the NAACP was no longer satisfied with small victories or tepid compromises. *Our Gang* was a vestige of the past, a "holdover," in the words of the Pittsburgh NAACP, a legacy of narrower times and expectations. The NAACP had outgrown *The Little Rascals*.

Even more so than it had in the past, *The Little Rascals* now attracted censure from groups on opposite sides of the political spectrum. Al Sweeney and the NAACP thought the films perpetuated negative stereotypes of African Americans, while Southern legislators and television stations thought it flouted local segregation customs. Both groups betrayed a profound anxiety over *The Little Rascals'* impact on children's racial attitudes. In the

former case, black and white children might presume black inferiority and white superiority; in the latter, black and white children might presume social equality. But which was it? Was *The Little Rascals* teaching children about racial equality—or was it, in fact, teaching its opposite? By extension, was the series a salutary vehicle of "how to play" and how to socialize effectively—or was it the opposite, a Pied Piper leading children astray with its troubling social messages?

That one series could be "decoded" in such different ways is ultimately a testament to *The Little Rascals'* widespread reach and to the dizzying variability of cultural and racial factors in shaping audience response.[53] It also revealed the complicating effects of time and memory on adult viewers. For some, *The Little Rascals* was a nostalgic touchstone, a reminder of the good old days—of childhood and movie palaces and simpler times. For others, it summoned up not nostalgia but trauma, a cultural memento of the "bad old days" of minstrel shows and slavery. The fact that *The Little Rascals'* primary audience was juvenile further raised the stakes for critics. Would children know the "right" way to watch the series? Would they take away from it a message of tolerance or one of inferiority? Should the show be endorsed or banned?

Whatever the fears of adults, kids all over the country, black and white, were still watching *The Little Rascals* in large numbers. They were watching *The Little Rascals* on WCPO-Cincinnati as part of *The Bean's Playhouse,* hosted by the "Stringbean" (Bud Chase), who dressed as a "ragged street kid," and his sidekick, "Louie the Louse" (Lee Fogel). They were watching *The Little Rascals* on KWTX in Central Texas, introduced by "Uncle Elihu" (Bob Martin) and his puppet, "P. J. Possum." They were watching *The Little Rascals* on KOTV-Tulsa as part of "Spanky's Playhouse," hosted by the real-life Spanky McFarland, all grown up but still dressed in his signature beanie and short pants. They were even watching *The Little Rascals* on WAFM-Birmingham, greeted by "Uncle Bill" (Bill Wright), who dressed in a candy-striped coat and entertained a studio audience of kids. Less than a hundred miles away, in Montgomery, the bus boycott was under way.[54]

Kids were watching *The Little Rascals* as television was becoming a powerful, even transformative force in the campaign for civil rights. The networks now hosted nightly newscasts, transmit-

ting to the nation the turmoil in the South. They began routinely to cover the movements of a young black preacher, Martin Luther King Jr., who eloquently spoke out against racial injustice. In 1963, CBS and NBC, the two leading national news shows, expanded from a fifteen- to thirty-minute format. With the increase in length came the need for more video, and the most dramatic video was coming from the South. As David Halberstam writes, "The scenes relayed from the Deep South into ordinary American homes each night had become among the most memorable and shocking of the era; it was as if millions of Americans could sit home and watch—often in the presence of their children—a struggle to attain the basic rights of democratic citizenship."[55] In places like Chicago, Los Angeles, and New York, one could catch an episode of *The Little Rascals* in the morning and then watch demonstrations on Walter Cronkite or the Huntley-Brinkley show that very evening.

If *The Little Rascals* was interracial fantasy, the civil rights movement was its grim reality. Yet both were, at heart, morality plays. *The Little Rascals* was about good versus bad—the Gang versus the neighborhood bully, or the humorless cop, or the sanctimonious adult. The civil rights movement, too, was a moral allegory pitting good against evil. Bull Connor was a made-for-TV villain, ordering the use of attack dogs and fire hoses on peaceful demonstrators in Birmingham. His name even sounded like what he was: an overgrown bully. The mobs that attacked freedom riders in Montgomery and brutalized protestors in Selma, the White Citizens' Councils that fiercely protested school desegregation, the Klansmen that bombed churches and homes—all of them fit easily into the media narrative of the bad guys versus the good.[56] It was a lesson that even the smallest child could understand.

It was also a lesson that even the smallest child could teach. Children weren't just watching civil rights demonstrations on television. They were also critical to the movement itself. Looking back, it was children who helped distill the struggle for civil rights to its essence. The first major legal victory of the movement, the 1954 case of *Brown v. Board of Education,* was filed on behalf of twenty school children in Topeka, Kansas. One of the children, Linda Brown, was in third grade when she was denied admission

to a white elementary school. Raised in an integrated neighborhood, Linda later recalled, "I just couldn't understand what was happening, you know, because I was so sure that I was going to get to go to school with Mona, Guinevere, Wanda, and all of my playmates."[57] The Supreme Court, when overturning the doctrine of "separate but equal," specifically cited segregation's devastating effects on children's psyches. In the court's published opinion, Chief Justice Earl Warren wrote, "To separate [black children] from others of similar age and qualifications solely because of their race generates a feeling of inferiority as to their status in the community that may affect their hearts and minds in a way unlikely ever to be undone."[58] Twenty-five years earlier, the *Chicago Defender* had said the same thing, that school was where children received those critical "first impressions that affect their lives."[59]

Schools were a logical opening front for the legal battle against Jim Crow because schools were where children's racial attitudes were shaped. Justice Warren acknowledged that schools also laid "the very foundation of good citizenship," acculturating the child to American values, preparing him for professional training, and helping him adapt to his environment. Deprived of equal access to education, black children were not only absorbing feelings of inferiority, they were being set up for a lifetime of second-class citizenship. For parents who had come of age during the Depression and wartime, childhood was already something to cherish and to protect, to indulge and to fret over.[60] For African American parents, the impulses were no different. They too wanted their children to enjoy a childhood free of want and instability. But they also wanted their children to enjoy a childhood free of racial segregation and degradation—and to grow into adulthood prepared to enjoy and practice their full citizenship rights.[61]

As a literal embodiment of the future, children became the flashpoint for anxieties on both sides of the racial divide. The murder of Emmett Till had terrified black parents and children not just for its brutality but for the tender age of its victim. "Bobo" Till was just fourteen, he read comic books and liked candy, he was an innocent kid. For murderers Bryant and Milam, however, Emmett Till was a black boy who was turning into a man. If you let a fourteen-year-old black boy whistle at a white woman, who knew what would happen next? That same reasoning informed school segregationists. According to their hysterical logic, inte-

gration led to miscegenation led to the destruction of society. It wasn't the innocence of little black children they cared about—it was the innocence of their own white children.

Despite the victory of *Brown v. Board of Education,* actual desegregation occurred slowly and unevenly. In 1957, nine black students attempted to integrate Little Rock Central High School but were blocked from entering the school building by National Guard troops sent by Governor Orval Faubus. President Eisenhower was forced to send in federal troops to enforce integration and protect the students from a white mob gathered outside the school. In places like Nashville, local officials drew up a so-called stairstep plan, where a grade a year would be desegregated, beginning with first grade in year one, second grade in year two, and so on. The thinking was that integration would be less volatile if it first occurred in the younger grades, a concession to local custom that tolerated black and white friendship in the "safe," prepubescent years.[62] On September 9, 1957, thirteen first graders desegregated the city's schools. The next morning, just after midnight, a bomb destroyed the east wing of Hattie Cotton Elementary School.

Children became among the most indelible images of the civil rights movement. Television cameras captured the moment when six-year-old Ruby Bridges integrated a New Orleans elementary school in November 1960. The school was surrounded by barricades, policemen, and a mob that chanted "2–4–6–8, we don't wanna integrate!" Seeing the commotion, little Ruby at first thought it was Mardi Gras. Escorted by four federal marshals, she climbed the enormous stairs to her new school. Wearing a dress and white cardigan, a ribbon in her hair and satchel in her hand, she looked impossibly tiny and impossibly innocent, an undeserving target for so much hate. A few years later, Norman Rockwell re-created the scene in his painting *The Problem We All Live With.* It would become one of the iconic images of the civil rights movement.[63]

What was so scary about Ruby Bridges? The moment she integrated the school, white parents dashed in and yanked their children from the classrooms. More than five hundred children were pulled from school that day. Looking back, Ruby commented, "They didn't see a child. They saw change, and what they thought was being taken from them. They never saw a child." The rest of

the world, however, saw Ruby. On television and in photographs, they saw a little girl who needed to be guarded by four adults just to go to school. They saw a little girl taunted by white adults, who screamed things like "Go home, nigger!"[64]

And what, after all, was so scary about Sunshine Sammy, Farina, Stymie, and Buckwheat? *The Little Rascals,* which had been enjoying strong ratings in the New Orleans market, could no longer be found on the local television lineup. It last appeared on the television schedule in 1959, beamed out of WLBT-TV in Jackson, Mississippi. Why the station declined to renew the syndication deal isn't known. But the timing, corresponding as it did with escalating local resistance to the federal school integration mandate, suggests the station balked at *The Little Rascals'* integrated cast. WLBT's station manager would later go on the air to protest the integration of the University of Mississippi by James Meredith, and the station would become so notorious for its segregationist bias that in 1969, the Supreme Court would vacate its license on the grounds that it breached the public trust.[65] Broadcasting scenes of Farina or Buckwheat sharing a classroom with white classmates could not have gone over well when local politicians, citizens, and even television station managers were actively resisting the desegregation of their own schools. Mississippi would not achieve complete integration of its schools until 1970. *The Little Rascals* would not reappear in local television listings until 1975.[66]

In Birmingham, the intersection of civil rights and the lives of children would reach its devastating apotheosis. Facing faltering support for their campaign in the city, James Bevel enjoined Martin Luther King Jr., to let schoolchildren participate in the demonstrations. King was reluctant: What if the children were hurt? Shouldn't they protect their young innocents? Bevel argued that such an attitude was foolish, that the children were the ones with the most at stake—they were the ones facing a lifetime of racism and thus the ones most eager for change. It would be a "children's crusade," he argued. Despite his misgivings, King finally agreed. On Thursday, May 2, 1963, hundreds of children left their schools in the middle of the day to protest. That day, more than six hundred were arrested. The next day, a thousand more showed up. So many were arrested that the city's paddy wagons were filled and the police resorted to using a school bus to transport the chil-

dren to jail. The nation watched as children as young as six years old peacefully protested, singing as they were herded to prison.

Taken by surprise, Bull Conner retaliated, ordering the use of high-pressure fire hoses and attack dogs. The cameras were there to capture images of children battered by the current, clinging to buildings and to each other, fending off snapping and lunging German shepherds. Watching the footage on the evening news, viewers across the nation saw an epic struggle between innocent children and the forces of racial hatred. As media historian Aniko Brodoghkozy writes, "[It was] a morally eligible Manichean polarization between obviously good versus obviously evil forces."[67] Public opinion rallied around the demonstrators, and Birmingham business leaders reluctantly agreed to desegregate. That August, Martin Luther King Jr. delivered his famous "I Have a Dream" speech, hoping that "One day right there in Alabama little black boys and black girls will join hands with little white boys and white girls as sisters and brothers."[68] A month later, on a Sunday morning, Klan members bombed the 16th Street Baptist Church, a former staging area for the Children's Crusade. Four young girls—Addie Mae Collins, Cynthia Wesley, Carole Robertson, and Denise McNair—were killed. In a chilling reminder of the murder of Emmett Till, the parents of one little girl were only able to identify her by her foot and a ring on one of her fingers.[69]

Children were the crusaders and the martyrs of the civil rights movement. And they marked a shift in representations of black childhood in the mainstream media. Where previously, the black child was figured as the pickaninny, a comic and occasionally pathetic figure, he or she was now figured as something more: human, vulnerable to injury and emotion, even heroic. Minstrel stereotypes like the pickaninny affirmed Jim Crow by suggesting blacks weren't human, that they weren't capable of full citizenship. Images of Ruby Bridges or the Children's Crusaders or the victims of the 16th Street Baptist Church bombing proved that they *were* human, that they felt pain, that they desired and deserved full citizenship rights. They, too, were "children of God," in King's words, and they joined all of God's children, "black men and white men, Jews and Gentiles, Protestants and Catholics," in craving freedom.[70]

President Lyndon B. Johnson would sign the Civil Rights

the watermelon jokes—you couldn't change Buckwheat's costume or Farina's pigtails. Keen to teach their children racial pride, parents worried that the series' pickaninny stereotyping would teach them the opposite—racial shame. In Memphis, Tennessee, one critic compared the series to *Amos 'n' Andy,* complaining, "The showing of the *Little Rascals* to Black children is an affront to every Black parent. It re-enforces the stereotype that our children are dumb, ignorant, and incapable of living productive lives. . . . It is morally wrong to stereotype our young people as clowns and idiots. This is harmful to a generation of dynamic, young, gifted and Black youth."[77] After three months of protest, local civil rights and media groups convinced WREG-TV to cancel the show in 1977. That same year, activists in Iowa protested *The Little Rascals* on KCCI-TV in Des Moines.[78] And in 1980, in response to a similar campaign, WRBL-TV cancelled *The Little Rascals* in Columbus, Georgia.[79] Even then, there were voices in the black community who defended the series. Billy Rowe, who had stood up for *Amos 'n' Andy* in the 1950s, stood up for *The Little Rascals* in the 1970s, maintaining that its scenes of integration were "before its time."[80]

During the 1960s, white segregationists had spearheaded the boycott of *The Little Rascals* at local television stations. During the 1970s, it was black citizens groups. Neither, however, could do much to stop *The Little Rascals* juggernaut. After a brief dip in the early 1970s, the newly edited package was picked up by more than a hundred stations across the country and continued to pull in strong ratings. Station managers in Minneapolis, Charlotte, and Tampa extolled the films' charms and unflagging popularity with viewers. King World Productions boasted that *The Little Rascals* was "the most successful children's series in the history of television programming," watched by "93% of television households in America."[81] The company produced an animated *Little Rascals Christmas Special,* a feature-length compilation film called *Rascal Dazzle* narrated by Jerry Lewis, and a series of animated public service announcements.[82] Created in the 1920s, it had survived the Depression, a world war, and the social upheaval of the 1960s. It had survived the advent of talkies, the threat of radio, and now the rise of television. It had survived the rise and fall of Jim Crow.

10

The Good Old Days

The passage of years has scattered the "Little Rascals,"
the youngest of whom are in their mid 40s. Apparently
there is no overwhelming pang of nostalgia for the old
days, since most of the alumni of the two-reelers have
lost track of each other and they don't seem to have any
great desire to track down old colleagues.
 —Bill Kaufman, *Milwaukee Journal,* June 21, 1975

The television revival of *The Little Rascals* brought with it
another upsurge of interest in the whereabouts of the *Our
Gang* kids. The series had been in syndication for more than two
decades and, despite protests over its racial content, continued
to expand its viewership into the 1970s. The kids who had first
watched *The Little Rascals* in 1955 were now parents themselves,
with their own kids watching *The Little Rascals* in 1975. Nostal-
gia welled up for yet another generation of viewers—the baby
boomers—who associated the series with their own childhoods.
What was up with Spanky now? Or Darla? Or Stymie? How had
they changed and grown up?

Rumors of a *Little Rascals* curse began to take hold around
this time. Several of the *Our Gang* stars had met tragic ends, their
lives cut short due to violence or drugs or plain bad luck. The first
to die was Norman "Chubby" Chaney, who mushroomed to three
hundred pounds after his retirement from *Our Gang.* Soon after
undergoing surgery for a glandular illness, he passed away in 1936
at the age of eighteen. Bobby "Wheezer" Hutchins was the next

to die, killed in an Army Air Corps training accident in 1945. He was twenty years old. A few years later, Billy "Froggy" Laughlin was killed in a motorcycle accident at the age of sixteen. Others, like Carl "Alfalfa" Switzer and Scotty Beckett, lived post-Gang lives marred by violence and run-ins with the law. Toward the end of his life, Switzer was arrested for illegally cutting down pine trees in Sequoia National Forest and was injured in a shooting outside a bar in Los Angeles. He died in 1959, shot to death by a former partner over a financial dispute. He was thirty-one years old. Scotty Beckett was arrested countless times for charges including drunk driving, drug possession, passing a bad check, carrying a concealed weapon, and assault. In 1968, he died in a nursing home following a severe beating. He was thirty-eight years old.[1]

Hal Roach scoffed at those who subscribed to the idea of a *Little Rascals* curse, pointing out that hundreds of children had appeared in the series and only a handful had met an unfortunate end. But the durability of the rumor—it was even the subject of an *E! True Hollywood Story*—spoke to the public's fascination with the series.[2] There was the irony of wholesome child stars coming to decidedly unwholesome ends, of course, and also the stereotype of the child star incapable of growing up and managing the transition to adulthood. Dickie Moore talked about going from family breadwinner to woeful has-been, Jackie Cooper about being robbed of a childhood. If the children had once been famous and wealthy, they were now neither. Most had had their careers derailed by adolescence, and none received residuals from television syndication—their contracts had been signed long before anyone knew how dominant and lucrative the medium would become.[3] Adding to the power of the curse was the frisson of premature mortality. All the victims were struck down when they were young, a reminder of the fragility of life and the ruthlessness of time.

If there *was* a *Little Rascals* curse, it was the curse of the child star, eternally haunted by the past. Fans of the series might have indulged in warm nostalgia for the "good old days," but the former actors generally did not. *The Little Rascals* reminded them of glory days, now long gone. Or it reminded them of the pressures of supporting a family during the Depression. Or it re-

minded them of the residuals they weren't receiving. Now that the series was on television constantly, it was nearly impossible to escape these images from the past, immortalized on screen. In a 1975 interview, Dickie Moore admitted that he had "mixed memories" about his time as a child star. Now fifty years old and the head of a public relations firm, Moore said, "It's difficult to look back and compete with yourself 40 years ago."[4] Stymie Beard concurred, "You know, it hurts to see yourself and the Little Rascals constantly on TV and you don't get any money out of it."[5] Tommy Bond chose not to look back at all. He called his years on *Our Gang* "just a part of my life that quickly passed and I went on with the process of growing up." Most of the *Our Gang* kids had lost touch with their former costars, and few seemed much interested in reconnecting after so many years.[6]

Like his former castmates, Allen "Farina" Hoskins—or Al, as he was now called—spent many years trying to distance himself from his past. He had had dreams of continuing his acting career or, better yet, working behind the scenes as a cameraman, but opportunities were limited and Al had a family to support. Along with many others in Hollywood, he was a casualty of anti-Communist hysteria during the McCarthy era, questioned by the House Un-American Activities Committee for having attended dances sponsored by the Young Communist League and the Socialist Workers Party when he was a teenager. His passport was confiscated, and he was blacklisted. "But it didn't matter," he later said. "I wasn't working anyway. But I didn't want to stick around and be another has-been. I wanted to do something."[7]

In 1952, shortly after appearing on *You Asked for It,* Al decamped to Northern California. It was a chance for a fresh start, in a place where no one knew he had once been a movie star. He started at the bottom, painting houses, washing dishes, doing "anything to make an honest buck."[8] Throughout, he emphatically refused to trade on his name.[9] His second wife, Franzy, didn't know he was Farina until they had known each other for six months.[10] Eventually, Al began working with the mentally disabled, rising through the ranks to become public relations director of the Alameda County Association for Retarded Citizens (ARC), a job he found immensely fulfilling. He raised six children, and in his free time, he practiced photography and wrote

poetry. Occasionally, fans and admirers would track him down, but he refused all requests for interviews. In his own words, "I stayed buried for a long, long time."[11]

Ernie Morrison, Stymie Beard, and Billie Thomas had also stepped out of the limelight. Ernie eventually left show business and spent seventeen years working as a quality control inspector for an aerospace company in Compton, retiring in the early 1970s.[12] Billie returned to MGM Studios after his stint in the army and worked as a Technicolor lab technician on films such as *Jaws* (1975) and *Logan's Run* (1976). He had a son, Bill Jr., and spent his free time listening to music, playing the drums, and pursuing his ham radio hobby.[13] Stymie, after years of drug abuse and time in and out of jail for petty crime, was sentenced to twenty years in federal prison for the sale and possession of heroin. He served six years, getting out in 1965. In despair, he checked into Syanon for a two-week visit and ended up staying for more than seven years, finally kicking his heroin habit.[14] All three men now lived in the Los Angeles area but, like everyone else, had drifted apart.

The Hal Roach Studios, site of their childhood antics, no longer existed. Hal Roach Jr. had taken over the studio from his father in 1955 and proceeded to run it into the ground.[15] The company went bankrupt in 1959. A few years later, all the props, equipment, and furnishings were sold at public auction—everything from lighting fixtures and camera dollies to a fake Mona Lisa and a six-foot pencil.[16] Over its nearly fifty-year existence, the studio had thrown almost nothing away. Still stashed in storehouses and closets were props from old Laurel and Hardy, Charley Chase, and Thelma Todd films. One closet contained original *Our Gang* props, a dusty, tangled heap of hobbyhorses and horns, toy guns and airplanes, bicycles and drums. Surveying the wreckage, a reporter from the *Los Angeles Times* felt a sharp pang of nostalgia. "This dark treasure," he wrote, "spoke more eloquently of days gone by than any other corner of the storied lot."[17] Soon after, the toys were unloaded like garage-sale castoffs for as little as one dollar apiece.[18]

The studio was razed a few months later—fifty-two buildings, including seven sound stages, scattered across a weed-choked, 14½–acre tract. The shuttered *Our Gang* café, Lake Laurel and Hardy (now green and murky), a medieval French village built

for Ingrid Bergman's *Joan of Arc*, an ersatz ocean liner covered with peeling paint: all were destined for the wrecking crew.[19] Just before demolition, a local television journalist interviewed the now seventy-year-old Hal Roach on the studio backlot. Portly, with white hair ringing his bald head, Roach appeared as wooden as the false storefronts, devoid of the charisma that had always characterized his in-person presence. If he felt any sadness at the demise of his eponymous studio, he didn't show it. "I have no feeling of regret," he said flatly. "The passing of a studio has no effect on me—it's just brick and mortar." He paused, then conceded, "I do regret the passing of the studio as a place for the filming of comedies." The cameras then cut to the unceremonious process of demolition, a Sherman tank lumbering over the ruins of a half-century of laughter. The "Lot o' Fun" was no more. It was replaced by light industrial buildings, businesses, and an automobile dealership.[20]

Journalists and fans persisted in tracking down the *Our Gang* actors, aided by organizations like Sons of the Desert, a Laurel and Hardy fan club that included many *Little Rascals* fans among its members. Slowly, the actors allowed themselves to be drawn back into public life. A few even enjoyed an unexpected career resurgence. Ernie, for example, had a cameo on the television show *Good Times*.[21] Stymie also appeared in *Good Times,* as well as *The Jeffersons* and *Sanford and Son*; he later voiced a small part in the animated *Little Rascals Special* that aired in 1979. For Stymie, the return to acting offered a new beginning after so many years lost to drugs. Among his many regrets was that his mother was not around to witness his redemption, having passed away in 1962.[22]

One person who did get to witness Stymie's comeback was his former best friend, Dickie Moore. In the early 1980s, the two men reunited after a hiatus of nearly fifty years. They met at a chicken and waffles place in Hollywood, where Stymie's picture was hanging on the wall.[23] Stymie was dressed in a beige suit and brown tie, a bit thicker around the middle but still sporting his signature derby on his head. He brought Dickie a gift—a photograph of the two boys, taken when they were working together at Hal Roach Studios.[24] To Dickie, he expressed his disappointment at not receiving residuals for *The Little Rascals* and confided that

he still kept Hal Roach's phone number on a slip of paper in his wallet. "Here I am with a couple of dollars in my pocket and the registration to my Chevy Nova, the only thing in my life I've ever owned," he said. "I wouldn't know how to live with my rent paid up." When Moore asked if he'd ever called up Roach, Stymie said no. "The man must be ninety-some years old," he said. "Maybe I should hate him for not sharing the TV money with us, but all the man has to do is smile at me and I'll forget the whole thing. He had a magic smile."[25]

Billie was more reluctant about making a so-called comeback. He was invited to officiate at beauty pageants and attend movie premieres, and he appeared on NBC's *Tomorrow Show* in 1974 with Spanky, Darla, and Stymie. When local kids knocked on his door to ask for pictures and autographs, he was delighted to see them. But otherwise, he declined to take up acting again, preferring to enjoy his private life.[26] His mother, Mattie, on the other hand, had different ideas. Ever the stage mother—or grandmother, now—she was confident that lightning would hit twice and that her grandson, Bill Jr., would repeat her son's Hollywood success. Bill, however, had no interest in being an actor. No matter—time after time, Mattie dragged her grandson to auditions, where he refused to talk and when he finally did, said things like "I don't want to be in the movies." Mattie finally gave up after Bill sabotaged an audition by purposely falling down a staircase. You couldn't repeat the past after all.[27]

Al was one of the last to come out of hiding. In his case, the impetus was personal. His mother, who had guided his career and carefully saved every press clipping and fan letter, passed away, leaving a trove of old 35 mm films, publicity photos, and *Our Gang* scripts. Al finally felt ready to face his past.[28] He must have felt a little like Rip Van Winkle. As a child, he had been considered a credit to his race, a pioneer, and a source of inspiration. Now, he was criticized for perpetuating racist stereotypes. He defended the series as showing "no difference" between black and white characters and for providing an early example of racial integration in film.[29] "On the screen, we were in all the party scenes and the White kids went through the same misadventures as the Black," he said. "We were not just the butt of every joke."[30] The central message, he maintained, "was that we're all just people—

sometimes good, sometimes bad."[31] In recognition of his role as a racial pioneer, Al was inducted into the Black Filmmakers Hall of Fame in 1975, along with Eartha Kitt, Quincy Jones, and Eddie "Rochester" Anderson.[32]

Ernie, Stymie, and Billie also faced criticism that the series was racially insensitive and a vestige of a past that was best forgotten. Ernie insisted that this was "foolish": "what these kids are doing has nothing to do with prejudice. If you look at kids, you'll see they do the same thing today."[33] When pressed about working for Roach, he answered, "When it came to race, Hal Roach was color-blind."[34] Billie also defended the series, pointing out that all the kids, regardless of race, were the target of practical jokes.[35] "We had a lot of fun together," he said. "Just like a family. We went to school together, played together, laughed together."[36] Stymie was the only actor to admit discomfort and even disgust with the films' racial portrayals. "It was *mammy* this and *mammy* that in those days," he grimaced. "There's no lines like that in [*Sanford and Son*], thank Jesus. We don't have to do that anymore."[37] Of the four black stars of *Our Gang*, Stymie was the one with the most radical political sympathies (he once autographed a photograph for Huey Newton, founder of the Black Panthers, that read, "To Huey. Power to the People. Stymie").[38] Despite his mixed feelings, Stymie too acknowledged that his experience on the series had been a good one. Once again, he was a celebrity, an experience he clearly relished. "A lot of kids are watching that old show," he said to a reporter, smiling as kids yelled out "Hey-y-y, STYMIE!" as he walked down the street.[39]

Actors who had once tried to distance themselves from the series now found themselves tentatively embracing it. On the one hand, the past was associated with childhood trauma, or economic instability, or racial insensitivity. It was something to escape and transcend in order to progress and grow up. On the other hand, once enough time had passed, memories blurred. Good times were remembered, bad times forgotten. Now on the other side of middle age, actors like Ernie, Al, Stymie, and Billie were perhaps more ready to go back to their childhoods now that it was irretrievably far away. As film historian Leonard Maltin noted, all the *Our Gang* actors "[went] through periods of resenting their childhood fame because it did not bring them happiness.

Some actively denied their past. But at a certain point they make their peace with it [and] say it was a great thing to be associated with."⁴⁰ The four men had forged new careers, or created new identities, or conquered addictions. They had married, had children, grown old. They had survived child stardom.

The Greek roots for "nostalgia" are *nostos,* meaning "return home," and *algia* meaning "longing." As the writer Svetlana Boym has argued, that "home" is not necessarily a place but a time—"the time of our childhood, the slower rhythms of our dreams."⁴¹ Nostalgia often welled up during times of personal or historical upheaval, a way of coping with change by seeking solace in a mythical past. Whether it was adults longing for the good old days of youth or segregationists longing for the good old days of plantation slavery, nostalgia was based on a fantasy of the past. It was one that even the *Our Gang* actors, who knew firsthand the reality behind Hollywood fantasy, were drawn to. The *Our Gang* kids were getting old, facing their own mortality. Al and Stymie had lost their mothers. To go back to *Our Gang* was to inhabit a time and place when mothers were alive and life seemed to unspool before them. Billie's mother was still alive, but she too longed for a return to the past, trying to model her grandson on her son. The *Little Rascals* curse affected everyone. It was the curse of nostalgia.

To be sure, Al Hoskins was less sentimental than most—"I try not to live in the past," he once said—but even he eventually agreed to attend an *Our Gang* reunion on July 31, 1980, in Hollywood, California.⁴² Ernie was going to be there. So were Billie, and Spanky, and Butch. They were all in their fifties or older, their hair thinning, their waistlines thick, their faces jowled and wrinkled. They were virtually unrecognizable from their younger, cherubic selves. Hal Roach was going to be there, too. He was eighty-eight years old and still robust, with the same wicked sense of humor. It had been almost sixty years since he first created *Our Gang.* The man who had discovered Harold Lloyd and paired Laurel with Hardy was looking forward to seeing Farina, his favorite of the *Our Gang* kids, again. Over the years, Sons of the Desert had organized other reunions of *Our Gang* and Laurel and Hardy cast members, but this was the first one that Al had agreed to attend.

Five days before the reunion, on July 26, 1980, Allen "Farina" Hoskins died of cancer in Oakland, California. He was fifty-nine years old. Over the next decade, his fellow "race kids" on *Our Gang* would also pass away. Billie "Buckwheat" Thomas died of a heart attack in Los Angeles on October 10, 1980, forty-six years to the day after his mother had brought him in to audition at Hal Roach Studios. He was forty-nine years old. Matthew "Stymie" Beard suffered a stroke at home shortly after his fifty-sixth birthday, lying undiscovered for two days before being rushed to USC Medical Center, where he died of pneumonia on January 8, 1981.[43] The original Gangster, Ernie "Sunshine Sammy" Morrison, died of cancer on July 24, 1989, in Lynwood, a suburb of Los Angeles. He was seventy-six years old. Hal Roach would outlive them all, passing away on November 2, 1992, at the age of one hundred.

Billie "Buckwheat" Thomas may have died, but a new Buckwheat was about to be born. In 1981, a young comedian named Eddie Murphy debuted his Buckwheat impression on *Saturday Night Live*. Dressed in the character's familiar striped shirt and suspenders and wearing an oversized afro wing, Murphy pretended to shill a compilation album called *Buh-Weet Sings*. He launched into off-key renditions of "Fee Times a Mady" (Three Times a Lady), "Wookin Pa Nub" (Looking for Love), and "Una Panoonah Banka" (Una Paloma Blanca), ending with Buckwheat's signature phrase, "O-Tay!"[44] The skit was an instant hit, and Murphy would reprise the role several times over the next couple of years. In one skit, he crooned "Ayby Nub" (Baby Love) and other Supremes ("Dupreems," in Buckwheat-speak) songs; in another, he plugged his new kids album, *Buh-Weet Sings Por De Tids*, on "The Uncle Tom Show," a children's show hosted by Tom Snyder (Joe Piscopo). When Robert Blake appeared as a host in 1982, the show staged a reunion with Murphy as Buckwheat, as well as with a fake Alfalfa, Darla, and Froggy.[45]

Born in 1961 in Brooklyn, New York, Murphy came of age in the 1970s, when *The Little Rascals* was ubiquitous on television. Growing up in a post–civil rights, urban city in the North, Murphy saw Buckwheat as an absurdity, a throwback to a place and time he couldn't even imagine and that had never really existed—the antebellum, plantation South popularized by

blackface minstrelsy. When asked how he came up with the gag, Murphy recalled riffing with an audience at a comedy club one night. He joked, "I'm from a predominantly black family, and I have yet to meet a brother named Buckwheat. I can just see him. 'How ya doin? My name's Buckwheat. Most people are named after their father. Well, I was named after my father's favorite breakfast cereal.'" The audience laughed uproariously, so Murphy kept going. "'Yeah, and I got a sister named Shredded Wheat. And I have a retarded brother named Special K.'"[46] In an appearance on *The Tonight Show* with Johnny Carson, Murphy went even further, joking about his absurdly named brothers "Stymie" and "Farina," along with his older sister "Trix" (a prostitute) and his big brother "Lucky Charms" (a homosexual).[47] The audience laughed because it knew Murphy was right. Black people didn't name their children after breakfast cereal—that was the outlandish notion white people had of black people. Buckwheat, in other words, wasn't really black. He was white America's inauthentic representation of blackness. Murphy lampooned other racial absurdities in Buckwheat, as well. Billie Thomas's childhood speech impediment was exaggerated for laughs, spoofing stereotypes of black people as inarticulate and ignorant. Murphy's afro, wide-eyed stare, and childlike delivery also skewered the historic infantalization of black men. Murphy was the overgrown pickaninny, a bumbling Sambo.

However, satire was slippery. While Murphy's impersonation of Buckwheat was, in executive producer Dick Ebersol's words, "one of the hottest characters in late-night television at the time," it wasn't always clear whether audiences were laughing *with* him or *at* him.[48] Were they in on the joke that Murphy's Buckwheat was supposed to be a parody? Or were they just laughing at another tongue-tied, infantile black man acting the fool? Critics like Leroy Clark of the NAACP called it a "second coming of Amos 'n' Andy"—that instead of mocking racist beliefs, Murphy was perpetuating them.[49] Clarence Page, a black columnist at the *Chicago Tribune,* complained, "what began as a satire of racial stereotyping quickly degenerated into the cheap humor it set out to lampoon."[50] Meanwhile, Billie Thomas had recently passed away, and his son, Bill Jr., was hurt that Murphy was portraying his father as an incoherent moron. George "Spanky" McFarland

agreed: "[Murphy] made Buckwheat into a stereotype that he wasn't, at the expense of the people in his family who are still alive."[51] In response, Murphy insisted his caricature wasn't meant as a personal offense, and Ebersol also apologized to Thomas, assuring him that the sketch "was absolutely not meant either to racially stereotype the speech patterns of black Americans or to attack your father."[52]

Meanwhile, the Buckwheat sketch had become so popular that Murphy found himself stereotyped by the stereotype, with audiences constantly clamoring for him to repeat his impersonation. "I can't stand it anymore," he told Ebersol. "Everywhere I go people say, 'Do Buckwheat, do this, do that.' I want to kill him."[53] At first, Ebersol thought Murphy was joking, but over the course of a year, Murphy would kill and rekill Buckwheat, as if to put a definitive end to a role and a stereotype that stubbornly refused to die. Satirizing the overwrought media coverage surrounding the recent assassination attempt on President Reagan, *Saturday Night Live* showed Ted Koppel (Joe Piscapo) repeatedly playing video footage of Buckwheat's shooting and described his death as the fall of an American icon, mourned by world leaders like Richard Nixon, Henry Kissinger, and Princess Diana. Later, Buckwheat is found alive, having staged his own death and gone into hiding. Discovered by Alfalfa, he is killed for real this time, shot by his friend in revenge for a childhood prank. This time, Buckwheat stayed dead, and Murphy retired his character.[54]

The series of "Buckwheat Is Dead" sketches were funny for the way they lambasted the media and imagined a violent feud between two characters better known for their youthful innocence. They also seemed to invoke *The Little Rascals* curse—the fake Buckwheat ostensibly shot while exiting 30 Rockefeller Plaza, the real Alfalfa shot while trying to collect a debt. Finally, they expertly hyperbolized Buckwheat's role in American culture. His shooting and death were reported in breathless headlines like "The Shooting of Buckwheat: America Stunned," "Emergency Surgery: America Waits and Worries," and "Buckwheat Dead: America Mourns." He was mock-eulogized by President Reagan ("we have lost a close and dear friend") and the pope ("The entire world mourns the loss of this great humanitarian. Buckwheat was a man of peace"), received a military funeral, and

was commemorated by a moment of silence. This was treatment befitting the assassination of JFK or Martin Luther King Jr., not a child comedy star from the 1930s. The real Buckwheat, Billie Thomas, had died only two years before, his death reported in a handful of obituaries but otherwise publicly unmarked.

Except that Buckwheat *had* become an iconic figure in American culture. He may not have been president of the United States or a Nobel Prize winner, but he was an indelible part of popular culture. Part of the success of Murphy's act was that everyone recognized the character on which his parody was based—much like they recognized Mr. Rogers and Gumby, the other kiddie cultural icons Murphy famously satirized. In fact, for kids growing up in the 1980s, Murphy's Buckwheat practically eclipsed the real Buckwheat and gave the character renewed, albeit skewed, life. Murphy had tried to "kill" Buckwheat, but Buckwheat wouldn't die. On television reruns of *The Little Rascals* and now *Saturday Night Live,* he lived on.

Buckwheat not only lived on, but he began to take on a twisted life of his own. Critics in the black community had been complaining for decades that Buckwheat was a derogatory stereotype that depicted black children as pickaninnies and clowns, and Murphy had skewered this stereotype with his Buckwheat impression. But now white racists began lobbing the name as a new and creative racial insult. In 1987, Ed Tyll, a radio talk show host, compared Congressman John Lewis, who suffered from a speech impediment caused by a beating during civil rights protests, to Buckwheat, with his garbled speech. Tyll later said he used the epithet "because [he] felt [Lewis's on-air] characterization of Lt. Oliver North was childish" and roundly denied accusations that he was racist.[55] Tyll was suspended and eventually reinstated after he apologized.[56] In Chicago, there was a brief uproar over Mayor Richard Daley allegedly using "Buckwheat" as a nickname for one of his black staffers—a nickname, it turns out, that his staffer had had since he was a teenager.[57] In 1992, a town official in Maryland referred to Martin Luther King Jr. Day as "Buckwheat's Birthday." He later defended himself, saying, "It's something I heard earlier that I repeated. It wasn't a prejudice thing."[58] Elsewhere, there were accusations of "Buckwheat" being used as a racial epithet against black students, customers, and employees.[59]

"Buckwheat" had originated in film as a "pickaninny," but he now entered the vernacular as a racial slur akin to "Sambo," "coon," or even the explosive "nigger." Calling John Lewis "Buckwheat" and describing Martin Luther King Jr. Day as "Buckwheat's Birthday" were verbal acts of violence and degradation. They reduced leaders of the civil rights movement to minstrel stereotypes, stripping them of manhood and dignity, depicting them as buffoons. "Buckwheat" became an easy verbal takedown for any African American who had stepped beyond his place, a way to reverse years of racial progress and sacrifice with one flippant word. And ironically, it owed some of its new rhetorical potency to Eddie Murphy, who had distilled *Our Gang*'s racial stereotyping into an easy, culturally available package. At the same time, "Buckwheat," like other racial epithets, became available for reappropriation, used by some African Americans as a tongue-in-cheek synonym for "dummy" or "idiot." It was in this way that Corey Poitier, a black Republican from Florida, claimed to use the term when he called out President Obama with a "Listen up, Buckwheat." "I wasn't meaning any harm," he later said. "Maybe it was a little insensitive. It's a term that my brother and I use. It was kind of a way of saying 'dummy,' like when I say to my brother, 'Hey, Buckwheat, cut that out.'"[60]

Meanwhile, Buckwheat seemed to proliferate—literally. At one time or another, there were at least six different impostors who claimed to be the "real" Buckwheat.[61] At the time of his death, Billie Thomas was fending off the spurious claims of one James Frazier, a San Fernando parks and recreation worker who maintained that he'd been discovered by Hal Roach while performing on a traveling riverboat show in New Jersey. In a profile published in the *Los Angeles Daily News,* Frazier maintained, "I loved every minute of it—I even love looking at it now."[62] Even more bizarre was the case of Bill English, a grocery bagger in Tempe, Arizona, who was interviewed by ABC's *20/20* as the "real" Buckwheat in 1990—ten years after Billie Thomas had died. English claimed he had changed his last name and refused to sign autographs so he would not be bothered at work. The day after the show aired, Bill Thomas Jr. and Spanky McFarland came forward to refute English's claims, and *20/20* issued an apology.[63]

Buckwheat was everywhere. He was a pop culture shibboleth,

an insult, a term of endearment. He was Billie Thomas, Eddie Murphy, and any number of pretenders. Toward the end of the 1980s, he had never been more popular, embraced by Generation Xers who were growing up and remembered *The Little Rascals* and Eddie Murphy's impression with fondness. In college towns and malls around the country, novelty shops were doing a brisk business in Buckwheat-themed merchandise: T-shirts emblazoned with Buckwheat's face, his hair sticking up and the words "O-Tay!" written below; posters with Buckwheat wearing his striped shirt and straw hat, hitching his fingers around his suspenders; even dolls and wristwatches and baseball caps. One best-selling image superimposed Buckwheat's head—all big hair and eyes and mouth—onto Rambo's body, toting a machine gun. "Buckbo," it said below. The mashup of two 1980s icons would have delighted Generation Xers, with its ironic juxtaposition of a young black boy and a muscular white man. But it, too, bore troubling signifiers. There were the pickaninny features, of course, melded onto a hypermasculine, gun-toting body, turning Buckbo into a parodic Black Panther—a Pick Panther. There was also the name Buckbo, which sounded an awful lot like Sambo, or black buck, eliciting a string of related racial stereotypes.

Clarence Page loathed this new Buckwheat craze. He loathed the resurrection of racial stereotypes that originated in Jim Crow. He loathed how "liberal white" college students defended their affection for Buckwheat merchandise by saying "Buckwheat's color had nothing to do with [their] buying the shirt." He also loathed how Eddie Murphy had breathed new life into a "cheap gag."[64] His indignation was shared by others who bristled at the popularity of Buckwheat novelty wear. At Sidwell Friends school, a Quaker academy in Bethesda, Maryland, a black parent complained when a white student appeared in a class photo wearing a Buckwheat T-shirt; many white parents, meanwhile, "said they'd never imagined the t-shirt would have caused offence."[65] On college campuses, students also raised concerns. A black student at Washington State University complained, "This kind of stuff just keeps up that stereotype that black people are ignorant or something. . . . I mean, they've got Buckwheat, they're calling him Buckbo, and he's all bug-eyed and he's got that big grin on his face, just like those old movies had." The student continued,

"Why didn't they use some other Lil' Rascals [*sic*] character, like Alfalfa or Spanky or something? . . . I mean, this is 1988. You wouldn't think that somebody would be selling something like that in this day and age."[66] An apocryphal rumor began to circulate that Bill Cosby, who had campaigned to pull *Amos 'n' Andy* from syndication, had bought up the rights to *The Little Rascals* in order to keep its racial stereotypes off the air.

Why didn't people just slap Alfalfa or Spanky's image on a T-shirt and call it a day? What was it about Buckwheat, in particular, that tapped into the cultural zeitgeist? The truth is, Alfalfa and Spanky T-shirts didn't fly off the shelves like Buckwheat T-shirts did. It was Buckwheat whom Eddie Murphy had parodied, Buckwheat who now carried a measure of pop-culture chic, Buckwheat who was embraced as an ironic icon of Generation X. And as Clarence Page and others had noted, it was mostly "liberal white" students who seemed to be buying and wearing Buckwheat T-shirts and defending their affection for the character. In their minds, they didn't see Buckwheat as a racial caricature. Born after the passage of major civil rights legislation, ignorant of the pickaninny's long racial history, they instead saw him as a generational mascot, a sign of cultural hipness, and a nostalgic link to their own childhoods.

The pickaninny had emerged as a nostalgic icon for the Old South during the political and social upheavals of Reconstruction. Faced with monumental change, white Southerners mythologized the past, conjuring up an antebellum fantasy of happy plantation slaves. Now, more than one hundred years after Reconstruction, Eddie Murphy had resurrected the pickaninny in order to kill it. But Buckwheat wouldn't die. White Generation Xers now embraced Buckwheat as their own nostalgic icon—not for the Old South, in this case, but for a childhood of *Little Rascals* reruns and *Saturday Night Live* sketches. Their affection would coalesce around Buckwheat in the late 1980s, as these same kids were entering college, perhaps moving away from home for the first time, making the bumpy transition into adulthood. Wearing a Buckwheat T-shirt was a sign of cultural relevance ("I'm hip!") and identification ("I'm Gen X"), but it was also a sign of personal upheaval. Faced with change, these kids, too, sought solace in an imagined past.

Did it matter that Buckwheat was black? Of course not, these fans protested. "Buckwheat's color had nothing to do with my buying the shirt." Or "I never imagined the t-shirt would have caused offence." But it's hard to imagine Alfalfa or Spanky engendering the same level of fandom, at least with white Generation Xers. Part of Buckwheat's appeal was that he was both familiar yet racially different. White fans could claim to be colorblind while enjoying Buckwheat's "safe" and unthreatening blackness. And for people like Clarence Page, this came uncomfortably close to minstrelsy, to the nation's long history of fetishizing "black" entertainment. He complained, "When people try to be colorblind, they sometimes end up blind to more than color."[67] Those who grew up in the 1970s and 1980s may not have known the past from which Buckwheat emerged, but it still clung to his character, despite Murphy's satire, despite the passage of time.

Who was the "real" Buckwheat? Was he a reviled Jim Crow stereotype or a Gen X icon? A charming scamp, an ironic parody, or a humorless slur? In 1996, *The Parent 'Hood,* a sitcom based on an upper-middle-class black family living in Harlem, tackled the Buckwheat issue head-on in an episode called "I'm O-tay, You're O-tay." Nicholas, the family's eight-year-old son, is struggling to decide which African American hero he will portray for Black History Month. After dismissing his family's more traditional suggestions of Martin Luther King Jr., Colin Powell, and Duke Ellington, Nicholas settles on Buckwheat, a decision that appalls his parents but prompts a family discussion about racial stereotypes in film and television. On the night of his class presentation, Nicholas gives a report about Buckwheat that acknowledges this racial history but also pays homage to the actors who were forced to work within these stereotypes and who paved the way for future African American actors. Billie, Ernie, Stymie, and Al were not alive to see the episode, but it would have almost certainly made them proud.[68]

For years, King World Productions, which still owned the rights to *The Little Rascals,* had attempted to turn the series into a feature-length film, announcing as early as 1975 that it had begun production on "The NEW Little Rascals."[69] Even after the company became a syndication behemoth in the 1980s, acquiring

the rights to *Wheel of Fortune, Jeopardy,* and *The Oprah Win-frey Show,* it continued to pursue its *Little Rascals* movie proj-ect on the side. Part of the reason for King World's interest was, of course, financial. *The Little Rascals* was a lucrative franchise, with a built-in audience and family-friendly appeal. But part of the reason was also sentimental. Charles King was a struggling salesman when he founded King World Productions in 1964, by scraping together $300,000 for the television rights to *The Little Rascals.* The success of the series helped the company find its foot-ing in the television syndication industry and become, for a while at least, profitable.[70]

In 1972, Charles King died of a heart attack, alone and on the road, selling the *Little Rascals* package to stations in San An-tonio. He was fifty-nine years old and left behind an ailing com-pany. While *The Little Rascals* had helped launch King World, it was now the source of its financial troubles. Concerns over racial stereotyping had cut into demand for the series, and the company was barely turning a profit. King's six children, led by his sons Roger, Bob, and Michael, took over the business, operating for a time from two rooms above a barbershop in New Jersey.[71] There was talk of getting out of the syndication business, maybe invest-ing in some McDonald's franchises.[72] Then Bob King decided to reedit the package to eliminate the most offensive racial humor, spending his nights working out of his home basement. The strat-egy worked brilliantly. *The Little Rascals* came back stronger than ever, playing in nearly two hundred markets around the country by the end of the decade. King World was back, too, expanding into game shows and talk shows in the 1980s to become a tele-vision empire, the "Kings of Syndication" and "first family of television."[73]

If King World's story sounded familiar, perhaps it was be-cause it sounded so much like Hal Roach's story. Charles King, described by one reporter as a "350-pound Irish-American bruis-er," was a charismatic, self-made man who had survived dramatic changes in the media landscape.[74] He had initially made it big as a radio syndicator, traveling the country in his signature black homburg with red carnation in his lapel. The rise of commercial television in the 1950s, however, had nearly ruined him. He was selling kitchen appliances and novelty records when he invested

money he didn't have in *The Little Rascals*. The series proved to be a lucky talisman, and the fortunes of King World always seemed to rise and fall with that of *The Little Rascals*. Roger, Bob, and Michael King revered the memory of their father and saw the series as inextricably tied to their personal and professional lives. To a reporter, they joked that their family was just a bunch of little (or big—Roger was 6' 3" and 250 pounds) rascals. According to Roger, he was the Alfalfa of the King Gang, while his baby brother Michael was its Spanky. Michael disagreed, joking that Roger was more like Butch, the bully. "Neither one of us was Waldo," Roger added. "My sister Diana was definitely Darla."[75]

In 1994, King World Productions finally succeeded in bringing *The Little Rascals* to movie theaters, partnering up with Universal Pictures and Amblin Entertainment, Steven Spielberg's production company. With their brash and colorful personalities, the King brothers seemed to reincarnate showmen like Hal Roach and Sid Grauman in promoting their new movie. "Some of the greatest names in the history of motion pictures, including Frank Capra and Laurel and Hardy worked on the series," Michael King told a reporter. "And it broke new ground on a lot of fronts. Black children were shown playing with white children. The special effects were cutting-edge."[76] Penelope Spheeris, a longtime fan of the series, was tapped to direct the movie. "I think in America here we feel like it's a treasure," she said. "Everybody feels like they own the Little Rascals. . . . So I tried to stay true to the characters and stories and everything."[77] While Spheeris and her fellow writers wove in many of the gags and plotlines from the original films, they did make some notable changes. In the remake, they kept Stymie and Buckwheat but carefully shed the racially charged signifiers of plantation dialect, minstrel shoes, and electrified hair. Stymie still wore his signature derby and vest, but Buckwheat now wore an oversized flannel shirt—clean and unragged—and had his hair in neat braids. There was no trace of speech impediment. Whoopi Goldberg, an avowed *Little Rascals* fan, signed on to play Buckwheat's mother. Magic Johnson was slated to play Stymie's father but had to bow out when he was picked to be the new Lakers coach.[78] Spheeris also added more Asian American, Latino, and African American faces, in an attempt to reach—and reflect—a more diverse audience. One paper

described the film as reviving Hal Roach's original premise of "a multiethnic group of pranksters."[79]

It had been seventy years since *Our Gang* was created, and the fantasy of racial friendship was still as powerful—and unlikely—in the 1990s as it had been in the 1920s. The series had been created in the years following the Red Summer of 1919, when race riots ripped through the country, fed by rising unemployment and competition for jobs between African Americans, immigrants, and working-class whites. *The Little Rascals* remake was released in the years following the Los Angeles Riots of 1992, when anger over the Rodney King verdict and despair over the ongoing recession triggered a six-day conflagration over police brutality and racial injustice. For many Americans, the L.A. Riots were a shock—it had been more than two decades since the major race riots of the 1960s, and many assumed race relations had improved. Instead, the L.A. Riots exposed new interracial tensions on top of the old—between the black and Korean communities, as well as the black and white communities. For days, the riots raged on, ending in more than fifty deaths, two thousand injuries, and 17,000 arrests. The damage to the city was estimated at one billion dollars.[80] Interracial relations didn't seem to be getting better; they seemed to be getting worse.

Los Angeles in the early 1990s was the Los Angeles of the O.G., not the Los Angeles of *Our Gang*. Ice-T's album *O.G.: Original Gangster* had debuted in 1991, and it depicted a very different city from the one associated with Hollywood. Born Tracy Marrow in Newark, New Jersey, Ice-T first moved to L.A. in the 1970s, when he was around thirteen years old. The racial covenants that had kept Ernie, Al, Stymie, and Billie out of certain neighborhoods had been declared illegal, but Los Angeles was still a city of rigid racial separation. The freeway system helped enforce the color line, facilitating white flight to the suburbs and boxing in the black community to the area now known as South Central. Ice-T was bused to the predominantly white Palms Junior High School, a short distance away from where Hal Roach Studios used to stand.[81] When he later moved to Crenshaw High, he found himself on an almost completely black campus. "Wasn't one white kid there," he wrote. "And just one Mexican. L.A. is fucking segregated like that."[82] At Crenshaw, gangs like the Crips

and Bloods—the Original Gangsters—were just beginning to take hold among students. Over the next decade, they would grow in size and influence, as the crack epidemic devastated South Central and gangs became increasingly involved in drug dealing and production. Gang-related murders exploded, turning the area around Central Avenue into a war zone.

Los Angeles was now known as "the gang capital of the nation."[83] While black gangs were the most notorious, there were youth gangs of every race and ethnicity—Samoan, Filipino, Mexican, Korean, Salvadorean, Vietnamese—reflecting what one reporter called "the simmering ethnic stewpot that is Los Angeles."[84] A hundred years earlier, ethnic street gangs had terrorized the slums of New York City; now they terrorized the ghettos of Los Angeles. Roach himself admitted that "gang" had become "a bad word," more associated with urban violence and crime than innocuous fun.[85] In *O.G.*'s title track, Ice-T rapped about a world where kids toted tec-9s, not toy pistols; where turf battles ended in a hail of bullets, not rotten vegetables. He wasn't "your everyday-type Prankster"—he was "Ice-T, the Original Gangster." A couple months after *O.G.* dropped, John Singleton released *Boyz n the Hood*, a film that starkly depicted how gang violence was destroying the lives of young black men in South Central. Even the title of the movie sounded like an ironic take on the neighborhood boys' gang of yore.

The Los Angeles Riots of 1992 prompted a round of soul-searching and analysis similar to that which followed the Chicago Riot of 1919.[86] A special committee convened by the California State Legislature blamed endemic segregation, discrimination, and poverty in South Central, but it also pointed to the exploding diversity of the city. Los Angeles, the committee wrote, was "a grand experiment—an experiment to see if all of the peoples and cultures of the world can be brought together in one metropolitan area, where they must both compete and cooperate in order for the region to prosper."[87] The committee was self-consciously invoking Alexis de Tocqueville's classic nineteenth-century treatise, *Democracy in America*, that famously described the young American nation as a "great experiment," founded on ideals of social equality. But as the riots had made clear and as the special committee ruefully pointed out, "the early results of the ex-

periment have not been particularly encouraging." The "grand experiment" was the American experiment, and the experiment was failing. More than two hundred years after its founding, the nation was still riven by racial and socioeconomic divisions, still falling short of its revolutionary ideals.

The 1994 *Little Rascals* remake, released in the years following the special committee's report, struck some critics as almost laughably naive given the racial climate. One reviewer sighed, "It is noble—but also a little weird and probably futile—to try to teach kids to love each other for their differences, though that has always seemed to be a beneficial aftereffect of the 'Our Gang' comedies."[88] Others noted the film's premise of happy diversity and complained that the movie had flattened or homogenized difference in the service of this ideal. A critic for the *Washington Post* declared, "The Rascals have represented the country's multi-ethnicity ever since Hal Roach introduced the rambunctious band in the 'Our Gang' comedies in 1922. This time around, the racial and sexual stereotypes are gone, but so is the diversity. Now, all the kids say 'Otay!'"[89] A reviewer for the *Chicago Tribune* was more caustic in his assessment: "Part of what keeps people interested in the pictures today—perhaps one reason for this pointless movie—is the fact that the gang was integrated. . . . Yet the new 'Little Rascals,' though it has a Stymie and a Buckwheat, doesn't do anything funny, surprising or fresh with the gang's multi-racial makeup."[90] The reviewers sounded almost—yes—nostalgic for the slapstick era, when racial and ethnic humor was routine and it was "otay" to acknowledge and even mock difference. The new *Little Rascals* movie was earnest, well-meaning—and hopelessly unfunny.

Despite—or perhaps because of—anxieties about the growing multiculturalism of American society, *The Little Rascals* remake was now seen as a model of "political correctness." A term that became widespread in the early 1990s, "politically correct" (or "PC") emerged as an often pejorative term for liberal beliefs regarding multiculturalism, affirmative action, and identity politics.[91] Making fun of a person's skin color was un-PC. Calling someone "Negro" or "Oriental" was un-PC. Blackface minstrelsy was un-PC. The original *Our Gang* shorts were definitely un-PC because of their racial gags and stereotyping. The new *Little*

Rascals movie, on the other hand, could have been rated "PC"—brightly, inoffensively multicultural, suitable for children.[92] On film, the Gang faced their own versions of strife, sabotage, and looting—strained friendships, the burning down of their clubhouse, and the theft of their prized go-cart—yet reconciled and rebuilt. As it had in the 1920s, the movie appeased contemporaneous cultural anxieties, promoted the ideal of a multiracial America, provided wholesome kids' fare, and indulged parental nostalgia for childhood. Widely panned by critics as unrealistic, saccharine, and humorless, the movie nonetheless found an audience that saw it as idealistic, charming, and funny. The film took in a respectable $10 million in its opening weekend, eventually earning more than $50 million by the end of the year.[93]

And that wasn't the last of the *Little Rascals* remakes. In 2014, twenty years after the first *Little Rascals* movie appeared, Universal Studios Home Entertainment released a follow-up called *The Little Rascals Save the Day.* If Hal Roach or Bob McGowan had been alive, they would have cried (or poured themselves a stiff drink). The film starred Eden Wood, a child actress best known for appearing on TLC's *Toddlers and Tiaras,* a child-pageant reality show in which she routinely appeared wearing sequins, feathers, and more makeup than a drag queen. Eden's mother Mickie was called a "stage mom," "control freak," and "baby pageant slave driver."[94] Had they appeared in Roach's office in 1921, one imagines they would have been unceremoniously kicked out. Instead, in 2014, Eden headlined *The Little Rascals Save the Day,* starring as Darla (wearing a dark pageboy wig over her blond hair). The film's direct-to-video release reflected the studio's modest expectations: this was a low-budget movie, aimed at families with young children who might watch and rewatch the video at home. And as far removed as this latest incarnation was from the original *Our Gang* films, it proved there was still life—and profit—in the old franchise. The reviews on Amazon were mostly positive, boosted by parents and grandparents who praised its "clean, slapstick fun" and its nostalgia factor.[95] That same year, the cast of the 1994 *Little Rascals* movie reunited for a twentieth-anniversary photo shoot, re-creating poses from the movie and providing a nostalgic thrill for fans who were now in their twenties and thirties.

In 1924, *Our Gang* offered a fantasy of the American melting pot. In 1944, it offered a fantasy of Uncle Sam's family. In 1964, it was the fantasy of racial integration. In 1994, the fantasy of PC multiculturalism. And in 2014? *Our Gang* offered the fantasy of postracial America. With President Obama's election in 2008 and the increasing acceptance of interracial marriage, some argued that the nation had entered an era free from the prejudice and discrimination of the past. The country, they claimed, had moved beyond the color line, moved beyond its "original sin" of slavery, moved beyond its obsession with race.[96] A film like *The Little Rascals Save the Day* seemed to affirm this vision, with its multicultural cast and color-blind casting. As one reviewer put it, the movie "progressively pays no mind to race."[97] Stymie and Buckwheat were once again brought back in modernized guise (Buckwheat's afro had even returned, suggesting it was no longer such a politically charged hairstyle). But the main players were not just black or white—they were themselves multiracial. Mary Ann was played by Jenna Ortega, an actress whose ethnicity is listed as "Latin/Hispanic, Mediterranean, Middle Eastern, Caucasian, Mixed, Pacific Islander, Caribbean."[98] The Woim was played by Rio Mangini, whose ethnicity is listed as "Caucasian, Mediterranean, Latin/Hispanic, Pacific Islander, Ambiguous."[99] Their "mixed" or "ambiguous" appearances reflected a nation that was also increasingly mixed or ambiguous, a hodgepodge of race and ethnicity that no longer lent itself to easy classification. Americans were now describing themselves as "Filatino" (Filipino/Latino), "Chicanese" (Chicano/Chinese), "Blaxican" (Black/Mexican), "Cablinasian" (Tiger Woods). Already, more than half of American children under the age of five were considered racial or ethnic minorities, and the country was projected to become a "majority-minority nation" in 2043.[100]

As enticing as this vision of postracial America was, it was swiftly derided by many as naive fantasy. If anything, they contended, history seemed to be repeating itself. After the shooting of Trayvon Martin, a seventeen-year-old African American boy, in 2012, Congressman John Lewis said, "I don't think anything disturbed me more since the murder of Emmett Till. And I remember when Emmett Till was murdered, lynched, on 28 August 1955." He continued, "This is not a post-racial society. Racism is

still deeply embedded in American society and you can't cover it up."[101] In 2014, the fatal shooting of Michael Brown, a black eighteen-year-old, by a white police officer in Ferguson, Missouri, sparked a series of race riots, first in the aftermath of the shooting, then again when a grand jury declined to indict the officer. Meanwhile, the rise of the Tea Party demonstrated the continued lure of a nostalgized, mythical American past among those fearful of a nation altered by immigration and social change.[102] No one could deny that the country had made enormous racial progress over the past century. But the persistence of institutional racism indicated that Du Bois's "problem of the twentieth century" was now a problem of the twenty-first.

Our Gang was created during the age of Jim Crow, when the nation was facing a wave of race riots and rising nativist and anti-immigrant sentiment. A century later, Jim Crow hadn't died so much as gone undercover, and the nation was still facing race riots, nativism, and anti-immigrant sentiment. Whether it was 1924 or 2014, *Our Gang* was still a fantasy of multiracial America as estranged from the real America as a toddler–pageant queen was from an actual toddler.

On July 4, 2014, the Sons of the Desert hosted a reunion of *Our Gang* stars as part of its 19th International Convention. Held at the Loews Hotel in Hollywood, near the tourist-choked corner of Hollywood Boulevard and Highland Avenue, the reunion was billed as the largest gathering of *Our Gang* actors since the organization's 1980 convention. It was a sadly diminished group. Aside from Sid Kibrick, who played the Woim, most were minor players on the series, now exceedingly elderly and frail. Lassie Lou Ahern, who appeared in a few *Our Gang* silent films, recalled playing with "Farina" on the set. And Mildred Kornman, who appeared as a chubby baby in the *Our Gang* silent film *Fourth Alarm,* was brought to tears remembering her "angel" of a sister, Mary Kornman. Many of the fans in the audience were nearly as old as the stars, some in motorized scooters and wheelchairs. A knot of fans gathered around to take photographs and get autographs. Across the ballroom, a small group of vendors was hawking *Our Gang* and Laurel and Hardy paraphernalia—everything from movie stills to T-shirts to fezzes. Business was slow.

The original *Our Gang* shorts had faded from the local television lineup, a result of shifting tastes and racial attitudes. It was no longer so unusual to see black and white children playing together on the television screen. Educational children's programs like *Sesame Street* and *Barney and Friends* featured diverse casts, as did popular animated cartoons like Disney's *Little Einsteins* and PBS's *Caillou*. The explosion of children's programming on cable networks like Nickelodeon, the Cartoon Network, and the Disney Channel meant that kids now had a dizzying array of choices. Gone were the days when *The Little Rascals* was the most enticing of a limited menu of programs. A new generation of children was watching the film remakes of the *Little Rascals* without knowing the originals from which they emerged. It was left to grown-up film buffs and nostalgists to seek out the series on bootleg videos, DVD collector's editions, and the Turner Classic Movies channel.

Will *Our Gang* live on? For nearly a century, the series has offered a fantasy of the "good old days," compellingly relived on celluloid. Generations of fans have been weaned on visions of a lost paradise, free from urbanization, or racial animus, or helicopter parents, or technology. At the same time, that past—idealized and fetishized—has fed into the nation's dreams of its future, its fantasies of a grand experiment or multiethnic stewpot or postracial utopia. The reality, of course, is that there has always been more than one imagined past, and more than one imagined future. Beneath the fantasy of the good old days lurks the legacy of slavery, of blackface minstrelsy, of Jim Crow. And beneath the fantasy of postracial democracy lurks continued racial disparities in health, education, incarceration rates, and wealth.[103] *Our Gang* lives on because it depicts a nation caught between its past and its future, its reality and its ideals, its worst and its best self. It taps into the innocence, naïveté, and optimism of childhood—and not just our childhood, but our children's. At those moments when racial progress has seemed most illusory and the dream of a united, multiracial America most foolish, adults have always placed their hope in the next generation. And that fantasy—that our children will do better and *be* better than us—is perhaps the most durable American fantasy of all.

Coming Home

We head home: through the gloss of rain or weight
of snow, or the plum blush of dusk, but always—home,
always under one sky, our sky. And always one moon
like a silent drum tapping on every rooftop
and every window, of one country—all of us—
facing the stars
hope—a new constellation
waiting for us to map it,
waiting for us to name it—together.

—Richard Blanco, "One Today,"
Inaugural Poem (2013)

In January 2013, I flew up to Northern California to meet Michael Hoskins, the son of Allen "Farina" Hoskins, for the first time. A retired firefighter, Michael had inherited several boxes of movie stills, posters, and clippings from his late father, or "Pop," as he was called. "Come on up and see them," Michael had told me over the phone, inviting me to his home in Fairfield, a small town located halfway between San Francisco and Sacramento.

I flew into Oakland, rented a car, and drove out of the city, over Carquinez Bridge, past the turnoff to Napa, past brown and black cows grazing in the hills outside Fairfield. It was a beautiful day, mild and sunny. Michael and his wife lived at the end of a quiet cul-de-sac, in a gracious two-story home painted a sage green. The lawn was meticulously groomed, with a frog lawn ornament and small sign that read "The Hoskins" to greet visitors.

Michael opened the door. He was in his sixties, a lean, athletic man with a greying goatee, freckles, and his father's smile. He introduced me to his wife, Lydia, or "B," who was elegant and youthful, with short hair. B had been very close to Pop and had encouraged Michael to meet with me and share his father's story. Behind them, watching television in the den, were their grandchildren, Mekhi and Mia Joy. Mekhi was about eight years old and Mia about six. Their parents were on a flight back from Washington, D.C., where they had gone to celebrate President Obama's second inauguration. They would be over later that day to pick their kids up.

For the rest of the day, sitting at the dining room table surrounded by boxes of material, I interviewed Michael about his father. Al Hoskins's experiences on *Our Gang* were "only positive," Michael said. "Pop had a childhood. He wasn't like Michael Jackson. He liked track, he went to school in South Central and met so many different people there." We looked through hundreds of movie stills and press clippings, some appended with handwritten notes by Jannie, Al's younger sister. Bobbie, Al's mother, had also clipped dozens of articles from black newspapers. There were fan mail and old vaudeville scripts, portraits of "Farina" posing next to a bust of Abraham Lincoln, "Farina" dressed as a New Year baby, "Farina" besieged by fans in Chicago. Al's old junior high and high school yearbooks were there, too, along with his official Quartermaster Corps portrait and some faded nightclub photos. I uncovered a stack of motion-picture camera manuals, including one for "le super Parvo," a 35 mm motion-picture camera popular during the silent film era. "Pop really wanted to be a cameraman—that was his love," Michael explained. "But there were no black cameramen then." Nothing made his father prouder, Michael said, than meeting successful black cinematographers when he was inducted into the Black Filmmakers Hall of Fame in the 1970s.

As an adult, Al was outgoing and charismatic, blessed with the "gift of the gab." "Everyone in Oakland knew him," Michael said. He was short, stocky, and "strong as a bull," and he smoked heavily until the end of his life. A devoted family man, Al and his wife Franzy raised six children with a firm but loving hand. When Michael played hooky from school—"we were just at a friend's

house, drinking beer, practicing our James Brown splits"—Pop found out and gave Michael a talking to he'd never forget. "He was a historian," Michael said. "He made us read about Afro-American history way before it became popular in schools. He was a stickler for knowing your past." A popular public speaker, Al was the subject of newspaper articles later in life, not for his early acting career but for his rehabilitation and advocacy work on behalf of the mentally disabled. In his late fifties, Al Hoskins was diagnosed with cancer. "It ate him up," Michael remembered. "The last six months, he really went downhill. It was tough on him." Among Al's papers was a small condolence card that had probably been included in a bouquet of flowers. "To Farina, my favorite actor," it read. "Hal Roach."

Around three in the afternoon, Michael's son and daughter-in-law arrived to pick up their kids. Michael called his son over. "Take a look at this!" he said, pointing to an old photo of Farina on the *Our Gang* set. "He looks just like Mekhi, with his missing teeth!" Mekhi came over as well, shyly peeking at his great-grandfather. Michael and B wanted to hear all about the trip to D.C., and Mekhi's parents showed us pictures from the inaugural parade, held on Martin Luther King Jr. Day. "Did you see the president? Did you see the president?" the kids asked, crowding around the digital camera. Their parents excitedly described coming within arm's reach of Michelle and Barack Obama, who had gotten out of their limousine to walk part of the way down Pennsylvania Avenue.

When I left that evening, Michael encouraged me to visit his father's former workplace, now called the ARC of Alameda County and located in San Leandro. Michael recalled visiting his father there long ago, back when it was located in Hayward. "People said the mentally disabled, they can't do normal jobs," Michael said. "But Pop said, they *can* do something. He set up workshops to show handicapped people could be employed. They weren't just vegetables. He set workshops up in Hayward, in Oakland, he kept going and going, he pushed it." Michael wished me luck on my project and hugged me goodbye. "Pop was small in stature, but he was a big man," he said.

A nonprofit organization dedicated to helping those with developmental disabilities, the ARC of Alameda County is housed in

a drab warehouse near the San Leandro marina, just south of the Oakland Airport. Like a lot of nonprofits, it relies on private donations and a crew of overworked and underpaid staff members to keep the place running. When I visited on a weekday afternoon, a harried staff member tried to answer my questions while supervising the day's programming. Thirty-three years had passed since Allen Hoskins passed away, and only a couple staffers even remembered him. One woman, who had been with the organization since 1973, remembered Al as "a very nice man" and added, "Someone told me he was a Little Rascal." A building had been dedicated to his memory, but the organization had since moved facilities. "Don't we still have the plaque here somewhere?" someone asked. After a few minutes, a staffer located it propped on top of a bookshelf next to a clock. Someone found a ladder and brought it down for me. Under a photograph of Al, wearing a dapper black beret and trench coat, read the dedication:

ALLEN C. HOSKINS
1920–1980
Al served the needs of the Disabled for 25 years
and of those, 15 years were served with ARC.
He was innovative, imaginative, and dedicated.
Al brought energy, style, and strength to
everything he did. Few people have contributed
so much to so many lives in the community,
especially for the Developmentally Disabled.
As a leader, he "lived in the future" and his
spirit is still here. He left us so much of himself.
THIS BUILDING WAS DEDICATED IN
HIS HONOR ON OCTOBER 25, 1984

Al's workshops were now part of the Vocational Development Center program housed at the facility. Five days a week, from 8:30 until 3:00, with two breaks and a half hour for lunch, workers came to the center to do contract work for various companies, getting paid by the piece. On days when there was no production contract to fill, they practiced counting and other job skills. I was ushered from the offices into the adjacent warehouse, a yawning space with shipping pallets stacked against the far wall and boxes swaddled in shrink wrap. Near the shipping and receiving doors were a few pink Formica tables topped with fake flowers and a

pool table covered with torn felt. Further down, several banquet tables had been set up in a large horseshoe configuration. Seated around the tables, hunched over their work, were twenty or thirty workers. Some were putting together Sun Maid Raisin cartons, red and brown chads scattered around their feet like confetti. Most were doing piecework, taking nuts and bolts and screws from white plastic bowls and placing them onto a laminated grid. Once sealed, they would be like the little hardware packs you found in IKEA packages.

All the workers were disabled, some in wheelchairs or with visible handicaps like missing arms, others mentally disabled, mumbling to no one in particular or aimlessly walking around the room. They were all adults ranging in age from their early twenties to sixties. They were white, Asian, black, and Latino. I heard some speaking in Chinese, some in Spanish. A few noticed me as soon as I walked in and stared at me curiously. One tall black man came up to me, touched my arm, and waved hello. Another, a paunchy white man in his fifties wearing a beanie and orthopedic brown walking shoes, followed me around until a supervisor intervened. "Matthew, I need you to go ahead and sit down," she said, gently ushering him to his seat. I walked beside the tables, watching workers intently filling their grids and having their work checked. From far away, they looked like they were playing bingo or tic-tac-toe.

It was the end of the workday, and buses were pulling up to the warehouse to take the workers home. Some were heading back to their families, others to assisted care facilities. I watched as they headed out, wearing baseball caps and carrying brightly colored backpacks, some of them with lunchboxes in their hands, carefully climbing into the waiting buses as their supervisors stood by. I thought about what Al Hoskins had said about these workers: "Give me the rejects," he said. "I can work with people who are nobodies. I love these people." I thought about how Al had escaped the curse of the child actor, how he had grown up and made a new life for himself. And I thought about how he ended up helping those who were, in some sense, perpetual children, vulnerable and naive, ignored or underestimated by society. They too were citizens; they too were Americans.

I watched the bus drive away. Then I, too, headed home.

ACKNOWLEDGMENTS

This project began where *Our Gang* began, in Los Angeles, California. As a postdoc at the University of Southern California, I took the Expo line from Culver City to the campus near Downtown L.A. From the rail station, I could see the former spot of Hal Roach Studios, now marked by a patch of grass, a plaque, and a bushy ficus tree. The lumberyard of *Our Gang* legend was where the station now stood, facing Washington Boulevard. Every week, I took the train along the same path the Pacific Electric trolley took during the heyday of Hal Roach Studios, crossing Crenshaw and Vermont before getting off at the USC stop. From there, I would walk to the Cinematic Arts Library, housed in the basement of Doheny Memorial Library—a gift of the same Doheny whose mansion on Chester Place was where Ernie "Sunshine Sammy" Morrison was supposedly discovered.

With the indefatigable help of archivist Ned Comstock, I first worked through the USC Hal Roach and MGM collections at the Cinematic Arts Library. I am deeply grateful to Ned for his encyclopedic knowledge of cinematic history and his Xeroxing and scanning of countless images and articles for me. Through Ned I was able to get in touch with Richard Bann, whose *Our Gang* book, coauthored with Leonard Maltin, was invaluable to my own research and who kindly agreed to meet with me at the Culver Hotel to answer some of my questions. I am grateful, too, to Dr. Todd Boyd of USC's School of Cinematic Arts for helping me think through this project in its early stages, and to Dr. Meg

Russett of the USC English Department and University Provost Elizabeth Garrett for their generous support of the Provost's Postdoctoral Scholarship in the Humanities. It strikes me as fitting that this project first took shape at USC, whose own history is so intertwined with the history I recount in this book.

This book may have started at USC, but it would not have been finished without the generous institutional support of the University of Nevada, Las Vegas, my academic home for the past few years. With the help of a university travel grant and a Faculty Opportunity Award, I was able to visit Elmira, New York, as well as attend the Sons of the Desert convention in Hollywood. My colleagues in the UNLV English department have been extraordinary in their encouragement and sense of community, and I feel lucky to have joined their ranks. Richard Harp and Chris Hudgins helped smooth my transition, and Anne Stevens, Megan Becker-Leckrone, and Kelly Mays provided wise counsel. To Emily Setina, Heather Lusty, Maile Chapman, Jessica Teague, and John Hay, thank you for being great colleagues and drinking buddies. I am grateful to Ed Nagelhout, Denise Tillery, and Beth Rosenberg for our regular writing workshops, and to Vince Perez, John Bowers, Jane Hafen, and countless others for reaching out to a junior faculty member. My friends Manoucheka Celeste and Miriam Melton-Villanueva have inspired and supported me when the monkeys threatened to take over the circus. Steven Hrdlicka provided exceptional research assistance, for which I am deeply grateful. I also thank my UNLV students, especially those from my African American literature and film graduate seminar and my early African American literature lecture course.

Many people helped with the research of this book. Don Sloper answered my questions about Doheny Mansion, and Gina Chung gave me a private tour of the house, even as it was being used as a shooting location for *Scandal*. Diane Janowski, Elmira city historian, helped orient me when I began my research into Hal Roach's childhood and even photographed Roach's house for me. Barbara Snedecor, director of the Center for Mark Twain Studies at Elmira College, ferried me around Elmira, taking me on a tour of Quarry Farm and allowing me to tag along on a fifth-grade tour of Mark Twain's study and Woodlawn Cemetery. I will always have fond memories of the students sitting among

the Langdon headstones in the dappled sunlight. Thanks, too, to Mark Woodhouse, archivist at Elmira College, for helping me track down the dates when Hal Roach most likely crossed paths with Twain. Many thanks to Rachel Dworkin, archivist at the Chemung County Historical Society, who gamely pulled down old almanacs and directories for me to leaf through and filled me in on the Klan Klolero that was held in Elmira in July 1925. I also thank Bob Satterfield, Richard Bann, and the Sons of the Desert for organizing *Our Gang* screenings and panels for the 2014 International Convention. For the fantastic photographs in the book, I am indebted to Marc Wanamaker of Bison Archives, who generously lent me images of Hal Roach Studios, and David Menefee, who allowed me to reproduce several images of Billie "Buckwheat" Thomas. Bob Demoss at *The Lucky Corner* (www .theluckycorner.com) offered to copy hard-to-find silent shorts for me, and his website was invaluable in providing production information and dates for *Our Gang* films. At UNLV, Priscilla Finley at Lied Library always promptly responded to my often vague and uncertain requests. Jeremy Berg put me in touch with Michael King of King World Productions. Cecilia Chao-Connolly took time out of her busy day to show me around the ARC of Alameda County. Finally, this book would not exist without the generous support of Michael and Lydia ("B") Hoskins. The Hoskinses welcomed me into their home, fed me pizza, and let me look through an absolute gold mine of material documenting Allen Hoskins's early life. This book is a testament to them and to their stewardship of Allen's legacy.

For almost two decades now, Lisa Sternlieb has taken my panicked phone calls and talked sense into me. I cherish her friendship and see her as a role model (despite her protests!). Henry Louis Gates Jr. was my advocate in graduate school and beyond, and I owe him an infinite debt in helping me find an academic home at UNLV. His generosity and loyalty—and his sage advice ("never back down from a bully!")—have helped me more than he knows. Jamaica Kincaid never wavered in her faith in me and my work, and I thank her for looking out for "little j." My past teachers—Deborah Nord, Maria DiBattista, Elaine Scarry, Werner Sollors, John Stauffer, Martin Harries—still inspire and influence me. I thank Laura Murphy, David Roh, and Anri

Yasuda for their loyalty and camaraderie, and Chris Lau Corey, Tarry Baker, Miki Terasawa, Lizzy Castruccio, Sharon Gi, Maria Wich-Vila, Janna Conner, Bob Chen, and Joyce Leong for being wonderful people. My gratitude also extends to my former colleagues at Loyola Marymount University: Alex Neel, Dermot Ryan, Robin Miskolcze, K. J. Peters, Stuart Chin, Barbara Rico, Aimee Ross, and Maria Jackson.

My parents, David and Sonia Lee, are the toughest people I know. Thank you for instilling in me discipline, passion, and resilience—and for letting me watch lots of TV. Robert and Bonnie Sonneborn have been extraordinary parents and grandparents, and I am grateful to be a part of their family. Nancy and Burt Malkiel were there at the inception of this project, when I first tentatively mentioned my book idea to them over dinner in New York. Nancy's early encouragement (and her gift of Melvin Ely's social history of *Amos 'n' Andy*) helped get this project off the ground; later, her careful reading of the entire manuscript strengthened the book immeasurably. My thanks go to Richard Morrison, who first took interest in my project when I approached the University of Minnesota Press, and to Doug Armato, who helped guide the book to publication. To Doug, especially, I am grateful for his shared vision and passion for this project and his sensitive comments on the manuscript. Erin Warholm-Wohlenhaus answered my questions, however trivial, with good humor. I also thank the two anonymous readers of the manuscript for their comments and suggestions.

As anyone with young children knows, balancing parenthood and professional life can be a herculean task. I am profoundly grateful to my husband, Brad Sonneborn, for being a loyal confidant and partner and for supporting me through the birth of two children, the vagaries of the job market, and a major geographic move. I thank Martha Trujillo for her loving care of my children; Ruth "Peppy" Weiss for being a doting great-grandmother; and Scott Sonneborn, Eryn Brown, Sharon Lee, and Paul Smith for being devoted aunts and uncles. This book is dedicated to my own little rascals, Lucy and Bobby, who fill me with delight, exasperation, and love. In so many ways, this book came to me at the right time—when I was already thinking of my own childhood and my children's, of nostalgia and the imagined past, and of the challenges and joys of adulthood. Don't grow up!

FILM APPENDIX

Films are listed in order of when they were filmed, with release dates in parentheses. Filmography details are from Leonard Maltin and Richard Bann, *The Little Rascals: The Life and Times of Our Gang* (New York: Crown Trade Paperbacks, 1992) and Robert Demoss, *The Lucky Corner*, January 3, 2005, http://www .theluckycorner.com.

ROACH PATHÉ SILENTS

Our Gang (1922)
Fire Fighters (1922)
Young Sherlocks (1922)
One Terrible Day (1922)
A Quiet Street (1922)
Saturday Morning (1922)
The Big Show (1923)
The Cobbler (1923)
The Champeen (1923)
Boys to Board (1923)
A Pleasant Journey (1923)
Giants vs. Yanks (1923)
Back Stage (1923)
Dogs of War (1923)
Lodge Night (1923)
Fast Company (1924)[1]
Stage Fright (1923)
July Days (1923)

Sunday Calm (1923)
No Noise (1923)
Derby Day (1923)
Tire Trouble (1924)
Big Business (1924)
The Buccaneers (1924)
Seein' Things (1924)
Commencement Day (1924)
It's a Bear (1924)
Cradle Robbers (1924)
Jubilo, Jr. (1924)
High Society (1924)
The Sun Down Limited (1924)
Every Man for Himself (1924)
The Mysterious Mystery! (1924)
The Big Town (1925)
Circus Fever (1925)
Dog Days (1925)

The Love Bug (1925)
Ask Grandma (1925)
Shootin' Injuns (1925)
Official Officers (1925)
Mary, Queen of Tots (1925)
Boys Will Be Joys (1925)
Better Movies (1925)
Your Own Back Yard (1925)
One Wild Ride (1925)
Good Cheer (1926)
Buried Treasure (1926)
Monkey Business (1926)
Baby Clothes (1926)
Uncle Tom's Uncle (1926)
Thundering Fleas (1926)
Shivering Spooks (1926)
The Fourth Alarm (1926)
War Feathers (1926)
Seeing the World (1927)
Telling Whoppers (1926)
Bring Home the Turkey (1927)
Ten Years Old (1927)
Love My Dog (1927)
Tired Business Men (1927)
Baby Brother (1927)
Chicken Feed (1927)
Olympic Games (1927)
The Glorious Fourth (1927)
Playin' Hookey (1928)
The Smile Wins (1928)

ROACH MGM SILENTS

Yale vs. Harvard (1927)
The Old Wallop (1927)
Heebee Jeebees (1927)
Dog Heaven (1927)
Spook Spoofing (1928)
Rainy Days (1928)
Edison, Marconi & Co. (1928)
Barnum & Ringling, Inc. (1928)
Fair and Muddy (1928)
Crazy House (1928)

Growing Pains (1928)
The Ol' Gray Hoss (1928)
School Begins (1928)
The Spanking Age (1928)
Election Day (1929)
Noisy Noises (1929)
The Holy Terror (1929)
Wiggle Your Ears (1929)
Fast Freight (1929)
Little Mother (1929)
Cat, Dog & Co. (1929)
Saturday's Lesson (1929)

ROACH MGM TALKIES

Small Talk (1929)
Railroadin' (1929)
Boxing Gloves (1929)
Lazy Days (1929)
Bouncing Babies (1929)
Moan & Groan, Inc. (1929)
Shivering Shakespeare (1930)
The First Seven Years (1930)
When the Wind Blows (1930)
Bear Shooters (1930)
A Tough Winter (1930)
Pups Is Pups (1930)
Teacher's Pet (1930)
School's Out (1930)
Helping Grandma (1931)
Love Business (1931)
Little Daddy (1931)
Bargain Day (1931)
Fly My Kite (1931)
Big Ears (1931)
Shiver My Timbers (1931)
Dogs Is Dogs (1931)
Readin' and Writin' (1932)
Free Eats (1932)
Spanky (1932)
Choo-Choo! (1932)
The Pooch (1932)
Hook and Ladder (1932)

Free Wheeling (1932)
Birthday Blues (1932)
A Lad an' a Lamp (1932)
Fish Hooky (1933)
Forgotten Babies (1933)
The Kid from Borneo (1933)
Mush and Milk (1933)
Bedtime Worries (1933)
Wild Poses (1933)
Hi'-Neighbor! (1934)
For Pete's Sake! (1934)
The First Round-Up (1934)
Honky Donkey (1934)
Mike Fright (1934)
Washee Ironee (1934)
Mama's Little Pirate (1934)
Shrimps for a Day (1934)
Anniversary Trouble (1935)
Beginner's Luck (1935)
Teacher's Beau (1935)
Sprucin' Up (1935)
The Lucky Corner (1936)
Little Papa (1935)
Little Sinner (1935)
Our Gang Follies of 1936 (1935)
Divot Diggers (1936)
The Pinch Singer (1936)
Second Childhood (1936)
Arbor Day (1936)
Bored of Education (1936)
Two Too Young (1936)
Pay as You Exit (1936)
Spooky Hooky (1936)
General Spanky (1936)[2]
Reunion in Rhythm (1937)
Glove Taps (1937)
Hearts Are Thumps (1937)
Three Smart Boys (1937)
Rushin' Ballet (1937)
Roamin' Holiday (1937)
Night 'n' Gales (1937)
Fishy Tales (1937)

Framing Youth (1937)
The Pigskin Palooka (1937)
Mail and Female (1937)
Our Gang Follies of 1938 (1937)
Canned Fishing (1938)
Bear Facts (1938)
Three Men in a Tub (1938)
Came the Brawn (1938)
Feed 'em and Weep (1938)
The Awful Tooth (1938)
Hide and Shriek (1938)

MGM TALKIES

The Little Ranger (1938)
Party Fever (1938)
Aladdin's Lantern (1938)
Men in Fright (1938)
Football Romeo (1938)
Practical Jokers (1938)
Alfalfa's Aunt (1939)
Tiny Troubles (1939)
Duel Personalities (1939)
Clown Princes (1939)
Cousin Wilbur (1939)
Joy Scouts (1939)
Dog Daze (1939)
Auto Antics (1939)
Captain Spanky's Show Boat (1939)
Dad for a Day (1939)
Time Out for Lessons (1939)
Alfalfa's Double (1940)
Bubbling Troubles (1940)
The Big Premiere (1940)
All about Hash (1940)
The New Pupil (1940)
Goin' Fishin' (1940)
Good Bad Boys (1940)
Waldo's Last Stand (1940)
Kiddie Kure (1940)
Fightin' Fools (1941)
Baby Blues (1941)

Ye Olde Minstrels (1941)
Come Back, Miss Pipps (1941)
1-2-3 Go! (1941)
Robot Wrecks (1941)
Helping Hands (1941)
Wedding Worries (1941)
Melodies Old and New (1942)
Going to Press (1942)
Don't Lie (1942)
Surprised Parties (1942)
Doin' Their Bit (1942)
Rover's Big Chance (1942)

Mighty Lak a Goat (1942)
Unexpected Riches (1942)
Benjamin Franklin, Jr. (1943)
Family Troubles (1943)
Election Daze (1943)
Calling All Kids (1943)
Farm Hands (1943)
Little Miss Pinkerton (1943)
Three Smart Guys (1943)
Radio Bugs (1944)
Dancing Romeo (1944)
Tale of a Dog (1944)

NOTES

INTRODUCTION

1. Mary Sharon, "How They Pick the Kids for Our Gang," date unknown (ca. 1925), Hal Roach Collection, Cinematic Arts Library, University of Southern California. A note on the article reads, "sold to new movie [magazine]."

2. Ruby Berkeley Goodwin, "At Home with Farina of 'Our Gang' Fame," *Topeka Plaindealer*, March 1, 1930, Allen Clayton Hoskins Papers, Fairfield, California. This may have been Sammy's father's own store—he reportedly owned a chain of grocery stores in the colored area of Los Angeles.

3. Leonard Maltin and Richard Bann, *The Little Rascals: The Life and Times of "Our Gang"* (New York: Three Rivers Press, 1992), 9; "'Our Gang' Has Great Time Playing at Work," *Los Angeles Times*, July 25, 1923, WF12.

4. Bernice Patton, "'Cry Baby' Farina, Movie Genius, Cries Way to Fame," *Pittsburgh Courier*, September 17, 1932, 16. Some sources claim Hoskins moved to Los Angeles when he was six months old.

5. Goodwin, "At Home with Farina."

6. Patton, "'Cry Baby' Farina," 16.

7. Maltin and Bann, *The Little Rascals*, 246.

8. The official name is Hal E. Roach Studios, but most people called it Hal Roach Studios, as I do in this book.

9. Patton, "'Cry Baby' Farina," 16.

10. Maltin and Bann, *The Little Rascals*, 31.

11. Goodwin, "At Home with Farina."

12. Pathécomedy, *Our Gang* advertisement, *Exhibitors Herald*, April 21, 1923, back cover.

13. Thomas Pegram, *One Hundred Percent American: The Rebirth and Decline of the Ku Klux Klan in the 1920s* (Lanham, Md.: Ivan R. Dee, 2011), 3.

14. C. Vann Woodward, *The Strange Career of Jim Crow* (New York: Oxford University Press, 2001), 97–100.

15. These plots are taken from *Thundering Fleas* (1926) and *No Noise* (1923).

16. The *Our Gang* short featuring the Cluck Cluck Klams is *Lodge Night* (1923). The short featuring the integrated baseball game is *Giants vs. Yanks* (1923). To be sure, there were still plenty of uncomfortable racial gags. In *Baby Brother* (1927), Joe Cobb, the Gang's token "fat boy," longs for a baby brother. Farina takes a neighbor's baby, paints him white with shoe polish, and sells him to Joe for three dollars. Joe is delighted, then perplexed when the polish washes off in the bath. "He's tarnished!" Joe cries—though he soon forgets all about it when the baby calls him "Papa!"

17. Mary Winship, "Our Gang," *Photoplay* 25, no. 4 (March 1924): 40.

18. Ibid.

19. "'Farina' Met by Jim-Crow Here," *New York Amsterdam News,* September 19, 1928, 1.

20. "Farina to Movies," *Chicago Defender,* February 4, 1939, 18.

21. Bernice Patton, "'Farina' Warms Way into the Heart of a Nation—Signed by First Nat'l," *Pittsburgh Courier,* October 1, 1932, A7.

22. Kolma Flake, "Gangway for the Gangsters!," possibly shopped to *Pictorial Review* by Sam W. B. Cohn, director of publicity, Hal Roach Studios, date unknown (ca. 1925), Hal Roach Collection, Cinematic Arts Library, University of Southern California.

23. Quoted in Maltin and Bann, *The Little Rascals,* 246.

24. Leonard Hall, "Retired at Eleven," *Photoplay* 40, no. 1 (June 1931): 35, 125.

25. *Photoplay* and other publications reported Sonny's salary was $500/week. Maltin and Bann claim it was $350/week (*The Little Rascals,* 246).

26. Hall, "Retired at Eleven," 125.

27. "'Our Gang' Star Is Dead," *Oakland Post,* July 30, 1980.

28. Lenore Lucas, "It's Corporal 'Farina' Now as Former 'Our Gang' Star Fights in Australia," *Chicago Defender,* May 22, 1943, 1.

29. Maltin and Bann, *The Little Rascals,* 247.

30. Lucas, "It's Corporal 'Farina' Now," 1.

31. Maltin and Bann, *The Little Rascals,* 230.

32. Executive Order 9981: Desegregation of the Armed Forces, July 26, 1948, General Records of the United States Government, Record Group 11, National Archives.

33. Martin Luther King Jr., "I Have a Dream" (1963), in *I Have a Dream: Writings and Speeches That Changed the World,* ed. James M. Washington (New York: HarperOne, 2003), 101.

34. Maltin and Bann, *The Little Rascals,* 230.

1. THE ETERNAL BOY

1. The Pacific Electric trolley ran by Hal Roach Studios. It was affectionately known as the "Red Car" because of its cherry-colored paint job.

2. Hal Roach, "Hal Roach on Film Comedy," *Silent Picture,* Spring 1970, 3. Roach described the girl as reminding him of a "trained animal." I have imagined some of the details around this episode, taking cues from AMC's 1992 documentary, *Hal Roach Turns 100 Years Old!,* which describes the girl as the daughter of a friend and shows a photograph of a young blond girl with a soft bob. Roach sometimes dates this episode to 1922.

3. Details about early Chemung County history taken from Ausburn Towner, *A History of the Valley and County of Chemung* (Syracuse, N.Y.: D. Mason, 1892). In *Walden,* Henry David Thoreau described the sound of a train whistle as "the scream of a hawk sailing over some farmer's yard": Thoreau, *Walden,* in *Walden, Civil Disobedience, and Other Writings,* ed. William Rossi (New York: W. W. Norton, 2008), 95.

4. Diane Janowski, "A Few Facts about Railroad Service in Elmira, New York," *Chemung County History,* 2013, http://www.chemunghistory.com/.

5. James E. Hare and James Arthur Kieffer, *Images of America: Elmira* (Charleston, S.C.: Arcadia Publishing, 2012), 8.

6. Richard Bann in discussion with the author, Culver Hotel, Culver City, California, October 30, 2012.

7. "The Kinetograph," *New York Sun,* May 28, 1891, 1.

8. Scott A. Shaw, "Table 1-6: Population of Chemung County, by Municipality, 1890–2000," in *Chemung County Data Book* (Elmira: Chemung County Planning Department, 2004), 12.

9. Diane Janowski, "Elmira, New York—100 Years Ago," *Chemung County History,* 2013, http://www.chemunghistory.com/.

10. The Elmira City Directory lists the Roach residence as 311 Columbia. Elsewhere, the address is reported as 309 Columbia and 357 First Street. According to the Elmira City Almanac, street numbers

changed as new homes were built, and the Roach boardinghouse may have had different addresses over the years. 357 First Street is listed in the almanac as the address of Roach's maternal grandparents, the Ballys, who lived in a building on the same property.

11. Diane Janowski, "Elmira Prison Camp 1864–1865," *Chemung County History*, 2013, http://www.chemunghistory.com/.

12. Clayton Wood Holmes, *The Elmira Prison Camp: A History of the Prison Camp at Elmira, NY* (New York: G. P. Putnam's Sons, 1912), 131. Woodlawn Cemetery eventually became the final resting place of Hal Roach and Mark Twain.

13. Barbara Ramsdell, "The John W. Jones Story," *John W. Jones Museum*, 2002, http://www.johnwjonesmuseum.org/jwjstory.html.

14. Mrs. Jennie Snyder, letter to friend, date unknown, Booth Library, Chemung County Historical Society. See also Tom Calarco, *Places of the Underground Railroad: A Geographical Guide* (Santa Barbara, Calif.: ABC-CLIO, 2011), 106–7.

15. Ramsdell, "The John W. Jones Story." See also Holmes, *The Elmira Prison Camp*, 130–32.

16. David Mills, "100 Years of Hal Roach," *Washington Post*, January 24, 1992, C2. I have culled much of the biographical information about Roach from published newspaper articles and interviews, verifying details where I could. Roach, like his grandfather, was a skilled raconteur who did not hesitate to embellish stories for effect. Charles Roach's father was James Roach, born in 1815 in Wicklow, Ireland. His mother was Elizabeth Carson, born in 1814 in Arlington, Virginia. Presumably Charles's mother's family owned the Virginia plantation. Most of the articles from local newspapers can be found in the Hal Roach clippings file at Booth Library, Chemung County Historical Society.

17. Hal Roach, "Hal Roach, Senior," in *The Real Tinsel*, ed. Bernard Rosenberg and Harry Silverstein (London: MacMillan, 1970), 13. Roach also claimed his grandfather's plantation was located where the Pentagon now stands and that Lee and his grandfather were "best friends." See also Daniel Aloi, "Roach Remembered the Gang in Elmira," *Elmira Star-Gazette*, November 13, 1992.

18. Roach, "Hal Roach, Senior," 13.

19. Ibid., 14. John Bally, Hal Roach's grandfather, was born in Geneva, Switzerland, in 1827 and died in Elmira in 1902. He is buried in Elmira's Woodlawn Cemetery.

20. Aloi, "Roach Remembered the Gang."

21. Tom Green, "Hal Roach Is Coming Home," *Elmira Star-Gazette*, August 13, 1986.

22. Allen C. Smith, "100 Years Ago in Elmira, New York," *Che-*

mung County History, 2013, http://www.chemunghistory.com/100years ago.html.

23. "The Great Chemung River Flood of 1902," *Elmira Gazette,* March 1, 1902, *Chemung County History,* 2013, http://www.chemung history.com/.

24. Charles Roach is listed as the manager of the Elmira Saddlery Company in the 1902 Elmira City Directory.

25. This photograph was published in an unidentified local newspaper (likely the *Elmira Gazette*) in 1924, twenty-two years after the 1902 flood. Hal Roach Papers, Booth Library, Chemung Valley Historical Society.

26. Smith, "100 Years Ago in Elmira, New York."

27. "Hal Roach," *Encyclopedia of World Biography,* 2008, http:// encyclopedia.com.

28. Paul T. Sweeney, "Glancing Back: Hal Roach Based Little Rascals on His Elmira Youth," *Chemung Valley Reporter,* August 18, 1994.

29. "Film Comedy Pioneer to Turn 100," *Victoria Advocate,* January 12, 1992, 11.

30. Peg Gallagher, "Hal Roach May Have a Few Things Left to Say to St. Patrick's Nuns," *Elmira Star-Gazette,* August 17, 1986. This anecdote was recalled by Jack Crowley, the son of the former Anna Bochnewich, a classmate of Roach's.

31. Sweeney, "Glancing Back."

32. On his mother's side, Rathbone was descended from John Arnot Jr., a congressman and banker; on his father's side, he was descended from Henry Rathbone, president of the Elmira Iron and Steel Rolling Mill.

33. Danielle Farnbaugh, "Film Pioneer Shares Memories," *Elmira Star-Gazette,* May 30, 1988. Roach was very much aware of John Arnot Rathbone's illustrious pedigree, recalling it nearly a century later. Ironically, Roach's companion in his later years was Frances Hilton, widow of hotel tycoon Conrad Hilton.

34. Farnbaugh, "Film Pioneer Shares Memories."

35. Sweeney, "Glancing Back."

36. "Beautiful Keuka Lake," *Elmira Daily Advertiser,* July 26, 1902; Robert V. Anderson, "Keuka Cottage Boy," *Crooked Lake Review,* May 1994.

37. Charles Champlin, "Hollywood's Oldest Storyteller," *Los Angeles Times,* January 12, 1992, 24.

38. Green, "Hal Roach Is Coming Home."

39. New Family Theater, advertisement, *Elmira Telegram,* January 20, 1907.

40. Moving pictures were usually shown at the end of vaudeville shows, allowing audiences time to file out of the theater. "Flickers" were so called because of the flicker effect of early silent film.

41. Green, "Hal Roach Is Coming Home." Al G. Field, leader of a famous blackface minstrel troupe, appeared at the Lyceum Theatre on January 20, 1908 ("Lyceum Theatre," *Elmira Morning Telegram,* date unknown [ca. January 1908]).

42. "Hal Roach Utilizes His First Camera While Boy in City," *Elmira Sunday Telegram,* April 19, 1931.

43. Tom Vitale, "Twain's Summer Home: Visiting Elmira, N.Y.," *All Things Considered,* National Public Radio, November 30, 2010.

44. Due to bad investments, Twain went bankrupt in the early 1890s and moved to Europe to save money. The death of his daughter Susie in 1896, followed by the illness and death of his wife, Livy, plunged him into a deep depression.

45. Gallagher, "Hal Roach May Have a Few Things Left to Say to St. Patrick's Nuns."

46. In April 1907, Twain returned to Elmira briefly to attend the dedication of the organ at Park Church, during which he delivered a speech. This is presumably the event that Roach remembers attending. Roach would have been fifteen years old. Many thanks to Mark Woodhouse, archivist for Elmira College's Mark Twain Collection, for his help in pinpointing this date.

47. Aloi, "Roach Remembered the Gang." Whether Twain spoke to young Hal for half an hour or not, Roach's stories regarding meeting the author are at least plausible, given the timing of Twain's visits to Elmira. Twain last summered at Quarry Farm in July 1903, when Roach was eleven years old.

48. Samuel Clemens to Dr. John Brown, June 22, 1876, *The Letters of Mark Twain, Complete,* ed. Albert Bigelow Paine, http://www.archive.org.

49. "GOLD! GOLD! GOLD! GOLD!," *Seattle Post-Intelligencer,* July 17, 1897, 1.

50. "All Is Now Excitement," *Seattle Daily Times,* July 3, 1897, 8.

51. Edwin Tappan Adney, *The Klondike Stampede* (New York: Harper and Brothers, 1900), 2.

52. Lisa Mighetto and Marcia Babcock Montgomery, *Hard Drive to the Klondike: Promoting Seattle during the Gold Rush* (Seattle: Historical Research Association, 1998), 59.

53. Ibid., 60.

54. Champlin, "Hollywood's Oldest Storyteller."

55. W. A. Pratt, *The Gold Fields of Cape Nome, Alaska* (Providence, R.I.: Card, 1900), 6–7.

56. Lanier McKee, *The Land of Nome: 1900–1901* (New York: Grafton Press, 1902), 9.

57. Ibid., 31. Roach was presumably farther south, closer to Valdez, where the climate and landscape were somewhat less harsh.

58. Roach, "Hal Roach, Senior," 14.

59. Ibid. See also Champlin, "Hollywood's Oldest Storyteller."

60. "'Hal' Roach, the Originator of 'Lonesome Luke,' Elmiran," *Elmira Advertiser,* September 15, 1916.

61. Roach, "Hal Roach, Senior," 14.

62. Ibid.

63. Ibid.

64. Robert Sklar, *Movie-Made America: A Cultural History of American Movies* (New York: Vintage Books, 1994), 67.

65. "The Sanitary Theater," *Moving Picture World,* March 11, 1911, 539.

66. Sklar, *Movie-Made America,* 16.

67. Ibid., 18.

68. Roach, "Hal Roach, Senior," 15.

69. Ibid., 15–16. See also Roach, "Hal Roach on Film Comedy," 2.

70. Aljean Harmetz, "The Prince of Silent Comedy," *New York Times,* March 12, 1984, 13.

71. Carol Burton Terry, "Hal Roach Remembers," *Newsday,* March 25, 1976, 46A.

72. Bann in discussion with the author.

73. William K. Everson, *The Films of Hal Roach* (Greenwich, Conn.: Museum of Modern Art, 1971), 81.

74. Roach, "Hal Roach, Senior," 17.

75. Mayme Ober Peak, "Hal Roach: He Forever Searches for New Talent and It Has Netted Him Millions," *Daily Boston Globe,* August 29, 1939.

76. Hal Roach, "Living with Laughter," *Films and Filming* 11, no. 1 (October 1964): 23–24.

77. Sklar, *Movie-Made America,* 69.

78. Richard Lewis Ward, *A History of the Hal Roach Studios* (Carbondale: Southern Illinois University Press, 2005), 13.

79. Ibid., 14, 22–26.

80. Gene Fernett, "The Comedy Factory of Hal Roach," *Classic Images* 97 (1983): 41.

81. "Hal Roach Turns 100 This Month!," *All Things Considered,* National Public Radio, January 26, 1992.

82. Ibid.

83. "'Hal' Roach, the Originator of 'Lonesome Luke.'"

84. Harmetz, "The Prince of Silent Comedy," 13; Sklar, *Movie-Made America*, 42, 46.

85. Preston Kaufmann, *Fox: The Last Word Story of the World's Finest Theatre* (Toms River, N.J.: Showcase Publications, 1980), 83–84.

86. Everson, *The Films of Hal Roach*, 15.

87. William Grimes, "Hal Roach Recalls His First Century," *New York Times*, January 23, 1992, 15.

88. Fernett, "The Comedy Factory," 41.

89. Ibid.

90. Roy Seawright, quoted in Brian Anthony and Andy Edmonds, *Smile When the Raindrops Fall: The Story of Charley Chase* (Lanham, Md.: Scarecrow Press, 1997), 44.

91. Ward, *A History of the Hal Roach Studios*, 30.

92. Ibid., 38.

93. Ibid., 34–36.

94. Harry Culver, "Speech Announcing Development of Culver City" (speech presented at California Club, Los Angeles, California, 1913), *Culver City Call*, October 31, 1914, https://www.culvercity.org/Visitors/CulverCityHistory/CulverSpeech.aspx.

95. Ibid. See also Julie Lugo Cerra, *Images of America: Culver City* (Charleston, S.C.: Arcadia Publishing, 2004), 9.

96. Advertisement, *Culver City Call*, December 29, 1913.

97. Cerra, *Images of America*, 17.

98. Julie Lugo Cerra and Marc Wanamaker, *Movie Studios of Culver City* (Charleston, S.C.: Arcadia Publishing, 2011).

99. "Hal Roach Studios," *Culver City History*, 2011, http://www.culvercity.org/Visitors/CulverCityHistory/HalRoachStudios.aspx.

100. Cerra and Wanamaker, *Movie Studios*, 108.

101. Fernett, "The Comedy Factory," 41.

102. "Part of Culver City Studio, Where Hal Roach Comedies Are Made," *Los Angeles Times*, August 22, 1923, WF8.

103. Ward, *A History of the Hal Roach Studios*, 39.

104. Roy Seawright, quoted in Anthony and Edmonds, *Smile When the Raindrops Fall*, 45.

105. Cerra and Wanamaker, *Movie Studios*, 108.

106. Ibid., 110.

107. Everson, *The Films of Hal Roach*, 26.

108. Bann in discussion with the author.

109. "Mother of Famed Hollywood Producer Hal Roach Likes to Live at Studio," *Lubbock Evening Journal*, December 17, 1954, 22.

110. Scotty Eyman, "Laughing All the Way: Pioneer Producer Hal Roach Put the Character in Comedy," *Washington Post,* November 8, 1992, G4.

111. Bernice Hirabayashi, "He Made a Fine Mess of Things," *Los Angeles Times,* January 16, 1992, 1.

112. Bann in discussion with the author.

113. Hirabayashi, "He Made a Fine Mess," 1.

114. Pathé advertisement, *Moving Picture World,* July 14, 1920.

115. Roach, "Hal Roach on Film Comedy," 3.

2. A BOY AND HIS GANG

1. Roach, "Hal Roach on Film Comedy," 3.

2. Ibid. In other articles, Roach claims he conceived of the idea for *Our Gang* after seeing his two children, Hal Jr. and Margaret, carouse with their friends. The lumberyard story sounded better, though, and Roach, a gifted storyteller, wasn't averse to embellishing the truth.

3. Some sources claim Morrison was born in 1913 ("Colored Boy Now Stars in Own Right," *Norfolk New Journal and Guide,* February 4, 1922, 1).

4. "Going to College," *Baltimore Afro-American,* November 28, 1925, A5. Morrison Sr. reported that he had worked for eight years as a cook "in the employ of the Federal Government." Like his son, he went by the nickname "Ernie," but in the interest of clarity, I refer to him as Morrison Sr. or "Ernie's father."

5. "Colored Boy Now Stars in Own Right," 1.

6. Richard Campanella, *Time and Place in New Orleans: Past Geographies in the Present Day* (Gretna, La.: Pelican Publishing, 2003).

7. Peirce F. Lewis, *New Orleans: The Making of an Urban Landscape* (Cambridge, Mass.: Center for American Places, 2003), 53.

8. Maltin and Bann, *The Little Rascals,* 243. Doheny's wealth reportedly exceeded even that of John D. Rockefeller, the so-called richest man in America.

9. Monsignor Francis Weber, *Southern California's First Family: The Dohenys of Los Angeles* (Fullerton, Calif.: Lorson's Books and Prints, 1993).

10. "Going to College," A5.

11. Tom Lansford, "New Orleans," *Encyclopedia of African American History,* Oxford African American Studies Center, 2015, http://www.oxfordaasc.com/.

12. Lynching statistics were compiled by the *Chicago Tribune,* Tuskegee Institute, and, beginning in 1912, the NAACP. My number is based on the NAACP estimates.

13. Lawrence De Graaf, "The City of Black Angels: Emergence of the Los Angeles Ghetto, 1890–1930," *Pacific Historical Review* 39, no. 3 (August 1970): 330; Quintard Taylor, *In Search of the Racial Frontier: African Americans in the American West, 1528–1990* (New York: Norton, 1998), 207.

14. De Graaf, "The City of Black Angels," 329.

15. Lonnie G. Bunch III, *Black Angelenos: The Afro-American in Los Angeles, 1850–1950* (Los Angeles: California Afro-American Museum, 1989), 20–21.

16. Ibid.

17. John S. M'Groarty, "The Emancipated," *Los Angeles Times*, February 12, 1909, III.1.

18. W. E. B. Du Bois, "Colored California," *Crisis* 6, no. 4 (August 1913): 193–94.

19. W. E. B. Du Bois, Editorial, *Crisis* 6, no. 3 (July 1913): 131.

20. Du Bois, "Colored California," 193–94. He writes, "Women have had difficulty in having gloves and shoes fitted at the stores, the hotels do not welcome colored people, the restaurants are not for all that hunger."

21. Bunch, *Black Angelenos*, 22–23; Josh Sides, *L.A. City Limits: African American Los Angeles from the Great Depression to the Present* (Berkeley: University of California Press, 2004), 12.

22. Louise McDonald, Letter, *Crisis* 4, no. 3 (July 1912): 148–49, quoted in Douglas Flamming, *Bound for Freedom: Black Los Angeles in Jim Crow America* (Berkeley: University of California Press, 2006), 81.

23. Augustus Hawkins, "Black Leadership in Los Angeles," interview by Clyde Woods, Oral History Program, Department of Special Collections, Young Research Library, University of California, Los Angeles, 15, 13–14. Joseph Bass, "Editor's Life Colorful," *California Eagle*, November 24, 1933.

24. De Graaf, "The City of Black Angels," 330; Taylor, *In Search of the Racial Frontier*, 223.

25. De Graaf, "The City of Black Angels," 332.

26. Teresa Grimes, *Historic Resources Associated with African Americans in Los Angeles, Los Angeles County, California* (Los Angeles: United States Department of the Interior, National Park Service, 2009), 1, http://www.nps.gov/nr/feature/afam/2010/Cover-African AmericansinLA.pdf.

27. "Nollie B. Murray," *California Eagle*, January 10, 1915, 1.

28. Grimes, *Historic Resources*, 4–5.

29. "'Sunshine Sammy' of Movie Fame," *Chicago Defender*, September 11, 1920, 1.

30. J. Max Bond, "The Negro in Los Angeles" (PhD diss., University of Southern California, 1936), 35.

31. Joseph Morrison would eventually open a chain of grocery stores and wholesale candy businesses in the area.

32. Maltin and Bann claim that Ernie Morrison Sr. worked as a cook at the Doheny Mansion in Beverly Hills (*The Little Rascals*, 243). The Dohenys did not build Greystone Mansion, their Beverly Hills residence, until 1927. They subsequently gifted the house to their son, Ned, who was murdered there by his secretary in 1929.

33. Don Sloper, *Los Angeles's Chester Place* (Charleston, S.C.: Arcadia Publishing, 2006), 34.

34. Ibid., 41.

35. Lucille Miller, letter, August 17, 1964, quoted by Don Sloper, e-mail message to author, April 26, 2013.

36. Dan La Botz, *Edward L. Doheny: Petroleum, Power, and Politics in the United States and Mexico* (New York: Praeger, 1991), 34.

37. "Going to College," A5. Morrison's father was probably bragging a little.

38. Lisa Teasley, "Saluting a Golden Era of Black Entertainers," *Los Angeles Times,* June 8, 1985, 1.

39. Maltin and Bann, *The Little Rascals,* 244.

40. According to one magazine, Doheny did not "drink, smoke, swear nor play golf." In other words, Hal Roach would have found him a total bore (Charles Frederick Carter, "How Doheny Got There," *Magazine of Wall Street,* May 13, 1922, 42). Daniel Leab relates a slightly different discovery story, claiming that Ernie's father was a cook for a movie producer and overheard a dinner guest mention that he was looking for a "colored comical baby" (Leab, *From Sambo to Superspade* [Boston: Houghton Mifflin, 1975], 55).

41. Sloper, *Los Angeles's Chester Place,* 111.

42. "Services Held for 'Little Rascal' Ernest Morrison," *New Pittsburgh Courier,* August 12, 1989.

43. "Going to College," A5.

44. Donald Bogle, *Bright Boulevards, Bold Dreams: The Story of Black Hollywood* (New York: Ballantine, 2006), 26.

45. Obituary for Ernest Frederic Morrison Jr., *Variety* 336, no. 3 (August 2, 1989): 83. See also Bogle, *Bright Boulevards, Bold Dreams,* 26.

46. Ward, *A History of the Hal Roach Studios,* 37.

47. Photograph of "Sunshine Sammy" Morrison signing movie contract, in Bogle, *Bright Boulevards, Bold Dreams,* 27.

48. "'Sunshine Sammy' of Movie Fame," 1.

49. Robin Bernstein, *Racial Innocence: Performing American Childhood from Slavery to Civil Rights* (New York: New York University

Press, 2011), 53. Bernstein argues that the image of the pickaninny metamorphosed in the second half of the nineteenth century, first employed by Stowe to depict the dehumanizing effects of slavery on Topsy but later used as a justification for Jim Crow.

50. Donald Bogle, *Toms, Coons, Mulattoes, Mammies, and Bucks: An Interpretive History of Blacks in American Films* (New York: Continuum International Publishing Group, 2001), 8–9.

51. Eugene W. Jackson II with Gwendolyn Sides St. Julian, *Eugene "Pineapple" Jackson: His Own Story* (Jefferson, N.C.: McFarland, 1999), 12.

52. Joseph Boskin maintains that *Little Black Sambo* was not written in the American Sambo tradition and that its Indian hero is "no buffoon." Helen Bannerman was born in Scotland and was likely influenced by British imperialism rather than American slavery. The widespread piracy of her book by American publishers, however, meant that later editions acquired more features of the American minstrel tradition. See Joseph Boskin, *Sambo: The Rise and Demise of an American Jester* (New York: Oxford University Press, 1988), 35–36.

53. Ann Heinrichs describes how the *Chicago Defender* and other black newspapers published favorable notices of *Little Black Sambo* operettas performed at local black schools in the 1930s. In 1932, Langston Hughes became one of the first prominent African Americans to speak out against the racial caricature in *Little Black Sambo*. See Anne Heinrichs, "Helen Bannerman's *Little Black Sambo*: Reception of Text," December 6, 2010, http://people.lis.illinois.edu/~heinric3/514LBS/LittleBlackSambo4.html.

54. Donald Bogle claims that at other times, Ernie's performances could be "surprisingly nonstereotypical." In films such as *Get Out and Get Under*, which Ernie filmed with Harold Lloyd, he appears "just a curious but pesky boy" who avoids the most obvious and offensive racial gags (*Bright Boulevards, Bold Dreams*, 31).

55. Trade advertisement for *The Pickaninny*, *Exhibitor's Trade Review* 11, no. 13 (February 25, 1922): 943. Quoted in Bogle, *Bright Boulevards, Bold Dreams*, 31.

56. *The Pickaninny*, directed by Robert Kerr and James Parrott, on *The Little Rascals Silent Shorts: Our Gang Gold* (1921; Chelsea, Mass.: GI Studios, 2012), DVD.

57. "Sunshine Sammy to Star in Two-Reeler," *Billboard* 33, no. 46 (November 12, 1921): 65.

58. "The Pickaninny," *Chicago Defender*, March 11, 1922.

59. It is unclear when Ernie's father quit his job as a cook, though by the time Ernie was signed to a long-term contract in 1918 or 1919, he

was making enough money to support his whole family. Joseph Morrison continued to pursue other business interests.

60. Photograph of Sunshine Sammy Morrison and Joseph Ernest Morrison, *Crisis* 29, no. 1 (November 1924): 32. Ernie is possibly wearing a uniform from the *Our Gang* film *Dogs of War* (1923).

61. "Going to College," A5. Morrison Sr. claimed, "most of the participants were white, there being but 600 of our own color in line."

62. "Sunshine Sammy General Choice of Afro Readers," *Baltimore Afro-American,* January 21, 1921, 8. Ernie's father told the paper that his son performed for "children of [his] own race . . . in order that he might inspire them" ("Going to College," A5).

63. "Sunshine Sammy General Choice of Afro Readers," 8.

64. "Little People of the Month," *Brownies' Book* 2, no. 2 (February 1921): 61.

65. "'Sunshine Sammy' would never do this in real life, but it's all right in the movies," *Brownies' Book* 2, no. 7 (July 1921): 203.

66. "At Hollywood: Dr. Vada Somerville, Dr. DuBois, Miss Anita Thompson, Ernest Morrison ('Sunshine Sammy'), Mrs. Beatrice Thompson and Mrs. F. M. Roberts at the Hal Roach Studios," *Crisis* 26, no. 2 (June 1923): 73. Dr. Somerville attended USC Dental School and was the first African American woman to earn a license to practice dentistry in California. Her husband, Dr. John Somerville, was the first black graduate of USC Dental School and later founded the Somerville Hotel on Central Avenue. Beatrice Thompson was executive secretary of the local NAACP chapter, and Anita, her daughter, was a young ingénue who developed a flirtation with Du Bois during this trip. Mrs. F. M. Roberts was presumably the wife of Fred Roberts, executive board member of the local NAACP chapter. See Flamming, *Bound for Freedom*, 212; David Levering Lewis, *W. E. B. Du Bois, 1919–1963: The Fight for Equality and the American Century* (New York: Henry Holt, 2000), 104.

67. W. E. B. Du Bois, *The Souls of Black Folk* (New York: W. W. Norton, 1999).

68. Bessie Woodson Yancey, "To Sunshine Sammy," from *Echoes from the Hills: A Book of Poems* (Washington, D.C.: Associated Publishers, 1939), 36.

69. See Bogle, *Bright Boulevards*, Bold Dreams, 32–33, and Jackson, *Eugene "Pineapple" Jackson*, 45.

70. Teasley, "Saluting a Golden Era," 1.

71. Ward, *A History of the Hal Roach Studios,* 37.

72. Tay Garnett, "How's Your Sense of Direction?" *Photoplay* 73, no. 9 (September 1939): 31.

73. Sonny "Farina" Hoskins often pretended to be a cameraman on the *Our Gang* set, but here, too, the job was foreclosed to him because of his race. Hoskins was a member of the camera club in high school and pursued filmmaking and photography as a hobby as an adult. According to his son, Michael, one of Hoskins's proudest moments was seeing a black cameraman plying his trade, fulfilling a dream Hoskins himself had not been able to achieve.

74. "Hi! Hi! The Gang's All Here!," *Pictures and the Picturegoer,* June 1924, 16. Mickey had also been a neighbor of the Kornmans in Utah (Bob McGowan, "A Hollywood Gang the Police Can't Stop," *Los Angeles Times,* October 15, 1933).

75. Roach, "Hal Roach on Film Comedy," 3.

76. Hal Roach, "The Pioneer Movie Producer Hal Roach," in *Hollywood Speaks! An Oral History,* ed. Mike Steen (New York: G. P. Putnam's Sons, 1974), 366. See also Maltin and Bann, *The Little Rascals,* 9.

77. Hal Hinson, "Funny Man Emeritus: Film Director Hal Roach at Age 96," *Washington Post,* May 22, 1988, 197. According to Brian Anthony and Andy Edmonds, the first *Our Gang* short was directed by Fred C. Newmeyer but was received poorly in previews. Bob McGowan reshot the picture and took over as *Our Gang's* director (Anthony and Edmonds, *Smile When the Raindrops Fall,* 53).

78. Bob McGowan, "Keep 'em Human," *Film Daily,* June 3, 1923, 19–20.

79. Flake, "Gangway for the Gangsters!"

80. *Our Gang* advertisement, *Exhibitors Herald,* November 24, 1923, back cover; "What the Picture Did for Me," *Exhibitors Herald,* May 11, 1924.

81. "Surplus," *Film Daily,* October 19, 1923, 1. Daniel Leab claims Sunshine Sammy was paid five times less than other popular white child actors (Leab, *From Sambo to Superspade,* 54). I have not been able to find payroll accounts to see if Ernie was paid commensurately to the other *Our Gang* kids. I suspect he would have been paid more, since he was the most established star.

82. Geraldyn Dismond, "The Negro Actor and the American Movies," *Close Up,* August 1929. Essay reprinted in *Black Films and Filmmakers,* ed. Lindsay Patterson (New York: Dodd, Mead, 1975), 9.

83. Patterson, *Black Films and Filmmakers,* 372; Bogle, *Toms, Coons, Mulattoes, Mammies, and Bucks,* 23.

84. Thomas Cripps, *Slow Fade to Black: The Negro in American Film, 1900–1942* (New York: Oxford University Press, 1993), 136–37.

85. Frederick Douglass, *Narrative of the Life of Frederick Douglass, an American Slave* (New York: Penguin, 2014), 46–47.

86. David K. Wiggins, "The Play of Slave Children in the Plantation Communities of the Old South, 1820–1860," *Journal of Sport History* 7, no. 2 (Summer 1980): 26, 30–31. Wiggins bases his findings on slave narratives collected through the Federal Writers Project between 1936 and 1938.

87. Woodward, *The Strange Career of Jim Crow,* 43.

88. Wiggins, "The Play of Slave Children," 31. See also Jearold Winston Holland, *Black Recreation: A Historical Perspective* (Chicago: Burnham, 2002), 96–97.

89. Blanche M. Knowlton, "Concerning Pickaninnies," *Reading Eagle,* January 8, 1905.

90. Ibid.

91. "Miscegenation in the United States," in *Encyclopedia of Sex and Gender,* ed. Fedwa Malti-Douglas (Detroit: Macmillan Reference, 2007), 1023–24.

92. "Speech of Senator Benjamin R. Tillman, March 23, 1900," *Congressional Record, 56th Congress, 1st Session,* 3223–24; reprinted in *Document Sets for the South in U.S. History,* ed. Richard Purday (Lexington, Mass.: D. C. Heath, 1991), 147.

93. Cripps, *Slow Fade to Black,* 135. To be sure, pickaninnies were sometimes depicted partially or completely naked, but this, along with their imperviousness to pain and their grotesque appearance, served to emasculate and dehumanize them—to render them nonsexual creatures.

94. David I. MacLeod, "Act Your Age: Boyhood, Adolescence, and the Rise of the Boy Scouts of America," *Journal of Social History* 16, no. 2 (1982): 8.

95. Mark Twain, *The Adventures of Tom Sawyer* (New York: Dover Publications, 1998), 183.

96. Jacob A. Riis, *How the Other Half Lives* (repr., New York: Bedford/St. Martin's, 2010), 210–22. See also "Jacob A. Riis," *Encyclopædia Britannica Online Academic Edition,* Encyclopædia Britannica Inc., 2013, http://academic.eb.com.

97. Steven Mintz, *Huck's Raft: A History of American Childhood* (Cambridge, Mass.: Belknap Press, 2006). Mintz describes *The Little Rascals* as the "urban offspring of Tom Sawyer and Huck Finn" (249).

98. J. Adams Puffer, "Boy Gangs and Boy Leaders," *McClure's Magazine,* October 1911, 678–89.

99. Ibid., 678.

100. J. Adams Puffer, *The Boy and His Gang* (Boston: Houghton Mifflin, 1912), 148.

101. Ibid., 27.

102. Ibid., 14.

103. Ibid.

104. Ibid., 75.

105. Ibid., 87–88.

106. Puffer's belief in innate gender difference, as well as the "savagery" of young boys, can be traced to G. Stanley Hall, the first president of the American Psychological Association and a pioneer in the fields of child psychology and educational psychology. Hall was then president of Clark University, where Puffer did his graduate work, and wrote the foreword to *The Boy and His Gang*, lauding its discovery that boys' gangs, far from being evil or unwholesome, actually cultivated "great fundamental virtues" like cooperation, self-sacrifice, and loyalty. A social Darwinist, Hall subscribed to Victorian beliefs in feminine domesticity and the maternal role of women in the family structure. He likewise believed that child development recapitulated human evolution. Thus, a boy between the ages of eight and twelve was likened to a pigmy—a kind of troglodyte with simple and barbaric impulses. It was during this liminal period that boys could exercise their spirits in preparation for the next evolutionary stage, that stormy period that Hall called "adolescence."

107. Joseph Lee, *Play in Education* (New York: Macmillan, 1915), 350, 355.

108. Woodward, *The Strange Career of Jim Crow*, 7; Isabel Wilkerson, *The Warmth of Other Suns: The Epic Story of America's Great Migration* (New York: Vintage, 2011), 40–41.

109. "Anti-Slavery in Millbury," *Liberator*, January 21, 1842, 2.

110. Woodward, *The Strange Career of Jim Crow*, 100.

111. John Haynes Holmes, "Address on Lynching," *Crisis* 3, no. 3 (January 1912): 109.

112. W. E. B. Du Bois, *Black Reconstruction in America, 1860–1880* (New York: Free Press, 1992), 30.

113. Justice Joseph McKenna, *Williams v. Mississippi*, 170 U.S. 213 (1898).

114. Rayford Logan, *The Negro in American Life and Thought: The Nadir, 1877–1901* (New York: Dial Press, 1954).

115. Wilkerson, *The Warmth of Other Suns*, 9.

116. L. Diane Barnes, "The Great Migration," *Encyclopedia of African American History, 1896–Present*, Oxford African American Studies Center, 2015, http://www.oxfordaasc.com/.

117. Ibid.

118. Chicago Commission on Race Relations, *The Negro in Chicago* (Chicago: University of Chicago Press, 1922), xv. For more on the Chicago Riot, see William M. Tuttle, *Race Riot: Chicago in the Red Sum-*

mer of 1919 (Urbana: University of Illinois Press, 1996) and Cameron McWhirter, *Red Summer: The Summer of 1919 and the Awakening of Black America* (New York: St. Martin's Griffin, 2012).

119. The phrase was coined by James Weldon Johnson.

120. Chicago Commission on Race Relations, *The Negro in Chicago,* xxiii.

121. W. E. B. Du Bois, *The Souls of Black Folk,* in *W. E. B. Du Bois: Writings* (New York: Library of America, 1987), 372.

122. Chicago Commission on Race Relations, *The Negro in Chicago,* xxiv.

123. The Chicago Commission on Race Relations gathered research from 1920 to 1921 and published its report in 1922. *Our Gang* was created in 1921 and first released in 1922.

124. Patton, "'Farina' Warms Way into the Heart of a Nation."

125. "Tracing 'Our Gang' with Dots and Dashes," date unknown (ca. 1937), MGM Collection, Cinematic Arts Library, University of Southern California.

126. Chicago Commission on Race Relations, *The Negro in Chicago,* 454.

3. 100 PERCENT AMERICAN

1. David E. Kyvig, *Daily Life in the United States, 1920–1939* (Westport, Conn.: Greenwood Press, 2002), 79.

2. The first theater to be air-conditioned was the Rivoli, Paramount's flagship theater in Times Square, in 1925.

3. Barbara Stones, *America Goes to the Movies* (North Hollywood, Calif.: National Association of Theatre Owners, 1993), 208. In fact, small Southern towns were often the last to get movie theaters at all.

4. Samuel L. Rothafel ("Roxy"), quoted in Ross Melnick, *Cinema Treasures: A New Look at Classic Movie Theaters* (St. Paul, Minn.: MBI Publishing, 2004), 19–20. Details of the Rialto Theater are taken from Melnick's book, as well as David Naylor, *American Picture Palaces: The Architecture of Fantasy* (New York: Van Nostrand-Reinhold, 1981). We know *Our Gang* shorts played at the Rialto and that they were prominently advertised by the theater ("N. Y. Rialto Gives 'Our Gang' Comedy Prominent Display in Newspaper Ads," *Exhibitor's Trade Review* 18, no. 10 (August 1, 1925): 57.

5. *Lodge Night,* on *The Little Rascals Silent Shorts: Our Gang Gold* (1923; Chelsea, Mass.: GI Studios, 2012), DVD.

6. Kyvig, *Daily Life in the United States,* 141.

7. According to Rachel Dworkin, archivist at the Chemung County Historical Society, over six thousand people attended the Klolero,

held July 1–5, 1925, and several local businesses and organizations took out advertisements in the event program, including the Elmira Association of Commerce. In 1923, James Weldon Johnson, then secretary to the National Association for the Advancement of Colored People, wrote a letter to the editor of the *New York Times,* warning its readers of the "masked terrorism, race hatred and intolerance" of the Klan up north (James Weldon Johnson, "Ku Klux Menace to the North," *New York Times,* July 6, 1923, 12). The following year, the Democratic Party held its National Convention at Madison Square Garden in New York City. Warring pro- and anti-Klan factions nearly split the party in two, forcing a record 103 ballots to agree upon a presidential candidate. Newspaper journalists and radio announcers took to calling the convention the "Klanbake."

8. John Strausbaugh, *Black Like You: Blackface, Whiteface, Insult & Imitation in American Popular Culture* (New York: Jeremy P. Tarcher/Penguin, 2006), 78.

9. Ibid., 115.

10. Ibid., 136. Williams died in New York City in 1922, shortly after collapsing on stage midshow. Two thousand people, most of them colored, attended his funeral. "Masons Honor Williams," *New York Times,* March 9, 1922, 15.

11. A. C. Betts wrote, "If you have a weak feature, book [*Our Gang*] with it, and this will balance your program fine" (Betts [Powers Theatre, Red Creek, New York], "What the Picture Did for Me," *Exhibitors Herald,* April 12, 1924, 84), and M. P. Forster reported that the *Our Gang* short "saved the show from being a failure" (Forster [Orpheum Theatre, Harrisburg, Illinois], "What the Picture Did for Me," *Exhibitors Herald,* February 9, 1924, 84).

12. Phil H. Heyde (Elks Theatre, Olney, Illinois), "What the Picture Did for Me," *Exhibitors Herald,* August 4, 1923, 68.

13. Charles Blaine (Morgan Theatre, Henrietta, Oklahoma), "What the Picture Did for Me," *Exhibitors Herald,* December 1, 1923, 85.

14. Anderson Amusement Co. (Grand Theatre, Dell Rapids, South Dakota), "What the Picture Did for Me," *Exhibitors Herald,* February 9, 1924, 84; Wm. E. Tragsdorf (Trags Theatre, Neillsville, Wisconsin), "What the Picture Did for Me," *Exhibitors Herald,* March 22, 1924, 85; Pugh Moore (Strand Theatre, McKenzie, Tennessee), "What the Picture Did for Me," *Exhibitors Herald,* May 31, 1924, 110.

15. D. A. White (Cozy Theatre, Checotah, Oklahoma), "What the Picture Did for Me," *Exhibitors Herald,* March 29, 1923, 80.

16. S. H. Borisky (American Theatre, Chattanooga, Tennessee), "What the Picture Did for Me," *Exhibitors Herald,* July 14, 1923, 92.

17. E. L. Golden (Mt. Vernon Theatre, Tallassee, Alabama), "What the Picture Did for Me," *Exhibitors Herald*, August 11, 1923, 82.

18. Clarence C. Fuller (Loxley Hall Theatre, Loxley, Alabama), "What the Picture Did for Me," *Exhibitors Herald*, August 15, 1925, 78.

19. E. T. Laqua (Gem Theatre, Hankinson, North Dakota), "What the Picture Did for Me," *Exhibitors Herald*, December 8, 1923, 78.

20. Sharon, "How They Pick the Kids for Our Gang."

21. "Interviewing 'Farina,'" *New York Amsterdam News*, September 26, 1928, 6.

22. Peggy Brooks to Farina Hoskins, date unknown (ca. 1925), Allen Clayton Hoskins Papers, Fairfield, California. This fan letter was sent on a postcard with a photograph of Farina dressed in his suit from *Your Own Back Yard* (released September 27, 1925).

23. Hugh G. Martin (American Theatre, Columbus, Georgia), "What the Picture Did for Me," *Exhibitors Herald*, September 15, 1923, 92.

24. M. J. Babin (Fairyland Theatre, White Castle, Louisiana), "What the Picture Did for Me," *Exhibitors Herald*, November 17, 1923, 85.

25. Roy L. Dowling (Ozark Theatre, Ozark, Alabama), "What the Picture Did for Me," *Exhibitors Herald*, February 16, 1924, 80.

26. Needham & Mattingly (De Luxe Theatre, Moline, Kansas), "What the Picture Did for Me," *Exhibitors Herald*, February 23, 1924, 94.

27. Chase was credited as "Charles Parrott," his real name.

28. McNamara played "Mack," a long-haired clown, and his Jewish colleague, Myer Marcus, played "Marcus," a blackface minstrel. Alex Jay, "Ink-Slinger Profiles: Tom McNamara," http://strippersguide.blogspot.com.

29. Joseph McBride, *Frank Capra: The Catastrophe of Success* (Oxford: University of Mississippi Press, 1992), 139. Frank Capra lasted only seven or eight weeks as an *Our Gang* gag writer, beginning his stint in late January or early February of 1924. *Lodge Night* would have appeared before he joined the *Our Gang* staff. Little is known about Thomas J. Crizer, another Hal Roach gag man.

30. Robert Demoss, "Charles Oelze," *The Lucky Corner*, November 2, 2006, http://www.theluckycorner.com.

31. John Steven McGroarty, "The Negro," *Los Angeles Times*, June 4, 1922, VIII3. See also Flamming, *Bound for Freedom*, 196–202.

32. "One Held in Night Raid," *Los Angeles Times*, April 24, 1922, I1. See also Flamming, *Bound for Freedom*, 204–5.

33. "Inglewood Raid Story Told to Jury by Victims," *Los Angeles Times*, August 10, 1922, II1.

34. "Klan Leader Halts Trial," *Los Angeles Times,* August 11, 1922, II1.

35. Flamming, *Bound for Freedom,* 205.

36. According to Robert Demoss, who consulted the 1923 datebook held in USC's Hal Roach Collection, filming on *Lodge Night* began February 12, 1923, and took fifteen days (Demoss, "Lodge Night: Film No. 15," *The Lucky Corner,* January 17, 2005, http://theluckycorner .com).

37. Leonard Maltin and Richard Bann write that Roach and his staff "did conceive ideas for *Our Gang* films from actual newspaper stories" (*The Little Rascals,* 149). In its October 16, 1921, issue, the *Los Angeles Times* reprinted a cartoon from the Louisville, Kentucky, *Courier-Journal* that may have been one of the inspirations for the *Our Gang* short. In addition to the white-hooded and robed figures of the KKK's "Imperial Wizard," "Exalted Cyclops," "Imperial Kleagle," and "Grand Goblin"—all actual Klan titles—the cartoonist added a retinue of Klan animals, each outfitted in white hoods and robes. There is the "Imperial Klux" (a masked chicken), the "Imperial Google" (a masked squirrel), and the "Imperial Goggle" (a masked pig). There is even an "Imperial Snooper," a masked intruder who peeks out from under a KKK-emblazoned tablecloth ("Political Cartoons of the 1920s: Ku Klux Klan," *Becoming Modern: America in the 1920s,* National Humanities Center, http://americainclass.org/sources/becomingmodern/).

38. Maltin and Bann, *The Little Rascals,* 26.

39. "Boys Playing 'Ku Klux Klan' Bind and Injure Ohio Child," *New York Times,* September 27, 1923, 1.

40. "Negro Boy Tortured and Burned at Stake in Georgia after Killing White Woman," *New York Times,* May 19, 1922, 1.

41. "Georgia Hastens to Catch Up with Texas," *Chicago Defender,* May 27, 1922, 1.

42. James Allen, *Without Sanctuary: Lynching Photography in America* (Santa Fe, N.M.: Twin Palms Publishers, 2000), plate 54. Details of Lige Daniels's lynching are taken from Amy Louise Woods, *Lynching and Spectacle: Witnessing Racial Violence in America, 1890–1940* (Chapel Hill: University of North Carolina Press, 2009), 90.

43. Bogle, *Bright Boulevards, Bold Dreams,* 41. Madame Sul-Te-Wan, who had appeared in Griffith's *Birth of a Nation,* and Noble Johnson, who had recently appeared in Cecil B. De Mille's *Ten Commandments,* were fairly well-known adult actors, but their fame was eclipsed by that of the *Our Gang* kids.

44. Maltin and Bann, *The Little Rascals,* 244.

45. Jackson, *Eugene "Pineapple" Jackson,* 13.

46. "'Our Gang' Has Great Time Playing at Work," WF12.

47. Ibid.

48. "'Our Gang' Has Big Christmas Party," *Illustrated Daily News,* date unknown (ca. December 1924), Allen Clayton Hoskins Papers, Fairfield, California.

49. Fifty years later, when my parents, recent immigrants from Korea, purchased their first home in a neighborhood adjacent to Culver City, my father was shocked when, flipping through the deed to the house, he came across the stipulation that "no person of African or Negro blood, lineage, or extraction" could buy or rent the property. By then, racial covenants had been declared unconstitutional.

50. An ad that appeared in *Exhibitors Herald* claimed *Our Gang* was "shown to more audiences," "praised by more exhibitors," and "reported on more times in the trade papers" than any of its competitors (*Our Gang* advertisement, *Exhibitors Herald,* June 6, 1925, 42–43).

51. "Tie-Up Our Gang," National Tie-Up and Exploitation Section, *Exhibitor's Trade Review* 18, no. 9 (July 25, 1925): 26–27.

52. Ibid.

53. Philip B. Peitz (Rialto Theatre, New England, North Dakota), "What the Picture Did for Me," *Exhibitors Herald,* October 24, 1925, 83.

54. See James H. Dorman, "Shaping the Popular Image of Post-Reconstruction American Blacks: The 'Coon Song' Phenomenon of the Gilded Age," *American Quarterly* 40, no. 4 (December 1988): 450–71.

55. Beanie Walker was perhaps punning on the white goat as a "white kid," or Farina as a scapegoat.

56. In the Greek myth, Narcissus falls in love with his own reflection in a pool of water and dies as a result of his infatuation. I am indebted to Kirk Askia Talib-Deen for the insight about the white goat as "kid."

57. "The Race Question in 'Our Gang,'" unidentified clipping, date unknown (ca. 1925), Allen Clayton Hoskins Papers, Fairfield, California. Since the article was personally clipped by Florence Hoskins, I make the assumption that it came from a black newspaper. (Hoskins received clippings from white newspapers from commercial clipping bureaus.)

58. Phillip K. Scheuer, "Hal Roach, Governor of the State of Laughter," *Los Angeles Times,* July 4, 1976, N34.

59. McBride, *Frank Capra,* 140–41. Capra was openly bigoted, speaking derogatorily of "Japs" and "cholos," as well as "niggers" (ibid., 36). In his autobiography, Capra claimed he lasted six months at Hal E. Roach Studios; according to McBride, his real tenure was "only seven or eight weeks" (139).

60. Wm. E. Tragsdorf (Trags Theatre, Neillsville, Wisconsin), "What the Picture Did for Me," *Exhibitors Herald,* June 21, 1924, 76.

61. Flake, "Gangway for the Gangsters!"

62. Winship, "Our Gang," 40.

63. Maltin and Bann, *The Little Rascals,* 46. The sheet music for "Stay in Your Own Backyard" was reissued in 1925 to capitalize on its appearance in the *Our Gang* short. Farina and the other members of the Gang were pictured on the new cover. For more on coon songs like "Stay in Your Own Backyard," see Dorman, "Shaping the Popular Image of Post-Reconstruction American Blacks," 463–64.

64. Maltin and Bann, *The Little Rascals,* 244.

65. Wm. E. Tragsdorf (Trags Theatre, Neillsville, Wisconsin), "What the Picture Did for Me," *Exhibitors Herald,* October 11, 1924, 82.

66. "Studio Gossip," *California Eagle,* July 4, 1924, 10.

4. SAMBO'S AWAKENING

1. Julia C. Conklin, "Sonny Boy Becomes Temperamental," *Movie Weekly,* date unknown (ca. 1923), Allen Clayton Hoskins Papers, Fairfield, California. Many of the sources in this chapter are press clippings from Hoskins's personal papers, some of which are missing dates and other identifying features. Where possible, I have given approximate dates.

2. "Relief from Heat Promised for Today," *Boston Daily Globe,* August 10, 1920.

3. Goodwin, "At Home with Farina."

4. McGowan, "A Hollywood Gang," H4.

5. A. L. Wooldridge, "Farina's Revolt," clipping from unidentified magazine, date unknown (ca. 1923), Allen Clayton Hoskins Papers.

6. Untitled Hoskins article, *Hartford Times,* March 7, 1924, Allen Clayton Hoskins Papers.

7. McGowan, "A Hollywood Gang," H4.

8. Jack Jungmeyer, "'Our Gang' Regular Kids; Have Their Own School," *Modesto News,* November 14, 1924, Allen Clayton Hoskins Papers.

9. Robert Parrish, who appeared in the 1927 *Our Gang* silent short *Olympic Games,* recalled McGowan as a "dour, pock-marked man who always wore a hat and vest and never smiled except when publicity pictures were being taken" (*Growing Up in Hollywood* [New York: Harcourt Brace Jovanovich, 1976], 47). One suspects that Parrish had limited interactions with McGowan and that McGowan favored the Gang's main players. McGowan was also quite ill during this time and had to go on leave at least twice.

10. "Bob McGowan, Chief of 'Our Gang,'" *Manchester Daily Mirror,* January 17, 1924, Allen Clayton Hoskins Papers.

11. "Seein' Things," *Film Daily,* March 30, 1924.

12. McGowan, "A Hollywood Gang," H4.

13. Aunt Mary, "Corner for Kiddies," clipping from unidentified magazine, April 7, 1923, Allen Clayton Hoskins Papers.

14. "Poor Farina Couldn't Stand His Own Grief," *Milwaukee Journal,* July 3, 1923, Allen Clayton Hoskins Papers.

15. Untitled clipping, *Film Daily,* December 1923/January 1924, Allen Clayton Hoskins Papers.

16. "Farina Center in Divorce Suit," *Los Angeles Times,* October 26, 1925, A2, Allen Clayton Hoskins Papers; "Farina's Mother's Divorce," clipping from unidentified newspaper, July 13, 1926, Allen Clayton Hoskins Papers.

17. Michael Hoskins in discussion with the author, Fairfield, California, January 22, 2013.

18. Richard Bann in discussion with the author, Culver Hotel, Culver City, California, October 30, 2012.

19. Quoted in Maltin and Bann, *The Little Rascals,* 237.

20. Ibid.

21. These descriptions of stock *Our Gang* expressions are taken from Parrish, *Growing Up in Hollywood,* 48.

22. Yvonne Hughes, "Dark-Hued Juveniles Tempted by Chicken," *Los Angeles Examiner,* November 5, 1923, Allen Clayton Hoskins Papers. Stan Laurel began working for Hal Roach Studios in 1923, after previously working for Roach at the Rolin Film Company. Laurel's famed partnership with Babe Hardy was still a few years in the future.

23. Untitled clipping, *Los Angeles Times,* January 2, 1924, Allen Clayton Hoskins Papers.

24. Louella Parsons, untitled clipping, *Los Angeles Examiner,* date unknown (ca. 1928), Allen Clayton Hoskins Papers.

25. "Interviewing 'Farina.'" According to the article, "the reporter learned from [Mrs. Hoskins] that 'Farina' is President Coolidge's favorite actor."

26. "Roach Signs Contract for Services of Youthful Star," clipping from unidentified newspaper, September 10, 1923, Allen Clayton Hoskins Papers.

27. Mayme Ober Peak, "'Our Gang' Goes to School Every Day to Learn to Be Something More than Movie Stars," *Boston Sunday Globe,* January 16, 1927, 15.

28. Maltin and Bann, *The Little Rascals,* 244.

29. Winship, "Our Gang," 108.

30. Sharon, "How They Pick the Kids for Our Gang."

31. Untitled Hoskins article, *Hartford Times*.

32. "Pickens Entertained by Movie Stars," *New York Amsterdam News*, May 19, 1926, 11. Louella Parsons also referred to Farina as wearing a "Julian Eltinge disguise" ("Allen Farina Hoskins Spends the Week Here: Youthful Star Pays Visit to American's Office," *Baltimore Afro-American*, October 13, 1928, Allen Clayton Hoskins Papers).

33. Maltin and Bann, *The Little Rascals*, 31.

34. Winship, "Our Gang," 108.

35. Unidentified *Your Own Back Yard* clipping, date unknown (ca. 1925), Allen Clayton Hoskins Papers.

36. Katherine Albert, "Looking on the Dark Side of Life," unidentified magazine clipping, date unknown (ca. 1928), Allen Clayton Hoskins Papers.

37. Ibid.

38. "Farina Can't Believe Lon Chaney Really Low [*sic*]," *San Diego Union*, April 21, 1928, Allen Clayton Hoskins Papers.

39. See untitled clipping, *Home News*, March 28, 1926, Allen Clayton Hoskins Papers. A girl identified as "Lorraine Younger" is dressed as Farina, posing beside a Lincoln impersonator.

40. Maltin and Bann, *The Little Rascals*, 241.

41. Goodwin, "At Home with Farina."

42. "Farina Celebrates," *Baltimore News*, September 1, 1927, Allen Clayton Hoskins Papers.

43. "Suppress Movie Scandals, Advises Little Farina," *New York Graphic*, November 14, 1924.

44. Carl Sandburg, review of *Commencement Day*, in *"The Movies Are": Carl Sandburg's Film Reviews and Essays, 1920–1928* (Chicago: Lake Claremont Press, 2000), 223.

45. "Farina and Gang Meet N. Y. Mayor" (reprinted from *Variety*), *Chicago Defender*, October 6, 1928, A3.

46. Dorothy Spensley, "See Young America First," *Motion Picture Magazine*, June 1929, Allen Clayton Hoskins Papers.

47. "Candy Bars to Shower from Skies," *Hollywood News*, March 22, 1929, Allen Clayton Hoskins Papers. All advertisements were clipped by Florence Hoskins and appear in the Allen Clayton Hoskins Papers.

48. "Allen Farina Hoskins Spends the Week Here: Youthful Star Pays Visit to American's Office," *St. Louis American*, October 13, 1928, Allen Clayton Hoskins Papers.

49. Photograph of Farina with "lots of other little brown folk," *Baltimore Afro-American*, December 1, 1928, Allen Clayton Hoskins Papers.

50. "Farina Gets Ovation from Chicago Kids," *Chicago Defender,* August 25, 1928, 1.

51. "The Billiken Story," *Chicago Defender,* August 4, 1951, 13.

52. David W. Kellum, "Bud Tells History of Billiken Club," *Chicago Defender,* May 3, 1930, A11.

53. "Farina," *Chicago Defender,* August 25, 1928.

54. "Farina Gets Ovation," 1.

55. Margaret Culberson to Farina Hoskins, ca. 1928, Allen Clayton Hoskins Papers.

56. "The Billiken Spirit," *Chicago Defender,* February 6, 1926, A5.

57. Ibid.

58. "What Is the New Negro?," *New York Amsterdam News,* March 3, 1926, 10. See also *The New Negro: Readings on Race, Representation, and African American Culture, 1892–1938,* ed. Henry Louis Gates Jr. and Gene Andrew Jarrett (Princeton: Princeton University Press, 2007).

59. "'Gang' Get Loving Cups at Gay Party," *Chicago Defender,* September 1, 1928. See also "Hollywood 'Gangsters' All Here," *Chicago Defender,* August 25, 1928, A3.

60. "Interviewing 'Farina,'" 6.

61. Ibid.

62. Louella Parsons, "MGM will Release Comedies by Farina and Roach 'Gang,'" *Los Angeles Examiner,* April 12, 1926.

63. Ward, *A History of the Hal Roach Studios,* 62–64.

64. Maltin and Bann, *The Little Rascals,* 4–5.

65. "Pickens Entertained by Movie Stars," 11. Pickens incorrectly refers to Jackie Condon as Jackie Coogan.

66. William Pickens, note to "Farina" Hoskins, date unknown (ca. 1926), Allen Clayton Hoskins Papers.

67. Flamming, *Bound for Freedom,* 223.

68. "Most Useful Negro Alive," date unknown (ca. 1926), Allen Clayton Hoskins Papers.

69. "The Gang," *New York Herald Tribune,* November 28, 1926, Allen Clayton Hoskins Papers.

70. "Florence Mills!" *Pittsburgh Courier,* November 12, 1927, A8.

71. Hannen Swaffer, "Florence Mills Again Tells Europe about the Race Problem in the US," *New York Amsterdam News,* August 10, 1927, 10.

72. "Florence Mills!" A8.

73. NAACP "Negro Musical Review" Program, Shrine Auditorium, Los Angeles, Calif., June 30, 1928, Allen Clayton Hoskins Papers. The details of Sonny Hoskins's movie contract are unknown, but it is likely he was limited to public appearances that specifically promoted

Our Gang. His Bud Billiken appearances presumably fell under these guidelines, as they promoted the series to the African American community and also included appearances by his fellow Gangsters.

5. EVERYMAN

1. Scott Eyman, *The Speed of Sound: Hollywood and the Talkie Revolution, 1926–1930* (New York: Simon and Schuster, 1997), 139–40.

2. Annual report of the directors to the stockholders of Hal Roach Studios, August 31, 1928, quoted in Ward, *A History of the Hal Roach Studios,* 72.

3. "35 of 40 Hal Roach Comedies to Have Synchronization," *Motion Picture News,* September 1, 1928, 725.

4. "Dialog and Sound in All Comedies, Says Roach," *Exhibitors Herald-World,* June 29, 1929, 141.

5. Ward, *A History of the Hal Roach Studios,* 73.

6. Unidentified clipping, date unknown (ca. 1928), Allen Clayton Hoskins Papers, Fairfield, California.

7. Hubbard Keavy, "Notes of Screen Life at Hollywood," *Cumberland News,* April 1, 1929, Allen Clayton Hoskins Papers.

8. "Our Gang's First Talkie," *London Picture Show,* July 6, 1929, Allen Clayton Hoskins Papers.

9. David Arlen, "Our Gang Speak Their Pieces," *Hollywood Magazine,* date unknown (ca. 1929), Allen Clayton Hoskins Papers.

10. Ibid.

11. "Comedy for the Screen: Hal Roach Gives His Views on Producing the Lighter Variety of Films," unidentified newspaper clipping, date unknown (ca. 1929), Allen Clayton Hoskins Papers.

12. "Farina Known as 'Sunny Boy,'" *Newark Star Eagle,* April 6, 1929, Allen Clayton Hoskins Papers.

13. "Comedy for the Screen."

14. "Farina Learns Spanish with Much Hesitation," *San Diego Union,* May 26, 1929, Allen Clayton Hoskins Papers.

15. Quoted in Richard Bann, "Program Notes," screening of *Las Fantasmas* (1930), 19th International Sons of the Desert Convention, Egyptian Theater, Hollywood, Calif., July 6, 2014.

16. Photograph, *St. Paul, Minnesota News,* October 6, 1929, Allen Clayton Hoskins Papers. The caption reads: "The Gang is discovered investigating some portable sound recording equipment."

17. "Our Gang Complete First Audien; Make 'Mikes' Do Tricks," *Exhibitors Herald,* May 4, 1929, 35.

18. Sklar, *Movie-Made America,* 53.

19. Quoted in Maltin and Bann, *The Little Rascals,* 85.

20. Bland Johaneson, "Drama, Fun; 'Our Gang' Talker," *New York Mirror*, June 17, 1929, Allen Clayton Hoskins Papers.

21. "Our Gang in 'Railroadin',"" *Los Angeles Inside Facts*, June 1, 1929, Allen Clayton Hoskins Papers.

22. Quoted in James L. Neibaur, *The Silent Films of Harry Langdon* (Lanham, Md.: Scarecrow Press, 2012), 208.

23. "Our Gang Loses Joe Cobb, Fat Boy," *Nashville Banner*, November 3, 1929, Allen Clayton Hoskins Papers.

24. Untitled clipping, *Baltimore Evening Sun*, date unknown (ca. 1929), Allen Clayton Hoskins Papers.

25. A. I. Wooldridge, "Once Big Movie Names Dropped from Rosters," *Denver Post*, October 13, 1929, Allen Clayton Hoskins Papers.

26. Ibid.

27. "Farina's Successor," *Variety*, June 19, 1929, Allen Clayton Hoskins Papers.

28. "New Colored Baby in Our Gang Comedies," *Hollywood News*, June 18, 1929, Allen Clayton Hoskins Papers.

29. "All Grown Up: Original Sweetheart of Movie Comedy Gang Finds Only One Playmate Left," *Casper (Wyoming) Herald*, November 15, 1929, Allen Clayton Hoskins Papers.

30. Bogle, *Toms, Coons, Mulattoes, Mammies, and Bucks*, 26.

31. Quoted in Cripps, *Slow Fade to Black*, 220.

32. Robert Benchley, "Hearts in Dixie (The First Real Talking Picture)," *Opportunity: A Journal of Negro Life* 7 (April 1929): 122–23.

33. Bogle, *Toms, Coons, Mulattoes, Mammies, and Bucks*, 28.

34. Delight Evans, "Hearts in Dixie: A Spiritual on the Screen," *Screenland*, date unknown (ca. 1929), Allen Clayton Hoskins Papers.

35. Louella Parsons, "Hearts in Dixie," *Los Angeles Examiner*, March 8, 1929.

36. Evans, "Hearts in Dixie."

37. Walter White, "A Letter from Walter White," *Close Up*, August 1929, 105.

38. Alain Locke and Sterling Brown, "Folk Values in a New Medium," in Patterson, *Black Films and Filmmakers*, 27.

39. Bogle, *Toms, Coons, Mulattoes, Mammies, and Bucks*, 27.

40. Ed Guerrero, *Framing Blackness: The African American Image in Film* (Philadelphia: Temple University Press, 1993), 19–20.

41. Arlen, "Our Gang Speak Their Pieces."

42. Hal E. Roach Studios Pressbook, date unknown (ca. 1929), Hal Roach Collection, Cinematic Arts Library, University of Southern California.

43. "Farina's Accent," *Variety* 92, no. 2 (July 25, 1928): 1. Never

mind that Sonny was nine years old and had been talking for a good eight years. The minute sound entered film, it was as if Sonny, previously mute, could now speak—and the voice of his filmic persona did not match!

44. Floyd J. Calvin, "Talkies May Help Race Artists!," *Pittsburgh Courier,* September 15, 1928, A1.

45. Lula Jones Garrett, "From the Front Row," *Baltimore Afro-American,* December 7, 1929, Allen Clayton Hoskins Papers.

46. "Our Gang in 'Railroadin'.'"

47. "Personality Sketch Farina," *Chicago Journal,* July 16, 1929, Allen Clayton Hoskins Papers.

48. Hal E. Roach Studios Pressbook (ca. 1929).

49. Jannie Hoskins, handwritten note on publicity still from *Lazy Days,* Allen Clayton Hoskins Papers.

50. "Sound Shorts: 'Lazy Days,'" *Billboard* 41, no. 46 (November 16, 1929): 24.

51. J. F. L. "Sound Shorts: 'Lazy Days,'" *Billboard* 42, no. 1 (January 4, 1930): 25.

52. Louella Parsons, "Broadway Actors Leave Hollywood in Large Numbers," *New York American,* July 19, 1929, Allen Clayton Hoskins Papers. Parsons reports that "'Lazy Daze' [*sic*], featuring Mr. Allan [*sic*] Clay Hoskins, is the first picture [released] since the new contract." *Lazy Days* was released on August 15, 1929, and was probably filmed a month earlier, around the time Sonny's contract was renewed.

53. "Farina to Retire? Not on Your Life," *Milwaukee Telegram,* August 25, 1929, Allen Clayton Hoskins Papers.

54. "Farina Signs New Contract," *Sacramento Bee,* July 27, 1929, Allen Clayton Hoskins Papers.

55. Untitled article, *Washington (D.C.) News,* December 2, 1929, Allen Clayton Hoskins Papers.

56. "'Farina' Now a Boy," *Newark Star Eagle,* July 23, 1929, Allen Clayton Hoskins Papers. The *Eagle* reported that "Farina . . . has at last outgrown his kid roles and recently has been cast as a boy."

57. Sklar, *Movie-Made America,* 161.

58. Bogle, *Bright Boulevards, Bold Dreams,* 100.

59. Quoted in Maltin and Bann, *The Little Rascals,* 97.

60. Bogle, *Bright Boulevards, Bold Dreams,* 98.

61. Mel Watkins, *Stepin Fetchit: The Life and Times of Lincoln Perry* (New York: Vintage, 2006), 127–28.

62. "Dark Temperament," *Motion Picture Classic,* June 1930, Allen Clayton Hoskins Papers. The magazine echoed the rumors regarding

Fetchit's difficult temperament: "Stepin Fetchit . . . got so lackadaisical and so difficult to deal with that his five-hundred dollar weekly check from Mr. Fox was abruptly cut off at the source, and Stepin found himself with two expensive cars, one chauffeur, no money and no job. . . . But Stepin has managed to re-connect and I hear he is enacting the role of 'nursemaid to a mule' with some degree of artistry for the Our Gang comedies."

63. Bogle, *Bright Boulevards, Bold Dreams,* 97.

64. Quoted in Bogle, *Toms, Coons, Mulattoes, Mammies, and Bucks,* 42.

65. Joseph McBride, "Stepin Fetchit Talks Back," *Film Quarterly,* Summer 1971, 423.

66. Jack Lait, "Farina Is Cooked," *Duluth (Minn.) News Tribune,* June 7, 1931, Allen Clayton Hoskins Papers.

67. Ibid.

68. "Gangsters Walk Plank," *Cleveland News,* July 18 (ca. 1933), Allen Clayton Hoskins Papers.

69. Captain Roscoe Fawcett, "Farina, Once of 'Our Gang' Now Sings Bass in His Church Choir," unidentified clipping from Bellingham, Wash., newspaper (ca. March 1932), Allen Clayton Hoskins Papers.

70. "'Our Gang' Grows Up, but Pete Keeps Right on in Starring Role," *Detroit Free Press,* January 29, 1933, Allen Clayton Hoskins Papers; "Filmdom's Cradle Roll Always Open," *Chicago Daily Journal,* date unknown (ca. 1931), Allen Clayton Hoskins Papers.

71. "Gangsters Walk Plank"; Dorothy Herzog, "Scouting the Cinema," *Los Angeles Herald,* November 11, 1929, Allen Clayton Hoskins Papers; "How Tempus Fugits," *Clarksburg (West Va.) Exponent,* February 2, 1930, Allen Clayton Hoskins Papers.

72. Mary Mayer, "Hollywood's Good Child Actors All Die Young," *Los Angeles Times,* August 28, 1932, B13.

73. "Ponce de Leon Hal Roach," *Exhibitors Herald,* December 20, 1924.

74. Ward, *A History of the Hal Roach Studios,* 84.

75. Sklar, *Movie-Made America,* 161.

76. Ibid.

77. Ibid.

78. Kyvig, *Daily Life in the United States,* 187.

79. This sum was reported by *Photoplay,* as well as several newspapers. Maltin and Bann claim Hoskins's final salary was $350/week. Papers often speculated on the salaries of stars. *Natal Mercury* in Durban, South Africa, claimed that "[Farina] is insured by the producer for

10,000 pounds!" ("What Farina's Worth," *Natal Mercury,* January 31, 1929, Allen Clayton Hoskins Papers).

80. Perhaps Junior Allen was not such a great actor once he started talking.

81. Publicity still, date unknown (ca. 1931), Allen Clayton Hoskins Papers.

82. "You Said a Mouthful," *Variety* 108, no. 11 (November 22, 1932): 17.

83. "Farina Loses His-er Curls," *Columbus Dispatch,* date unknown (ca. 1933), Allen Clayton Hoskins Papers.

84. "Farina Sho' Nuff Boy When Pigtails Cut Off," *Los Angeles Times,* September 11, 1932, B8.

85. Hal Roach Studios press release, date unknown (ca. 1932), Hal Roach Collection, Cinematic Arts Library, University of Southern California.

86. Hall, "Retired at Eleven," 35, 125.

87. Ibid.

6. THE NEW NEGRO

1. According to Hal Roach Studios press materials, Stymie was the fourth of seven children when he began to appear in *Our Gang* (Hal Roach Collection, Cinematic Arts Library, University of Southern California). Johnny Mae's name was sometimes spelled "Johnnie Mae."

2. E. M. Tucker, "Healthiest Year in History of the Southwest," *Los Angeles Times,* January 1, 1925, F16.

3. Dana Bartlett, "The City Beautiful Achieved," *Los Angeles Times,* January 1, 1925, H12.

4. Tucker, "Healthiest Year," F16.

5. Some sources claim Stymie had thirteen brothers and sisters.

6. Beard's filmography also includes *Uncle Tom's Cabin* (1927), *Hearts in Dixie* (1929), and *Show Boat* (1936). He was uncredited in these roles.

7. Susan Murphy, "Stymie 'Gangs' Up on Heroin," *SoCal* 68, no. 47 (November 24, 1975): 8. Leonard Maltin and Richard Bann attribute these words to Bob McGowan (Maltin and Bann, *The Little Rascals,* 259).

8. Maltin and Bann, *The Little Rascals,* 259.

9. McGowan, "A Hollywood Gang," H4.

10. "The Man Who Directs Our Gang," *Screenland,* date unknown, Hal Roach Collection, Cinematic Arts Library, University of Southern California.

11. Dorothy DeBorba, from *Our Gang: Inside the Clubhouse,* direct-

ed by Bob Lang (Sacramento, Calif.: Camellia City Telecasters, 1984), VHS.

12. Rebecca Gulick, *Those Little Rascals: A Pictorial History of Our Gang* (Greenwich, Conn.: Brompton Books, 1993), 38.

13. Beard's actual salary is somewhat unclear. *Chicago Defender* reported that Stymie started at $75/week and received a raise, at age eight, to $175/week ("No Breadline Here," *Chicago Defender,* August 19, 1933). Richard Lamperski claims he made $500/week by the time he retired (Lamperski, *"Whatever Became of . . ."* [New York: Crown, 1974], 174). In an article in the *Los Angeles Sentinel,* Beard tells the reporter that he eventually made $150/week (Leanna Y. Ford, "Stymie Returns with a Little Help from Friends," *Los Angeles Sentinel,* June 28, 1973, A16). According to records in the Hal Roach Collection at the University of Southern California, William "Buckwheat" Thomas began making $40/week in 1935, eventually earning $125/week in his fifth year. Darla Hood earned the most of the children in 1935, starting at $75/week but going up to $700/week in her final year. Beard's estimate is probably the most accurate. $150/week was the equivalent of $2,000/week in today's dollars—not too shabby.

14. U.S. Bureau of the Census, *Historical Statistics of the United States, Colonial Times to 1957* (Washington, D.C.: U.S. Government Printing Office, 1960). In 1932, 23 percent of the labor force was unemployed (12.06 million people); in 1933, the number had risen to almost 25 percent (12.83 million people).

15. Tommy Bond with Ron Genini, *Darn Right It's Butch: Memories of "Our Gang"* (Wayne, Penn.: Morgan Press, 1994), 48.

16. James Sellman, "Great Depression," in *Africana: The Encyclopedia of the African and African American Experience,* ed. Kwame Anthony Appiah and Henry Louis Gates Jr., Oxford African American Studies Center, 2015, http://www.oxfordaasc.com/.

17. Quoted in Dick Moore, *Twinkle, Twinkle, Little Star but Don't Have Sex or Take the Car* (New York: Harper and Row, 1984), 185.

18. Ford, "Stymie Returns," A16.

19. Quoted in Moore, *Twinkle, Twinkle, Little Star,* 114–15.

20. De Graaf, "The City of Black Angels," 323–52.

21. Stymie recalled sibling resentment to Dick Moore: "Every Christmas, all the little Rascals would get a present from the studio. They didn't give one to all the kids, but I'd get one and some of my brothers and sisters got presents too. That helped out some. There was resentment, though" (Moore, *Twinkle, Twinkle, Little Star,* 18).

22. Skip Ferderber, "I Wish Mom Could See Me Now," *Los Angeles Times,* November 22, 1973, F36.

23. Richard West, "Stymie of 'Our Gang' Comedies Dies," *Los Angeles Times,* January 9, 1981, 3.

24. Maltin and Bann, *The Little Rascals,* 259.

25. Ibid. Also quoted in Moore, *Twinkle, Twinkle, Little Star,* 17.

26. Stymie Beard, from *Our Gang: Inside the Clubhouse,* directed by Lang.

27. Bond, *Darn Right It's Butch,* 26–28, 23.

28. Maltin and Bann, *The Little Rascals,* 133.

29. Ibid., 106.

30. Ibid. Others, like Tommy Bond, found the lack of structure bewildering: "We might be told to look scared, but McGowan didn't direct except to say, 'Look more scared'" (Bond, *Darn Right It's Butch,* 25).

31. Maltin and Bann, *The Little Rascals,* 133.

32. McGowan, "A Hollywood Gang," H4.

33. Ibid.

34. Ibid.

35. Murphy, "Stymie 'Gangs' Up," 8.

36. Ibid.

37. Maltin and Bann, *The Little Rascals,* 257.

38. Ibid., 253.

39. Jackie Cooper, from *Our Gang: Inside the Clubhouse,* directed by Lang.

40. Jean Darling, interview by Tony Villecco, *Silent Stars Speak: Interviews with Twelve Cinema Pioneers* (Jefferson, N.C.: McFarland, 2001), 68–69. Darling did remember Farina's mother as "lovely and so nice" (69).

41. Demoss, "Charles Oelze."

42. Quoted in Moore, *Twinkle, Twinkle, Little Star,* 18.

43. Ibid, 55.

44. Ibid.

45. Undated *Our Gang* pressbook (ca. 1932), Hal Roach Collection, Cinematic Arts Library, University of Southern California.

46. Murphy, "Stymie 'Gangs' Up," 8.

47. Moore, *Twinkle, Twinkle, Little Star,* 17.

48. Ibid., 29.

49. Mickey Rooney and Baby Peggy were students at Fairfax High School in the 1930s. The oil field was on the corner of Fairfax and Third Street, where the Park La Brea Apartments now stand.

50. Ibid., 82.

51. Quoted in Moore, *Twinkle, Twinkle, Little Star,* 82.

52. Ibid., 17.

53. Kyvig, *Daily Life in the United States,* 62.

54. Kyvig, *Daily Life in the United States,* 72. See also Melvin Patrick Ely, *The Adventures of Amos 'n' Andy* (Charlottesville: University of Virginia Press, 1991).

55. Kyvig, *Daily Life in the United States,* 87.

56. Thomas Doherty, *Pre-Code Hollywood: Sex, Immorality, and Insurrection in American Cinema, 1930–1934* (New York: Columbia University Press, 1999), 31.

57. Quoted in Doherty, *Pre-Code Hollywood,* 29.

58. Ibid., 28.

59. Ibid., 29.

60. Ibid., 30.

61. Sid Silverman, "What the Grosses Say," *Variety* 105, no. 3 (December 29, 1931): 1.

62. W. R. Wilkerson, "The Studios Are in Trouble," *Hollywood Reporter,* March 7, 1933, 1, 4. Quoted in Doherty, *Pre-Code Hollywood,* 30.

63. Doherty, *Pre-Code Hollywood,* 35.

64. Ibid., 18. Doherty also quotes *Film Daily Year Book of 1934,* which pegged the Depression low weekly attendance figure at forty million.

65. Sklar, *Movie-Made America,* 176.

66. While these story lines were admittedly Depression-era clichés, other *Our Gang* shorts were startlingly subversive. In *Pups Is Pups,* released in August 1930, the Gang, playing in their shantytown playground, discovers a newspaper ad looking for "ten colored boys . . . to act as pages" at a local society pet show. Crestfallen that only "boys like Farina" can earn some extra cash, the rest of the Gang resorts to blackface in an attempt to fool the society dames into hiring them. The effect is, of course, appalling (and the scene was censored in television syndication), but it drew attention to a world gone upside-down. Service positions such as pageboys, maids, porters, and butlers were often consigned to African Americans. The fact that Farina's skin color is here considered a desirable trait—even when it further reflects his subordinate status—suggests the extreme social disorder of the period. White was black, black was white, and even children were willing to upend racial codes in order to get a job.

67. Henry Louis Gates Jr. recalls, "the first artichoke I ever saw" was in this famous episode with Stymie: "He couldn't figure out how to eat it! I never forgot that" (e-mail to author, January 28, 2013).

68. Strausbaugh, *Black Like You,* 238.

69. Henry Louis Gates Jr., *The Signifyin' Monkey: A Theory of African American Literary Criticism* (New York: Oxford University Press, 2014), 22.

70. See Orlando Patterson, *Slavery and Social Death: A Comparative Study* (Cambridge, Mass.: Harvard University Press, 1985) for a discussion of how a slave is dispossessed of "power, natality, and honor" (27).

71. As some critics have argued, Harris was performing a kind of literary minstrelsy by assuming the narrative persona and dialect of a black man. See Boskin, *Sambo*. In 1946, Walt Disney released *Song of the South*, based on Harris's tales. Alice Walker talks about how her family no longer read Harris's stories after seeing the negative depictions of African Americans in the Disney film (see Evelyn C. White, *Alice Walker: A Life* [New York: W. W. Norton, 2004], 347). In response to protests, Disney has never released the film on home video in the United States.

72. Hugh Keenan, "Joel Chandler Harris' *Tales of Uncle Remus*: For Mixed Audiences," in *Touchstones: Reflections on the Best in Children's Literature*, vol. 2 (Lanham, Mass.: Scarecrow Press, 1987), 118–26.

73. Langston Hughes, "Justice," in *Scottsboro Limited, Four Poems and a Play in Verse* (New York: Golden Stair Press, 1932).

74. Hollace Ransdell, representing the ACLU, "Report on Scottsboro, Alabama, Case," May 27, 1931. Quoted in James A. Miller, *Remembering Scottsboro: The Legacy of an Infamous Trial* (Princeton, N.J.: Princeton University Press, 2009), 15.

75. Andrew Erish, "Illegitimate Dad of 'Kong,'" *Los Angeles Times*, January 8, 2006, E6.

76. Robert E. Sherwood, "Movie Album," *Oklahoma City Oklahoman*, May 25, 1930.

77. Dickie Moore, "The Rascals and Racial Issues," in *The Little Rascals: The Complete Collection* (Santa Monica: Genius Entertainment, 2008), DVD.

78. The actual line was "My daddy's just a crap-shootin' fool!" but the racial humor is the same.

79. Associated Press, "Matt Beard," *St. Petersburg Times*, February 26, 1973, 8-A.

80. Maltin and Bann, *The Little Rascals*, 109n.

81. Maltin and Bann report, "Wheezer's father caused production problems for Hal Roach, and one of the kids, who didn't wish to be quoted, said that Wheezer was ill-treated by one of his parents in an attempt to keep him from outgrowing his role" (*The Little Rascals*, 253).

82. Quoted in Maltin and Bann, *The Little Rascals*, 133.

83. McGowan, "A Hollywood Gang," H4.

84. Robert Vann, "This Year I See Millions of Negroes Turning the Picture of Abraham Lincoln to the Wall," *Pittsburgh Courier*, Sep-

tember 17, 1932, 12. Quoted in Nancy Joan Weiss, *Farewell to the Party of Lincoln: Black Politics in the Age of FDR* (Princeton: Princeton University Press, 1983), 426. Weiss's book offers an excellent analysis of how and why African American voters shifted their political allegiance away from the Republican party to the Democrats in the 1930s. For more on African Americans and the New Deal, see also Harvey Sitkoff, *A New Deal for Blacks: The Emergence of Civil Rights as a National Issue: The Depression Decade* (New York: Oxford University Press, 2008).

85. "For Roosevelt," *Baltimore Afro-American,* August 27, 1932, 21.

7. MOVIE-MADE CHILDREN

1. Maltin and Bann, *The Little Rascals,* 267.

2. Ibid., 128.

3. Jackie Lynn Taylor, from *Our Gang: Inside the Clubhouse,* directed by Lang; Hal Roach Studios Pressbook, date unknown (ca. 1934), Hal Roach Collection, Cinematic Arts Library, University of Southern California.

4. Maltin and Bann, *The Little Rascals,* 141.

5. Maltin and Bann credit Carlena as Buckwheat, but Robert Demoss of the *Our Gang* website *The Lucky Corner,* http://www.lucky corner.com, notes that she is never referred to by this name in the short and is referred to as "Carolina Beard" in the cutting continuity script. "Buckwheat" may have been the catch-all name for the various children who played Stymie's younger sibling in the 1934 season.

6. Maltin and Bann, *The Little Rascals,* 142.

7. As Robin Bernstein argues, the white child is figured as capable of pain, bedridden from illness, and bereft when her doll is smashed. Carlena, on the other hand, betrays no emotion throughout the short. See Bernstein, *Racial Innocence.*

8. In fact, this was not even the first *Our Gang* short that included a lynching gag. In the 1929 short *Moan & Groan, Inc.,* the Gang tosses Farina a rope to hoist him up from the basement, and Farina unthinkingly wraps it around his neck. Looking down at Farina, Jackie Cooper yells, "What're you trying to do? Hang yourself?" Only then does Farina wrap the rope around his waist. The humor is morbid and perhaps in keeping with the short's "haunted house" plot. The short was later eliminated from the King World syndication package.

9. Sitkoff, *A New Deal for Blacks,* 105–6. See also Weiss, *Farewell to the Party of Lincoln.*

10. Quoted by Randy Skretvedt, *Laurel and Hardy: The Magic Behind the Movies* (Beverly Hills: Past Times Publishing, 1994), 290.

11. Ibid., 333.

12. Ward, *A History of the Hal Roach Studios*, 87–88.

13. Weiss, *Farewell to the Party of Lincoln*, 297.

14. See Sitkoff, *A New Deal for Blacks*, 202–23.

15. Quoted in Moore, *Twinkle, Twinkle, Little Star*, 85–86.

16. Ibid.

17. Ibid., 105–6.

18. Quoted in Maltin and Bann, *The Little Rascals*, 156.

19. Ibid., 7.

20. Temple disputes this story in her autobiography, *Child Star: An Autobiography* (New York: McGraw-Hill, 1988), though Roach steadfastly insisted it was true. Quoted in Maltin and Bann, *The Little Rascals*, 7.

21. Lester David and Irene David, *The Shirley Temple Story* (New York: Putnam, 1983), 16. Shirley Temple Black also attributed this quote to Roosevelt in her autobiography. John F. Kasson, author of *The Little Girl Who Fought the Great Depression: Shirley Temple and 1930s America* (New York: W. W. Norton, 2014), suspects the quotation might be apocryphal (261).

22. Quoted in Bogle, *Bright Boulevards, Bold Dreams*, 155.

23. Rainier Spencer points out that Southern audiences did in fact object to the staircase dance sequence performed by Robinson and Temple in *The Little Colonel* (Rainier Spencer, "Imitation of Life," ENG 795 graduate lecture, University of Nevada, Las Vegas, February 20, 2014).

24. Sklar, *Movie-Made America*, 175.

25. Several scholars have written on the odd eroticization of childhood innocence in the figure of Shirley Temple. See, for example, James Kincaid, *Erotic Innocence: The Culture of Child Molesting* (Durham, N.C.: Duke University Press, 1998) and Ara Osterweil, "Reconstructing Shirley: Pedophilia and Interracial Romance in Hollywood's Age of Innocence," *Camera Obscura* 24, no. 3 (2009): 1–39.

26. Sklar, *Movie-Made America*, 32.

27. *Our Gang* advertisement, *Exhibitors Herald*, November 11, 1923, back cover. The advertisement collates several exhibitors' reviews: "They are clean and full of action"; "Clean, wholesome, and funny"; "the cleanest and best comedies on the market."

28. Hal Roach Studios, Lobby Card for *Our Gang* film *Better Movies*, 1925, in Kathryn Lee Scott and Michael Hawks, *Lobby Cards: The Classic Comedies* (Los Angeles: Pomegranate Press, 1997).

29. Moore, *Twinkle, Twinkle, Little Star*, 17.

30. Henry James Forman, *Our Movie Made Children* (New York: Macmillan, 1933), 19.

31. Ibid.

32. Ibid., 11.

33. Ibid., 162.

34. Ibid., 124.

35. Ibid., 125.

36. See Garth S. Jowett, Ian C. Jarvie, and Kathryn H. Fuller, *Children and the Movies: Media Influence and the Payne Fund Controversy* (New York: Cambridge University Press, 1996).

37. "Worthy Successor," *Atlanta Daily World*, September 15, 1935, A1.

38. Jacob Anderson, "'Buckwheat' Is Now New King of 'Our Gang,'" *Norfolk New Journal and Guide*, August 17, 1935, 13.

39. Lawrence F. LaMar, "Call Buckwheat the New Sunshine Sammy," *Chicago Defender*, September 20, 1941, 20.

40. The Thomases reportedly lived at 1162 East Fifty-first Street, between Vernon Avenue and Slauson Boulevard.

41. Willard Brown, quoted in Bogle, *Bright Boulevards, Bold Dreams*, 117. The Thomases actually lived at 1315 East 110th Street, between Central and Compton.

42. Quoted in William Thomas Jr. and David W. Menefee, *"Otay!" The Billie "Buckwheat" Thomas Story* (Albany, Ga.: BearManor Media, 2010), 20.

43. "Rounding Up 'Our Gang,'" *New York Times*, June 26, 1938, 126.

44. According to *National Geographic*, the odds of being hit by lightning in your lifetime is 1 in 3,000.

45. "Two Up for Promising 'Our Gang' Roles to Kids," *Billboard* 49, no. 40 (October 2, 1937): 5.

46. Maltin and Bann, *The Little Rascals*, 267.

47. Ibid. "'Buckwheat' Is the New King of 'Our Gang,'" *Kansas City Plaindealer*, August 16, 1935; "'Buckwheat' Is a Great Double for Farina," *Atlanta Daily World*, August 10, 1936, 2. Several of these details are also repeated in a studio publicity biography located in the Hal Roach Collection, Cinematic Arts Library, University of Southern California. See also Yussuf J. Simmonds, "William 'Buckwheat' Thomas," *Los Angeles Sentinel*, November 15–21, 2007, A13.

48. Thomas and Menefee, *"Otay!,"* 22–23. Buckwheat's name may have also been taken from the minstrel duo "Buck and Wheat," who appeared on the 1930s *Aunt Jemima* old-time radio show.

49. Ibid., 24–25. Robert Blake claims to have seen Billie tearing off his clothes after shooting ended, though this seems unlikely since Blake joined the cast well after Billie stopped dressing in girls' clothing.

50. David W. Kellum, "Bud Spends an Afternoon with Juvenile Movie Star," *Chicago Defender*, May 9, 1936, 15.

51. "'Buckwheat' Is a Great Double," 2; "'Buckwheat' Filling Farina's Shoes Nicely," *Pittsburgh Courier,* August 8, 1936, 2.

52. Hal Roach Studios, *Our Gang* pressbook for *Shrimps for a Day,* 1935, Hal Roach Collection, Cinematic Arts Library, University of Southern California.

53. "Our Gang—Past and Present," *Chicago Defender,* August 1, 1936, 11; "'Our Gang' Is Fifteen Years Young and Fed: Hollywood Party Given for Original Kids and Their Current Successors," *Washington Post,* July 20, 1936, X10. A 1937 Fox Movietone Newsreel documented the festivities. In the footage, Porky was paired with Joe as the Gang's "fat boy," Johnny Downs with Spanky as the Gang's "all-American boy," Farina with Buckwheat as the "colored boy," and Jackie Condon with Alfalfa as the Gang's kid with the crazy hair (*Our Gang,* fifteenth anniversary reunion party, Hal Roach Studios, Fox Movietone Newsreel, 1936; screened for 19th International Sons of the Desert Convention, Egyptian Theatre, Hollywood, Calif., July 6, 2014).

54. Some of these scenes look like actual shots taken from *Hallelujah!*

55. Maltin and Bann, *The Little Rascals,* 169.

56. Ibid.

57. Hal Roach Studios, *Our Gang* advertisement, *Film Daily,* June 16, 1936, 17–19.

58. B. R. Crisler, "Film Gossip of the Week: Hal Roach Marches On," *New York Times,* November 8, 1936, X5.

59. Maltin and Bann, *The Little Rascals,* 267.

60. *General Spanky* script, Hal Roach Collection, Cinematic Arts Library, University of Southern California. I was unable to locate a copy of the film and thus relied on the script to re-create dialogue and setting.

61. "General Spanky," *Film Daily,* October 27, 1936, 13.

62. Hal Roach, *The Real Tinsel,* ed. Bernard Rosenberg and Harry Silverstein (London: Macmillan, 1970), 28.

63. *Our Gang Follies of 1938* script draft, November 3, 1937, Hal Roach Collection, Cinematic Arts Library, University of Southern California. Hal Roach Studios was located across the street from Lionel Hampton's West Coast version of the Cotton Club.

64. "Jim Crow Saves 'Our Gang' Star from the Measles," *Chicago Defender,* May 9, 1936, 9. On the same day, the *Baltimore Afro-American* published a photograph of the Gang gathered around a table, along with the caption, "The Gang is now quarantined in Detroit, where the measles got Spanky first, Buckwheat second, and Darlo [*sic*] next. Everybody's got it but Alfalfa, and he's being watched. All shows

have been canceled indefinitely" ("They Have the Measles Now," *Baltimore Afro-American,* May 9, 1936, 7). Perhaps Buckwheat eventually did come down with the measles, after all. To add to the confusion, *Variety* reported that Spanky, Alfalfa, and Darla were the children stricken by measles, but added a parenthetical that Alfalfa was "colored" ("Measles Epidemic Cuts 'Our Gang' Down to Three Kids and a Dog," *Variety* 122, no. 8 [May 6, 1936]: 57). It appears that the press confused Buckwheat and Alfalfa in their reporting, perhaps as a result of the boys' cereal grain nicknames.

65. Kellum, "Bud Spends an Afternoon with Juvenile Movie Star," 15.

66. "'Our Gang' Star Visits Defender," *Chicago Defender,* May 9, 1936, 15.

67. Bernice Patton, "Buckwheat Sheds Pigtails, Steals Spotlight in 'General Spanky' Latest 'Our Gang' Picture," *Pittsburgh Courier,* November 14, 1936, A11. Patton also took a photograph with Billie and his mother ("'Our Gang' Star Poses," *Pittsburgh Courier,* December 5, 1936, 21).

68. Loren Miller, "Hollywood's New Negro Films," *Crisis* 45, no. 1 (January 1938): 9.

69. Quoted in Edgar Dale, "The Movie and Race Relations," *Crisis* 44, no. 10 (October 1937): 295–96. Winsten's article was reportedly published in the *New York Post* on April 7, 1937. Winsten writes, "In *Spanky McFarland* [*sic*] the colored boy wanted to act as the white boy's slave." Winsten had confused the movie's title, *General Spanky.*

70. Dale, "The Movie and Race Relations," 295–96.

71. Cripps, *Slow Fade to Black,* 265.

72. Quoted in Bogle, *Bright Boulevards, Bold Dreams,* 117.

73. "Rounding Up 'Our Gang,'" 126.

74. William Weaver, "Roach Parlays Unit Production into Six Features in His Stride," *Motion Picture Herald,* April 16, 1938, 23–24.

75. For Porky, the trauma remained fresh even as an adult. He recalled, "Five years ago, I had to attend a pretrial conference at MGM, and when I crossed this same threshold again after almost five decades, well, wham! I just about came unscrewed" (quoted in Maltin and Bann, *The Little Rascals,* 237).

76. Bond, *Darn Right It's Butch,* 73.

77. Quoted in Maltin and Bann, *The Little Rascals,* 202.

8. THE GOOD SOLDIER

1. Several writers have since concluded that "Hitler's snub" was something of a myth. Hitler did not congratulate any gold medal

winners after the opening day of the Olympics. For example, see Clarence Lusane, *Hitler's Black Victims: The Historical Experience of Afro-Germans, European Blacks, Africans, and African Americans in the Nazi Era* (London: Routledge, 2003), 209.

2. Quoted in Jeremy Schaap, *Triumph: The Untold Story of Jesse Owens and Hitler's Olympics* (New York: Mariner Books, 2008), 211.

3. Quoted in Walter Wilson, "Old Jim Crow in Uniform," *Crisis* 46, no. 3 (March 1939): 93. This is from Part Two of a two-part series. Houston was writing to Chief of Staff of the U.S. Armed Forces Douglas MacArthur in 1934.

4. Quoted in Maltin and Bann, *The Little Rascals*, 197. Darla Hood echoed some of these sentiments: "The M-G-M pictures were carefully thought out, planned, and rehearsed, and they were beautifully made, but they're nowhere the same as the Hal Roach comedies, that's for sure" (ibid., 202).

5. Quoted in Maltin and Bann, *The Little Rascals*, 197. George Sidney also recounted cutting the cameras, pulling Alfalfa aside, and threatening to punch him in the face the minute he turned twenty-one ("Alfalfa and the Gang," *E! Mysteries and Scandals*, season 1, episode 43, January 4, 1999).

6. Maltin and Bann, *The Little Rascals*, 270–71, 204. Tommy Bond recalled the urination prank, describing how "the hot lights, drying the urine, caused such a stink it was believed a skunk had entered the studio. The adults opened the windows frantically, but never found out about Alfalfa" (Bond, *Darn Right It's Butch*, 83–84).

7. Scott Eyman, *Lion of Hollywood: The Life and Legend of Louis B. Mayer* (New York: Simon and Schuster, 2005), 287.

8. Ibid., 290. Mayer was viewed by some as a benevolent father figure, by others as a tyrant. One screenwriter described how Mayer was often seen on the lot, head down, "not saying hello to anyone" (ibid.).

9. Ibid., 220.

10. "Alfalfa and the Gang."

11. Quoted in Thomas and Menefee, *"Otay!,"* 46.

12. Horn and Morgan, Inc. (Star Theatre, Hay Springs, Nebraska), "What the Picture Did for Me," *Motion Picture Herald*, April 15, 1939.

13. C. L. Niles (Niles Theatre, Anamosa, Iowa), "What the Picture Did for Me," *Motion Picture Herald*, August 17, 1940.

14. C. L. Niles (Niles Theatre, Anamosa, Iowa), "What the Picture Did for Me," *Motion Picture Herald*, May 13, 1939.

15. C. L. Niles (Niles Theatre, Anamosa, Iowa), "What the Picture Did for Me," *Motion Picture Herald*, April 26, 1941.

16. "Flag Salute," *Crisis* 47, no. 4 (November 1940): front cover.

17. Clayton R. Koppes and Gregory D. Black, *Hollywood Goes to War: How Politics, Profits, and Propaganda Shaped World War II Movies* (New York: Free Press, 1987), 86.

18. Benjamin Mays, "The Negro and the Present War," *Crisis* 49, no. 5 (May 1942): 160.

19. Ibid., 165.

20. Quoted in Clayton Koppes and Gregory Black, "Blacks, Loyalty, and Motion Picture Propaganda in World War II," in *Controlling Hollywood: Censorship and Regulation in the Studio Era,* ed. Matthew Bernstein (New Brunswick: Rutgers University Press, 1999), 136.

21. Koppes and Black, *Hollywood Goes to War,* 180–84.

22. Ibid., 86–90.

23. Michael Hoskins believes his father witnessed race rioting in Texas during World War II. This may have been the Beaumont Race Riot of 1943, when shipyard workers rioted in response to a white woman's accusation that a black man had raped her (Michael Hoskins in discussion with the author, Fairfield, California, January 22, 2013).

24. *Baby Blues* could also be read as an OWI-approved, MGM-produced update of Roach's 1934 short *Washee Ironee,* where the Chinese boy is again depicted as not so bad after all.

25. In *Doin' Their Bit* (1942), the kids mount a show for their local servicemen, with a comedy routine by Spanky and Froggy in which they play soldiers who talk about "killing the Japs."

26. As recently as the 1937 Roach short *Hearts Are Thumps,* the Gang had depicted "Americanized Jap kids"—as the script described them—in a positive way, celebrating Valentine's Day by eating rice cakes and whispering sweet nothings to each other in Japanese (*Hearts Are Thumps* script, Hal Roach Collection, School of Cinematic Arts, University of Southern California).

27. These are all taken from script treatments for *Unexpected Riches* (previously titled "Treasure Hunters") from MGM Collection, School of Cinematic Arts, University of Southern California. The treatments are dated "9-29-41," "10-28-41," and "11-5-41."

28. Cahn directed his last *Our Gang* short in 1943, at which point Herbert Glazer was already directing most of the films. Sam Baerwitz was brought in for a one-off, *Calling All Kids* (1943).

29. Quoted in Maltin and Bann, *The Little Rascals,* 267.

30. Ibid.

31. Quoted in Ira Berkow, "Joe Louis Was There Earlier," *New York Times,* April 22, 1997, B13. The exchange was recalled by Irwin Rosee, a publicist. Maggi M. Morehouse records Louis's response as, "There may be a whole lot wrong with America, but there's nothing

that Hitler can fix" (Morehouse, *Fighting in the Jim Crow Army: Black Men and Women Remember World War II* [Lanham, Md.: Rowman and Littlefield, 2000], 8).

32. Roach, "Hal Roach, Senior," 22.

33. During his vaudeville years, Ernie was accused of luring a young "chorine" into his apartment and impregnating her. To avoid a trial, he pleaded guilty and agreed to support the child. See "'Sunshine Sammy' Accused by Girl," *New York Amsterdam News,* August 5, 1931, 1; "Indicts Sunshine Sammy; Accused by Chorine Here," *New York Amsterdam News,* August 19, 1931, 1; and "Court Suspends 'Sunshine Sammy' on Charge of Attack Lodged by Chorine," *New York Amsterdam News,* December 16, 1931, 1.

34. Franklin D. Roosevelt, telegram to National Conference of the Entertainment Industry for War Activities, date unknown (ca. June 1943), reprinted in *Variety* 150, no. 13 (June 9, 1943): 3.

35. Scott Allen Nollen, *Louis Armstrong: The Life, Music, and Screen Career* (Jefferson, N.C.: McFarland, 2004), 3.

36. "Farina to Movies."

37. While Allen Hoskins was sent to the Pacific front during the war, his Japanese American classmates were rounded up and sent to internment camps.

38. "Warriors and Defenders," *Time,* June 23, 1941.

39. "Remember Farina," *Norfolk Journal and Guide,* July 5, 1941, Allen Clayton Hoskins Papers, Fairfield, California.

40. "Farina of 'Our Gang' Films, Now Soldier, Meets Old Friend," *Los Angeles Times,* June 6, 1941, 3.

41. M. Hoskins in discussion with the author.

42. See Philip McGuire, *Taps for a Jim Crow Army: Letters from Black Soldiers in World War II* (Lexington: University Press of Kentucky, 1983), 59–60.

43. Anonymous to *Richmond Afro-American,* November 22, 1943, quoted in McGuire, *Taps for a Jim Crow Army,* 67.

44. Anonymous to NAACP, March 19, 1945, in McGuire, *Taps for a Jim Crow Army,* 179.

45. Private Bert B. Babero to Truman K. Gibson, Civilian Aide to Secretary of War, February 13, 1944, quoted in McGuire, *Taps for a Jim Crow Army,* 50. According to Michael Hoskins, his father felt similar frustration when he saw German POWs allowed to go to movie theaters closed off to black soldiers (Hoskins in discussion with the author).

46. Carol Lynn McKibben, *Racial Beachhead: Diversity and De-*

mocracy in a Military Town (Stanford: Stanford University Press, 2012), 37.

47. Lenore Lucas, "Big Name Athletes, Stars Frequent Red Cross Service Club 'Down Under,'" *Pittsburgh Courier,* May 22, 1943, 14.

48. Harry Levette, "Hattie McDaniels Is Hostess to Soldiers," *Norfolk New Journal and Guide,* July 18, 1942, 16.

49. Harry Levette, "Hollywood in Brief," *Norfolk New Journal and Guide,* August 15, 1942, 17.

50. "'Stymie' in Comeback," *Chicago Defender,* December 21, 1935, 17.

51. "Juvenile Movie Actor in Court," *Pittsburgh Courier,* February 24, 1940, 19.

52. "Matthew (Stymie) Beard, 'Our Gang' Star of the 1930s," *San Bernardino County Sun,* January 9, 1981, 2.

53. Ford, "Stymie Returns," A16.

54. "Matthew (Stymie) Beard, 'Our Gang' Star of the 1930s," 2.

55. Ford, "Stymie Returns," A16.

56. Gary Edgerton, *The Columbia History of American Television* (New York: Columbia University Press, 2007), 80.

57. President Harry Truman, Address to the NAACP at the Lincoln Memorial, June 28, 1947, quoted in Michael Gardner, *Harry Truman and Civil Rights: Moral Courage and Political Risks* (Carbondale: Southern Illinois University Press, 2003), 29. For more on the speech and Truman's record on civil rights, see Raymond Geselbracht, *The Civil Rights Legacy of Harry S. Truman* (Kirksville, Mo.: Truman State University Press, 2007). Both books perhaps overemphasize Truman's "moral courage" over the political expediency of supporting civil rights.

58. Mary Dudziak, *Cold War Civil Rights: Race and the Image of American Democracy* (Princeton: Princeton University Press, 2011), 25.

59. Thomas and Menefee, *"Otay!,"* 92–93.

60. Edgerton, *Columbia History of American Television,* 78.

61. As Gary Edgerton and others make clear, television had been around for a while but had not achieved widespread usage due to the prohibitive cost of sets and the lack of programming. In 1939, RCA President David Sarnoff announced television's "coming-out party" at the World's Fair, but sales of sets were disappointing. The outbreak of World War II further impeded the commercial development of television. See Edgerton, *Columbia History of American Television,* 13–15.

62. Lynn Spigel, *Make Room for TV: Television and the Family Ideal in Postwar America* (Chicago: University of Chicago Press, 1992), 1.

63. Edgerton, *Columbia History of American Television*, 91.

64. Cited in Leo Bogart, *The Age of Television* (New York: F. Ungar Publishing, 1956), 236.

65. Cited in Bogart, *The Age of Television*, 246.

66. Thomas Doherty writes, "The arrival of television in 1946 coincided with classical Hollywood's last great season, when a weekly audience of 90 million paying spectators flocked to ornate palaces and homey neighborhood theaters. In a few short years, what Hollywood called 'free television' (the implication being that anything free could not be worth much) had metastasized to lethal levels" (Doherty, *Cold War, Cool Medium: Television, McCarthyism, and American Culture* [New York: Columbia University Press, 2005], 6).

67. Erik Barnouw, *Tube of Plenty* (New York: Oxford University Press, 1990), 114.

68. Spigel, *Make Room for TV*, 37–39. See also Cecilia Tichi, *Electronic Hearth: Creating an American Television Culture* (New York: Oxford University Press, 1992).

69. Mintz, *Huck's Raft*, 298.

70. Bogart, *The Age of Television*, 25, 258, 262, 274.

71. "Television: Negro Performers Win Better Roles in TV Than in Any Other Entertainment Medium," *Ebony* 5, no. 8 (June 1950): 22–23.

72. "Television Broadens Racial Understanding," *Pittsburgh Courier*, March 13, 1954, 18. Cited in Doherty, *Cold War, Cool Medium*, 71.

73. Doherty, *Cold War, Cool Medium*, 72.

74. Ed Sullivan, "Can TV Crack America's Color Line?," *Ebony* 6, no. 7 (May 1951): 60–61.

75. Doherty, *Cold War, Cool Medium*, 72. See also J. Fred MacDonald, *Blacks and White TV: Afro-Americans in Television since 1948* (Chicago: Nelson-Hall Publishers, 1983), 2–4.

76. Ward, *A History of the Hal Roach Studios*, 133–34.

77. Ibid., 134–36. Ward writes that one Memphis theater defied the ban and screened *Curley*, without any repercussions from Memphis authorities. The film, however, was a poor box-office draw, earning only two hundred dollars, an amount dwarfed by the legal fees incurred in the case.

78. "Hollywood Is Humming," *Time*, October 29, 1951.

79. Maltin and Bann, *The Little Rascals*, 3.

80. In an article in *Boxoffice* from September 1950, Joseph Auerbach of Monogram Pictures reported that *The Little Rascals* had booked $273,000 in contracts since it was first reissued. See "'Our Gang' as Reissues Reported Grossing Big," *Boxoffice* 57, no. 22 (September 30, 1950): 20.

81. "Our Gang's 200G TV Pix Rights," *Variety* 183, no. 10 (August 15, 1951): 28. In a *TV Guide* article, Roach claimed he sold the rights to Interstate TV for $27,000: "Hail, Hail, Our Gang's All Here!" *TV Guide* 3, no. 20 (March 14, 1955): 6.

82. Ward, *A History of the Hal Roach Studios,* 144.

9. THE LITTLE RASCALS

1. John Barrow, "Here's a Picture of Emmett Till Painted by Those Who Knew Him," *Chicago Defender,* October 1, 1955, 4.

2. Mamie Till-Mobley, *Death of Innocence: The Story of the Hate Crime That Changed America* (New York: One World/Ballantine, 2004), 100–101.

3. Mamie Till, from "The Murder of Emmett Till," *American Experience,* PBS, aired January 20, 2003, transcript, http://www.pbs.org/wgbh/americanexperience.

4. Ibid.

5. Muhammad Ali with Richard Durham, *The Greatest: My Own Story* (New York: Random House, 1975), 34–35.

6. John Edgar Wideman, "The Killing of Black Boys," *Essence* 28, no. 7 (November 1997): 122.

7. Mamie Till, from "The Murder of Emmett Till," transcript.

8. Harriet Pollack and Christopher Metress, *Emmett Till in Literary Memory and Imagination* (Baton Rouge: Louisiana State University Press, 2008), 1–7.

9. "The Life of a Negro Isn't Worth a Whistle," *Freies Volk,* September 28, 1955. Cited in "Timeline: The Murder of Emmett Till," from "The Murder of Emmett Till."

10. David Halberstam, *The Fifties* (New York: Ballantine, 1994), 437.

11. Mamie Till-Mobley would call her son a "sacrificial lamb" of the civil rights movement. Christopher Metress describes how Till's murder "[was] reconfigured as a Christlike sacrifice and young Emmett [was] reconceived as savior and redeemer" ("On That Third Day He Rose: Sacramental Memory and the Lynching of Emmett Till," in Pollack and Metress, *Emmett Till in Literary Memory,* 8).

12. J. P. Shanley, "New Generation of Fans for 'Our Gang,'" *New York Times,* May 8, 1955, X11.

13. "Our Gang Films Are OK on WPIX," *Billboard* 67, no. 9 (February 26, 1955): 8.

14. Shanley, "New Generation of Fans," X11.

15. Interstate Television, *Little Rascals* advertisement, *Billboard* 67, no. 14 (April 2, 1955): 9. The ratings were taken by Arbitron in

January or February 1955 and represent the "cumulative ratings" over a weeklong period.

CITY	STATION	TIME	RATING
Detroit	WXYZ	6:00	46.0
Seattle	KING	4:30	44.5
Philly	WPTZ	6:00	44.0
SLC	KSL	4:00	35.7
Denver	KBTV	5:00	31.1
LA	KNXT	5:00	30.6
SF	KRON	5:00	29.9
Cleveland	WEWS	6:00	26.4
Minneapolis	WCCO	5:30	20.8

16. Jack Gayer, "Old 'Our Gang' Films Swamp TV Opposition," *Los Angeles Times,* April 21, 1955, 32.

17. "Our Gang Wins Friends: TV-Film: 'Little Rascals' Series Quickly Climbs to Top-Rated Show in All Markets," *Billboard* 67, no. 5 (January 29, 1955): 7.

18. "More Supply of 'Our Gang,'" *Billboard* 68, no. 24 (June 30, 1956): 4. The article reads, "Stations may get a chance to refurbish their successful 'Our Gang' programs now that MGM has come to a decision about TV distribution. Metro has a group of 50 'Our Gang' films which it will probably put into the TV market in due time. . . . Interstate's group of 93 'Our Gang' comedies, which it calls 'The Little Rascals,' first hit in the fall of 1954. Shortly thereafter a smaller group of silent 'Our Gangs' was put into TV by Onyx Pictures. Stations have been seeking a worthy continuation since then." I have not been able to corroborate the "fall of 1954" syndication date. Most articles seem to date syndication to 1955. For more on *Our Gang*'s messy syndication history, see Maltin and Bann, *The Little Rascals,* 227–31.

19. Maltin and Bann, *The Little Rascals,* 229.

20. "Hail, Hail, Our Gang's All Here!"

21. Art Baker, *You Asked for It,* episode 5, aired 1951, Dumont Television Network, https://archive.org. See also "Silent OUR GANG KIDS on You Asked For It!," YouTube video, 7:00, posted by Ron Hall, November 27, 2013, https://www.youtube.com. All subsequent descriptions of this episode are taken from this video.

22. This was Michael Hoskins, Allen's son with his first wife.

23. John Crosby, "Guess the Children Have Better Taste than Adults," *Washington Post and Times Herald,* June 22, 1955, 40.

24. Shanley, "New Generation of Fans," X11.

25. WPIX-NY screened the *Little Rascals* "Monday through Saturday at 5:30 pm and Monday through Friday at 10:30 pm" ("Clubhouse Gang Comedies," *TV Radio Mirror* 44, no. 4 [September 1955]: 8). *Billboard* speculated, "Perhaps one of the reasons for 'Little Rascals' success on TV despite its prior theatrical runs is the fact that its current kiddie audience was too young to have seen the films when they originally played theaters years ago. The films, additionally, have a strong following among nostalgic adults" ("Our Gang Wins Friends," 7). A WBNS-TV (Columbus, Ohio) advertisement in *Sponsor* also claimed, "Adults who remember [the Gang] from years before, now re-live their delightful antics with the youngsters of today" (WBNS-TV, advertisement, *Sponsor,* October 3, 1955, 65). *The Little Rascals* played at 4:30 p.m. and was introduced by the station clown, Bob Marvin.

26. J. P. Shanley, "TV: Children's Programs," *New York Times,* June 11, 1955, 33.

27. "How to Play," *Sponsor,* February 8, 1958, 37. Lynn Spigel writes that television was sometimes figured as a "remedy for problem children." She writes, "Women's magazines and child psychologists such as Benjamin Spock, whose *Baby and Childcare* had sold a million copies by 1951, gave an endless stream of advice to mothers on ways to prevent their children from becoming antisocial and emotionally impaired . . . parents believed television would keep their children off the streets" (Spigel, *Make Room for TV,* 45).

28. John Crosby, "Gentle, Instructive Show Scores Hit with Children," *Hartford Courant,* June 13, 1955.

29. "Clubhouse Gang Comedies," 8.

30. In a "US Public TV" poll cited in *Sponsor* magazine, pollsters asked "How does TV film audience composition vary?" For the *Little Rascals,* 41 men, 53 women, 24 teens, and 95 children out of a total 213 subjects claimed they watched the show. To be sure, the sample size was very small, but it is clear that a substantial number of men and women were also watching the series ("Audience Composition," *Sponsor,* July 11, 1955, 146).

31. Interstate Television, *The Little Rascals* advertisement, *Billboard* 67, no. 22 (May 28, 1955): 18.

32. "Chesty Sports Pile Up Chips," *Sponsor,* January 30, 1960, 43. WEWS in Cleveland ran a "test" where the hostess asked kids watching the *Little Rascals* to enter a cartoon contest and six thousand kids responded. Ruffles the Clown of Ruffles potato chips sponsored the *Little Rascals* in Indianapolis. Local television stations lured in sponsors with advertisements touting the *Rascals'* high ratings. WFGA-TV in

Jacksonville, Fla., advertised that "a half-a-million youngsters in Jacksonville's $1½ billion market watch the *Little Rascals*—and they'll see your sales message" (WFGA-TV, advertisement, *Sponsor*, March 22, 1958, 70).

33. "TV's Perennial," *Broadcasting* 61, no. 24 (December 18, 1961): 52.

34. "Webs Brush Off Talmadge Beef on Negro Talent," *Variety* 185, no. 5 (January 9, 1952): 1, 20.

35. Doherty, *Cold War, Cool Medium*, 72–73.

36. Ibid.

37. Quoted in Jeff Kisseloff, *The Box: An Oral History of Television, 1920–1961* (New York: Viking, 1995), 284. The *Zane Grey Theater* television series ran on CBS from 1956 to 1961 and then entered television syndication. Southern stations presumably declined to purchase the reruns in the 1960s.

38. These are oral recollections and are, of course, imperfect. Did Feiner only sell certain episodes to Southern television stations? (Usually, the films were syndicated as a bundle, but perhaps different deals were struck.) Did stations themselves recut episodes? (Again, this seems laborious and also counterproductive, since the black stars were in countless scenes.)

39. WLBT, advertisement, *Sponsor*, August 20, 1956, 30.

40. "Telepulse Ratings: Top Spots," *Sponsor*, June 28, 1958, 44–45. I cannot definitively determine whether these shows were censored or edited by the local stations to make them more palatable to local Jim Crow codes. The New Orleans market received its signal from WLBT-Jackson.

41. I have not been able to break out numbers for the African American viewership of *The Little Rascals*. In Interstate Television polls from the 1950s, *The Little Rascals* garnered high ratings in Detroit, Cleveland, and New York, cities with substantial African American populations.

42. "Death of 'Alfalfa' Is Cause for Yarn about Pal 'Sunshine Sammy,'" *Chicago Defender*, January 31, 1959, 18.

43. "'Farina' and 'Sunshine' Still Best Seller Aces," *Chicago Defender*, May 30, 1959, 18. The legal dispute took place in Kansas between the local television station and Loew's, Inc.

44. Al Sweeney, "From the City Desk," *Cleveland Call and Post*, February 8, 1958, 2.

45. "NAACP Raps Certain Local TV Programs," *Pittsburgh Courier*, September 19, 1959, 6.

46. Quoted in Ely, *The Adventures of Amos 'n' Andy*, 215–16.

47. Billy Rowe, "Billy Rowe's Notebook," *Pittsburgh Courier*, July

7, 1951. Quoted in Ely, *The Adventures of Amos 'n' Andy*, 217. Rowe did concede that "to many children across the nation this show will be their idea of how Negroes behave." For more on contemporaneous reactions to *Amos 'n' Andy*, see Paul L. Jones, "Amos 'n' Andy Television Show Offends Some, Pleases Others," *Pittsburgh Courier*, July 28, 1951, 3.

48. In his memoir, *Colored People*, Henry Louis Gates Jr. writes, "Seeing somebody colored on TV was an event. 'Colored, colored, on Channel Two,' you'd hear someone shout. . . . And *everybody* loved *Amos 'n' Andy*—I don't care what people say today. For colored people, the day they took *Amos 'n' Andy* off the air was one of the saddest days in Piedmont. . . . What was special to us about *Amos 'n' Andy* was that their world was *all* colored, just like ours. Of course, *they* had colored judges and lawyers and doctors and nurses, which we could only dream about having, or becoming,—and we *did* dream about those things" (Gates, *Colored People: A Memoir* [New York: Vintage, 1995], 22).

49. "NBC's 'Talent Has No Color' Projects Negro Contribs to New High in '52," *Variety* 190, no. 2 (March 18, 1953): 1, 34.

50. Ely, *The Adventures of Amos 'n' Andy*, 238–39.

51. Ursula Halloran to Henry Lee Moon, Director of Public Relations at NAACP, June 7, 1955, *Papers of the NAACP*, Part 15: Segregation and Discrimination, Complaints and Responses, 1940–1955, Series B: Administrative Files, ProQuest.

52. "NAACP: 100 Years of History," *NAACP*, http://www.naacp.org. In other NAACP sources, membership is estimated at 300,000 in 1947 and 309,000 in 1955 (*NAACP: Celebrating a Century: 100 Years in Pictures* [Layton, Utah: Gibbs Smith, 2009], 182). I cannot account for the discrepancy in statistics.

53. This term is used by Stuart Hall to describe the way television discourse was differently interpreted based on a consumer's cultural background. See Stuart Hall, "Encoding/Decoding," in *Media Studies: A Reader*, ed. Sue Thornham, Caroline Bassett, and Paul Marris (New York: New York University Press, 2010), 41.

54. Tim Hollis, *Hi There, Boys and Girls! America's Local Children's TV Programs* (Jackson: University of Mississippi Press, 2001), 214, 283, 230, 26.

55. David Halberstam, *The Children* (New York: Ballantine, 1999), 496.

56. Halberstam likewise deemed the civil rights struggle "nothing less than a continuing morality play" (*The Children*, 485).

57. "*Brown v. Board of Education*," *PBS NewsHour*, aired May 12, 2004, transcript, http://www.pbs.org/newshour/bb/law-jan-june04-brown_05-12/.

58. *Brown v. Board of Education,* 347 U.S. 483 (1954), Record Group 21, Records of the U.S. District Court of Kansas, National Archives, Central Plains Region, Kansas City, Missouri.

59. "Farina" (*Chicago Defender*).

60. Mintz, *Huck's Raft,* 277.

61. Civil rights activist Jim Lawson, for one, suspected segregation didn't just hurt black children. He remembered watching his young son playing happily with little white boys in Memphis, Tennessee. None of the children seemed aware of any difference in skin color. Sooner or later, though, a white adult would intervene and pull the white child away. Lawson wondered if the white child felt a sense of confusion and inadequacy, and he became increasingly convinced that segregation was causing damage "on both sides of the racial ledger" (Halberstam, *The Children,* 485).

62. Halberstam, *The Children,* 54.

63. Henry Louis Gates Jr., "Ruby Bridges Goes to School," from *The African Americans: Many Rivers to Cross,* episode 5, "Rise! (1940–1948)," PBS, aired November 17, 2013.

64. Ibid.

65. For more, see Kay Mills, *Changing Channels: The Civil Rights Case That Changed Television* (Oxford: University of Mississippi Press, 2004).

66. The television schedule in *New Orleans Times-Picayune* lists the *Our Gang* film *Boxing Gloves* (1929) airing on September 15, 1975, on Channel 26.,

67. Aniko Bodroghkozy, *Equal Time: Television and the Civil Rights Movement* (Champaign: University of Illinois Press, 2013), 113.

68. King, "I Have a Dream," 101.

69. Charlayne Hunter-Gault, "Fifty Years After the Birmingham Children's Crusade," *New Yorker,* May 2, 2013.

70. King, "I Have a Dream," 101.

71. Malcolm X, interview by Dr. Kenneth Clark, June 1963, transcript, http://www.pbs.org.

72. Maltin and Bann, *The Little Rascals,* 230.

73. "'Little Rascals' in Return to KBSC-TV after Editing Job," *Variety* 268, no. 7 (September 27, 1972): 31.

74. Quoted in Daniel Pedersen, "Another Episode of 'Little Rascals,'" *Des Moines Register,* December 2, 1977, 43.

75. Pederson, "Another Episode of 'Little Rascals,'" 43.

76. "'Our Gang' Bumped by Omaha TVer; See Racist Angles," *Variety* 287, no. 1 (February 12, 1975): 57.

77. Gale Jones Carson, "Blacks Protest Showing of Series 'Little Rascals,'" *Memphis Tri-State Defender,* September 17, 1977.

78. Pederson, "Another Episode of 'Little Rascals,'" 9. It appears this protest was not successful. Two weeks later, the paper reported that the Iowa Civil Rights Commission had decided not to pursue further action against KCCI (Daniel Pederson, "Iowa Civil Rights Commission Drops Effort to Block Rascals," *Des Moines Register,* December 16, 1977, 9).

79. James Gibson, "Ch. 3 Drops the Little Rascals!" *Columbus Times,* July 31, 1980.

80. Billy Rowe, "Billy Rowe's Note Book," *Chicago Metro News,* July 16, 1977.

81. King World Productions, *Little Rascals* advertisement ("The Little Rascals Series—a Worldwide Classic"), *Variety* 11, no. 298 (April 16, 1980): 72.

82. For more on other attempted remakes of the series, see Maltin and Bann, *The Little Rascals,* 8n.

10. THE GOOD OLD DAYS

1. Maltin and Bann, *The Little Rascals,* 243–77.

2. "The Curse of the Little Rascals," *E! True Hollywood Story,* aired November 24, 2002.

3. Several of the actors would express annoyance when fans and friends assumed they had made a "killing" through their acting careers. Allen Hoskins complained, "I'm sick and tired of people thinking I get residuals. . . . I haven't got no pot of money" ("No Residuals Farina Reports," *Indiana Evening Gazette,* February 5, 1979). Richard Lamperski once joked that fan adulation was "better than residuals," a comment Billie found amusing (Thomas and Menefee, *"Otay!,"* 120).

4. Bill Kaufman, "Nostalgia Isn't Overwhelming: Years Scatter 'The Little Rascals,'" *Victoria Advocate,* May 17, 1975. Also reprinted as "'Our Gang' Survivors Scorn Memory Lane," *Milwaukee Journal,* June 21, 1975.

5. Moore, *Twinkle, Twinkle, Little Star,* 19.

6. Kaufman, "Nostalgia Isn't Overwhelming."

7. "No Residuals Farina Reports."

8. Ibid.

9. "Black 'Little Rascals' Don't Get a Dime From Reruns: 'Farina,'" *Jet,* July 19, 1979, 22–23.

10. "No Residuals Farina Reports."

11. Maltin and Bann, *The Little Rascals,* 246.

12. Davan Maharaj, "'Little Rascal' Player Ernest Morrison Dies," *Los Angeles Times,* July 31, 1989.

13. Thomas and Menefee, *"Otay!,"* 106.

14. Ferderber, "I Wish Mom Could See Me Now," F36. *Ebony*

reported that Stymie learned to drive a Greyhound bus and became the center's head of transportation ("Whatever Happened to Matthew (Stymie) Beard?," *Ebony* 30, no. 3 [January 1975]: 134). In Helen Oakley Dance's *Stormy Monday: The T-Bone Walker Story* (Baton Rouge: Louisiana State University Press, 1987), T-Bone Walker remembered that Stymie was head of the Syanon Gospel Family Choir and was in charge of the Syanon bus drivers (208).

15. In 1960, Hal Roach reportedly planned to revive the *Our Gang* comedies starring triplets Tom, Dick, and Harry O'Leary. For reasons that are unclear, this plan did not go anywhere. See "Movie Mopheads," *Life,* May 23, 1960, 98.

16. "5,000 Items Auctioned in Hal Roach Ring Down," *Variety* 231, no. 11 (August 7, 1963): 11.

17. Jack Smith, "Echoes of Mirth Fade as Roach Studio Falls," *Los Angeles Times,* July 1, 1963, A1.

18. Everett M. Smith, "An Auction for Collectors of Memorabilia," *Christian Science Monitor,* September 6, 1963, 21.

19. Smith, "Echoes of Mirth Fade," A1.

20. Richard Bann, "Program Notes," screening of unaired footage from the demolition of Hal Roach Studios (1963), 19th International Sons of the Desert Convention, Egyptian Theater, Hollywood, Calif., July 6, 2014. See also Ward, *The History of the Hal Roach Studios,* 155.

21. Several sources claim Morrison also appeared in *The Jeffersons,* but I have been unable to corroborate this. According to the Internet Movie Database, http://www.IMDB.com, Ernie Wheelwright played a character named Bo Morrison in one episode in 1979. I suspect that someone once transposed the names, and subsequent writers perpetuated the mistake.

22. Moore, *Twinkle, Twinkle, Little Star,* 19.

23. Moore did not specify the name of the chicken and waffles place, but I wonder if it's Roscoe's House of Chicken and Waffles, a popular spot for black celebrities. The menu still lists a dish called "Stymie's Choice"—fried or smothered chicken livers or giblets, served with grits, eggs, and a hot biscuit. I have not been able to confirm whether the dish was named after Stymie Beard.

24. Moore, *Twinkle, Twinkle, Little Star,* 17; Dennis McLellan, "Film Pioneer Hal Roach, Comedy King, Dies at 100," *Los Angeles Times,* November 3, 1992, 1.

25. Moore, *Twinkle, Twinkle, Little Star,* 17.

26. Thomas and Menefee, *"Otay!,"* 106; Maltin and Bann, *The Little Rascals,* 268.

27. Thomas and Menefee, *"Otay!,"* 110–15.

28. "Allen Hoskins Is Dead at 59; Played in 'Our Gang' Comedies," *Hartford Courant,* July 28, 1980.

29. "Our Gang Star Is Dead."

30. "Black 'Little Rascals' Don't Get a Dime," 22.

31. Quoted in Maltin and Bann, *The Little Rascals,* 247.

32. Allen C. Hoskins obituary, *Jet,* August 14, 1980.

33. Maltin and Bann, *The Little Rascals,* 245.

34. Ernie Morrison, from *Our Gang: Inside the Clubhouse,* directed by Lang.

35. Thomas and Menefee, *"Otay!,"* 91.

36. Maltin and Bann, *The Little Rascals,* 268.

37. Ferderber, "I Wish My Mom Could See Me Now," F36.

38. Autographed photograph of Stymie Beard, ca. late 1970s, Series 5, Box 7, Folder 26, Dr. Huey P. Newton Foundation Inc. Collection, Department of Special Collections and University Archives, Stanford University.

39. Skip Ferderber, "'Stymie' Famous Again: 'Our Gang' Character Led 'Life of Horror,'" *Los Angeles Times,* June 18, 1973, D10.

40. Leonard Maltin, quoted in Tom Ferran, "Rascals Were Beloved in Their Time," *Cleveland Plain Dealer,* December 13, 1992.

41. Svetlana Boym, "Nostalgia and Its Discontents," *Hedgehog Review* 9, no. 2 (Summer 2007): 8.

42. Doris Worsham, "'Our Gang' Actor Views Roles of Blacks in Films," *Oakland Tribune,* February 14, 1975.

43. "Stymie, of Lil' Rascals, Suffers Stroke in L.A.," *Jet,* January 22, 1981, 58.

44. "Buh-Weet Sings," *Saturday Night Live,* season 7, episode 2, NBC, aired October 10, 1981.

45. "The Uncle Tom Show," *Saturday Night Live,* season 7, episode 5, NBC, aired January 30, 1982; "Buh-Weet and de Dupreems," *Saturday Night Live,* season 7, episode 14, NBC, aired March 20, 1982; Opening Monologue, *Saturday Night Live,* season 8, episode 6, NBC, aired November 13, 1982.

46. Tony Schwartz, "How an Amiable Youth Became a TV Star at 20," *New York Times,* October 26, 1981, 21.

47. Eddie Murphy, comedy routine, *The Tonight Show Starring Johnny Carson,* aired January 1, 1982, https://www.youtube.com.

48. Tom Shales and James Andrew Miller, *Live from New York: An Uncensored History of Saturday Night Live* (New York: Hachette, 2008), 253.

49. Leroy Clark, "The Second Coming of Amos 'n' Andy," *New Crisis* 107, no. 1 (January–February 2000): 34–35.

50. Clarence Page, "Buckwheat Craze Was Bad Enough the First Time," *Chicago Tribune*, August 26, 1987, 17.

51. Vicky Edwards Gehrt, "His Gang: Spanky McFarland Remembers His Long Stint as a 'Little Rascal,'" *Chicago Tribune*, March 26, 1993, 3.

52. Thomas and Menefee, *"Otay!,"* 126.

53. Shales and Miller, *Live from New York*, 253.

54. "Buckwheat Buys the Farm," *Saturday Night Live*, season 8, episode 15, NBC, aired March 12, 1983; "Buckwheat Dead," *Saturday Night Live*, season 8, episode 16, NBC, aired March 19, 1983; "Buckwheat's Still Alive" and "The End of Buckwheat," *Saturday Night Live*, season 10, episode 9, NBC, aired December 15, 1984.

55. "Atlanta Radio Host Under Fire," *USA Today*, July 20, 1987.

56. "Tyll Back On Air," *Pittsburgh Post-Gazette*, July 23, 1987.

57. Roger Simon, "Windy City Campaign Blows Hot, Cold," *Los Angeles Times*, March 30, 1989, 12. The staffer, Larry Benas, claimed, "[Daley] never called me Buckwheat, but Buckwheat is my nickname. It has been my nickname ever since I was a teenager and there was the Little Rascals and I did this move on the roof and I got the name Buckwheat. That's my nickname. But Daley never called me Buckwheat."

58. "Town Official Under Fire for King Day Insult," *Maryland News-Journal*, January 23, 1992.

59. See Bob Herbert, "Bias Intensified by Inertia," *New York Times*, January 24, 1997; Meg Sullivan, "Protest Filed over Alleged Racial Slur by Teacher," *Los Angeles Times*, January 21, 1988; Eric Zorn, "Regardless of Intent, NU Rowdies' Taunt Was a Bad Call," *Chicago Tribune*, February 16, 1999.

60. Kyle Munzenrieder, "Obama Called 'Buckwheat' by Lone Republican in District 17 Race," *Miami New Times*, March 24, 2010.

61. Erich Nunn, "William Thomas," *African American National Biography*, Oxford African American Studies Center, 2008, http://www.oxfordaasc.com.

62. Quoted in Thomas and Menefee, *"Otay!,"* 130–31.

63. Ibid., 132. "Farina" Hoskins also continued to have imposters. In 1970, for example, Elizabeth Kasey of Baltimore, Md., claimed to the *Afro-American* that she was the real Farina (Edith House, "Our Gang Star Grows Up," *Baltimore Afro-American*, August 8, 1970, A1).

64. Page, "Buckwheat Craze," 17.

65. Marco della Cava, "Parents Have the Power to Raise Colorblind Children," *USA Today*, September 18, 1989.

66. David Fisher, "Some Blacks See No Humor in 'Buckwheat' Stereotypes," *Moscow-Pullman Daily News*, April 29, 1988.

67. Page, "Buckwheat Craze," 17.

68. "I'm O-Tay, You're O-Tay," *The Parent 'Hood,* season 2, episode 16, WB, aired February 21, 1996.

69. "'New Little Rascals' to Be Feature Film," *Back Stage* 16, no. 6 (February 7, 1975): 24.

70. Tom Dunkel, "Big Bucks, Tough Tactics," *New York Times,* September 17, 1989, A56. Elsewhere, the number is quoted as $250,000 (Dennis McDougal, "The Big Rascals: The King Brothers Rule in TV Syndication," *Los Angeles Times,* December 18, 1988).

71. Angela Carfagna, "Michael King's World," *FDU Magazine* 11, no. 2 (Fall/Winter 2003).

72. McDougal, "The Big Rascals."

73. Carfagna, "Michael King's World"; Kathryn Baker, "Kings of Syndication," *The Free-Lance Star,* November 21, 1987, 37.

74. McDougal, "The Big Rascals."

75. Ibid. Michael King confirmed the importance of *The Little Rascals* to King World's history and also related the long struggle to get the 1994 *Little Rascals* movie made (Michael King, telephone discussion with the author, February 13, 2013).

76. Elaine Dutka, "It's a Wrap for Spanky's Gang," *Los Angeles Times,* April 6, 1994.

77. Penelope Spheeris, interview, Argentina Brunetti Papers, Margaret Herrick Library, Academy of Motion Picture Arts and Sciences.

78. Barry Koltnow, "Little Rascals Little Darlings, Says Director," *Toronto Star,* August 2, 1994, C5.

79. Pancho Doll, "Reel Life: Spielberg Company Remakes Multiethnic 'Little Rascals' Film," *Los Angeles Times,* July 28, 1994, 4.

80. Eric Bennett, "Los Angeles Riot of 1992," *Africana: The Encyclopedia of the African and African American Experience, Second Edition,* Oxford African American Studies Center, 2005, http://www.oxfordaasc.com.

81. Ice-T and Douglas Century, *Ice: A Memoir of Gangster Life and Redemption* (New York: One World/Ballantine, 2012), 18.

82. Ibid., 20.

83. Tom Brokaw, *Gangs, Cops, and Drugs,* NBC News Productions, aired August 15, 1989. See also Robert Reinhold, "Gang Violence Shocks Los Angeles," *New York Times,* February 8, 1988.

84. Reinhold, "Gang Violence."

85. Roach, "Living with Laughter," 23.

86. Critics like Cornel West believed "race was the visible catalyst, not the underlying cause" of the riots, an opinion shared by the labor historian Mike Davis. See West, *Race Matters* (Boston: Beacon Press, 2001), 1.

87. "The Los Angeles Experiment: A Human Relations Challenge,"

To Rebuild Is Not Enough: Final Report and Recommendation of the Assembly Special Committee on the Los Angeles Crisis, September 28, 1992.

88. Rita Kempley, "Otay! Still That Old Gang of Ours," *Washington Post,* August 5, 1994, C6. Many critics noted that the film still employed sexual stereotypes. Desson Howe, for example, criticized the film for "perpetuat[ing] boy-girl stereotypes and gender enmity" ("Out of the Mouths of Babes," *Washington Post,* August 5, 1994, N38).

89. Kempley, "Otay!," C6. Of course, Porky and Buckwheat had both said "Otay!" in the original *Our Gang* comedies, but the phrase was now associated solely with Buckwheat, at least partly due to Eddie Murphy's parody.

90. Michael Wilmington, "'Little Rascals' Almost Criminal Remake Abandons Kids in Time Warp," *Chicago Tribune,* August 5, 1994, 7C.

91. For a helpful genealogy of the term "politically correct," see Harold K. Bush, "A Brief History of PC, with Annotated Bibliography," *American Studies International* 33, no. 1 (April 1995): 42–64. Bush traces the "height of initial PC mania" to the fall and winter of 1990–91, when essays by Richard Bernstein, John Searle, and Dinesh D'Souza sparked controversy over liberal biases in higher education.

92. As noted earlier, the one decidedly "un-PC" aspect of the 1994 *Little Rascals* remake was the treatment of gender.

93. David J. Fox, "A 'Clear' Triumph at Box Office," *Los Angeles Times,* August 8, 1994; "US Top 100 1994 Box Office," *Screen International,* January 27, 1995, 47. On a purely anecdotal note, I am often taken aback at how many of my students, most of whom were born in the early 1990s, fondly remember the 1994 *Little Rascals* movie, either from seeing it in the theater or watching it on home video.

94. Eric Spitznagel, "Mickie Wood, Mother of Controversial Child Pageant Star Eden Wood, Responds to Her Critics with Fart Noises," *Vanity Fair,* August 18, 2011.

95. Ryan J. Dejonghe, review of *Little Rascals Save the Day,* March 31, 2014, http://www.amazon.com.

96. See Michael C. Dobson and Lawrence D. Bobo, "One Year Later and the Myth of a Post-Racial Society," *Du Bois Review* 6, no. 2 (2009): 247–49. Dobson and Bobo attribute to Lou Dobbs the claim that America in the "21st century [is a] post-partisan, post-racial society" (247).

97. Tom Russo, "Rascals, Dinosaurs, Bieber, and More," *Boston Globe,* April 6, 2014, N14.

98. Jenna Ortega, resume, http://www.IMDB.com.

99. Rio Mangini, resume, http://www.IMDB.com.

100. Lise Funderburg, "The Changing Face of America," *National Geographic,* October 2013. See also D'vera Cohn, "Are Minority Births the Majority Yet?" *Pew Research Center,* June 4, 2014; Hope Yen, "Census: White Majority in U.S. Gone by 2043," Associated Press, *NBC News,* June 13, 2013. The U.S. Census Bureau issued a press release on December 12, 2012, predicting the country would become a "majority-minority nation" by 2043.

101. Paul Lewis, "March on Washington Leader John Lewis: 'This is Not a Post-Racial Society,'" *Guardian,* August 7, 2013.

102. See Jill Lepore, *The White of Their Eyes: The Tea Party's Revolution and Battle over American History* (Princeton: Princeton University Press, 2011).

103. Michelle Alexander, *The New Jim Crow: Mass Incarceration in the Age of Colorblindness* (New York: New Press, 2012).

FILM APPENDIX

1. Filming of *Fast Company* began in March 1923 but wasn't completed until the following year, when it was finally released.

2. *General Spanky* was *Our Gang*'s sole feature-length film.

BIBLIOGRAPHIC ESSAY

Hal Roach never met a story he couldn't improve. His biographer Richard Bann once called him out on one of his many "embellishments," protesting, "That didn't happen! I was right there!" and Roach retorted, "Well, my story's better!" (related in discussion between Bann and the author, Culver Hotel, Culver City, California, October 30, 2012). With this book, I tried to preserve the rollicking quality of the *Our Gang* story while maintaining a scholar's attention to historical context, evidence, and methodology. This essay is intended for those readers who wish to delve further into the theoretical and historical materials from which I draw. It is by no means exhaustive, but I hope it may be useful to students and scholars.

FILM HISTORY

Robert Sklar's *Movie-Made America: A Cultural History of American Movies* (New York: Vintage, 1994) is a lively cultural history of American cinema, expansive in scope and still the definitive text in the field. William Everson's *American Silent Film* (Boston: Da Capo Press, 1998) provides a useful survey of early silent films and the transition to the "talkies," as does Scott Eyman's *Speed of Sound: Hollywood and the Talkie Revolution, 1926–1930* (New York: Simon and Schuster, 1997). Everson also wrote *The Films of Hal Roach* (Greenwich, Conn.: Museum of Modern Art, 1971), a more detailed analysis of Roach's oeuvre. Thomas Doherty has written several narrowly sliced cultural histories of American film and television, including *Pre-Code Hollywood: Sex, Immorality, and Insurrection in American Cinema, 1930–1934* (New York: Columbia University Press, 1999), *Projections of War: Hollywood, American Culture, and World War II* (New York: Columbia University

Press, 1993), and *Cold War, Cool Medium: Television, McCarthyism, and American Culture* (New York: Columbia University Press, 2005). Each convincingly reveals the social and political forces that shaped mass media.

My own study is indebted to the work of several film historians who examine racial representations in Hollywood. Donald Bogle provides a vivid taxonomy of black stereotypes in *Toms, Coons, Mulattoes, Mammies, and Bucks: An Interpretive History of Blacks in American Films* (London: Bloomsbury, 2001), with especially memorable descriptions of Lincoln Perry, aka Stepin Fetchit. Bogle's *Bright Boulevards, Bold Dreams: The Story of Black Hollywood* (New York: Ballantine, 2006) also compellingly evokes, decade by decade, the black film community in Los Angeles. Drier in tone is Thomas Cripps's *Slow Fade to Black: The Negro in American Film, 1900–1942* (New York: Oxford University Press, 1993), a useful compendium of black representation in early twentieth-century film. Writing from a Marxist perspective, Ed Guerrero, in *Framing Blackness: The African American Image in Film* (Philadelphia: Temple University Press, 1993), depicts how Hollywood profited from black stereotypes from the silent film era to the present. Ann Everett's *Returning the Gaze: A Geneology of Black Film Criticism, 1909–1949* (Durham, N.C.: Duke University Press, 2001) looks at how black film critics responded to racialized images in the cinema in the first half of the twentieth century.

In addition to extensive archival work with the Hal Roach Collection at the Cinematic Arts Library at the University of Southern California and the private papers of Allen Clayton Hoskins (held by Michael Hoskins), I relied heavily on Leonard Maltin and Richard Bann's *The Little Rascals: The Life and Times of "Our Gang"* (New York: Three Rivers Press, 1992) and Richard Lewis Ward's *A History of the Hal Roach Studios* (Carbondale: Southern Illinois University Press, 2005). Maltin and Bann's book is a fan favorite, providing a complete filmography, hundreds of photographs, and countless anecdotes about the making of the series. Ward's book is a meticulously researched account of Hal Roach Studios' nearly fifty-year existence and is an integral source for any scholar of the Laugh Factory to the World.

MEDIA AND PERFORMANCE STUDIES

First published twenty years ago but still vital to our understanding of minstrelsy's impact on American culture, Eric Lott's *Love and Theft: Blackface Minstrelsy and the American Working Class* (New York: Oxford University Press, 1993; 20th anniversary ed., 2013) traces the contradictory impulses of desire, appropriation, and fear that charac-

terized white America's obsession with black culture in the nineteenth century. More recently, Yuval Taylor and Jake Austen have written an overview of minstrelsy's influence in radio, film, television, and music from the nineteenth century to the present day. Their *Darkest America: Black Minstrelsy from Slavery to Hip-Hop* (New York: W. W. Norton, 2012) is concise and highly readable. W. T. Lhamon Jr. approaches minstrelsy from a sociological perspective in *Raising Cain: Blackface Performance from Jim Crow to Hip Hop* (Cambridge, Mass.: Harvard University Press, 1998). His work appears alongside essays by several other scholars of blackface performance in Stephen Foster's edited collection, *Burnt Cork: Traditions and Legacies of Blackface Minstrelsy* (Amherst: University of Massachusetts Press, 2012), a useful introduction to current work in the field. Older but still relevant is Joseph Boskin's *Sambo: The Rise and Demise of an American Jester* (New York: Oxford University Press, 1988), which focuses on the durability of one racial stereotype across time. Robert Toll's *Blacking Up: The Minstrel Show in Nineteenth-Century America* (New York: Oxford University Press, 1974) is one of the earliest attempts to decipher the cultural work of minstrel shows. A comprehensive history of black humor, Mel Watkins's *On the Real Side: A History of African American Comedy* (Chicago: Chicago Review Press, 1999) uncovers the coded, subversive possibilities of minstrelsy.

Within performance studies, Robin Bernstein's *Racial Innocence: Performing American Childhood from Slavery to Civil Rights* (New York: New York University Press, 2011) is a virtuosic analysis of the way ideologies of race and childhood intersect in theater, literature, and material culture. In *The Amalgamation Waltz: Race, Performance, and the Ruses of Memory* (Minneapolis: University of Minnesota Press, 2011), Tavia Nyong'o focuses on performances of interracialism or racial hybridity in theater, music, and the visual arts. His article on *Our Gang,* "Racial Kitsch and Black Performance," *Yale Journal of Criticism* 15, no. 2 (2002): 371–91, unsparingly examines the racialized performances of *Our Gang*'s black stars. Daphne Brooks's *Bodies in Dissent: Spectacular Performances of Race and Freedom, 1850–1910* (Durham, N.C.: Duke University Press, 2006) is a fascinating interdisciplinary study of race, performance, and literature that unpacks the ideological complexity of Bert Williams's minstrel performances. Another helpful text is Saidiya V. Hartman's *Scenes of Subjection: Terror, Slavery, and Self-Making in Nineteenth-Century America* (New York: Oxford University Press, 1997), which analyzes spectacles of race and power in the antebellum and postbellum periods.

Stuart Hall's essays "Encoding/Decoding" and "Racist Ideologies

and the Media," both in *Media Studies: A Reader,* ed. Sue Thornham, Caroline Bassett, and Paul Marris (New York: New York University Press, 2010), are decades old but still essential to understanding media reception from a cultural studies standpoint. Sasha Torres's *Black, White, and in Color: Television and Black Civil Rights* (Princeton: Princeton University Press, 2003) investigates how the interests of network television and the civil rights movement aligned between 1955 and 1965. In *Equal Time: Television and the Civil Rights Movement* (Champaign: University of Illinois Press, 2013), Aniko Bodroghkozy looks at how television helped reconfigure racial attitudes during this same period. For a broader perspective on black representation in film and television, Valerie Smith's edited collection *Representing Blackness: Issues in Film and Video* (New Brunswick, N.J.: Rutgers University Press, 1997) brings together essays by historians, cultural critics, and race scholars. For an accessible historical overview of racial stereotypes on television, see Donald Bogle's *Prime Time Blues: African Americans on Network Television* (New York: Farrar, Straus, and Giroux, 2001).

AFRICAN AMERICAN HISTORY

Al Hoskins taught his children about African American history before it was routinely taught in schools. If he were alive, he would be astonished and gratified by the quality and quantity of scholarship produced today.

My work builds on two seminal studies of race in America, both initially published in the mid-twentieth century. The first, *An American Dilemma: The Negro Problem and Modern Democracy* (New Brunswick, N.J.: Transaction Publishers, 2009), is a magisterial history and sociological study of American race relations. Written by a Nobel Prize–winning Swedish economist, *An American Dilemma* documents the continued obstacles to African American participation in the "American Creed" and displays Gunnar Myrdal's unflinching objectivity toward the incendiary topic of race. The second, C. Vann Woodward's *The Strange Career of Jim Crow* (New York: Oxford University Press, 2001), provides a surprising and illuminating history of the color line, showing that Jim Crow laws were a relatively recent invention and that racial mixing occurred more frequently in the antebellum and Reconstruction South. Both Myrdal's and Woodward's studies were tremendously influential to the civil rights movement and remain critical to any understanding of the nation's racial history.

Nineteenth- and twentieth-century African American history is haunted by the specter of the Ku Klux Klan, racial terror, and lynching. For more on the Klan's history, from its beginnings in Reconstruction

to its revivals in the 1920s and post–World War II, see David Chalmers's *Hooded Americanism: The History of the Ku Klux Klan* (Durham, N.C.: Duke University Press, 1987). Nancy Maclean's *Behind the Mask of Chivalry: The Making of the Second Ku Klux Klan* (New York: Oxford University Press, 1994) looks more closely at how the racial hatred of 1920s Klan members emerged from white, middle-class anxiety over social, economic, and racial change. Thomas Pegram's *One Hundred Percent American: The Rebirth and Decline of the Ku Klux Klan in the 1920s* (Lanham, Md.: Ivan R. Dee, 2011) considers the Klan's restrictive definitions of "American" and its metamorphosis into a more mainstream, national fraternal organization.

Reading about racial violence is one thing; seeing images is another. James Allen's *Without Sanctuary: Lynching Photography in America* (Santa Fe: Twin Palms Publishers, 2000) brings together a chilling visual archive of lynching photographs and souvenir postcards. In *Lynching and Spectacle: Witnessing Racial Violence in America, 1890–1940* (Chapel Hill: University of North Carolina Press, 2009), Amy Louise Woods contends that lynching's visual impact made it a perverse form of "racial performance," meant to affirm white supremacy and consolidate white identity—something it had in common with racial performance in film and other media. Woods also argues that images of lynching were eventually deployed to support the NAACP's antilynching campaign in the first decades of the twentieth century.

Despite the grim reality of American race relations, the nostalgic fantasy of the Old South still resonated powerfully in American popular culture in the postbellum period and beyond. Karen L. Cox's *Dreaming of Dixie: How the South Was Created in American Popular Culture* (Chapel Hill: University of North Carolina Press, 2011) investigates how music, radio, travel literature, and movies shaped Americans' view of the South from the late nineteenth century through World War II. Tara McPherson's *Reconstructing Dixie: Race, Gender, and Nostalgia in the Imagined South* (Durham, N.C.: Duke University Press, 2003) looks at how cultural representations of the American South from the 1930s to the present helped obscure and distort the region's racial history.

Even as films like *The Littlest Rebel* and *Gone with the Wind* promulgated a sentimental fantasy of the South, scandals like the Scottsboro trials painted a very different picture of Southern justice and Jim Crow hysteria. Dan Carter's *Scottsboro: A Tragedy of the American South* (Baton Rouge: Louisiana State University Press, 2007) remains the classic account of the Scottsboro case, revealing how it set off a wave of protests and legal challenges that turned it into

an international cause célèbre. In *A New Deal For Blacks: The Emergence of Civil Rights as a National Issue: The Depression Decade* (New York: Oxford University Press, 2008), Harvey Sitkoff describes how the seeds of the civil rights movement were planted in the 1930s, as African Americans responded to the Scottsboro debacle and sought an end to lynching, segregation, and other forms of racial injustice. In her book *Farewell to the Party of Lincoln: Black Politics in the Age of FDR* (Princeton: Princeton University Press, 1983), Nancy Weiss shows how black voters shifted their political allegiances to the Democratic Party in the 1930s, throwing their support to Franklin D. Roosevelt and his New Deal coalition despite FDR's flimsy record on racial issues. With the outbreak of World War II, America's discriminatory policies at home increasingly conflicted with its rhetoric of democracy abroad. Maggi M. Morehouse's *Fighting in the Jim Crow Army: Black Men and Women Remember World War II* (Lanham, Md.: Rowman and Littlefield, 2000) and Phillip McGuire's *Taps for a Jim Crow Army: Letters from Black Soldiers in World War II* (Lexington: University Press of Kentucky, 1983) collect poignant first-person accounts of black soldiers and their experiences of racism in the segregated armed forces.

Any study of the civil rights movement must begin with Taylor Branch's authoritative trilogy *America in the King Years* (New York: Simon and Schuster, 1988–2006), a sprawling social history of the 1950s and 1960s that pivots on the figure of Martin Luther King Jr. David Halberstam's *The Children* (New York: Ballantine, 1999) is the eminently readable account of the young men and women who comprised the Student Nonviolent Coordinating Committee (SNCC). For more on how the mainstream news media consolidated support for the civil rights movement by publicizing events like Emmett Till's murder and the Montgomery bus boycott, see Gene Roberts and Hank Klibanoff's *The Race Beat: The Press, the Civil Rights Struggle, and the Awakening of a Nation* (New York: Vintage, 2007). The role of the black press in giving voice to racial issues and creating what Benedict Anderson has called an "imagined community" is described in Armistead S. Pride and Clint C. Wilson's *A History of the Black Press* (Washington, D.C.: Howard University Press, 1997) and Patrick Washburn's *The African American Newspaper: Voice of Freedom* (Evanston, Ill.: Northwestern University Press, 2006). The latter tracks the rise and decline of the black newspaper, with particularly useful accounts of the *Pittsburgh Courier* and *Chicago Defender,* two newspapers that avidly followed the lives of *Our Gang*'s black stars.

Finally, I include two recent works of history and social analysis that represent the inspiring and groundbreaking research being done

today. The first is Isabel Wilkerson's *The Warmth of Other Suns: The Epic Story of America's Great Migration* (New York: Vintage, 2011), a brilliant work of narrative history that incorporates the individual accounts of African Americans fleeing the Jim Crow South for the "promised land" of the North, Midwest, and West. The second is Michelle Alexander's *The New Jim Crow: Mass Incarceration in the Age of Colorblindness* (New York: New Press, 2012), a devastating exposé of the continued legacy of Jim Crow, as mass incarceration has turned into a new form of social and racial control.

LITERARY THEORY, CRITICAL RACE THEORY, AND CULTURAL STUDIES

As a student and teacher of African American literature, my theoretical foundation emerges from the world of literary criticism. Figures like W. E. B. Du Bois and Alain Locke theorized black consciousness in the early twentieth century, developing such critical terms as "double consciousness" (Du Bois, *The Souls of Black Folk* [New York: W. W. Norton, 1999]) and "The New Negro" (Locke, "The New Negro," in *The New Negro: Readings on Race, Representation, and African American Culture, 1892–1938*, ed. Henry Louis Gates Jr. and Gene Andrew Jarrett [Princeton: Princeton University Press, 2007]). In *The Signifyin' Monkey: A Theory of African American Literary Criticism* (New York: Oxford University Press, 2014), Henry Louis Gates Jr. establishes a lineage between the African and African American vernacular tradition; his theory of "signifyin'"—a kind of double-voicedness that mirrors the bifurcation of double-consciousness—was particularly useful in understanding the character of Stymie Beard. Toni Morrison's *Playing in the Dark: Whiteness and the Literary Imagination* (New York: Vintage, 1993) is primarily a study of the "Africanist" presence in white American literature, but her arguments are portable to minstrelsy, vaudeville, film, and other cultural forms haunted by the legacy of slavery. Further afield but still invaluable in understanding the vexed position of *Our Gang*'s black stars, Evelyn Brooks Higgenbotham's *Righteous Discontent: The Woman's Movement in the Black Baptist Church, 1880–1920* (Cambridge, Mass.: Harvard University Press, 1994) first described how "the politics of respectability" required black women to improve themselves while proving their respectability to white audiences. Someone like Farina Hoskins was likewise a tool of respectability, or "uplift" politics, appeasing white fears of blackness while advancing a reformist agenda.

In the past few decades, critical race theory has complicated the way we look at race and society, questioning ideals of cultural pluralism,

color blindness, and "postracialism." Derrick A. Bell's "Who's Afraid of Critical Race Theory?," *University of Illinois Law Review,* no. 4 (1995) reminds us of the persistence of institutional racism and our obligation to remain attentive to such injustices. Richard Delgado and Jean Stefancic's *Critical Race Theory: An Introduction* (New York: New York University Press, 2012) provides a breakdown of the origins and major tenets of the field, while compiling essays on everything from intergroup relations to intersectionality to crime (including Michelle Alexander's work on the "new Jim Crow"). Critical race theory has enriched discussions of racial representations in film, especially regarding issues of black spectatorship. Manthia Diawara's "Black Spectatorship: Problems of Identification and Resistance," in *Black American Cinema,* ed. Manthia Diawara (London: Routledge, 1993) argues for a type of "resistant spectatorship," in which black spectators respond oppositionally to racial representations in mainstream, or "dominant," white cinema. His analysis of "resistant spectatorship" to Eddie Murphy's character in white Hollywood films helps us understand why white and black audiences responded so divergently to *Our Gang*—and to Murphy's *Saturday Night Live* parody.

Linked to critical race theory is the field of whiteness studies, which looks at how racial "whiteness" is likewise culturally constructed. David R. Roediger's *The Wages of Whiteness: Race and the Making of the American Working Class* (New York: Verso, 1991) and Noel Ignatiev's *How the Irish Became White* (London: Routledge, 2008) are in some ways complementary texts to Eric Lott's *Love and Theft,* demonstrating how white workers and the Irish "became white" in the nineteenth century to distance themselves from African Americans, fellow victims of economic exploitation. Grace Elizabeth Hale's *Making Whiteness: The Culture of Segregation in the South, 1890–1940* (New York: Vintage, 1999) describes how the culture of segregation was built on this construction of whiteness. Richard Dyer's *White: Essays on Race and Culture* (London: Routledge, 1997) is an example of how the field has reoriented film and cultural studies, asking us to look at cinematic constructions of whiteness with the same critical eye as constructions of blackness.

Finally, my book is fundamentally a work of cultural studies, indebted to the groundbreaking work of Stuart Hall, whose essays "Cultural Studies: Two Paradigms," *Media, Culture, and Society* 2 (1980) and "Race, Culture, and Communications: Looking Backward and Forward at Cultural Studies," *Rethinking Marxism* 5, no. 1 (1992) argue for how political and social context shape culture and how "cultural racism" is still evident in contemporary mass media.

CHILDHOOD STUDIES

For a brisk, readable history of American childhood from the colonial days to the present, see Steven Mintz's *Huck's Raft: A History of American Childhood* (Cambridge, Mass.: Belknap Press, 2006). Mintz describes the myth of the carefree, innocent American child while acknowledging how the lives of African Americans, immigrants, and the poor diverged from this myth. Kenneth Kidd's *Making American Boys: Boyology and the Feral Tale* (Minneapolis: University of Minnesota Press, 2005) studies "boy culture" from the mid-nineteenth to late twentieth century and provides useful context for the "All-American boy" archetype in *Our Gang*. Notably absent from this idealistic vision of American childhood is the black child, who more often than not is represented as a pickaninny, inhuman, unfeeling, and comic. Robin Bernstein's *Racial Innocence* (also mentioned in the section on Media and Performance Studies) insightfully breaks down representations of black and white childhood, analyzing everything from topsy-turvy dolls to Uncle Tom handkerchiefs.

Caroline Levander brings together childhood studies and cultural studies in *Cradle of Liberty: Race, the Child, and National Belonging from Thomas Jefferson to W. E. B. Du Bois* (Durham, N.C.: Duke University Press, 2006), which investigates how children—black and white—were integral to the creation of an American national identity. Kristina DuRocher describes the various ways white children were indoctrinated into the code of Jim Crow in *Raising Racists: The Socialization of White Children in the Jim Crow South* (Lexington: University Press of Kentucky, 2011). Katharine Capshaw's *Civil Rights Childhood: Picturing Liberation in African American Photobooks* (Minneapolis: University of Minnesota Press, 2014) looks at how children's photographic books helped alter the dominant cultural image of the black child, transforming him or her into an agent of social and political change.

INDEX

Abbott, Robert Sengstacke, 82, 85

Academy Award for Live Action Short Film, 161

Adventures of Tom Sawyer, The (Twain), 37

African Americans: actors' roles, 100–101, 163–64, 173–74, 187, 299n48; athletes, 166–67; attitudes toward black actors, 163–64; in *Birth of a Nation*, xv; Black Filmmakers Hall of Fame, 219; black Gang members as role models, x, xvii, 28, 30–31, 82–84, 87, 88, 163, 202–3, 219, 263n62; and Communist Party of the United States, 144, 146; and FDR, 136–37, 172; Great Migration, xv, 41–42, 128; Harlem Renaissance, 128; in Los Angeles (1910s), 24–26, 260n20; in Los Angeles (1930s), 115–16; movies as shaping perception of, 152–54; newspapers, 81–82, 187–88; as performers in minstrel shows, 50–51; positive depictions in *Our Gang*, 34; post–World War II, xviii, 185–88; praise for *Our Gang*, 43–44; and radio, 124; reaction to Buckwheat revival, 222, 226–27, 228; reaction to *The Little Rascals*, 200–202, 203–4, 210–12, 297n41, 301n78; trickster in folklore, 128–30, 131–32; Underground Railroad, 4; unemployment during Depression, 115; white fears of sexuality of, 36, 108–9, 111, 134–35, 149, 206–7; World War I, 167; World War II, 172–74. *See also* civil rights movement; Jim Crow; lynchings; National Association for the Advancement of Colored People

Ahern, Lassie Lou, 236

Alameda County Association for Retarded Citizens (ARC), 215, 240–41

Alaska, 10–11

Julia Lee is assistant professor of English at the University of Nevada, Las Vegas. She is author of *The American Slave Narrative and the Victorian Novel*.

Henry Louis Gates Jr. is the Alphonse Fletcher University Professor and director of the Hutchins Center for African and African American Research at Harvard University. He is an Emmy Award–winning filmmaker and author of *Life upon These Shores: Looking at African American History, 1513–2008* and *In Search of Our Roots: How Nineteen Extraordinary African Americans Reclaimed Their Past*.